A Material World

The Pennsylvania State University Press

University Park, Pennsylvania

EDITED BY GEORGE W. BOUDREAU AND
MARGARETTA MARKLE LOVELL

A Material World

CULTURE, SOCIETY, AND

THE LIFE OF THINGS

IN EARLY ANGLO-AMERICA

Part of chapter 7 previously appeared in *The Power of Objects in Eighteenth-Century British America*, by Jennifer Van Horn (Chapel Hill: University of North Carolina Press, 2017), chapter 5.

This publication has been supported by grants from the Chipstone Foundation and the National Society of The Colonial Dames of America in the Commonwealth of Pennsylvania.

Library of Congress Cataloging-in-Publication Data

Names: Boudreau, George W., editor. | Lovell, Margaretta M., editor.
Title: A material world : culture, society, and the life of things in
 early Anglo-America / edited by George W. Boudreau and Margaretta Markle
 Lovell.
Description: University Park, Pennsylvania : The Pennsylvania State University
 Press, [2019] | Includes bibliographical references and index.
Summary: "A collection of essays that examine early American cultural, political,
 and social history through a material lens, exploring the meanings of objects
 ranging from artworks and domestic furnishings to Penn's Treaty Tree"—
 Provided by publisher.
Identifiers: LCCN 2018030800 | ISBN 9780271081151 (cloth : alk. paper)
Subjects: LCSH: Material culture—United States—History—18th century.
 | United States—Civilization—18th century. | United States—Social life and
 customs—18th century. | Politics and culture—United States—History—18th
 century.
Classification: LCC E162 .M33 2019 | DDC 973.2—dc23
LC record available at https://lccn.loc.gov/2018030800

The Pennsylvania State University Press is a member of the Association of University Presses.

It is the policy of The Pennsylvania State University Press to use acid-free paper. Publications on uncoated stock satisfy the minimum requirements of American National Standard for Information Sciences—Permanence of Paper for Printed Library Material, ANSI z39.48–1992.

In memory of Robert L. McNeil Jr.
(1915–2010)

Longtime friend and patron
Not just of this project, but of early
Americanists everywhere

Contents

Contents

viii

Acknowledgments

Editing a volume like this one, with contributors scattered over many miles, topics covering diverse subfields, and two editors separated by a continent (and three time zones) has been a challenge, but one that we have enjoyed greatly. As this book goes to press, we are happy to acknowledge many friends of the project.

A Material World began as a series of conversations. Inspired by our late friend and colleague Allis Eaton Bennett, we began discussing portraits and the stuff of early American culture in a colonial revival garden in Philadelphia's Society Hill many years ago. That conversation led to correspondence, discussions at conferences, and a great deal of mentoring on Margaretta Lovell's part for her eventual coeditor.

As these conversations grew into a book, we decided that we would dedicate it to our mutual friend and benefactor Robert Lincoln McNeil Jr. Bob's passion for early American art and architecture led to a lifetime of collecting and supporting numerous organizations and museums, many of which resonate in the pages that follow. At early moments of our careers (and those of many scholars and museums), he provided critical support. We were glad we could share this book's dedication page with him, just before his death.

We are especially grateful for the wonderful, smart, and supportive editorial team at Penn State University Press. From our first conversation, Kathryn Yahner was an inquisitive, supportive, often funny, and very well organized editor who helped transform this volume from an idea into a completed book. Hannah Hebert took on the daunting task of moving the manuscripts through the final stages with good advice and great patience. Finally, Suzanne Wolk brought her splendid editorial eye, finding many errors and omissions that we had missed. We couldn't have asked for more outstanding work than these three women gave to *A Material World*.

Several organizations contributed in various ways to this book's publication. Richard Dunn, Daniel Richter, and Amy Baxter-Bellamy at the McNeil Center for Early American Studies, and the late Frances Delmar and former superintendent Mary Bomar at Independence National Historical Park, along with INHP chief curator Karie Diethorn, allowed us to use their spaces and collections. The American Philosophical Society provided a venue for early discussions.

A book like this is costly to produce, and in addition to the support and generosity of Penn State University Press, we were very fortunate to receive funding from the National Society of Colonial Dames of America in the Commonwealth of

Pennsylvania (and its former president, Anne L. B. Burnett), the Chipstone Foundation (and its executive director and chief curator, Jonathan Prown), the Jay D. McEvoy Chair of the University of California at Berkeley, Rutgers University's School of Arts and Sciences, and the College of the Holy Cross to support illustration and design.

A Material World would not be complete without the numerous illustrations that fill these pages. While individual authors take the opportunity to thank the curators and collections whose illustrations follow, the editors would like to thank several people and institutions who aided in the book's production, including Erin Beasley (Smithsonian National Portrait Gallery), Claire Blechman (Peabody Essex Museum), Elizabeth Bray (British Museum), Karie Diethorn (Independence National Historical Park), Sierra Dixon (Connecticut Historical Society), Susan Grinols (Fine Arts Museums of San Francisco), Andy Harrison (Johns Hopkins Medical Institutions), Nicole Joniec and Ann McShane (Library Company of Philadelphia), Camilla Marking and Daragh Kenny (National Gallery, London), Susan Newton (Winterthur), Jaclyn Penny (American Antiquarian Society), Richard Sieber (Philadelphia Museum of Art), and Alexander Till (Pennsylvania Academy of the Fine Arts).

Most of all, we thank the splendid cohort of authors whose prose fills these pages. They've been brilliant, patient, and challenging at the many turns that led from ideas to a book. To them, we raise a friendly glass across the miles and shout, "HUZZAH!"

Finally, we thank our families and the many friends whose support has aided in this long project.

Introduction

CULTURE, SOCIETY, AND THE MATERIAL WORLD

MARGARETTA MARKLE LOVELL

THE "TURN" THAT HAS made the legibility of objects a central concern for the history and literature disciplines, as well as for its more traditional homelands in anthropology and art history, has been revolving for some decades now. The challenge has been, and continues to be, harnessing the visual (and tactile) power of objects to questions that enlarge our understanding of first-order scholarly problems concerning culture and society. This volume represents recent research on early America that addresses this issue from a wide variety of perspectives.

Originally prompted by conversations at the symposium celebrating the opening of the newly constructed McNeil Center for Early American Studies at the University of Pennsylvania in 2005, this collection of essays asks two basic questions: how can we better understand the material world of the colonial and early national period, and how can "reading" these objects shed light on significant dimensions of social experience and cultural practices invisible in the written record? At this point, scholars from many disciplinary corners have developed an appetite for reading objects for evidence of the lives and values of the groups and individuals who imagined, fabricated, bought, and integrated them into their daily lives. Studying the social lives of objects, in other words, has the potential to give us new insights into the social lives of people, many of whom left us no other record of their activities, allegiances, or attitudes. In short, at its richest, close attention to visual and material culture can teach us how these objects were *thought*, and further, how that thinking can broaden our field of evidence.

Two key points stand out in material culture studies in general and in these essays in particular. First, the inclusion of objects as evidence underlines the cross-cultural

movement of people, raw materials, and ideas. Fundamental to thinking about objects in the 1720–1850 period under consideration here is the underlying fact of migration (and transmutation during migration) not only of physical objects but of their economic value and social power. The "Atlantic world" we see here is not just one in which things move from place to place or in which they exhibit "influence" (mimicry) or express class identity and social hierarchies, but also one in which complex economic, ethical, mnemonic, and political issues play out in the transport, design, use, and preservation of objects as quotidian as an "old cane chair" (in Laura Keim's essay) or as fashionable as a dressing table of Honduran mahogany, African rosewood, London design forms, and Charleston-specific ideas about the female face (in Jennifer Van Horn's essay). These studies focus on Britishness, not as an established worldview but as a quality with many facets, exported variously to disparate destinations, and morphing in unexpected ways over time and through space.

Second, these essays investigate the political life of seemingly unpolitical objects—a rock in Plymouth, Massachusetts, or an elm tree in Philadelphia (in Patricia Johnston's and George Boudreau's essays, respectively). We see the political nature of space when an elaborate house at the heart of Salem is razed, not just to make room for an even more fashionable domestic establishment but to eradicate physical evidence of one of the Revolution's losers, a notorious Loyalist (as Emily Murphy recounts). Objects, in other words, have the capacity to concentrate and make immediate concepts—including political alignments and antipathies—that otherwise might appear more diffuse. An object is a singular "remark." Although it can be perceived over time and over a sequence of visual investigations from multiple perspectives, it is nevertheless a single statement, and this oversimplification is its strength when an object carries political or ideological freight. Objects are assaulted or cherished as proxies for people and ideas—they suffer political aggression and political sanctity precisely because they are inert and silent, ready to receive the imprint of human sentiment. And yet even rocks and trees, these emphatically natural materials, are selected on the basis of long-standing human associations and value systems: granite had an aura of permanence and manly endurance; the elm tree was historically associated with strength and domesticity. The rock at Plymouth and William Penn's Treaty Tree, in other words, had prehistories as culturally invested materials.

While some of the objects discussed here are notable singularities, others gain their explanatory power as sets (for instance, the five-bay, double-pile, hip-roofed Georgian or "gentleman's" house form described by Stephen Hague), and sometimes within the context of personal assemblages (as the relics John Fanning Watson gathered, loved, and shared with his antiquarian friends in Philadelphia in the 1820s, as we learn from Laura Keim). On the most basic level, a surviving object can tell us about what tools and materials were available when it was made, including what concentrations of capital it required, what artisanal dexterity and ingenuity were involved in its

making, what knowledge and design ideas were available, what patronage was possible, and, not least, what level of care it has received over the intervening generations. In studying object sets, we can learn even more—about regional preferences and variants, habituated practices and inventions, diffusion and change.

Although often treated separately, visual culture—usually understood as comprising flat, two-dimensional representational objects produced in multiples for a popular audience—is here aggregated into the more encompassing category of material culture, which includes all objects modified or given particular meaning by humans. In dealing with visual culture assemblages, sets are the norm. Here, for instance, political cartoons (in Nancy Siegel's essay) accrue meaning not as singular visual events but in aggregate, that is, as a set of many different but related engraved prints that use repeated visual tropes and are produced in sizeable editions. Of course, all questions concerning sets of objects also involve issues of unit price, market depth, transportation systems, and diffusion through space. These issues are common to visual culture (revolutionary cartoons sympathetic to the cause of colonial independence produced in England, for instance) and to material culture (such as wooden-works shelf clocks produced in Connecticut, described in Paul G. E. Clemens and Edward S. Cooke Jr.'s essay).

Space, of course, is the medium through which objects flow, and in these essays the geographic focus is both diffuse—the oceans of the Atlantic world and the prairies of the Louisiana Purchase, for instance—and very particular (Boston, Philadelphia, Charlottesville, Charleston, London, Salem). The sea and the prairie are places of passage for ships and expeditions, with their cargoes of things, people, and ideas, places where the raw products of nature are gathered for analysis and use. Urban space, by contrast, figures here as a contact zone in which objects are summoned into being by desire, hope, competition, money, and aggression—where objects are made by knowledgeable hands, bought and sold, shared, valued, and repurposed. They become invested, in a word, with meaning by those who touch them, love them, or abhor them. If any further reason were needed for our close attention to objects, it is that the individuals and groups whose political, social, and cultural lives interest us paid close attention to them, and in the analysis of their valuing we track back through objects to those for whom they were meaningful and for whom they constituted the materials of daily living and personal identity.

If we think of object assemblages—the universe of Georgian houses, for instance, or an antiquarian's drawer of relics—as another kind of archive, we can mine them with the same intensity with which we pursue the verbal record of letters, diaries, and account books accidentally left to us to probe. We become eavesdroppers on incomplete conversations, some of which prove inconsequential, others of which prove our point. In order to unravel their unintended narratives, however, one must learn to attend to their languages and their implications. Formerly, art-oriented readers

have tended to insert objects into systems of "influence," and evaluate them on an imitation-to-innovation scale, while socially oriented object readers have tended to interpret them only, or mainly, as evidence of social emulation, a model in which objects spar as competitive champions on behalf of their owner-patrons. Both of these interpretive models are limiting and incorporate judgmental, even moral, overtones. The essays collected here seek more elusive, more grounded meanings. They reject those interpretive frameworks and seek meanings more congruent with contemporaneous value systems and more agile interpretive readings of patterns. That said, these essays do not propose a new orthodoxy for the reading of objects or the analysis of object data, or a new model for interpreting object sets, each study being tailored—and I take this to be a good thing—to the individual case at hand and judged by a single measure: is it persuasive?

Our interrogative hypothesis in assembling these essays was to ask whether, within an interdisciplinary framework, scholars could—by examining portraits, prints, decorative art objects, taxidermied heads, urban spaces, buildings, and other material objects—gain a new understanding of how the colonists of British America and the citizens of the new Republic constructed their identities, understood the world around them, and measured their place within it. These essays accomplish just that, and they testify eloquently to the wealth of perspectives and diversity of scholarship in this broad and promising field of inquiry.

Part 1, "Canvas and Culture: Portraits in Anglo-America," focuses on portraits and the mechanisms by which painters, their sitters, portrait audiences, and others constructed and recognized personal identity and group identity. George Boudreau, in "Picturing Penn: Portraits, Public Memory, and the Political Culture of Late Colonial Pennsylvania," focuses on retrospective visions of the early colonial period that employed powerful object talismans to link past and present. He explicates Benjamin West's iconic *Penn's Treaty with the Indians* (1771–72)—a canvas commissioned by Thomas Penn, son of Pennsylvania's seventeenth-century proprietor, and his aristocratic wife, Lady Juliana Fermor Penn and reproduced in the widely circulated medium of a popular print—within the vexed context of eighteenth-century Pennsylvania politics. Intended to bolster the claims of the Penn family, the utopic image of the wise Quaker founder peacefully establishing mutual respect and trade with the Lenni Lenape promotes a mythic vision of beneficent settlement. Boudreau points to West's incorporation of his own family's transatlantic memories and to the composition's more public role in the suppression of political enmity between the Penns and other prominent players in the years leading up to the American Revolution. This discussion of West's image positions it as a powerful projected memory of a seventeenth-century event infused with eighteenth-century politics.

If Boudreau's essay asks us to attend to a painting that served as a proxy for publicly endorsed and publicly recognized transatlantic colonial politics, Carol

Eaton Soltis's essay, "Ascending the Stair: Charles Willson Peale's *Staircase Group*, Reimagining a Grand-Manner Portrait in Federal Philadelphia," describes sociopolitical visual cues of a very different order in a painting usually understood (only) as evidence of a taste for trompe l'oeil, or "deception" art (disparaged among the cognoscenti in London but enthusiastically endorsed in the American context). If this is a testament to a taste for illusionistic wit and provincial literalness, Soltis argues, it is even more centrally a statement of Republican sentiments evidenced in the scale, pose, clothing, and pictorial structure of a double portrait that is also an explicitly antiaristocratic appropriation of a grand-manner format, a work that argues for the promise of a nonroyal, self-propelled elite based on personal achievement in the new nation.

Part 2, "Objects with Meaning," turns to the meanings we can discover in the attitudes toward objects and materials prized, used, and well understood in the long eighteenth century. Ellen G. Miles attends to the code embedded in artists' standardized canvas sizes in "Artists' Materials and the Transatlantic Craft Traditions of Eighteenth-Century American Portrait Painting." Far from arbitrary, she argues, the stretched canvas itself, before any face was affixed to it, carried a well-understood identity and pricing structure. In attending to this "substrate" dimension of objects, Miles's study exemplifies an important recent departure in material culture studies— the social history of materials.[1] Like book sizes that are based on a standardized eighteenth-century sheet of paper folded two, three, or four times, canvas sizes were based on cutting a full-size canvas (suitable for the life-size standing adult figure, or grand-manner portrait) into two, four, or eight segments, with comparable reductions in artistic effort, price, and value. Once painted, of course, these canvases became unique, but it is provocative to think of them, in their underlying structure, as participating not only in a web of cultural assumptions about the meaning of each format, but also in the context of the increasingly standardized fabrication techniques that developed over the course of the nineteenth century.

"Clock Making in Southwestern Connecticut, 1760–1820," by Paul G. E. Clemens and Edward S. Cooke Jr., tracks the successful development of small clocks fitted with inexpensive wooden works in the first two decades of the nineteenth century, a matter of entrepreneurial enterprise, new cultural imperatives in terms of keeping clock time even in rural areas, and the dawn of steam power efficiencies. Although still taxed as luxury goods, the clocks made by Eli Terry and Seth Thomas in rural Fairfield, Connecticut, Clemens and Cooke argue, belie common assumptions concerning the urban locale of Yankee ingenuity, in this case resulting in an innovative consumer product that quickly became available throughout the young United States and its territories at affordable prices. Essentially the result of invention, capital concentration, and a new power source, these clocks offer a paradigm for the relationship between makers, objects, consumers, and markets that became characteristic of

nineteenth-century business. Clemens and Cooke's study focuses on the key concept of consumerism, its historical roots, and its economic and social dynamics.[2]

Part 3, "Spaces of Power: Houses and Objects," turns to houses and the objects within them, picking up issues of politics, ideology, power, class, and self-fashioning in the domestic realm. In "Face, Place, and Power: James Logan, Stenton, and the Anglo-American Gentleman's House," Stephen G. Hague describes James Logan's building and residence at his country home outside Philadelphia from 1714 to his death at midcentury, contextualizing the cupola-proud home as both a relatively common transatlantic house type and the site of unique intellectual and bibliophilic activity. Hague tracks the coincidence of tax lists characterizing Logan as a "gentleman" or "Esq." with the project to build this two-and-a-half-story, five-bay, double-pile structure associated with the lower echelon of Britain's ruling elite and familiar on both sides of the Atlantic from the 1680s. While the house was one of hundreds of its type marking gentry status and land-based wealth (Logan, William Penn's secretary, owned eighteen thousand acres) in England, Ireland, and the New World, Logan's 2,681 books (in nine languages, with his marginalia, notes, and translations attesting to his readership) mark this assemblage of objects and his linguistic prowess as probably unique in the colonies and rare anywhere. In this study Hague wrestles with a topic full of potential—the social history of three-dimensional domestic space.[3]

If Logan's was a familiar, even common, gentry house type sheltering an extraordinary library and an extraordinarily learned proprietor, Thomas Jefferson's was a unique house with an equally unusual assemblage of objects that point eloquently to the character, education, assumptions, and hopes of their very different owner. "Trophy Heads at Monticello" focuses on Jefferson's lifelong project to create an environment rich in narratives animating historical and ideological projects that could, for him, illuminate the causes, virtues, and downstream effects of the Revolution and western expansion. His assemblage of heads—painted, sculpted, excavated, taxidermied—together with theories of the relation between external visage and internal character, theories of the power of models to generate aspiration and virtue in viewers, and theories of the progress of history, were characteristic of Jefferson's generation, but nowhere so vividly enacted in an object assemblage as at Monticello. Like the essays by Boudreau and by Johnston and Keim, discussed below, my essay focuses on the complications of objects assembled to exemplify, prompt, and bear witness to political narratives and exemplars.[4]

Turning to the question of what the close analysis of a single domestic object can tell us about its user, the user's face, and the social world she inhabited, Jennifer Van Horn animates one elite object in "'Painting' Faces and 'Dressing' Tables: Concealment in Colonial Dressing Furniture." While "showy" in materials and workmanship, the mahogany dressing table made in Charleston circa 1785 that anchors Van Horn's inquiry was not for show. Its adjustable looking glass and multiple fitted decorative

compartments for cosmetics were hidden when the object was not in use; and "dressing" the face in the colonies in that decade was not the sociable event that it was in Europe. The object's beauty and intricacies, then, were a matter of personal secret delight, while the resulting polished female "face" was a public delight. Enmeshed in anxious commentary about masking, counterfeiting, and deception, the object itself is coy and closed. Van Horn's study, like some of the recent pathbreaking work in the study of material culture, uses an object as a prompt for rethinking fundamental questions of gender, reinserting women into historical narratives.[5]

Part 4, "Revolutions of Image and Place," considers more public, more overtly political objects that explicitly declared patriotic sentiments during the Revolution itself and its immediate aftermath. Nancy Siegel, in "Mommy Dearest: Britannia, America, and Mother-Daughter Conflicts in Eighteenth-Century Prints and Medals," investigates the feisty "Indian Princess" figures—icons for the thirteen rebellious colonies—that populate political cartoons in the tumultuous revolutionary years. Satirical and often violent, these widely circulated prints, published mostly in London but also in the colonies, appropriated a comely allegorical Native American female figure that had been in circulation representing an iconic "America" since the sixteenth century, and positioned her as "daughter" to a matronly classicized Britannia. Assaulted, coerced, raped, and dismembered, her cartoon body externalized and condensed complicated narratives of colonial injury and outrage. An exhausted icon, following the Revolution she was displaced by a classicizing female iconic "Liberty."

Equally aggressive in a more genteel way, Elias Hasket Derby's elaborate homes and furnishings, according to Emily A. Murphy's "'The Family of Derby Has a Taste in This Way': The Homes of Elias Hasket and Elizabeth Derby, 1762–1799," expressed aggression toward and triumph over Britain and her sympathizers. Derby's wealth was derived from waterborne investments—fishing in the mid-eighteenth century, extremely successful privateering during the Revolution, and a fleet of China traders in the 1780s and '90s. He patronized New England's most celebrated architects, silversmiths, and furniture designers of his day and put his stamp on his hometown (Salem) by ripping down the home of a Loyalist grandee to construct an eagle-topped Republican mansion, thus making a grand show of both patriotism and profit. For Derby—as for Logan and Jefferson before him—the home and its contents were an eloquent marker of personal identity within the turbulent economic, political, and intellectual context of the transatlantic and global long eighteenth century. Scholarship focused on reading such changes in public experience of both urban and rural space in quotidian contexts has opened new promising avenues in the study of the spatial dimensions of material culture.[6]

Part 5, "Imagining Pasts: Images and Memory in Early America," looks at the role of objects in the construction of retrospective histories of the colonial past. Patricia Johnston's "From Region to Nation: M. F. Cornè's *Landing of the Pilgrims* and the

Circulation of Images in the Early Republic" returns to Elias Hasket Derby to probe a painting he ordered from an Italian immigrant artist, M. F. Cornè, in 1803 titled *Landing of the Pilgrims*, and tracks both backward to the source of this creatively inaccurate rendering of the landing scene, and forward through its many replications to its universal popular power throughout the nineteenth century. A scene pictured on canvas and on Staffordshire pitchers, described in orations, and invoked in poetry and sermons, the Pilgrim landing, Johnston argues, was a regional myth about the migration of British culture to the New World, and a national fable about the first step, not only upon a rock but upon a trajectory that would mature into national religious freedom and a self-governing democracy. An unformed rock in this case becomes an expansive rhetorical device with extraordinary mythic power.

If the Pilgrims' rock became a very public object intended to inspire future generations, the small bits of paper, cloth, and wood gathered in the home of John Fanning Watson in Philadelphia—as we learn in Laura C. Keim's "Remembering the 'Olden Time': John Fanning Watson's Cultivation of Memory and Relics in Early National Philadelphia"—were treasured as intimate and personal links to a seemingly sacred and fast receding past. Gathering relics—elm from the tree under which William Penn signed the Treaty with the Indians, a bit of mahogany from the home Columbus built—Watson and his circle basked in the association with the deep past, and the sense of literally touching that past in their handling pieces of wood, textile scraps, and other fragments of objects that had witnessed history in the making. Here was history as emotionally charged fragment. More broadly, Keim relates, Watson and such friends as Deborah Logan, who patiently transcribed James Logan's correspondence of a century earlier, founded the Historical Society of Pennsylvania, and preserved the archives as well as the objects that allowed them (and today allow us) to access shadows of past events not only in words but also in eloquent objects.

Together, these essays suggest a cross section of the objects, methods, and questions that recent scholars have knit into studies that build material culture windows into early America's social, political, and ideological past. By doing "readings" of objects and object sets, these authors point us toward new ways of thinking about identity, place, and creativity. They suggest that objects can be powerful agents as well as trace residue of significant social facts and ideological positions. More than the written record, objects insist that we think about the international movement of materials, ideas, and money, and about the almost magical transformations of those materials into shimmering talismans with the power to form, concentrate, and distort opinion and memory.

These essays reminds us to consider the environmental riches and the extraction industries at the base of most objects under scrutiny here: the clockworks that were maple trees, the dressing table that was a tropical mahogany tree, and the small box that was the Treaty elm, for instance. Factory assembly (or disassembly) systems, capital

concentrations, standardized parts, and the vigorous conversion of "free" common resources to human use—all characteristic of "modern" business practices—were, as these essays make clear, already successful in the early decades of the nineteenth century. The enabling codfish, the vast forests, the fertile soils were as important as these narratives of ideology legible in crafted (and found) objects, images, and houses.

NOTES

1. Among the most important materials-based studies are Jennifer L. Anderson's *Mahogany: The Costs of Luxury in Early America* (Cambridge: Harvard University Press, 2012); and Jennifer L. Roberts's chapter on Audubon in *Transporting Visions: The Movement of Images in Early America* (Berkeley: University of California Press, 2014), a study that points to meaning in the physical scale of a sheet of paper as much as in a depicted subject.

2. Notable works on consumerism and material culture in the American context include Cary Carson, Ronald Hoffman, and Peter J. Albert, eds., *Of Consuming Interests: The Style of Life in the Eighteenth Century* (Charlottesville: University Press of Virginia, 1994); Anne Smart Martin, "Makers, Buyers, and Users: Consumerism as a Material Culture Framework," *Winterthur Portfolio* 28, nos. 2–3 (1993): 141–57; Ann Smart Martin, *Buying into the World of Goods: Early Consumers in Backcountry Virginia* (Baltimore: Johns Hopkins University Press, 2008); and David Jaffee, *A New Nation of Goods: The Material Culture of Early America* (Philadelphia: University of Pennsylvania Press, 2010).

3. For multiple perspectives on the social history of space, see Daniel Maudlin and Bernard L. Herman, eds., *Building the British Atlantic World: Spaces, Places, and Material Culture, 1600–1850* (Chapel Hill: University of North Carolina Press, 2016). The most original analysis of domestic space as social space is probably still Robert St. George's "'Set Thine House in Order': The Domestication of the Yeomanry in Seventeenth-Century New England," in *New England Begins: The Seventeenth Century*, edited by Jonathan L. Fairbanks and Robert F. Trent, 3 vols., exh. cat. (Boston: Museum of Fine Arts, 1982), 3:159–88.

4. Interesting recent work that explicitly explores the nexus of vision and political narratives about citizenship includes Wendy Bellion, *Citizen Spectator: Art, Illusion, and Visual Perception in Early National America* (Chapel Hill: University of North Carolina Press for the Omohundro Institute of Early American History and Culture, 2011).

5. Exemplary work concerning women and objects includes Laurel Ulrich, *The Age of Homespun: Objects and Stories in the Creation of an American Myth* (New York: Knopf, 2001); and Laurel Thatcher Ulrich, Ivan Gaskell, Sara J. Schechner, and Sarah Anne Carter, *Tangible Things: Making History Through Objects* (Oxford: Oxford University Press, 2015). For thoughtful deep readings of individual (and unlikely) case-study objects, see Jennifer Van Horn, *The Power of Objects in Eighteenth-Century British America* (Chapel Hill: University of North Carolina Press for the Omohundro Institute of Early American History and Culture, 2017).

6. See, for instance, Kirk Savage, *Monument Wars: Washington, D.C., the National Mall, and the Transformation of the Memorial Landscape* (Berkeley: University of California Press, 2009), and recent collections of essays, one focused on New England— Martha J. McNamara and Georgia B. Barnhill, eds., *New Views of New England: Studies in Material and Visual Culture, 1680–1830* (Charlottesville: University of Virginia Press, 2012) —and the other on international dimensions of American culture: Patricia Johnston and Caroline Frank, eds., *Global Trade and Visual Arts in Federal New England* (Lebanon: University Press of New England, 2014).

Canvas and Culture

PORTRAITS IN ANGLO-AMERICA

Picturing Penn

PORTRAITS, PUBLIC MEMORY, AND THE POLITICAL CULTURE OF LATE COLONIAL PENNSYLVANIA

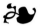

GEORGE W. BOUDREAU

ON JULY 12, 1775, Benjamin West prepared a gift to ship to his brother, far away in their native colony of Pennsylvania. West had left home fifteen years earlier, scraping together the money he had acquired painting portraits for Pennsylvania's grandees. His flattering images—if amateurish and stiff, by contemporary standards—had drawn praise and patronage among the colony's political elite, a group that had provided additional funds for the young artist. His benefactors probably imagined a return to the colony in time that would bring an established artist who could fill their walls with fashionable framed images. But that return had never happened. "Benny" West had studied in Italy and established himself as a painter on the continent, and then relocated to London, just as King George III's reign was bringing a new emphasis on the fine arts to the mother country. The young colonial artist had moved into circles that included aristocrats, royals, and the men and women who painted them. By 1775, he had come a long way from the youth whose work had delighted the newly rich of Philadelphia, and not just in geographical terms.[1]

That July, West wrote his brother, "I could not neglect so favorable an opportunity as this by Capt. Falconer to send you the print of Wm. Penn's treaty with the Indians when he founded the Province of Pennsylvania." It was probably the first time that the image that would grow to iconic status was seen on American soil. When West's parcel arrived at his brother William's home in the village of Upper Darby, eighteen miles west of Philadelphia, the contents must have seemed fantastic.

The twenty-four-by-nineteen-inch scroll of paper bore an engraved image of a crowd of men and women in a place familiar to the Pennsylvania farmer: a row of brick buildings in the background, with the Delaware River to their right, crowded with tall-masted ships and small craft bringing cargo to shore. The engraving copied, in mirror image, the history painting in oil that Benjamin West had completed a few years earlier, and showed a group of Indians gathered in the foreground under the branches of a massive elm tree. To their right, a group of European colonists stand, bearing products symbolic of the coming colonization: maps, trade cloth, and trunks of other prestige goods essential to Indian/white diplomacy and economics, an inter-action probably well ingrained in the minds of boys like the Wests growing up in the American colonies (fig. 1.1).

Yet the figure at the center of the engraving may have been both familiar and surprising: a portly man stands between the two groups, his face and figure literally bridging the two worlds of natives and newcomers. Most surprising, perhaps, was that the man was readily recognizable as a Quaker. Public presentations of Quakers as a people set apart by their dress were a rarity in Anglo-American history, and few if any public images commemorated or celebrated Friends' historical accomplishments a few decades earlier. When artists had attempted to portray Quakers, it had been to show novelty or deliver criticism. Not all Friends followed the patterns of dress that later centuries would associate with them. Quakers might pray and indeed live dif-ferently from their contemporary Anglo-Americans; their "thee and thou" might give auditory signal to non-Friends that they adhered to different theological and cultural practices, yet they did not necessarily broadcast these facts with visual or material clues. Benjamin West's massive oil-on-canvas history painting, which John Boydell had translated into an affordable engraving for public sale at his shop in Cheapside, London, changed all that. West sought to tell a Quaker story with visual signals. There could be no doubt about what was going on in West's painting or Boydell's print of it, no doubt that the white men portrayed in the work were Quakers. That the Friends in the center of the painting, like the Native Americans who faced them, were inac-curately dressed and placed before an anachronistic row of buildings didn't matter.

Benjamin West was crafting a useable past with his paintbrush, employing visual signals that attempted to make a messy history more tidy. He did so at a moment when a very troubled past was about to become an even greater struggle, when intra-colonial strife was poised to turn into the greatest revolution the world had seen to date. That conflict would split families and religious groups and shatter political bonds. Benjamin West's image was an attempt to bring those groups together in a shared memory, even if that memory wasn't exactly accurate. Grounded in his own family's story, it was an attempt to use art to arbitrate and persuade that would ini-tially fail, but would eventually win a bigger historical victory than West could ever have imagined.

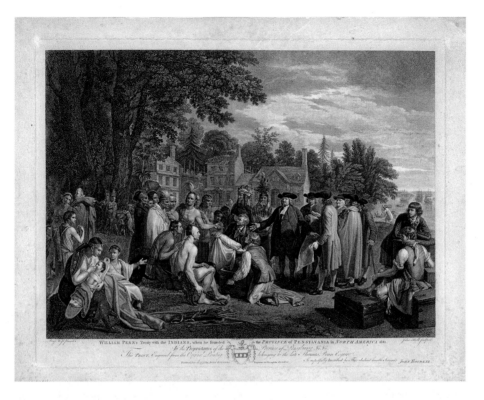

FIG. 1.1 John Hall after Benjamin West, *Penn's Treaty with the Indians, when he founded the province of Pennsylvania in North America 1681*. Published June 12, 1775, by John Boydell, engraver in Cheapside, London. Copper engraving, image 427 × 588 mm, sheet 483 × 620 mm. The Library of Congress Prints and Photographs Division, Washington, D.C. West's *Penn's Treaty* used faces and places familiar to the artist and his viewers in both England and America in the 1770s.

 The West brothers could not have known that the simple act of one sibling's sending a present to another would mark the arrival of one of America's most significant historical images on American soil. In time, the image of William Penn, clothed in the plain cut and color of Quaker dress, would become immediately recognizable as a symbol of Friends' beliefs and their role in an imagined past.[2] But in 1775, the image meant something much different. West's rendition of William Penn's legacy grew out of a decades-long conflict over the Pennsylvania colony's past. The nature of that past, growing out of one era of warfare and leading into another one, all the while coupling the leadership of a group of religious pacifists with a transatlantic world of cultural practices that set them apart, created Pennsylvania's unique story by the 1770s. Benjamin West's use of the image of the founder was a radical departure from decades of past practice, for no one had seen William Penn in the colony for three-quarters of a century. West's historical fabrication was a last-minute attempt to employ the image of the founder to invoke his beliefs and actions, to connect them to an imagined earlier,

better history, and to change the social perception of Quakers as inept or complicit in ills that had befallen the colony that bore the Penn family's name. It was a struggle that went back nearly a century before *Penn's Treaty with the Indians* arrived on American shores.

THE ABSENTEE PROPRIETOR

The roots of the struggle over Penn's legacy lay in his various plans for establishing his colony and the reality that followed them. After several attempts to come up with a workable charter, Penn had settled on a neofeudal system that placed him and his offspring at the political center of his planned "Holy Experiment." The diversity he created in the first years of planning and settlement might quickly turn to chaos, but in Penn's view, all of that would be overcome by his presence, by the respect he would earn from the diverse first settlers, Friends and non-Friends, and from their Indian neighbors.[3]

The problem was that his presence soon gave way to a prolonged and eventually permanent absence. Penn had planned to settle permanently in the Delaware Valley, but within two years of his arrival in 1682, he was needed back in London to advocate for a boundary that favored his claims over those of his rivals, the proprietors of Maryland. During this period, Penn's status as a leader of the Society of Friends, and as a man who had influence and power in the capital of the empire, was reflected in the words and works of both his supporters and his enemies. A 1698 anti-Quaker satirical engraving, possibly the first image of William Penn for public consumption, portrayed him seated among his coreligionists. Each man is dressed in a plain, dark suit with a simple collar, and the Quakers' broad-brimmed hats are evident throughout the small print. Penn's status within Quakerism is revealed in his placement in the image: he sits on the facing bench at the center of the "synod," next to George Whitehead, the meeting's leader (fig. 1.2).

William Penn did not return to Pennsylvania until 1699 owing to courtly intrigues, legal imbroglios, financial concerns, and the Glorious Revolution, and he was forced to return to the mother country again in less than two years' time. When Penn left Pennsylvania in 1701, it was the last time he was seen in the colony. A variety of financial and governmental problems kept the proprietor from his colony, and by 1710 he was negotiating to sell the proprietorship to Queen Anne's government. A massive stroke in November 1712 incapacitated him before that sale could be carried out. Had he died immediately, his heirs might have completed the transaction, and Pennsylvania would have become a royal colony. Instead, Penn retained the title yet was incapable of administering the colony for the rest of his life. Hannah Callowhill Penn, his second wife, acted as his regent until his death in 1718, and spent the years that followed protecting

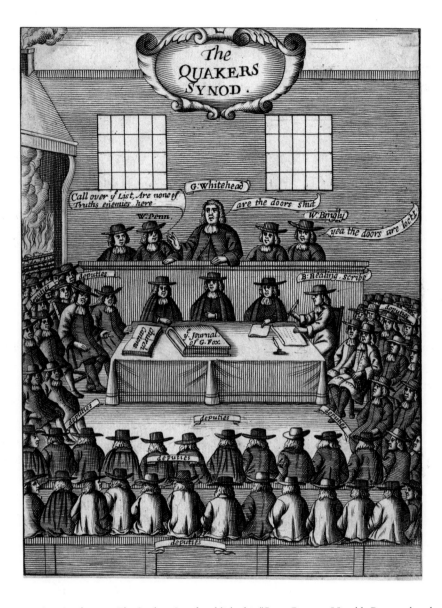

FIG. 1.2 Artist unknown, *The Quakers Synod*, published in "Some Reasons Humbly Proposed to the Lords Spiritual and Temporal Assembled in Parliament, why the Quakers Principles and Practices should be Examined, and Censured or Suppressed," May 21, 1689. According to the British Museum catalogue, the engraving was also the frontispiece of the anti-Quaker author Francis Bugg's "A seasonable caveat against the prevalency of Quakerism [. . .]" (London: Printed for the author, and sold by J. Robinson, at the Golden Lion in St. Paul's Church-Yard; and Ch. Brome, at the Gun at the West-End of St. Paul's; and Geo. Strahan, at the Ball over-against the Royal-Exchange, 1701) [ESTC T47255; ESTC system no. 006419102]. 189 × 140 mm. © The Trustees of the British Museum. All rights reserved. As early as 1689, Friends' opponents identified their religious beliefs with a distinctive plain style. It is unlikely that William Penn ever adopted Quaker plainness, an ideal that developed more fully decades after his death.

the interests of her young sons John, Thomas, and Richard, who were born between 1700 and 1706. The sons, like Pennsylvania, came to maturity without a father, remembering childhood and family tales about the patriarch in much the same way that the colonists would continue to spin myths about their founding father.[4]

The Penns were absentee proprietors from the time William left in 1701 until his son Thomas arrived in Philadelphia in 1732, during which time Penn's legacy grew to legendary proportions. Colonists gave him credit for the growth and prosperity of their colony, feeling pride and relief that the frontier conflicts that plagued other colonies did not occur in Pennsylvania, and honoring Penn for establishing the peaceful coexistence with Native Americans that seemed to make it all possible.

But a core aspect of consolidated, effective power was absent from Pennsylvania during this era. To a great extent, Anglo-Americans used images to connect with, understand, and support their leaders; faces and places were essential to subjects' connection to leadership. Paintings, prints, and decorative arts were all critical to the ways in which English people on both sides of the Atlantic showed affection for the monarchy and deference to the government. In Pennsylvania, this was not the case. No portrait of Penn graced the young government's meeting rooms; no ceremonial space in a capitol building or town hall heralded the governmental system that he had created. Unlike other colonies, or indeed the mother country, Penn's government had no impressive, symbolic place to associate with the colony's central leadership.[5]

Averse to portraits of himself once he joined the Society of Friends, Penn had no similar dislike of impressive displays of his wealth and power in the form of places. He planned to construct a mansion house near Philadelphia's Centre Square, and he desired a country seat at Fairmount, on a bluff overlooking both his colonial village and the Schuylkill River, two impressive displays of Anglo-American gentility that never came to fruition after Penn returned to England in 1684.[6]

Penn planned to have a suitably British country estate that would display his status in society through the construction of Pennsbury, north of Philadelphia along the Delaware. The country house that he had built there figured in several maps of the new colony, as early as 1687. But again, Penn's absence resulted in the decline in status for the propriety site. Artisan and memoirist William Moraley juxtaposed the Penn family's physical presence in the colony with their perceived role in it during the first decades of the eighteenth century. "The Family of Penn have very great Respect paid them by all Sorts of Persons, tho' they have no share in the Administration of the Government Affairs. They received, when I was there, about 14,000 Pounds per Annum, for Quit Rent, as an acknowledgment to them as Proprietors, at about Five Shillings every hundred Acres." But Moraley's somewhat inaccurate belief that the Penns played no part in the government was buttressed by the family's remaining physical presence in their colony: the estate north of the capital that had fallen into decrepitude. "They have a fine Seat at Pennsbury, eight Miles from Philadelphia, near

the River, but it is now in a ruinous Condition. It has a large Orchard, stored with Apples and Peach Trees. The Family built this House in One Thousand Six Hundred and Eighty Two. I was there in 1731."[7]

But even as Penn's legacy in Pennsylvania was coming to be identified with overgrown fields and a decaying house, the tale of his founding and the ideas behind it began to spread throughout the world. Voltaire read Penn's works during his exile in England in 1728 and 1729, and in *Letters Concerning the English Nation* he called Penn a truly enlightened leader, one of the great lawgivers of history. Pennsylvania, he said, was a land based on the principles of the Enlightenment, and Penn's agreement with the Lenni Lenape was the only treaty in history that included no sworn oaths and was never broken. That perception was perpetuated in the writings of other philosophes and became the international image of Pennsylvania by the latter half of the eighteenth century.[8]

19

CONFLICTING LEGACIES

The year after William Moraley visited Pennsbury, Penn's sons began an overhaul of colonial policy that would significantly challenge the widespread legacy of their father. In the 1730s, Pennsylvania's land policy and cultural beliefs came into conflict amid the growing pains of an expanding colonial population. As colonists created their own interpretations of William Penn in the years immediately following his death, the Penn family likewise crafted a different view of their dead patriarch. Penn had died in debt in 1718, the result of bad business sense, generosity when he could not afford it, and the failure of his colonists to pay the quitrents on the lands in America. By the time the sons of Hannah and William Penn reached maturity, they were ready to take what they saw as their rightful station, and their money, in Pennsylvania. One of the first steps in that transformation was to have a family member in residence in the colony, and thus Thomas Penn journeyed to Pennsylvania in 1732. The proprietary family's increased interest would have drastic consequences for the colony.[9]

Thomas Penn, William and Hannah's second son, was a junior partner in the proprietorship with his older brother, John, along with their younger brother, Richard. When he reached Pennsylvania, colonists had already created an image of the founder that shaped Pennsylvania society and politics, and this image shaped the colony's identity throughout the world.[10] The *American Weekly Mercury*, the colony's first newspaper, welcomed Thomas in 1732 with a poetic tribute that gushed over the proprietor and his family:

Welcome to us, thou happy one of three,
Who of this Province claim Propriety;

A Province still increasing every Year
And may it still increase on Thy arrival here.
Thy wish'd for Presence, as the Welcome Spring,
Renews and gives fresh Life to every thing.

After lines that sang the praises of the colony's spaces and natural resources, the poet connected Penn's arrival to the history of peace and friendship between Indians and colonists:

The *Indian Nations* coming far and near,
When understanding Thy arrival here;
With Presents will their Homage pay to Thee,
In Testimony of their Loyalty.
The *Indians* Reverence the name of PENN,
Thou'lt be both Lord and Brother unto them.

Indeed, the poet proclaimed, the young proprietor could expect praise, companionship, and support from the prospering inhabitants of a thriving colony, but all of this good fortune lay on the foundation that his father had built.

Live long and happy as thy worthy Sire,
(Whom Nobles for His Wisdom did admire,)
Before He pass'd His long and happy Days,
His Country's Honour, Ornament and Praise.
Whose prudent Conduct Crown'd with good success,
Rais'd this great Province from a Wilderness:
And tho' He's gone, this Land of Yours will be,
PENN's Monument to all Posterity.[11]

The Penns and their supporters saw that the key to new power and renewed influence lay in land sales and distribution, and that interactions with Native Americans were at the center of that issue. Land policy began to change with Thomas Penn's arrival in the colony in August 1732 and his brother John's presence there in 1734–35. Their expectation of land profits led to the infamous Walking Purchase of 1737, in which proprietary agent James Logan negotiated with or without the consent of Thomas and John Penn to acquire the land that is now northeastern Pennsylvania.[12]

The years that followed witnessed a rising level of animosity between frontier colonists and Native Americans and growing tensions between the western settlers and the proprietors and their supporters. William Penn's legacy became a critical part of that conflict. Penn's sons evoked the image of their father (a man who had been

incapacitated when they were very young and whom they probably remembered as an invalid) and took up his mantle, according to their own perception of what that role should be. On the other side of the widening political gap, colonial leaders, from elected assemblymen to the middling artisans and shopkeepers who formed benefit clubs, never tired of reminding the Penns of the importance of their father's beliefs. The four-year-old Library Company of Philadelphia, for example, marked the arrival of John Penn in the colony by telling the chief proprietor, "As nothing can be more glorious than the true Patriot, whose sole View is the Public Good, so no one ever merited that Title more justly than the great and honourable Founder of this Province; That excellent Constitution it enjoys, so perfectly adapted to the true Ends of Government, Security, and Freedom, clearly demonstrates the Wisdom and Humanity of that great and good Man your Father, who first modelled and established it; And with Pleasure we observe, that the same Wisdom, and the same benevolent disposition is the distinguishing Character of his Successors." The warning seems only slightly veiled: don't mess with your father's colony. But the Penns and their supporters did alter the long-standing social order, and the following decades saw Penn's peace unravel.[13]

As the colony became even more troubled in the late 1740s and 1750s, even as the population of Pennsylvania and its capital city grew to be among the largest in British North America, the legacy of Penn's government was further called into question. The situation grew especially tense when French and Spanish privateers attacked the coast of "the three lower counties" (now the state of Delaware) in 1747, setting off a panic among Pennsylvanians, who saw that the peace of their colony, guaranteed for more than seven decades by William Penn's founding, was incapable of protecting them from the perceived threat and imagined imminent attack on Philadelphia. Quaker pacifism, the religious ideology that had kept the colony safe from the wars that had crippled and depopulated other colonies, now seemed to emasculate Pennsylvania's government in the midst of crisis. The Penns, by now only marginally Quaker, seemed incapable of doing anything to stop the threat of a French attack.

In this vacuum, Benjamin Franklin emerged as the political hero of the moment. He called colonists to arms (literally) in an anonymous pamphlet titled *Plain Truth*; he helped fund the Associators, an extralegal militia that rose up to protect Philadelphia; and he refused to take an officer's post, instead serving as a common soldier.[14] Indeed, *Plain Truth* put the colony's Quaker leadership at the center of the increasing dangers Pennsylvania faced. "The Enemy, no doubt, have been told, That the People of Pennsylvania are Quakers, and against all Defence, from a Principle of Conscience; this, tho' true of a Part, and that a small Part only of the Inhabitants, is commonly said of the Whole; and what may make it look probable to Strangers, is, that in Fact, nothing is done by any Part of the People towards their Defence. But to refuse Defending one's self or one's Country, is so unusual a Thing among Mankind, that possibly they may not believe it, till by Experience they find, they can come higher and higher up our

River, seize our Vessels, land and plunder our Plantations and Villages, and retire with their Booty unmolested. Will not this confirm the Report, and give them the greatest Encouragement to strike one bold Stroke for the City, and for the whole Plunder of the River?"[15]

Franklin's pamphlet went on to reveal a rising tide of animosity between Quaker and non-Quaker factions in the city in late 1747. "*What*, say they, *shall we lay out our Money to protect the Trade of Quakers? Shall we fight to defend Quakers? No; Let the Trade perish, and the City burn; let what will happen, we shall never lift a Finger to prevent it.* Yet the Quakers have *conscience* to plead for their Resolution not to fight, which these Gentlemen have not: *Conscience* with you, Gentlemen, is on the other Side of the Question: *Conscience* enjoins it as a DUTY on you (and indeed I think it such on every Man) to defend your Country, your Friends, your Aged Parents, your Wives, and helpless Children: And yet you resolve not to perform this Duty, but act *contrary* to *your own* Consciences, because the Quakers act *according* to *theirs*."[16]

The French navy never sailed up the Delaware River, but the lasting legacy of the autumn of 1747 was a common perception that the Quaker leaders of the town and colony were incapable of protecting ordinary citizens' lives and property, and that the Penn family and their hirelings didn't much care. Franklin, a keen student of history and politics, used the founding myth of William Penn to support his position. In October 1748 he included a commemoration of Penn in the pages of his *Poor Richard Improved* almanac: "On the 14th of this month, Anno 1644, was born William Penn, the great founder of this Province; who prudently and benevolently sought success to himself by no other means, than securing the liberty, and endeavouring the happiness of his people. Let no envious mind grudge his posterity those advantages which arise to them from the wisdom and goodness of their ancestor; and to which their own merit, as well as the laws, give them an additional title."[17]

Following the crisis in 1747, the Penns' rule seemed increasingly incapable of protecting the lives and livelihoods of Pennsylvania colonists. The situation worsened when, in 1755, the old peace between colonists and the Lenni Lenape finally collapsed, with violent outbreaks on the frontier at the start of the Seven Years' War. As Franklin and his cohort grew in prestige throughout that war, the proprietors seemed to do nothing but frustrate any effort to tax their sizeable land holdings to pay for the colony's defense.[18]

The animosity grew when the Pennsylvania Assembly sent Franklin to Britain in 1757, hoping to negotiate an agreement in which the Penns would pay for the protection of frontier settlements that had the potential to line the pockets of the proprietary family and the men who supported their position. Franklin's frustration with the proprietors would remain with him for years. When he wrote his autobiography decades later, it was the account of his negotiations with Thomas Penn that stopped the flow of Franklin's writing, not once but twice—and permanently.[19]

Thomas Penn would eventually characterize Franklin's militia as guilty of "little less than treason," and he called Franklin "the sort of tribune of the people" for the popularity he gained in the colony after 1747. Thus a hatred that would reshape Pennsylvania's political history was born. Franklin, rising in fame thanks to his electrical experiments as well as popularity for his civic involvement, developed an equal scorn for Thomas Penn, calling him "mean and grasping." In 1767, Franklin told his friend Thomas Livezy that he would receive news of Thomas Penn's death joyfully and celebrate it with a glass of wine.[20]

As the gap between the proprietary and antiproprietary/Quaker factions widened, each side sought to use the legitimizing force of history to support its position, adopting visual images of William Penn and Quakerism to do so. Israel Pemberton, the Quaker leader who established the Friendly Association for Regaining and Preserving Peace with the Indians by Pacific Measures, attempted to draw support for plans that would quiet strife on the colony's frontier and commissioned a 1757 peace medal that showed William Penn—easily identifiable by the broad-brimmed Quaker hat (which he never actually wore)—sitting in council with a Native American (fig. 1.3). As Penn passes the peace pipe on the coin's reverse, a smiling sun shines down on the proceedings. This medal marked the first use of Penn's image as an arbiter of politics and society, the first time easily identifiable Quaker dress was incorporated to explain the political crises that surrounded Pennsylvania colonists. But it would not be the last.[21]

IMAGINING PENN

This use of physical imagery is striking, given the two contradictory facts we know about Quakers and portraiture in the long eighteenth century: (1) Quakers did not believe in having their portraits made. They believed portraiture was vain and an affront to God, and (2) the walls of Quaker libraries, archives, house museums, and other historic sites are lined with the portraits painted of Quakers in this period.[22]

Irony aside, images of Quakers during the eighteenth century grappled with a variety of social and cultural legacies that were developing and changing over time. Like many of his contemporary moderate Friends in late seventeenth-century England, William Penn seems to have disapproved of formal portraiture. Penn never disavowed fine clothing or dressed hair as a part of his conversion to the Society of Friends in the 1660s, but he never sat for a formal portrait in adulthood, never followed in the footsteps of his naval-officer father, who commissioned portraits showing his prestige and power. The only images made during his lifetime that survive are a youthful head-and-shoulders painting of questionable provenance that exists today only in posthumous copies of the original, probably destroyed in the eighteenth century in

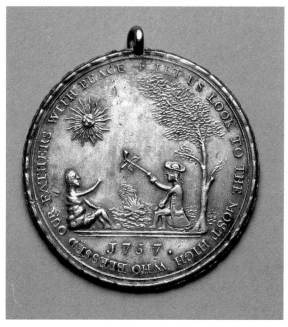

FIG. I.3 Obverse and reverse. Edward Duffield, engraver, *Peace Medal* (from the Friendly Association for Regaining and Preserving Peace), 1757. Struck by Joseph Richardson (1711–1784). The Library Company of Philadelphia. Connecting imperial stability and local heritage, Duffield's Friendly Association medal displays the highly popular King George II on its front, while the image on the reverse depicts an idealized past, with a Quaker in his broad-brimmed hat sitting peacefully with a Lenni Lenape.

a fire, and a chalk-and-crayon sketch of the scowling Quaker sitting in court. Thus memories of Penn's face would have been vague at best by the time the colony's frontier erupted and its capital saw rising animosity in the late 1750s.[23]

Historical curiosities and artifacts were readily for sale in the eighteenth century, and the movement that led to the creation of private collections and cabinets of curiosities likewise had images of founding Quakers among the wares for sale. Henry Home, Lord Kames acquired one such image, and in 1760 he offered Franklin a portrait alleged to be of William Penn. The correspondence between the two men reveals the complicated history and mythology both of Quakers and portraiture and of Penn's legacy. But as Franklin's analytical mind appraised the painting, he examined it both as a physical object and as an aspect of the cultural history of the Penn family and Quakers in general: "I could wish to know the History of the Picture before it came into your Hands, and the Grounds for supposing it his," Franklin wrote, revealing an expansive mind and the breadth of Enlightenment thinking. "I have at present some Doubts about it; first, because the primitive Quakers us'd to declare against Pictures as a vain Expence; a Man's suffering his Portrait to be taken was condemn'd as Pride; and I think to this day it is very little practis'd among them." Franklin also showed familiarity with the material culture of art history in his critique. "Then it is on a Board, and I imagine the Practice of painting Portraits on Boards did not come down so low as Penn's Time; but of this I am not certain."

Finally, Franklin's analysis of a supposed image of the founder showed his connections with other thinkers and with the politics of art:

> My other Reason is an Anecdote I have heard, viz. That when old Lord Cobham was adorning his Gardens at Stowe with the Busts of famous Men, he made Enquiry of the Family for a Picture of Wm. Penn, in order to get a Bust form'd from it, but could find none. That Sylvanus Bevan, an old Quaker Apothecary, remarkable for the Notice he takes of Countenances, and a Knack he has of cutting in Ivory strong Likenesses of Persons he has once seen, hearing of Lord Cobham's Desire, set himself to recollect Penn's Face, with which he had been well acquainted; and cut a little Bust of him in Ivory which he sent to Lord Cobham, without any Letter of Notice that it was Penn's. But my Lord who had personally known Penn, on seeing it, immediately cry'd out, Whence came this? It is William Penn himself! And from this little Bust, they say, the large one in the Gardens was formed. I doubt, too, whether the Whisker was not quite out of Use at the time when Penn must have been of the Age appearing in the Face of that Picture. And yet notwithstanding these Reasons, I am not without some Hope that it may be his; because I know some eminent Quakers have had their Pictures privately drawn, and deposited with trusty Friends; and I know also that there is extant at Philadelphia a very good Picture of Mrs. Penn, his last Wife. After all, I own

I have a strong Desire to be satisfy'd concerning this Picture; and as Bevan is yet living here, and some other old Quakers that remember William Penn, who died but in 1718, I could wish to have it sent me carefully pack'd in a Box by the Waggon (for I would not trust it by Sea) that I may obtain their Opinion, The Charges I shall very chearfully pay; and if it proves to be Penn's Picture, I shall be greatly oblig'd to your Lordship for Leave to take a Copy of it, and will carefully return the Original.[24]

Renowned as a writer, natural philosopher, and political leader, Franklin might add the title "art historian," or even "material culture specialist," to an already crowded résumé based on the observations he makes in the Kames letter. He sees the proffered painting not just as a face in a frame—something his contemporary collectors and leaders often didn't care about—but as a material text, unpacking its physical nature and structure.

Franklin's observations on the subject of the painting also reveal the level of information Pennsylvania politicians would have had about Penn's actual appearance and how they came by it. The information about the Bevan bust and the perceptions about how earlier Friends embraced a primitive appearance (even though this was not yet necessarily the case) reveal how these topics were already being comprehended and communicated at the end of the 1750s. Penn's image conveyed Penn's legacy, even though the exact nature of both was subject to debate.

Penn's legacy lay not just in how his image and words were understood but in how this was conveyed to the generation of his descendants who now controlled the colony. With the conclusion of the Seven Years' War and the increase in potential conflicts on the frontier, the proprietors once again sent a family member to serve as lieutenant governor. John Penn was the son of William Penn's youngest surviving son, Richard, and the nephew of Thomas, the chief proprietor; he arrived as governor of Pennsylvania late in 1763, once again receiving the acclamation that surrounded the arrival of any member of the proprietary family in the colony. But the constant references to the founder seem to have begun to wear thin for his progeny: Benjamin Franklin recalled that at one point, hearing that they were about to be addressed by a group of colonists, a Penn grumbled, "Then I suppose we shall hear more about our Father."[25]

Governor Penn's cheers were not to last long. He arrived at the beginning of what his uncle called the "greatest confusion ever known in Pennsylvania," and was forced to deal almost immediately with frontier uprisings, an attack on the capital by western ruffians, and a movement in the Assembly to take governmental control away from his family and give it to the British Crown. The young governor seemed ill prepared to handle these crises. Benjamin Franklin, writing shortly after the Paxton Boys' attack, wrote to a friend that John Penn "did me the Honour, on an Alarm, to run to my House at Midnight, with his Counselors at his Heels, for Advice, and made it his Head Quarters for some time: And within four and twenty Hours, your old

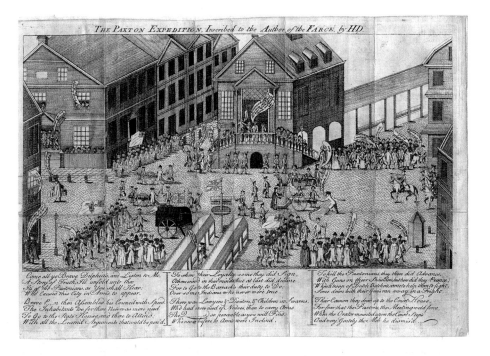

FIG. 1.4 Henry Dawkins, *The Paxton Expedition. Inscribed to the Author of the Farce by H.D.* (Philadelphia, 1764). 25 × 36 cm. The Library Company of Philadelphia.

Friend was a common Soldier, a Counsellor, a kind of Dictator, an Ambassador to the Country Mob, and on their Returning home, Nobody, again." When John Penn wrote to his uncle about the incident, he never mentioned Benjamin Franklin.[26]

The Paxton event brought unprecedented strife to Philadelphia, and a new form of interpreting that strife: a public print that showed the factions' meeting at Philadelphia's town house, where Second Street crossed High. In the view of the scene engraved by Henry Dawkins ("H.D."), Philadelphia is presented in a decidedly un-Quaker-like way, with guns, militiamen, and army troops filling the streets (fig. 1.4). But while the action takes place directly outside the Friends' Great Meetinghouse, no one in the image has the distinctive appearance of a Friend, and a close observation of the engraving suggests that the men shouting from the second floor of the structure are not decrying violence but shouting orders to a passing grog seller. Quakers and Quakerism were not central to the action. But that was about to change.

By the following year, the political divide between Franklin's "Quaker" party and the proprietary party had grown wider, the disagreement over the true successor of William Penn more vociferous. As the debate continued, images and words about the nature of Quakers and William Penn increased. The opposing factions used visual imagery in the form of cheaply produced broadsides that laid out the two sides' points of view.[27]

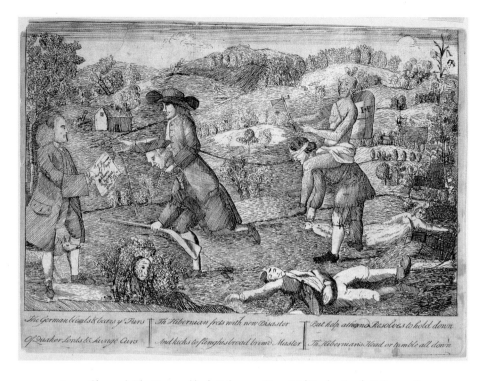

FIG. 1.5 James Claypool, *The German bleeds & bears ye Furs / Of Quaker Lords & Savage Curs* (Philadelphia, 1764). Three columns of text below image. Cartoon, 7 ¼ × 10 in. (19 × 25 cm). The Library Company of Philadelphia.

In the months that followed, visual imagery's role as a political weapon expanded. Cartoonists transformed Franklin into a stock image, identifiable by the physic wig he now sported—denoting his role as a man of science—and the spectacles already associated with him. But Friends bore the brunt of the sarcasm in these images. One, portraying a Quaker and an Indian literally riding two manacled frontiersmen, bears a poetic caption that begins "The German bleeds & bears ye Furs / Of Quaker Lords & Savage Curs," saying that Friends were not just irresponsible as colonists suffered; they were complicit in it (fig. 1.5). The second connected Quaker values and practices with lust for Indians and foolish naïveté: "An Indian Squaw King Wampum spies / Which makes his lustful passions rise / But while he doth a friendly Jobb / She dives her Hand into his Fob / And thence conveys as we are told / His Watch whose Cases were of Gold" (fig. 1.6). Any frequenter of Philadelphia's taverns or other gathering places would have had the chance to chuckle at these damning views of Quakers and the leader of the "Quaker party," Benjamin Franklin.[28]

The widening schism in Pennsylvania's political realm and the opposing parties' use of such images led Thomas Penn to enter the fray, commissioning Benjamin West to

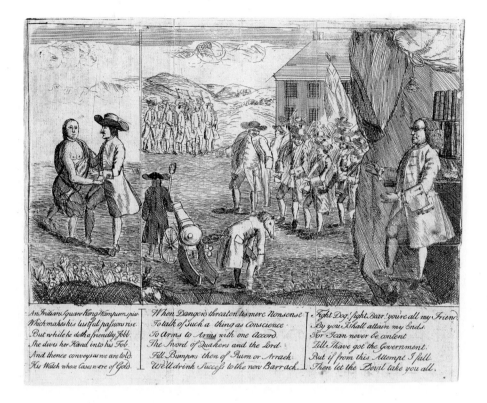

An Indian Squaw King Wampum spies
Which makes his lustful passion rise.
But while he doth a friendly Job,
She dives her Hand into his Fob,
And thence conveys as we are told,
His Watch whose Cases were of Gold.

When Danger's threaten us mere Nonsense
To talk of such a thing as Conscience.
To Arms to Arms with one Accord.
The Sword of Quakers and the Lord.
Fill Bumpers then of Rum or Arrach.
We'll drink Success to the new Barrack.

Fight Dog, fight Bear, you're all my Friend.
By you I shall attain my Ends.
For I can never be content
Till I have got the Government.
But if from this Attempt I fall,
Then let the Devil take you all.

FIG. 1.6 James Claypool (attributed), *An Indian Squaw King Wampum Spies* (Philadelphia, 1764).
Cartoon, 8 ¼ × 10 ¼ in. The Library Company of Philadelphia.

paint a history painting of his father at the moment of Pennsylvania's founding. West's
path to becoming one of Georgian London's most accomplished history painters was an
unusual one. After showing a great deal of promise as a youth, he had been embraced by
the circle of Pennsylvanians at the center of the proprietary party—wealthy landowners,
merchants, and lawyers who had risen or been cemented into the colony's upper social
echelons through their associations with William Penn's heirs. Political association led
to business opportunity, and by the 1750s these men were seeking to secure their status
by acquiring the trappings of education and material possessions that Anglo-American
society associated with its upper ranks. These families' scions embraced the young
painter in the classrooms of the College of Philadelphia—then headed by the popular,
controversial Reverend William Smith—and in the parlors where these young men and
their female friends recited poems, performed music, and read plays. A court painter
for this court party seemed only natural. In 1760, Benjamin West accompanied three of
these proprietary-faction youths on a voyage to Italy, packing commissions and letters
of credit from Chief Justice William Allen and others, along with his art supplies.[29]

FIG. 1.7 Benjamin West, *Self-Portrait*, 1758/59. Watercolor on ivory, 2 ½ × 1 ¹³⁄₁₆ in. (6.4 × 4.6 cm). Yale University Art Gallery, Lelia A. and John Hill Morgan, B.A. 1893, LL.B. 1896, M.A. (Hon.) 1929, Collection, 1940.529. Photo: Yale University Art Gallery. West's relatively simple brown suit and plainly dressed hair reveal his middling status, rather than his Quaker heritage, about the time he turned twenty. His hat, tucked under his left arm, is clearly a fashionable black tricorne one, not the broad-brimmed style representative of Friends.

While his wealthy friends embarked on a grand tour, West went to work, studying the techniques and styles that placed Italy at the center of the world's artistic culture in the eighteenth century. He arrived in Rome on July 10, 1760, and immediately began to gain the notice of his fellow English subjects because of the unusual combination of background and career path that he represented: a Quaker who was an artist. Was West a Quaker? The question may be impossible to answer definitively. In the memoir he related to John Galt decades later, he described himself as one numerous times. Yet his parents—like many midcentury Friends—had been read out of meeting. Did he subscribe to Quaker practices of dress? Perhaps. West's first self-portrait, a miniature probably painted in 1758 or 1759, showed the young artist in simply dressed hair and a coat of plain brown cloth. West gave the picture to a young lady friend and did not see it again until visitors to London brought it to show him in 1816. When one of these visitors said that the cut of the coat in the miniature appeared to be Quaker dress, West replied, "I was once a Quaker, and have never left the principle." Yet that interpretation seems fanciful. West's clothing, including the hat tucked under his left arm (which lacks a broad brim), were not so different from those worn by other middling-rank colonists of the period (fig. 1.7). His move to the Old World brought on new sartorial style. A few years into his time in Europe, Angelica Kauffman's 1763 pencil sketch depicts West in the high-style Van

Dyck costume that both artists used to show Englishmen remaking their pasts via connection to an earlier Cavalier history.[30]

It might be best to describe West as a Quaker when convenient. He used the unusual, even exotic status of being a Friend by birthright to gain entry into the presence of Italian Catholic leaders and British aristocrats, and he would continue to permit what one biographer has called this "gentle fraud" for the rest of his life.[31]

West settled in London in the late summer of 1763, arriving there just as four of his patrons from Pennsylvania were in the imperial capital and finding a ready circle of friends and supporters as he began his career in England. In addition to Lieutenant Governor James Hamilton (see fig. 2.4) and his kinsman by marriage, William Allen, West found Provost William Smith, who was in London with the New York attorney John Jay, as the two men were raising funds for the new colleges in the colonies. And West found Samuel Powel, who like himself was a descendant of Quakers who had immigrated to the New World, but who also felt little connection to that religious heritage by this point in his life. On September 1, 1763, Powel made an introduction that would prove of great importance to the young painter, and to the history of history painting in the Anglo-American world: "Mr. West is arrived from Italy with the great character as a painter. I had the pleasure of a good deal of his company and of introducing him to Mr. Penn."[32]

Along with other members of Pennsylvania's newly very wealthy elite who supported the Penns and their land policies, the Allens considered Thomas Penn's wife, Lady Juliana Fermor Penn, their benefactor. Described after the Revolution as "the former queen of Pennsylvania," Juliana Fermor was the youngest daughter of the Earl of Pomfret, and was twenty-six years younger than her husband. It is tempting to look for the political and cultural changes occurring in midcentury Pennsylvania in the companion portraits Arthur Devis painted of Thomas Penn and his bride around the time of their marriage in 1751. Thomas Penn's surroundings of muted brown walls and bare floor seem Quakerly enough. His suit, while of fine-quality cloth, might still fit with the oft-cited Friends' admonition to have things "of the best sort, but plain" (fig. 1.8). But the bride's costume and setting reveal a very different narrative: she is sumptuously dressed in lace and shimmering fabric, and her fashionable panniers and quilted petticoat create a lavish display of wealth and prominence. This bodily display fits well into its setting, as the green silk on the room's wall is en suite with that covering the settee behind her. The rococo frame above the mantel holds a pastoral scene, and carefully placed porcelain ornaments cover each visible surface (fig. 1.9). The Penns' marriage paved the way for a new, image-conscious reality for Pennsylvania's proprietary leadership.[33]

This material reality greeted Penn supporters who traveled to London, and they followed the tastes favored by Lady Juliana. When West arrived there, the presence of these grand tourists smoothed the way for him just as his career was beginning to

FIG. 1.8 Arthur Devis, *Portrait of the Right Honorable Thomas Penn*, 1752. Oil
on canvas, 36 ⅛ × 31 ⅛ in. (91.8 × 79.1 cm). Philadelphia Museum of Art, 125th
Anniversary Acquisition, gift of Susanne Strassburger Anderson, Valerie Anderson
Readman, and Veronica Anderson Macdonald from the estate of Mae Bourne and
Ralph Beaver Strassburger, 2004-201-1.

flourish. William Allen gives a glimpse of West's presence and position in the cohort
in a letter to his friend Benjamin Chew dated January 27, 1764: "While I was writing
this My Lady Juliana Penn called upon us to go and see our Country man Wests
Painting, he is really a wonder of a man and has so far out stripped all the painters
of his time as to get into high esteem at once, whereas the famous Reynolds was five
years at work before he got into Vogue, as has been the case with all the others who
generally drudged a longer time before they had any thing of a name: If he keeps his

FIG. 1.9 Arthur Devis, *Portrait of Lady Juliana Penn*, 1752. Oil on canvas, 36 ⅛
× 31 ⅛ in. (91.8 × 79.1 cm). Philadelphia Museum of Art, 125th Anniversary
Acquisition, gift of Susanne Strassburger Anderson, Valerie Anderson Readman,
and Veronica Anderson Macdonald from the estate of Mae Bourne and Ralph
Beaver Strassburger, 2004-201-2. The Penns' portraits, painted about the time of
their marriage, reveal their elevated status in society and the material accompani-
ments that the partnership included. Lady Juliana's rich silk gown, the lavish wall
hangings, matching upholstery, and porcelain decorations all reveal a cultured
noblewoman, typical of Devis's style. The comparative simplicity of Thomas Penn's
clothing and surroundings leads the viewer to wonder whether his parents' Quaker
faith had some long-lasting influence. Penn had definitely left the Friends by the
time of his marriage.

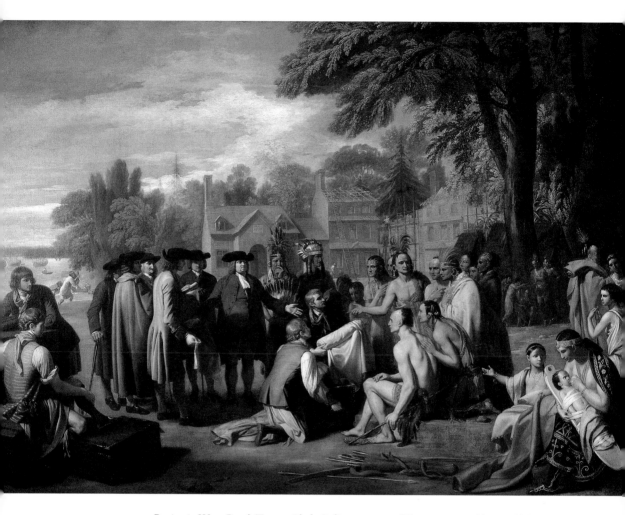

FIG. 1.10 Benjamin West, *Penn's Treaty with the Indians*, 1771–72. Oil on canvas, 75 ½ × 107 ¾ in. (191.8 × 273.7 cm). Courtesy of the Pennsylvania Academy of the Fine Arts, Philadelphia, gift of Mrs. Sarah Harrison (The Joseph Harrison Jr. Collection), 1878.1.10.

health he will make money very fast, he is not like to return among us so that you will not be able to have Mrs. Chew and your little flock painted."[34]

This growing connection to the proprietors and their clique led to the commission of the history painting that would grapple with Pennsylvania's recent troubled past and the implications of its founder's religion for the province. Thomas Penn and his wife commissioned the painting from Benjamin West at a moment when his status as a painter was on the rise and their status as proprietors was becoming suspect at best. By the late 1760s, opposition partisans in the Quaker party were equating the Penn legacy with haughty followers, out-of-touch governors, and an Indian policy

that left white settlers' bodies strewn on the fields of the frontier. It was this image problem that led Thomas Penn to enter into a contest for memory and meaning by commissioning West's *Penn's Treaty with the Indians* (1771–72)

While this painting has inspired volumes of scholarship over the centuries, its connection to the reality of late colonial culture and politics has been overlooked or misinterpreted. In looking at West's picture, scholars have concentrated on what the Penn image became: one of the most recognizable images of any colonial American, a symbol of Quakerism that became so ubiquitous by the nineteenth century that Quaker families gave prints of it as wedding presents, a view that was reproduced on everything from dinner plates, to calendars, to printed textiles and book illustrations. Historians have tended to concentrate on what happened to the painting, rather than on what was happening when Thomas Penn commissioned it. The image actually illustrates the cultural politics of 1770s Pennsylvania and the ways in which combatants fought over the image of William Penn.

Benjamin West completed *Penn's Treaty* just as he was establishing himself as one of Britain's most significant artists. In 1770, he had achieved acclaim for his masterly *Death of General Wolfe*, a history painting depicting the scene of James Wolfe's martyrdom during the Battle of Quebec in 1759. Augustan Britons embraced history as a relevant morality tale that educated as well as inspired, and historical depictions were everywhere in the literature and fine art of the period. But West's *Wolfe* was a radical departure from the tastes of the time, breaking with the fashion for neoclassicism to show a scene in modern dress. West later recalled that George III himself sputtered "that it was thought very ridiculous to exhibit heroes in coats, breeches, and cock'd hats." And yet West persevered, creating a sensation and a new reputation that established him as the preeminent artist of historical subjects in Augustan London. The resulting image was both inspiring and familiar, showing the cost of empire and its idealized martyred heroes. The buzz that the painting created allowed West to focus on being a history painter, and not just the drudgery—as he perceived it—of painting the faces and dress of fashionable London and its environs.[35]

In the years that led up to the unveiling of *The Death of General Wolfe*, Benjamin West had received some of his most lucrative commissions from Pennsylvania's newly rich proprietary supporters, who had acquired great fortunes investing in lands that the Penns had gained through the Walking Purchase, and now used that wealth to take grand tours that began in London. William Allen, leader of the proprietary party and now one of the colony's wealthiest men, had become one of West's principal benefactors in 1760, and when visiting Europe in the years that followed he commissioned portraits of his sons John and Andrew, daughter Anne, and himself. In 1763, William Allen's sons Andrew and James were two of the five American colonists to pose for *The Cricketers*, one of West's first major group paintings, showing those provincials in the most British of sports. Altogether, the Allen portraits reflected the family's dynastic

ambitions and elevated role in proprietary politics. In 1763, shortly after she returned to Pennsylvania with her father, Anne Allen was courted by and married Governor John Penn, Thomas's nephew. Thus the two families, connected through politics, were connected by marriage as well. Thomas and Juliana Penn's choice of Benjamin West was much like that of their Allen kin: his paintings would depict the family's place in society, creating a dynastic image that cemented their position in Pennsylvania and within the British Empire.[36]

Thomas Penn ceased any participation in the Quaker meeting at the time of his 1751 marriage, but he fully understood the significance of Quakers as cultural symbols and the role of his father in public memory in colonial Pennsylvania, and these factors influenced the painting of his father's treaty that he commissioned from Benjamin West. The inaccuracies—William Penn's age, his girth, and especially his dress—were carefully crafted to evoke a romantic view of the colonial patriarch as he was remembered, not as he had been. West used his own father's memories of Penn, albeit long distant and, again, romanticized, to portray the founder. He chose William Penn's clothing, and that of the men surrounding him, to suggest a contemporary identification with Quakerism, rather than to accurately show what Penn looked like in 1681.

West, like Thomas Penn, understood what it meant to be the son of a Quaker who did not follow those beliefs himself. In his July 1775 letter to his brother, he wrote, "I have taken the Liberty to introduce the Likeness of our father and brother of Reading into the picture of the group of Friends that accompany Wm. Penn, that is the likeness of our brother that stands immediately behind Penn, resting on his cane. I need not point out the figure of our Father. I believe you will find some likeness of him in the print." Using family members or close associates as models was nothing new, and indeed *Penn's Treaty* includes the likeness of no fewer than five members of the West family: his father, John West, and half brother, Thomas, in the group surrounding William Penn, while West's wife, the American-born Elizabeth Shewell, and sons Rafael and Benjamin served as models for the Native American family in the painting's foreground. What was more unusual was that West had to identify to his brother William which man in the picture was their "brother of Reading," i.e., Thomas West. When John West had immigrated to Pennsylvania in 1714, he left behind his pregnant wife in the mother country. That wife died in childbirth, and their son—Thomas— was raised by his maternal grandparents in England, while his father remarried and began a new family (which included Benjamin) in the New World. Thus West used *Penn's Treaty* as a family reunion of sorts, a way of showing his American kinsmen and others the continuity of his clan, at the same time that it connected them with an imagined Quaker past—which was doubly ironic, because both of Benjamin West's parents had been read out of meeting or were in bad standing with the Quaker community. That the painting evoked a reimagined, idealized past reflected both West's path and the colony's, and the proprietary family that it served.[37]

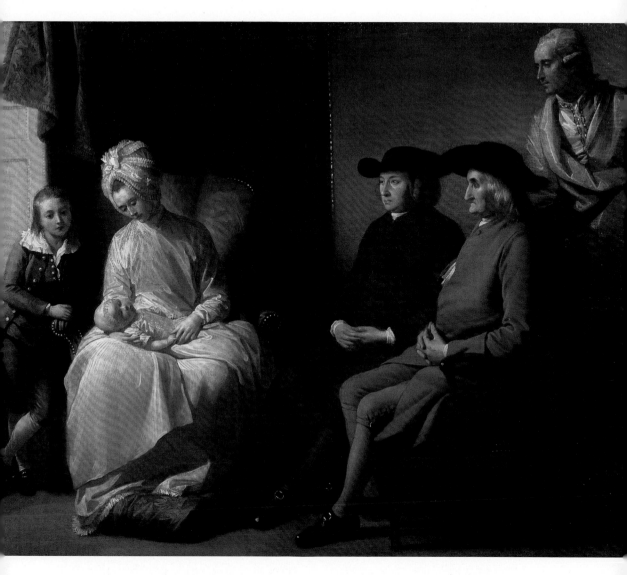

FIG. 1.11 Benjamin West, *The Artist and His Family*, ca. 1772. Oil on canvas, 20 ½ × 26 ¼ in. (52.1 × 66.7 cm). Yale Center for British Art, Paul Mellon Collection, B1981.25.674. West captured the challenges of heritage when he painted this family portrait. While he sometimes described himself as a Quaker, when that identity served some purpose, he was no practicing Friend then or earlier. Here, he juxtaposed his young family's stylish London dress with that of his father and brother, whose plain style and broad-brimmed hats connect them clearly to Quaker culture.

In the same year that West painted *Penn's Treaty*, he also created a stunning image of his own family: his wife, young son, and newborn fill the left side of *The Artist and His Family* (fig. 1.11). The sumptuous clothing of Elizabeth West and her sons, Raphael and Benjamin Jr., the fine furniture, and the elaborate drapes and wall covering contrast

FIG. I.12 Augustin de Saint-Aubin after a drawing by Charles-Nicolas Cochin, *Benjamin Franklin*, 1777. Engraving, plate: 8 ⅛ × 5 ⅞ in. Philadelphia Museum of Art, gift of Mrs. John D. Rockefeller Jr., 1946-51-138. Never a Friend, and often in clear defiance of Quaker practice and beliefs, Franklin used a confected identity as he navigated Paris's salons and court during the American Revolution. "This Quaker is in the complete costume of his sect," the Abbé de Flamarens wrote.

with the two figures immediately to her right: Benjamin West's brother Thomas and their aged father, John. The two men, in the plain style that denotes their Quaker faith, gaze admiringly at mother and child. Benjamin West added his own self-portrait, standing above his father and brother, brush and palette in hand, ready to capture the moment. The contrast in hairstyle, clothing, and stance among the three West men is striking, but the painter was also sending the message that while families could differ greatly in their religious beliefs, they were still family, bound together by lineage and affection. West did the same thing, at almost the same time, for the Penn family. Thomas Penn had formally and finally left Quakerism at the time of his marriage to Lady Juliana in 1751, and he had little interest in or affection for the faith of his parents. But in *Penn's Treaty*, West showed that the family legacy of the Penns was the Quaker peace that had started with Thomas's father and that continued to be possible under William Penn's sons and grandsons. West went so far as to add his own father (who was born nine years after the Shackamaxon meeting) to the group of Quaker men surrounding William Penn in the painting. Symbolically, he made Penn and Quakerism familiar as well as familial by adding recognizable clothing and faces.[38]

As West's image of his own family showed the complexities of religious and personal identity changing within a family structure, his portrayal of Pennsylvania's founding moment strove to express familiarity and solidity, connecting past and present. From the time it was painted, Thomas and Juliana Penn intended *Penn's Treaty with the Indians* to be an image for public consumption. The painting was included in the Royal Academy's annual exhibition in London in 1772, where Horace Walpole noted that it was "the best of his works in the Exhibition." But that was just the beginning of its audience. Penn immediately allowed it to be copied by noted printmaker John Hall, and by January 1773 the as yet incomplete prints were being advertised. Benjamin West had crafted an image of Pennsylvania's founder that supported Thomas Penn's image of his father and his needs as proprietor, an image that could be widely, inexpensively distributed. But by the time the prints were done in 1775, Thomas Penn had died, and his family was struggling with the revolutionary crisis taking place in their colony.[39]

Pennsylvania's historical connections to William Penn and his family were sorely tested during the American Revolution. Quakers and their pacifism were damned by one side and then the other as military conflict broke out. By the spring of 1776, Thomas Paine, who shared the Penn family's connection to a Quaker past, was blasting the founder and his heirs for their actions both recent and distant: "Perhaps no country in Europe can furnish greater instances of imposition and extortion than is to be found in the conduct of the Proprietaries of Pennsylvania," Paine wrote. "A striking absurdity appears . . . which is, that *William Penn*, one of the first and most principal of the people called Quakers, and who held even the bearing of arms to be sinful, should, nevertheless, accept . . . the grant of the province of *Pennsylvania, as a reward for a 'signal battle and victory fought and obtained by his father'* . . . to William Penn, therefore, this province was the price of blood."[40]

Despite vociferous protests, the Penns lost political control of the colony at the start of the Revolution. No longer a political or financial threat associated with the proprietary faction, the image of the founder became useful to revolutionary Pennsylvanians once again. Arriving in Paris in late 1776, Benjamin Franklin delighted in being perceived as "le bonne quackeur" (fig. 1.12). A half century later, the image of Pennsylvania's founder, clothed in the drab simplicity associated with the Quaker faith, would be copied and recopied by artists espousing Friends' beliefs and their role in an imagined past. As the nineteenth century progressed, Edward Hicks made a career of painting copies of the West narrative in dozens of *Peaceable Kingdoms*; in the decades that followed, West's *Penn's Treaty* would come to decorate everything from bed hangings to biscuit tins, meal platters to children's primers. Indeed, despite its many anachronisms, *Penn's Treaty* became ubiquitous in American textbooks and continues to be found in them today.[41]

As Friends retreated from the political sphere, the useful William Penn reemerged. In 1792, as a new generation of leaders gained control of Pennsylvania, they used the tried-and-true method of waging peace with Native Americans, falling back on the peace and justice that William Penn had secured in his initial meetings with the Lenni Lenape ancestors. Addressing "Brother Onas Governor" (literally, Brother Pen, or Penn, as William Penn was known), Sagoyewatha (Red Jacket) responded to being shown an image of William Penn negotiating with the Lenni Lenape at Shackamaxon, saying, "In address [*sic*] to us the other day, in this ancient Council Chamber where our forefathers have often conversed together several things struck my attention very forcibly when you told us this was the place in which our forefathers often Met on peaceable terms it gave us sensible pleasure and more joy than we could express."

> Tho we have not writings like you; yet we remember often to have heard of the friendship had existed [*sic*] between our forefathers and yours The Picture to which you drew our attention brought fresh to our minds the friendly conferences that used to be held between the former governor of Pennsylvania and our tribe and the love which your forefathers had of Peace and the friendly disposition of our People it is still our wish, as well as yours to preserve peace between our tribes and you and it would be well if the same Spirit among the Indians to the Westward and thro' every part of the United States.[42]

West's *Penn's Treaty with the Indians* looked down on peace negotiators in the capital of the new nation, once again asserting the image as a symbol of both a useful and an ornamental past, a role that it would continue to play for generations to follow.[43]

NOTES

I would like to thank the staffs of the David Library of the American Revolution, the Library Company of Philadelphia, the Historical Society of Pennsylvania, the British Museum, the Quaker Collection at Haverford College, the Pennsylvania Academy of the Fine Arts, the Philadelphia History Museum, and Independence National Historical Park for their numerous kindnesses while I was doing the research for this essay. Special thanks to Karie Diethorn and Judith Van Burkirk, whose careful reading and insightful comments added clarity and strength to this essay, and to my amazing coeditor, Margaretta Lovell, who taught me so much during our time editing together. Thanks also to Zara Anishanslin, Carol Baldridge, Linda Eaton, Kathleen Foster, Stephen Hague, Laura Johnson, Anna Marley, John Murrin, Patricia C. O'Connell, Daniel Richter, and Anne Verplanck for their advice and counsel, and of course, to Paul J. Alles, who has spent a great deal of time with this subject and this book for a great number of years. Three late friends, Frances K. Delmar, William Pencak, and especially Allis Eaton Bennett greatly influenced this work during its long period of gestation.

1. Benjamin West to William West, July 12, 1775, archives of Independence National Historical Park, Philadelphia, INDE 13778. This long-forgotten letter is the only known document by West that describes his *Penn's Treaty*, written at the time of the image's creation. Joseph Harrison Jr. purchased the letter in the nineteenth century, and it was displayed for many years near West's

original painting when it hung on the second floor of Independence Hall. In 1961, the National Park Service returned the painting to the Pennsylvania Academy of the Fine Arts, its owner since Sarah Harrison, Joseph Harrison's widow, had donated the painting in 1878. See Acting Superintendent Dennis Kurjack to Joseph J. Fraser Jr., director of the academy, April 4, 1961, PAFA archives. My thanks to Karie Diethorn, INHP's chief curator, for helping me track down this long-lost source. On young West's nickname among his friends, see Joseph Shippen to Edward Shippen, July 13, 1760, Balch-Shippen Papers, vol. 1, doc. 114, Historical Society of Pennsylvania. The *Pennsylvania Evening Packet* of September 12, 1775, reported that Captain Falconer's ship had arrived in Philadelphia that day (413). On West and London's arts community in the era, see Douglas Fordham, *British Art and the Seven Years' War: Allegiance and Autonomy* (Philadelphia: University of Pennsylvania Press, 2010); and Charles Saumarez Smith, *The Company of Artists: The Origins of the Royal Academy of Arts in London* (London: Modern Arts Press, 2012).

2. Numerous art historians have explored the meanings of *Penn's Treaty*. See especially Helmut von Erffa and Allen Staley, *The Paintings of Benjamin West* (New Haven: Yale University Press, 1986), 68–69, 206–8; Ellen Starr Brinton, "Benjamin West's Painting of Penn's Treaty with the Indians," *Bulletin of Friends' Historical Association* 30, no. 2 (1941): 99–189; Anne Cannon Palumbo, "Averting 'Present Commotions': History as Politics in *Penn's Treaty*," *American Art* 9, no. 3 (1995): 38. Ann Uhry Abrams engages the same political climate and some of the same source material in her essay "Benjamin West's Documentation of Colonial History: William Penn's Treaty with the Indians," *Art Bulletin* 64, no. 1 (1982): 59–75, but with a focus on traditional art-historical methodologies. See also her monograph *The Valiant Hero: Benjamin West and Grand-Style History Painting* (Washington, D.C.: Smithsonian Institution Press, 1985).

3. See Rowland Bertoff and John M. Murrin, "Feudalism, Communalism, and the Yeoman Freeholder: The American Revolution Considered as a Social Accident," in *Essays on the American Revolution*, edited by Stephen G. Kurtz and James H. Hutson (Chapel Hill: University of North Carolina Press for the Omohundro Institute of Early American History and Culture, 1973), 256–88; Stephen C. Harper, "Delawares and Pennsylvanians after the Walking Purchase," in *Friends and Enemies in Penn's Woods: Indians, Colonists, and the Racial Construction of Pennsylvania*, edited by William Pencak and Daniel K. Richter (University Park: Pennsylvania State University Press, 2004), 167–79.

4. For example, see the message from the Pennsylvania Colonial Assembly to Sir William Keith, *American Weekly Mercury*, February 9, 1724–25; and message from the counties of Newcastle, Kent, and Sussex to Lieutenant Governor Patrick Gordon, *American Weekly Mercury*, November 9, 1727; Mary Maples Dunn, *William Penn: Politics and Conscience* (Princeton: Princeton University Press, 1967); Richard S. Dunn and Mary Maples Dunn, eds., *The World of William Penn* (Philadelphia: University of Pennsylvania Press, 1986); Alison Duncan Hirsch, "'Instructions from a Woman': Hannah Penn and the Pennsylvania Proprietorship" (PhD diss., Columbia University, 1991).

5. See Brendan McConville, *The King's Three Faces: The Rise and Fall of Royal America, 1688–1776* (Chapel Hill: University of North Carolina Press for the Omohundro Institute of Early American History and Culture, 2006), 128–37.

6. Jessica Choppin Roney, *Governed by a Spirit of Opposition: The Origins of American Political Practice in Colonial Philadelphia* (Baltimore: Johns Hopkins University Press, 2014), chap. 1; Elizabeth Milroy, *The Grid and the River: Philadelphia's Green Places, 1682–1876* (University Park: Pennsylvania State University Press, 2016), 56–60.

7. Susan E. Klepp and Billy G. Smith, eds., *The Infortunate: The Voyage and Adventures of William Moraley, an Indentured Servant*, 2nd ed. (University Park: Pennsylvania State University Press, 2005), 67–68. My thanks to Daniel Miller, museum assistant at the rebuilt Pennsbury Manor, for sharing the museum's archive of various images of the house in the seventeenth and eighteenth centuries.

8. Voltaire, *Letters concerning the English Nation* (London: T. Pridden, Fleet Street, 1776), 34–38.

9. Richard S. Dunn, "Penny Wise and Pound Foolish: Penn as a Businessman," in Dunn and Dunn, *World of William Penn*, 37–54.

10. The story of the inheritance of the proprietorship is complicated—doubly so because the Penn heirs were particularly uncreative in selecting names for the men in the family. Penn's three sons by his second marriage inherited his proprietorship, with John Penn receiving a half share while his younger brothers Thomas and Richard received quarter shares. When John died childless in 1746, Thomas inherited his share. Thomas, a bachelor until 1751, had Richard's son John as his heir until his daughter was born in 1753. This John, Richard's son, would eventually become the last colonial governor of Pennsylvania. This is a simplified Penn genealogy; numerous other Johns, Richards, and Williams run through the pages of the family story. For more information, see Lorett Treese, *The*

Storm Gathering: The Penn Family and the American Revolution (University Park: Pennsylvania State University Press, 1992), 205.

11. "On the Arrival of the Honorable Thomas Penn, Esq; One of the Proprietors of the Province of Pennsylvania," *American Weekly Mercury*, August 10, 1732.

12. John Penn was born in Philadelphia on February 29, 1700, during his parents' sojourn there, and he returned to England with them the following year. As noted above (n. 10), under William Penn's will, John received 50 percent of the Pennsylvania proprietorship, while his younger brothers Thomas and Richard received one quarter each. When John died childless in 1746, Thomas inherited his share of the colony. On the Walking Purchase, see Francis Jennings, "The Scandalous Indian Policy of William Penn's Sons: Deeds and Documents of the Walking Purchase," *Pennsylvania History* 37 (1970): 19–39; Harper, "Delawares and Pennsylvanians"; Jon Parmenter, "Rethinking *William Penn's Treaty with the Indians*: Benjamin West, Thomas Penn, and the Legacy of Native-Newcomer Relations in Colonial Pennsylvania," *Proteus* 19, no. 1 (2002): 38–44; James Merrell, *Into the American Woods: Negotiators on the Pennsylvania Frontier* (New York: W. W. Norton, 1999).

13. Minute books of the Library Company of Philadelphia, May 31, 1735, LCP archives.

14. Sally Griffith, "'Order, Discipline, and a Few Cannon': Benjamin Franklin, the Association, and the Rhetoric and Practice of Boosterism," *Pennsylvania Magazine of History and Biography* 116, no. 2 (1992): 131–55. On the Associators, see Joseph Seymour, *The Pennsylvania Associators, 1747–1777* (Yardley, Pa.: Westholme Publishing, 2012).

15. Benjamin Franklin, *Plain truth, or Serious considerations on the present state of the city of Philadelphia, and province of Pennsylvania, By a tradesman of Philadelphia* (Philadelphia, 1747), 11–12.

16. Franklin, 17–18.

17. Benjamin Franklin, *Poor Richard Improved* (Philadelphia: B. Franklin, 1748), unpaginated, reprinted in *Early American Imprints, Series I: Evans, 1639–1800*, no. 5952, accessed May 6, 2018, https://www.readex.com/content/early-american-imprints-series-i-evans-1639-1800.

18. Peter Silver, *Our Savage Neighbors: How Indian War Transformed Early America* (New York: W. W. Norton, 2009), chap. 4.

19. *The Autobiography of Benjamin Franklin*, edited by Leonard W. Labaree, Ralph L. Ketcham, Helen C. Boatfield, and Helene H. Fineman (New Haven: Yale University Press, 1964), 259, 262–63. My thanks to the archival staff of the Huntington Library, who in June 2012 gave me the rare privilege of spending four hours with the original hand-written manuscript of the autobiography. On Franklin's time in London and his relation to the Penns, see Sheila L. Skemp, *The Making of a Patriot: Benjamin Franklin at the Cockpit* (New York: Oxford University Press, 2013), 67–72; and George Goodwin, *Benjamin Franklin in London: The British Life of America's Founding Father* (New Haven: Yale University Press, 2016).

20. Walter Isaacson, *Benjamin Franklin: An American Life* (New York: Simon and Schuster, 2003), 126; Charles Coleman Sellers, "The Beginning: A Monument to Probity, Candor, and Peace," in *Symbols of Peace: William Penn's Treaty with the Indians* (Philadelphia: Pennsylvania Academy of the Fine Arts, 1976), unpaginated.

21. The 1757 medal is often incorrectly called the second, not first, use of the Quakers/Penn in a publicly consumed political image. This arises from the misinterpreting of Lewis Pingo's 1775 medal, which shows a bust of William Penn on the front and Penn shaking hands with an Indian on the back. This medal shows Penn's birth and death dates (1644–1718), and was catalogued in some collections as "c. 1720." Rather than being a source for West's presentation of the founder in *Penn's Treaty*, it is likely that Pingo based his distinctive image of Penn as a portly older man in plain Quaker clothing on West's publicly displayed history painting. Scholars who have used this incorrect date of circa 1720 include Abrams, "Benjamin West's Documentation," 70–71; and Palumbo, "Averting 'Present Commotions,'" 38. My thanks to the staffs of the Coins and Medals Department of the British Museum and the American Numismatic Society for their help in unraveling this mystery. On the Friendly Associators, see Merrell, *Into the American Woods*, 16; Silver, *Our Savage Neighbors*, 28, 85, 92, 99–101; and Bethany Wiggin, "'For Each and Every House to Wish for Peace': Christoph Saur's *High German American Almanac* and the French and Indian War in Pennsylvania," in *Empires of God: Religious Encounters in the Early Modern Atlantic*, edited by Linda Gregerson and Susan Juster (Philadelphia: University of Pennsylvania Press, 2011), 154–74. On the use of history by Enlightenment thinkers, see Hugh Trevor-Roper, *History and the Enlightenment* (New Haven: Yale University Press, 2010).

22. My thanks to the staff of the Friends Historical Library, Swarthmore College, for pointing this out, during the course of this research, by literally pointing to the walls surrounding their reading room. Among the paintings hanging there is a study by Benjamin West of his father in Quaker garb.

23. Dianne C. Johnson, "Living in the Light: Quakerism and Colonial Portraiture," in *Quaker Aesthetics: Reflections on a Quaker Ethic in American Design and Consumption*, edited by Emma Jones Lapsansky and Anne A. Verplanck (Philadelphia: University of Pennsylvania Press, 2003), 122–48; J. William Frost, "'Wear the Sword as Long as Thou Canst': William Penn in Myth and History," *Explorations in Early American Culture* 4 (2000): 13–45; Richard Saunders, "The Development of Painting in Early Pennsylvania," in *Worldly Goods: The Arts of Early Pennsylvania, 1680–1758*, edited by Jack Lindsey (Philadelphia: Philadelphia Museum of Art, 1999), 53–68.

24. Franklin to Lord Kames, January 3, 1760, in *The Papers of Benjamin Franklin*, edited by Leonard W. Labaree, Helen C. Boatfield, Helene H. Fineman, and James H. Hutson, 42 vols. to date (New Haven: Yale University Press, 1959–), 9:7.

25. *Pennsylvania Gazette*, June 5, 1735; Benjamin Franklin, "Preface to the Speech of Joseph Galloway," in *The Writings of Benjamin Franklin*, edited by Albert Henry Smyth, 10 vols. (London: Macmillan, 1905–7), 4:346, quoted in Wesley Frank Craven, *The Legend of the Founding Fathers* (New York: New York University Press, 1956), 39.

26. Franklin to John Fothergill, March 14, 1764, in *Benjamin Franklin: Writings*, edited by J. A. Leo Lemay (New York: Library of America, 1987), 804. For a more complete explanation of the Paxton Boys, see Daniel K. Richter, *Facing East from Indian Country: A Native History of Early America* (Cambridge: Harvard University Press, 2001), 201–8; Kevin Kenney, *Peaceable Kingdom Lost: The Paxton Boys and the Destruction of William Penn's Holy Experiment* (New York: Oxford University Press, 2009); and, most recently, "Digital Paxton: Digital Collection, Critical Edition, and Teaching Platform," http://digitalpaxton.org/works/digital-paxton/index.

27. On the political broadsides and cartoons of 1764, see Martin P. Snyder, *City of Independence: Views of Philadelphia Before 1800* (New York: Praeger, 1975), 74–80; Alison G. Olson, "Political Humor, Deference, and the American Revolution," *Early American Studies* 3, no. 2 (2005): 363–82; Page Talbott, ed., *Benjamin Franklin: In Search of a Better World* (New Haven: Yale University Press, 2005).

28. On the cartoons associated with this political crisis, see "Digital Paxton," www.digitalpaxton.org/. On Franklin's changing persona and his portraits, see Wayne Craven, "The American and British Portraits of Benjamin Franklin," in *Reappraising Benjamin Franklin: A Bicentennial Perspective*, edited by J. A. Leo Lemay (Newark: University of Delaware Press, 1993), 247–71; and

Brandon Brame Fortune and Deborah J. Warner, *Franklin and His Friends: Portraying the Man of Science in Eighteenth-Century America* (Philadelphia: University of Pennsylvania Press in association with the Smithsonian National Portrait Gallery, 1999).

29. Carl Bridenbaugh and Jessica Bridenbaugh, *Rebels and Gentlemen: Philadelphia in the Age of Franklin* (New York: Reynal and Hitchcock, 1942), 170–71; George W. Boudreau, "Provost Smith and His Circle: The College of Philadelphia and the Cultural Transformation of Pennsylvania," in *Educating the Youth of Pennsylvania: Worlds of Learning in the Age of Franklin*, edited by John Pollack (New Castle, Del.: Oak Knoll Press, 2009); Kevin J. McGinley, "The 1757 College of Philadelphia Production of *Alfred: A Masque*—Some New Observations," *Huntington Library Quarterly* 77, no. 1 (2014): 37–58; Abrams, "Benjamin West's Documentation," 63–64; Anne M. Ousterhout, *The Most Learned Woman in America: A Life of Elizabeth Graeme Fergusson* (University Park: Pennsylvania State University Press, 2003).

30. Von Erffa and Staley, *Paintings of Benjamin West*, 2, 4, 450; John C. Galt, *The Life, Studies, and Works of Benjamin West, Esq.: President of the Royal Academy of London* (London: T. Cadell and W. Davies, 1820), 55, 145.

31. Robert C. Alberts, *Benjamin West: A Biography* (Boston: Houghton Mifflin, 1978), 31; see also Susan Rather, *The American School: Artists and Status in the Late Colonial and Early National Era* (New Haven: Yale University Press for the Paul Mellon Centre for Studies in British Art, 2016), chaps. 3 and 5.

32. Samuel Powel to George Roberts, September 1, 1763, quoted in Alberts, *Benjamin West*, 57.

33. My thanks to Kathleen Foster and the staff of the Philadelphia Museum of Art for allowing me to study their curatorial files for the two Devis portraits, which the PMA acquired in 2002. Family legend among the Penn descendants, noted in these acquisition files, holds that Lady Juliana was painted in the London home of her father. However, these two portraits, perhaps painted some time apart, are very typical of Devis's work, and the themes of his interiors and sitters are often repeated. See Ellen G. D'Oench, *The Conversation Piece: Arthur Devis and His Contemporaries* (New Haven: Yale Center for British Art, 1980); and Kate Retford, "From the Interior to Interiority: The Conversation Piece in Georgian England," *Journal of Design History* 20, no. 4 (2007): 291–307.

34. David A. Kimball and Miriam Quinn, "William Allen–Benjamin Chew Correspondence,

1763–1764," *Pennsylvania Magazine of History and Biography* 90, no. 2 (1966): 221–23.

35. Mark Salber Phillips, "History Painting Redistanced: From Benjamin West to David Wilkie," *Modern Intellectual History* 11, no. 3 (2014): 611–29; David Pets Corbett and Sarah Monks, "Anglo-American Artistic Exchange Between Britain and the USA," *Art History* 34, no. 4 (2011): 630–51; and Sarah Monks, "The Wolfe Man: Benjamin West's Anglo-American Accent," *Art History* 34, no. 4 (2011): 652–73.

36. The group of portraits of the Shippen-Allen family has received very little scholarly attention, in contrast to the extensive research that has been published on Charles Willson Peale's works portraying the John Cadwalader family. My belief is that this was an issue of access. The Cadwaladers stayed in Philadelphia, and their portraits continued to be known to locals and were held up as striking examples of late colonial work by an American artist. In contrast, with the coming of the Revolution, the Allens—and their art—moved to England, where the paintings remain in private ownership, occasionally being lent to public shows over the course of the last century. See von Erffa and Staley, *Paintings of Benjamin West*, 21–27, 484–86 and more recently, Roland Arkell, *Loyalties in Revolutionary Times: The Cricketers by Benjamin West and Other Allen Family Portraits*, exh. cat. (Philadelphia: Freeman's, 2018).

37. Alberts, *Benjamin West*, 8–9.

38. For *The Artist and His Family*, see Margaretta M. Lovell, *Art in a Season of Revolution: Painters, Artisans, and Patrons in Early America* (Philadelphia: University of Pennsylvania Press, 2005), chap. 5; Kate Retford, *The Art of Domestic Life: Family Portraiture in Eighteenth-Century England* (New Haven: Yale University Press for the Paul Mellon Centre for Studies in British Art, 2006), 123–27; von Erffa and Staley, *Paintings of Benjamin West*, 461–62.

39. E. McSherry Fowble, *Two Centuries of Prints in America, 1680–1880: A Selective Catalogue of the Winterthur Museum Collection* (Charlottesville: University Press of Virginia for the Winterthur Museum, 1987), 202–3.

40. [Thomas Paine], *Four Letters on Interesting Subjects* (Philadelphia: Styner and Cist, 1776), 12.

41. There was no correlation between the proprietary/Quaker split and that between Whigs and Tories during the revolutionary struggle that followed. On the fate of the Penn lands, see Juliana Penn to John Adams, December 24, 1782, in *Founding Families: Digital Editions of the Papers of the Winthrops and the Adamses*, edited by C. James Taylor (Boston: Massachusetts Historical Society, 2018), vol. 14, https://www.masshist.org/publications/apde2/view?id=ADMS-06-14-02-0094; and Treese, *Storm Gathering*. In 1779, the state of Pennsylvania voted a £130,000 settlement for the family, who later also filed for Loyalist claims from the British government. Parliament granted the family £4,000 a year in perpetuity. See Jacqueline Miller, "Franklin and Friends: Benjamin Franklin's Ties to Quakers and Quakerism," *Pennsylvania History* 57, no. 4 (1990): 318–36; Carolyn Weekley, *Kingdoms of Edward Hicks* (New York: Harry N. Abrams for the Abby Aldrich Rockefeller Folk Art Museum, 1999). The Winterthur Museum has a Penn family printed textile quilt, which shows West's *Penn's Treaty* in red. My thanks to Linda Eaton for her insight on this and other objects.

42. "Executive Minutes of Thomas Mifflin, 2 April 1792," *Pennsylvania Archives*, edited by Gertrude MacKinney, 9th ser., vol. 1 (Harrisburg: Department of Property and Supplies, 1931), 345–46. My thanks to Daniel Richter for calling my attention to this document.

43. I am proceeding from an assumption here. No record exists of what image Red Jacket is referring to in this speech. When Independence Hall was restored by the National Park Service in the twentieth century, curators chose to use a copy of the oil painting believed to be a youthful William Penn in breastplate—a painting that was not in the American colonies during the colonial or early national periods. An engraving of West's *Penn's Treaty* is a far more likely candidate for the Penn portrait that negotiators viewed. It was certainly available in Philadelphia by 1792, and it was the only readily available portrait that could convey the impression that Red Jacket commented upon. My thanks to Karie Diethorn for her help with this interpretation.

44

Ascending the Stair

CHARLES WILLSON PEALE'S *STAIRCASE GROUP*,
REIMAGINING A GRAND-MANNER PORTRAIT IN
FEDERAL PHILADELPHIA

CAROL EATON SOLTIS

CHARLES WILLSON PEALE CONCEIVED *The Staircase Group* as an ambitious portrait. Ambitious in scale, it was also ambitious in its display of technical artistic skill. As a trompe l'oeil picture intended for public display, it has long been taken at face value and praised for its convincing realism. This essay, by contrast, explores aspects of the portrait beyond its immediate visual effect to recapture a fuller understanding of the picture's identity as an example of Peale's grand-manner portraiture radically reimagined to address the temper of its time and manifest the artist's political values and cultural ambitions (fig. 2.1).

While many of the formal and conceptual aspects of the picture discussed in this essay may have been apparent to various members of its early audiences, the further it was removed from its initial display at the exhibition of the nation's first art academy, the Columbianum, held between late May and early July 1795, and its installation in the Peale Museum immediately thereafter, the more obscure its broader and more time-sensitive ambitions became. In fact, by 1854, when the painting collection of the Peale Museum was sold at auction, the understanding of Peale's portrait of his two sons on a staircase was reduced to simply an illusion. And until relatively recently, the portrait's trompe l'oeil illusionism has sufficed as a full explanation of its identity.

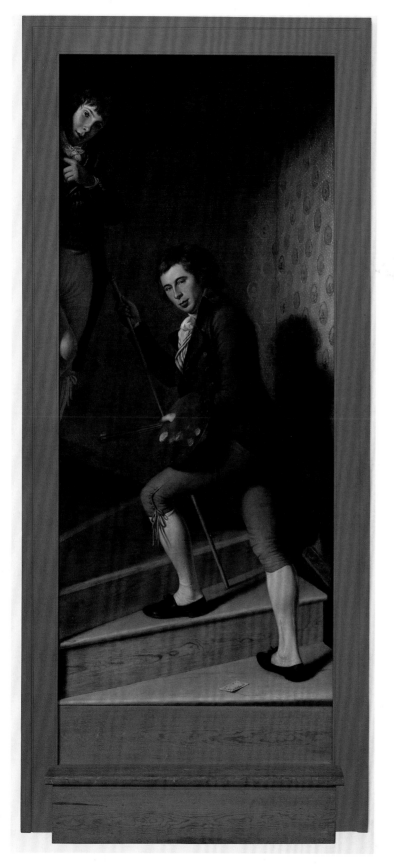

FIG. 2.1 Charles Willson Peale, *The Staircase Group*, 1795. Oil on canvas, 89 ½ × 39 ⅜ in. (227.3 × 100 cm). Philadelphia Museum of Art, The George W. Elkins Collection, E1945-1-1.

CHANGING TIMES, REVISING JUDGMENTS

The text describing *The Staircase Group* from the auction catalogue of M. Thomas & Sons summarizes the perception of the picture in the mid-nineteenth century:

> 100. The Staircase. This is a famous picture by C. W. Peale, representing his two sons, Titian and Raphael, life size. All who have visited Peale's Museum recollect this remarkable painting; its perfect truth to nature is such, that many people have been deceived into the belief that it was a real staircase, with persons ascending it. It was not unusual for persons to approach it, and place one foot on the first step, which was a real one, and dogs have been known to run against it, in the attempt to ascend. Mr. Peale had but little imagination as a painter, but was remarkable for the faculty of depicting visible objects faithfully on canvass [*sic*], and hence the fidelity of his portraits, and pictures of still life. He was so well aware of the peculiarity of his talent in this way that he was always careful to have before him an exact representation of the picture he intended to paint; and in this instance he had an actual staircase constructed, and placed his two sons upon it, in the positions in which they appear on the canvass.[1]

The sale of "Peale's Museum Gallery" was the final component of Charles Willson Peale's enterprising and educational mission, known as Peale's Philadelphia Museum, to be dismantled. As the museum began to slide into financial ruin, a Philadelphia bank took possession of the painting collection, protecting it from an earlier 1848 sheriff's sale, which included most of the museum's natural science displays and anthropological artifacts. P. T. Barnum had been one of the major beneficiaries of that sale, and he set about establishing and promoting his own museum, in which Peale's carefully prepared and researched displays shared space with bizarre and contrived curiosities. But in December 1851, a pyrotechnic event gone awry put an end to Barnum's Philadelphia Museum and its Peale acquisitions.[2] Although Barnum left town, his sensibility was a staple of the mid-century cultural scene, and the eye-catching illusionism of Peale's portrait of his two sons was readily annexed into it by the auctioneers. While the catalogue description praised Peale's technical facility and ingenuity, it denigrated his artistic imagination and so presented the portrait not as a work of art but as an attention-grabbing attraction set to earn top dollar. Fortunately, the portrait was purchased by the Philadelphia collector Joseph Harrison Jr. (1810–1874), who also acquired *The Artist in His Museum* and numerous other pictures.[3] In 1910, *The Staircase Group* was sold to a member of the Peale family, from the estate sale of Mrs. Harrison, and in 1945 it was acquired by the Philadelphia Museum of Art.

Nearly a century after the 1854 auction, a historian and direct descendant of Peale, Charles Coleman Sellers (1903–1980), recontextualized *The Staircase Group* within

the framework of the 1795 exhibition at the Columbianum. In his entry on the picture in his catalogue raisonné of Peale's portraiture, Sellers described it as a purposeful "tour de force" in which the artist sought to affirm his technical expertise, and commented generally on its later success as a deception at the Peale Museum.[4] Although this reception of the picture was an important part of its history and documents its timeless effect on unsuspecting viewers, who encountered it in an appropriately prepared context, Sellers's comments neglected to address the work as an example of the art of portraiture. In this, he echoed the reductionist view presented in the 1854 catalogue. "The famous Staircase," he stated, "is first recorded in the catalogue of the exhibition of the Columbianum. And there can be little doubt that it was painted for that particular occasion, a 'tour de force' in which Peale showed the young men, the fellow professionals, the amateurs and connoisseurs who he had gathered about him in this venture, that his hand had not lost its cunning for all his late preoccupation with natural history." Sellers went on to note that "the piece is a 'deception'—deliberately intended to be mistaken by the spectator for reality, and as such it enjoyed an astonishing success. The figures, which must of course be life size, were placed in a natural but wholly unportrait-like pose, and the whole, instead of being hung upon a wall, was set in the frame of a doorway. The doorway apparently opened into a winding stair, leading upward, and the illusion was completed by an actual step built out into the room at the base of the painted steps. Raphaelle is going up the stair, Titian, his younger brother, looking round the corner from above."[5]

Although Sellers did not repeat the traditional trompe l'oeil narratives about dogs or beguiled viewers running into the canvas and dropped the unsubstantiated story of the construction of a model staircase, he affirmed the central message of the 1854 text. Both commentaries thus reflected what had become widely accepted academic dogma that defined "deceptions," or trompe l'oeil pictures, as extra-artistic expressions in which imagination was inoperative or unnecessary because artistic imagination and intense realism were judged mutually exclusive. Sir Joshua Reynolds, for example, in his widely accepted *Discourses on Art*, stated that "the whole beauty and grandeur of the art consists . . . in being able to get above all singular forms, local customs, particularities, and details of every kind."[6] Sellers's observation that the figures "were placed in a natural but wholly unportrait-like pose" is similar to the 1854 statement that Peale could paint only what was literally in front of him. But Charles Willson Peale's vision was more sophisticated, ambitious, and inclusive than either the chatty mid-nineteenth-century auction catalogue or Sellers's later comments allowed. This was confirmed by Charles's son, Rembrandt Peale (1778–1860), who was the source of the famous story of Washington's mistaking the portrait for the brothers' actual presence during a visit to Peale's museum. Although Rembrandt repeated the litany of praise for the picture's trompe l'oeil efficacy, he also asserted that there was more

to the picture than its illusionism, noting that "if this first homage bestowed on the picture was not indicative of its merit, it was, at least, another instance of Washington's habitual politeness."[7]

Decades of research on the person and the art of Charles Willson Peale have established a basis for enlarging our understanding of *The Staircase Group*. Phoebe Lloyd's "A Death in the Family," which explored the pictorial references in Peale's *Rachel Weeping* (1772; enlarged 1776; retouched 1818; Philadelphia Museum of Art, Gift of the Barra Foundation, 1977), and Roger Stein's seminal essay "Charles Willson Peale's Expressive Design," on Peale's *The Artist in His Museum* (1822; Pennsylvania Academy of the Fine Arts, Gift of Mrs. Sarah Harrison, the Joseph Harrison, Jr. Collection) have led to a wealth of studies in which Peale's use of iconography, art-historical precedents, and "expressive design" in his portraiture has been impressively explored.[8] The writings of Sidney Hart, David Ward, and others have yielded a rich perspective on the patriarch's ideals, preoccupations, personality, and contributions to his society.[9] In a slightly different vein, Wendy Bellion's work on the practice of visual deception in Philadelphia between 1795 and 1836 has offered a broader historical, artistic, and political context for Peale's famous trompe l'oeil picture.[10] Taken together, such studies make it virtually inconceivable that Peale would have created an important large-scale portrait for public display that was devoid of social, political, artistic, and personal references. Seeing only an illusion in *The Staircase Group* is no longer an option.

Peale, however, is not the only artist who, over time, has been subjected to the dualistic academic or popular judgment that too much realism indicates a lack of content, or whose multiple goals have needed to be rediscovered. Recent studies in European painting, such as those by Eric Jan Sluijter on Gerrit Dou (1613–1675), and other works on Dutch artists prized for their high finish and virtuosic illusionism, have pointed out that these artists not only sought to delight or deceive the eye, but that their work was as likely as less realistic works to convey meaning through iconography, pictorial conventions, and other visual references.[11] In fact, trompe l'oeil pictures that unite seemingly literal representations with emblematic, personal, literary, artistic, or other intellectual references have a long and distinguished history. As Susan Feagin observes in her essay "Presentation and Representation," this unusual category of illusionistic painting presents an "opportunity for artists to use the ontological wobble set up by a painting's dual functions to play with ideas about appearance and reality, precepts and concepts, spirituality and physicality, paradoxes of self-reference, visual puns, and the relation of the work in question to other works of art and the history of art."[12]

The illusion of reality need not be separate from imagination, intellectual content, or art-historical references, and their cohabitation in a work of art can in fact make for an unusually stimulating artistic encounter.

CHARLES WILLSON PEALE IN 1794

Almost exactly a year before the debut of *The Staircase Group* at the Columbianum exhibition, Charles Willson Peale announced his "Retirement from Portrait Painting." He wrote that because he was "so engrossed by his Museum," he was recommending that "his Sons, Raphael and Rembrandt as Portrait Painters, whose likenesses, and the excellency of their colouring, he presumes to hope and believes, will give general satisfaction."[13] Both young men seemed set on an artistic career, but Rembrandt had been particularly dedicated to excelling as an artist from an early age.[14] Although Peale did not depict this eager and talented son in *The Staircase Group*, he did present him with his copy of Antonio Palomino de Castro y Velasco's *Account of the lives and works of the most eminent Spanish Painters, sculptors and architects*, a book given to him in 1780 by the Philadelphia printer and bookseller William Dunlap, which celebrated artists gifted with the ability to paint likenesses so fine they were able to deceive viewers.[15] By September, Peale had also announced that he had moved his family and his museum of art and natural science from Third and Lombard Streets to the prestigious location of Philosophical Hall on State House Square.[16] Because the educational mission of his museum had "an affinity" with the purposes of the American Philosophical Society, Peale was given a ten-year lease to all but two rooms, which were retained by the society. Elected to the society in 1786, the year he founded his museum, he became a curator of its scientific collections in 1788 and also served as the society's first librarian. As David Brigham has noted, this move in the fall of 1794 placed Peale in "fellowship with the most prominent institutions of intellectual activity and academic purpose in Philadelphia. Philosophical Hall added to the museum the weight of science, reason, and objectivity."[17] It also placed Peale at the epicenter of the political and cultural life of the new nation's capital city, with its infusion of international wealth, influence, sophistication, and intellectual, social, and cultural ambition. The museum's impressive board had elected Secretary of State Thomas Jefferson its president in 1792, and it included such diverse political, scientific, and religious notables as the enormously wealthy and sophisticated Senator William Bingham, Governor Thomas Mifflin, Secretary of the Treasury Alexander Hamilton, Congressman James Madison, the multifaceted astronomer and inventor David Rittenhouse, the physician and anatomist Caspar Wistar, Bishop William White (chaplain to the Continental Congress and later chaplain to the U.S. Senate), and the Rev. Dr. Ashbel Green, chaplain to Congress and professor of mathematics and natural science at Princeton.[18] As a group, they supported the museum's identity as a serious institution with international connections and a mission to educate and enlighten the public through "rational amusement" and "useful knowledge." Along with its portrait collection, the museum presented natural science displays organized according to the Linnaean system, which was designed to illustrate an encompassing divine order. Scientific experiments, lectures, and a zoo enlivened its offerings.[19]

The Staircase Group was created within the context of the Peale Museum's serious and expanding cultural ambitions, and of the creation of the Columbianum, "an Association of Artists in America for the protection and encouragement of the Fine Arts." For Peale, the vision of *"an academy or school for Architecture, Sculpture and Painting"* was a civic commitment to further the fine arts and a personal commitment to facilitate the artistic education and opportunities of his children. Peale held the initial meeting for this group at the museum in December 1794. The original sixteen members recruited fourteen more artists by their next meeting. Many were British and European artists who had arrived in Philadelphia seeking opportunities for patronage among the city's established elite and the benefits of a newly settled, affluent, international society.[20] The energy in federal Philadelphia seemed to bode well for the arts. Within months of its establishment, however, this new organization broke down over political differences among its members that went to the heart of the organization's projected governance and curriculum.[21] These differences played out in mean-spirited attacks in the press—so much so that in early April, Peale's "faction" judged it wise to publish a conciliatory statement in the *Aurora General Advertiser* smoothing over former differences between the two groups so as not to detract from the public's interest in the Columbianum's first, and only, exhibition, which was scheduled to open at Independence Hall on May 22, 1795. Since neither published reviews nor private papers providing contemporary commentary on the exhibition and its reception have survived, only the exhibition's incomplete catalogue and Rembrandt Peale's much later comments remain as sources for evaluating its contents and speculating on its intentions and success.[22] Although slight, these sources reveal an interesting collection of pictures representing virtually all genres. They also attest to the fact that Charles Willson Peale had rescinded his pledge to "retire" from portrait painting; along with five other unidentified portraits, he presented his "Whole length-Portraits of two of his Sons on a stair case." Whether he painted this portrait expressly for display at the Columbianum exhibition or to welcome visitors on their entry into his new museum is unknown. Certainly, the proximity of these two notable events suggests that the inventive, pragmatic Peale conceived a richly associative, multipurpose picture suitable for both purposes.

51

THE EXHIBITION

The Columbianum's catalogue reflected the new institution's commitment to the utilitarian applications of its artistic training, along with its support of the fine arts. In an inclusive gesture, a small number of works by amateur and decorative painters were shown, but the essential thrust of the exhibition was to showcase the artistic accomplishments of professional artists born or practicing art in America. While

FIG. 2.2 Samuel Lewis, *A Deception*, ca. 1805–8. Pen and brush and black and brown inks, watercolor, blue-green matte opaque paint, gold metallic paint, and graphite, with scratching out, on wove paper, 16 ³⁄₁₆ × 10 ¹³⁄₁₆ in. (41.3 × 27.8 cm). Philadelphia Museum of Art, gift of the McNeil Americana Collection, 2012-172-163.

some were deceased or no longer resident there, others were actively engaged in their professions, and, according to Rembrandt Peale, many works were for sale. There was a surprisingly large number of landscape paintings, but genre, history painting, and the art of sculpture had meager representation.[23] There was an ample assortment of portrait miniatures, and although not as numerous as landscapes and portraits, still lifes were well represented. There were also six "deceptions," which may be viewed as adjuncts to still life. The three by Raphaelle Peale were titled *A Bill*, *A Deception*, and *A Covered Painting*. The highly skilled cartographer and drawing master Samuel Lewis (1753/54–1822) contributed three works, all titled *A Deception* (fig. 2.2).[24] But the most ambitious deception was Charles Willson Peale's "Portraits of two of his Sons on a stair case," although it was not listed as such.

Peale's portrait was listed among approximately forty-five portraits by a variety of artists who were, or had been, active in Philadelphia.[25] Among the most interesting works that can be identified was Joseph Wright's portrait of his young relative,

FIG. 2.3 Joseph Wright, *John Coats Browne of Philadelphia*, ca. 1784. Oil on canvas, 61 ⅜ × 43 ¼ in. (155.9 × 109.9 cm). Fine Arts Museum of San Francisco, gift of Mr. and Mrs. John D. Rockefeller 3rd, 1979.7.107.

John Coats Browne of Philadelphia (fig. 2.3). Wright (1756–1793), the Royal Academy–trained son of the internationally famous American-born wax modeler Patience Wright (1725–1786), showed his subject in a full-length grand-manner format. Complete with drapery and an impressive architectural background, the figure was based on Wright's sketches, made in London, of Thomas Gainsborough's portrait of Jonathan Buttall (*The Blue Boy*, ca. 1770, Huntington Library, Art Collections, and Botanical Gardens, San Marino, California). As Monroe Fabian has noted, "We may have here an example of the artist's devilish humor," in that Wright's subject was the son of a Philadelphia-area blacksmith, and Buttall was the son of a wealthy British ironmonger. Certainly, it was a creatively naturalized application of the grand-manner portrait for an American subject.[26]

Charles's brother, James Peale (1749–1831), submitted a conversation piece titled *A Family, small whole lengths, in Oil*.[27] His sons, Raphaelle and Rembrandt, both presented five portraits showcasing their skill in delineating men, women, and children,

FIG. 2.4 Benjamin West, *James Hamilton*, 1767. Oil on canvas, 95 × 61 in. (241.3 × 154.9 cm). Courtesy of Independence National Historical Park, Philadelphia.

and Rembrandt added a self-portrait. But the artists in the exhibition against whom Charles Willson Peale most probably measured himself were the internationally successful American-born history and portrait painters Benjamin West (1738–1820), John Singleton Copley (1738–1815), and John Trumbull (1756–1843). Cast as a triumvirate representing the splendid future of American art, the names of these men had already become a refrain that would be repeated frequently in the years that followed. Their work was, of necessity, an important component of the Columbianum's display. Trumbull was represented by three oil portraits in miniature. Painted after his return from London in 1789, they were related to his patriotic campaign to capture the best likeness of the revolutionary notables for his large commemorative historical canvases. Typically his freshest and most lively productions despite, or perhaps because of, their scale, they were fine and timely choices.[28] Benjamin West's new status as president of London's Royal Academy, along with his local roots and his reputation for nurturing

American-born artists like Peale, made him an important exemplar.[29] Two uniden-
tified half-length West portraits were on display, as was his grand-manner portrait
of James Hamilton, no doubt a sentimental favorite for Peale, since his left hand was
memorialized on its canvas (fig. 2.4). Peale had literally encountered West at work on
this portrait the first day he presented himself to the artist in his London studio in
1767. The timing was providential, as Hamilton's brother-in-law, Chief Justice William
Allen (1704–1780) of Philadelphia, had written Peale's letter of introduction to West.
Hamilton, who had been lieutenant governor of Pennsylvania, was abroad on a medi-
cal visit, and Peale's first job in West's studio was to pose for Hamilton's hands.[30] In the
finished portrait, the Hamilton/Peale hand rests gracefully on a velvet-covered table,
while the other is connected solidly to his hip. Handsomely attired and shown full
length with a sword at his side, the governor's sturdy figure stands before a window
through which we see a cloud-filled sky, along with a flourish of drapery and a sturdy
column, a traditional symbol of constancy and fortitude. It was a portrait that bespoke
the pictorial ambitions of both sitter and artist.

Although the only portrait listed in the catalogue by Copley is a *Portrait in Crayon*,
Rembrandt Peale's "Reminiscences" record the addition of the artist's masterly *Portrait
of Mr. and Mrs. Thomas Mifflin*.[31] The inclusion of this picture, with its stunning
realism and highly articulated details, may be seen as both an homage to Copley's
American work and a personal challenge to Peale. In Boston in 1766, Copley had
provided Peale with some of his earliest training and insights into the profession of
portrait painting.[32] But in the early 1770s, after Peale's return from London, the two
artists were in direct competition. As Jules Prown has noted, "Copley seems to have
been stung by the challenge of the impressive double and family group portraits that
Peale was producing in the Middle Colonies." When Peale heard of Copley's success-
ful stint of portrait painting in New York in 1772, he wrote defensively to his friend
John Beale Bordley that there were "a number of New Yorkers having been here, who
have given me the character of being the best painter in America—that I paint more
certain and handsomer likenesses than Copley. What more could I wish?"[33] Although
the itinerant Peale did not relocate from Maryland to Philadelphia until 1776, he
painted numerous impressive portraits of Pennsylvanians prior to that date, includ-
ing five Cadwalader family portraits in Philadelphia between 1770 and 1772 (fig. 2.5).
Still, during the summer of 1773, while visiting Boston, the Mifflins commissioned
Copley to paint their portrait (fig. 2.6). Copley considered it one of his best works,
and a Bostonian, Samuel Eliot, wrote a friend in Philadelphia that the portrait would
"furnish Philadelphia with one of the best pictures it has to boast."[34] We do not know
exactly when Peale first encountered Copley's portrait, but it is likely that it served as
a spur to his creativity in 1795. In his portrait of the Mifflins, as in many of his other
works, Copley achieved what Margaretta Lovell describes as "an ability to take the
anti-realist elements of artifice, imitation, social convention and visual metaphors

FIG. 2.5 Charles Willson Peale, *Portrait of John and Elizabeth Lloyd Cadwalader and Their Daughter Anne*, 1772. Signed and dated beneath table: "C. W. Peale/ pinx 1772." Oil on canvas, 50 ½ × 41 ¼ in. (128.3 × 104.8 cm). Philadelphia Museum of Art, Purchased for the Cadwalader Collection with funds contributed by the Mabel Pew Myrin Trust and the gift of an anonymous donor, 1983-90-3.

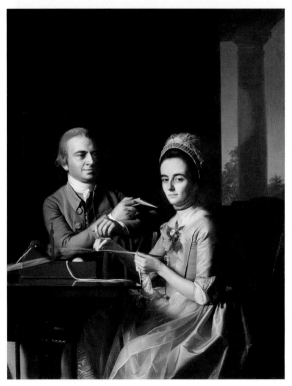

FIG. 2.6 John Singleton Copley, *Portrait of Mr. and Mrs. Thomas Mifflin (Sarah Morris)*, 1773. Oil on ticking, 61 ⅝ × 48 in. (156.5 × 121.9 cm). Philadelphia Museum of Art, 125th Anniversary Acquisition. Bequest of Mrs. Esther F. Wistar to The Historical Society of Pennsylvania in 1900, and acquired by the Philadelphia Museum of Art by mutual agreement with the Society through the generosity of Mr. and Mrs. Fitz Eugene Dixon Jr., and significant contributions from Stephanie S. Eglin, and other donors to the Philadelphia Museum of Art, as well as the George W. Elkins Fund and the W. P. Wilstach Fund, and through the generosity of Maxine and Howard H. Lewis to the Historical Society of Pennsylvania, EW1999-45-1.

of social ideals and weave these disparate threads together with optical fidelity into a seamless whole."[35] Although Peale had not yet attempted to achieve such "optical fidelity," he had spent most of the previous two decades working with the "anti-realist" elements in his grand-manner portraiture. Thus he surely had no trouble in "reading" the content of Copley's portrait. Not only would Peale easily have read the intimate placement of the Mifflins as a visual metaphor for the ideal of the companionate marriage of the later eighteenth century, and the column as part of the grand-manner vocabulary of strength, stability, and status; he also would have recognized the political statement of colonial self-sufficiency presented by Mrs. Mifflin's loom.[36] Peale, like Mifflin, was a radical Whig committed to the Revolution, and Copley's inclusion of the loom was in fact similar to Peale's naturalized imagery referencing colonial opposition in his 1770 portrait of his patron John Beale Bordley.[37] Despite political differences and similarities with their patrons, both Copley and Peale knew their sitters and creatively employed imagery from the real world that also functioned emblematically in their portraits. Both men knew that realism could easily enter into a symbolic discourse.

But there are also interesting formal similarities between Copley's portrait of the Mifflins and Peale's portrait of his two sons. Both works are double portraits in which the figure on the right looks steadily out at the viewer after being distracted from his/her activity, and both set their subjects against a darkened space with a vertical orientation. Both pictures display a masterly use of chiaroscuro, with the faces of both Thomas Mifflin and Titian Ramsay Peale emerging from shadow into light. Peale would later comment that a face half in shadow was "the most difficult of all portraits."[38] But the most compelling and artistically daunting point of comparison between these two paintings rests in what Paul Staiti calls Copley's "unprecedented skill in transcribing material things onto canvas."[39] The intense realism of Copley's polished table and the loom are matched, however, by Peale's keenly observed yellow pine stairs. And the shimmer and textures of Mrs. Mifflin's dress and scarf are countered by the carefully observed folds in the leather of Raphaelle's buckskin breeches and his silky striped vest. Peale appears to have challenged Copley with bravado. But he also added a special twist by moving beyond brilliant realism into calculated illusionism and creating a composition that embraced both grand-manner portraiture and the then internationally popular genre known as deception.[40]

Although *The Staircase Group* heralds the greater naturalism of Charles Willson Peale's later art, there is little in his painting prior to this time that would have predicted the appearance of this picture.[41] Yet it is easily accounted for in the context of the significant contemporary interest in and presence of trompe l'oeil representations and wax sculpture in both Europe and America. Although there is little doubt that Peale's interest in illusionistic painting centered around displaying a time-honored artistic skill, the contemporary political climate surely added a certain frisson to the mix, for, as Bellion has observed, in postrevolutionary America, and particularly at

the time of the Columbianum exhibit, trompe l'oeil pictures might also be seen as "a challenge to spectators to discern fact from illusion," and "detection and exposure of false appearances demonstrated one's mettle as a fit citizen of the republic."[42] Peale's *Staircase Group* was far from an anomaly; it was in fact au courant.

LIKENESS AND PRESENCE IN THE MUSEUM AND AT THE COLUMBIANUM

The Staircase Group was not Charles Willson Peale's first foray into illusionism. It was preceded by his life-sized wax self-portrait, an endeavor recorded for posterity by the Rev. Manasseh Cutler on his visit to Peale's museum at Third and Lombard in July 1787. Cutler recalled seeing Peale "standing with a pencil in one hand and a small sheet of ivory in the other, and his eyes directed to the opposite side of the room as though he was taking some object on his ivory sheet." When Peale appeared in the flesh, Cutler was amazed, because "he appeared to me to be [as] absolutely alive as the other.... To what perfection is this art capable of being carried!"[43] Life-sized wax sculpture was not a novelty in Philadelphia in the late 1780s, but Peale's presentation of himself in wax was unusual.[44] While other waxes in the city ranged from anatomical displays to presentations of the famous or the frightening designed to teach, shock, or entertain, Peale presented a simulacrum of his ordinary self in a typical place doing typical work. Seamlessly integrating this three-dimensional trompe l'oeil into his museum, he established his presence whether he was in residence or not. Cutler, a student of history and natural science as well as a cleric, also admired Peale's "romantic and pleasing" habitats, in which the artist presented his expertly preserved birds and beasts in characteristic attitudes. Both Peale's displays and his worldview were informed by the *Systema Naturae* of Linnaeus, whose work sprang from the deep-seated belief that it was possible to understand God's wisdom by studying his creation. Peale's presentation of specimens in their typical habitats, and as part of a harmonious system in which all things had a purpose and worked cooperatively, remained constant. As late as 1823, when he was devising his emblematic schema for his *Staircase Self-Portrait* for Rubens Peale's Baltimore museum, Peale considered including a bust of Linnaeus to represent the important place of this naturalist and his taxonomy in his life and work. One might conclude that Peale's placement of his wax double in his museum made him an integral part of that display and another specimen in the great order of creation.[45] Arguably, his later placement of *The Staircase Group* in his newly configured museum of art and science in Philosophical Hall similarly established the presence and central role of his sons in this new endeavor.

When *The Staircase Group* was painted, Raphaelle Peale (1774–1825) was twenty-one and working to fulfill his father's ambition that he become a successful artist. Titian Ramsay Peale (1780–1798) was not quite fifteen, but he was intensely

dedicated to the study of natural science and its presentation in the museum. Both lived and worked in Philosophical Hall and might typically be found there applying themselves to their individual pursuits. The placement of their portrait in a closed-off doorway readily enticed visitors to follow Raphaelle up the staircase as Titian beckoned. This placement of the picture followed the European tradition of staging life-sized illusions of people or perspective views in "the domestic space of a home or collection to astonish and impress visitors, and to elicit wonder and admiration for those who made and possessed them."[46] The power of Peale's illusionistic portrait to initially emulate life rather than to present itself as art powerfully established the young men's actual presence and indicated their participation in the life and work of the museum. Peale's desire to wed some of his children to his museum enterprise was expressed in a letter to George Walton in 1793, in which he stated, "I have labored to instruct my children to be industrious and careful that they may help themselves and be useful members of the community—and as I have several, some amongst them will be able to assist me."[47] Peale's 1795 *Staircase Group* served him well as an admired attraction in his museum, but its full message, addressed in greater detail below, surely began to wane after Titian's death from yellow fever in September 1798. Titian's role at the museum was significant, and in June 1799 Charles wrote a naturalist friend, "I shall say no more of this mournful tale, you know my loss, & I may justly say a *public Loss*. I strive to bear up against this affliction, but I have such frequent call to remember his assiduous labours, while perusing my favorite pursuits, that the Woods as well as my Study often witness my pangs—and knowing the importance of my labours to put my Museum in a lasting condition, and thereby secure its permanent establishment, I sometimes fear this *cankerworm*, Grief, will prey on my Vitals, and shorten my days."[48]

The gradual but obvious dissolution of Raphaelle Peale's private life and public career also became a troubling reality at odds with the optimistic image of 1795.[49] Considering Peale's acute personal losses in both these instances, it is not surprising that he later had little to say about his stunning picture beyond its successful illusion.[50] Over time, the identities of the young men in the portrait became obscure, but the picture remained in the museum, and its immediate pictorial effect remained powerful.

Of all painted or drawn artistic deceptions, trompe l'oeil portraiture is the shortest-lived in its illusionistic impact. Once the visitor approaches the canvas and the figures do not move, their presence is recognized as an illusion, and the "moment of recognition," when the painting becomes "about the artist and the artist's craft," occurs.[51] This short time frame suited Peale well, in that one of his goals for the museum, as for the earlier exhibit at the Columbianum, was public recognition of his painterly skill. As he put it in his autobiography, "If a painter . . . paints a portrait in such perfection as to produce a perfect illusion of sight, in such perfection that the spectator believes the real person is there, that happy painter will deserve to be caressed by the greatest of mortal beings."[52]

Although this statement dates from a later period in the artist's life, Peale assim-
ilated this template for artistic success years earlier through at least two books he
is known to have owned and read, his copy of Palomino's *Lives*, noted above, and
Matthew Pilkington's *Gentleman's and Connoisseur's Dictionary of Painters*. Palomino
asserted that artists whose works were as "vivid as nature" "deserved immortal
Honour," and noted that Velázquez's great skill as a painter caused him to be "caressed
by the grandees and the most Excellent painters."[53] He also described how Velázquez
received "Universal applause" when one of his portraits was "placed among a group
of very fine paintings on display in Rome"; "in the opinion of all Painters of different
Nations, all the rest look'd like Painting, but this alone seem'd to be a Reality, and there-
upon Velasquez was admitted a Member of the Roman Academy."[54] In Pilkington's
Gentleman's and Connoisseur's Dictionary of Painters, Peale read of the masterly realism
of the celebrated Dutch artist Gerrit Dou.[55] Pilkington judged Dou ("Douw") "most
wonderful in his finishing" and added that although "imperfect connoisseurs" deni-
grated artists like Dou, "persons of finest taste in Italy appreciate and collect them."[56]
Peale wrote in the margin, "the critics are often severe on a labored Picture, but I think
that a piece [smelling?] of the pallet is a commendation of the painter, nature is very
perfect, and a judicious painter cannot finish too high."[57] Pilkington also discussed the
enormously successful practitioner of illusionistic painting Samuel van Hoogstraten
(1627–1678), noting that he was richly rewarded for his work by "the Emperor in
Vienna," who enjoyed being surprised by his pictures. At some point, Charles gave
Pilkington's *Dictionary* to Raphaelle, whose name is prominently inscribed on its title
page. Charles had himself received it as a gift from his English patron and friend
Edmund Jennings (1731–1819) in 1770, not long after its publication in London. It
provided Peale with a wide variety of artists and referenced a full spectrum of liter-
ature on the arts.[58] A rich resource and an inspiration well suited to a busy, creative,
and eclectic artist like Peale, it celebrated the realism of northern painting as well as
the idealism of the classical tradition. It did not privilege line or design over color but
strongly advocated the value of both. The works of Palomino and Pilkington provided
Peale with examples of artists who flourished as a result of their abilities in realistic
depiction, an aesthetic that Peale increasingly sought to master.

The French theorist Roger de Piles (1635–1709) was among the authors whom
Pilkington consulted in constructing his work. As Thomas Puttfarken has noted, de
Piles's thought was in "sharp divergence to academic theory" and "embraced *tromperie*,
deception and illusion."[59] He also insisted on the importance of the *first effect* of a
painting, and his words seem to have been echoed in those of Peale, cited earlier. De
Piles wrote, "true painting, by force & great truth of its imitation, ought . . . to call the
spectator, to surprise him & oblige him to approach it, as if he intended to converse
with the figures."[60] It was this immediate attraction and dramatic, forceful illusion
that he believed would then draw the spectator to what he called the "qualities of the

painting that would keep his interest and affect him long after the first visual effect made its impression."[61] The qualities de Piles referred to were "the traditional parts of painting," that is, artistic form, execution, and invention, and he described the rationale for the *first effect*: "Tis in vain to adorn a stately palace with the greatest rarities, if we have forgot to make doors to it. . . . All visible objects enter the understanding by the faculty of seeing. . . . The first care therefore of the painter . . . should be, to make this entrance free and agreeable."[62]

61

Like de Piles, Charles Willson Peale judged trompe l'oeil or compelling realism an artistic achievement. It was a skill that represented the artist's control and agency. But as Richard Leppert has noted, "The trompe l'oeil deception must in the end be recognized, else the picture, in succeeding too well to deceive, fails as a painting."[63] It is at this point of recognition of the illusion that the quality of the image and the content behind it may be studied and contemplated.

The presentation of *The Staircase Group* at the Columbianum showcased the portrait at a moment when its relevance for Peale and the community was at its peak. That it was not identified as a deception in the catalogue, but rather as "Whole length-Portraits of two of his Sons on a stair case," suggests an exhibition strategy that protected the important "first effect" of its illusion while also maintaining its identity as a portrait. Here, at the Columbianum, the training ground for aspiring artists, Peale displayed his skills in design, drawing, perspective, realistically modulated color, and high finish, and his mastery of chiaroscuro. He also showcased his ability to manage anatomically convincing life-sized figures and provided convincing depictions of a variety of physical surfaces, ranging from flesh and fabrics to wooden stairs and wallpaper. In traditional trompe l'oeil fashion, he signed his picture by including a ticket to the Peale Museum on a lower step. Not only did this identify Peale as the artist, but it also established where his sons were located within the painting and in real life. The closer visitors came to the picture, the less convincing the illusion—but the more visible the ticket—became (fig. 2.7).[64] Also, by depicting two young men frequently seen in the community, Peale provided the public an opportunity to confirm or deny his skill as a sensitive and accurate portraitist. Viewers who could identify Peale's sons by name, as many undoubtedly could in this circumscribed group of exhibition goers, would be reminded of the young men's carefully chosen namesakes, Raphaelle and Titian, selected by their father from Pilkington's *Dictionary of Painters*.[65] According to Pilkington, Raphaelle Peale's namesake, Raffaello Sanzio (1483–1520), was "instructed in the rudiments of art by his father but through study of nature and the antique, he acquired remarkable correctness in drawing and design." Not only did he "excel in portraiture, as well as in history but his easel pictures were exquisitely finished." Titian Ramsay Peale's namesake, the great Venetian Tiziano Vecellio (ca. 1490–1576), "made nature his principal study, and imitated it faithfully and happily." His color was "accounted the standard of excellence to all professors of the art," and he produced

FIG. 2.7 Admission ticket to Peale's Museum, 1794. Engraving, 2 ½ × 3 ½ in. (6.4 × 8.9 cm). Philadelphia Museum of Art, gift of Jack L. Lindsey in honor of H. Richard Dietrich Jr., and Robert L. McNeil Jr., 1997-172-2.

"superior portraits" with "astonishing tints." His "color had all the look of real flesh— his colors breathe."[66] How simple and appropriate that the Columbianum's first art exhibition included a portrait of the namesakes of two of the greatest artists in the history of Western painting, masters of design and color, respectively.

THE STAIRCASE AS A GRAND-MANNER PORTRAIT

If *The Staircase Group* was more than an illusion, it was also more than the likenesses of two of Peale's famously named sons. Far from being the "wholly unportrait-like pose" that Charles Coleman Sellers judged it to be, the portrait's composition and scale fit easily into the impressive body of grand-manner portraiture that Peale created during the 1770s, 1780s, and early 1790s.[67] His experience in West's London studio had pre- pared him to return to America ready to celebrate the status, values, and ideals of his Maryland and Pennsylvania patrons through grand-manner portraiture.[68] Success in this genre presupposed an artist's ability to work on a large scale, master the depiction of the human figure, and be sufficiently inventive to deftly communicate something

about the person or persons being portrayed. This ability to convey meaningful content through pictorial structure, iconography, and pose or gesture was an essential part of this practice. Interestingly, Peale was instructed at the historical moment when British artists were seeking to establish their own national school, and, like Peale, many felt they were learning a new language. Werner Busch has remarked that Sir Joshua Reynolds (1723–1792) lamented that British artists had to learn "by precept" what Continental artists had learned as a "mother tongue." "We are constrained," he said, "to have recourse to a sort of Grammar or Dictionary, as the only means of recovering a dead language."[69] Like his British contemporaries, Peale sought fluency in this visual language and compiled sketches and a large collection of prints to nurture his and his children's visual imaginations. He gained facility in constructing his portraiture through "precept" and ably matched imagery and content for effective visual presentation. This process of searching for appropriate artistic precedents was in fact not unlike the taxonomy he followed in the creation of the natural science displays he constructed in postrevolutionary Philadelphia. In both cases, a drive to define, categorize, and bring order to the visual world and the place of God's creatures within it was in play.[70]

Although Peale painted numerous double portraits of parents and children and pairs of children, his double portrait of two mature siblings had no immediate predecessors. However, he had encountered a striking example of such a grouping in West's London studio. This was the life-sized portrait of the Drummond brothers that West first exhibited at the Society of Artists in 1768 and that was engraved shortly thereafter (fig. 2.8). The portrait depicts the two eldest sons of West's patron Robert Hay Drummond (1711–1776), the archbishop of York, who, like Peale later on, was deeply involved in his children's education.[71] Robert, the elder brother, holds a scroll and rests his forearm on his younger brother's shoulder. Robert's other hand points upward to a circular temple inscribed with the words *virtutis* and *honoris*. Behind them is a statue of Minerva, the Roman goddess of wisdom. The seriousness with which Drummond approached the subject with West, the coupling of the fraternal figures, and the boy's hand pointing to a construction symbolic of high purpose may have lingered in Peale's memory. It clearly influenced his miniature portrait, commissioned by John Beale Bordley's half brother, Edmund Jennings III (1731–1819), of Bordley's sons, Matthias and Thomas, who had recently arrived in London on their way to Eton. In this small double portrait, the elder boy's hand also rests on his younger brother's shoulder as he points to a passage in a book. Behind them the dome of St. Paul's Cathedral is visible, and next to them is a bust of Minerva (fig. 2.9).[72] Both pictures find their inspiration in the "friendship portraits" introduced into Britain by Sir Anthony van Dyck (1599–1641), and in 1783 Peale created the double portrait *Gouverneur Morris and Robert Morris*, which also reflected this visual tradition (fig. 2.10).[73] Possibly derived from a print after the much copied and frequently adapted Van

64

FIG. 2.8 Valentine Green (English, 1739–1813), engraving after Benjamin West, *Mr. Robert Drummond and Mr. Thomas Drummond, Sons of Robert Archbishop of York*, ca. 1769. Mezzotint, 24 ¼ × 15 ⁵⁄₁₆ in. (61.6 × 39 cm). The British Museum, London, 1838,0425.26. © The Trustees of the British Museum. All rights reserved.

FIG. 2.9 Charles Willson Peale, *Matthias and Thomas Bordley*, 1767. Watercolor on ivory, 3 ⅝ × 4 ⅛ in. (9.2 × 10.5 cm). Smithsonian American Art Museum, Washington, D.C., Museum purchase and gift of Mr. and Mrs. Murray Lloyd Goldsborough Jr., 1974.113.

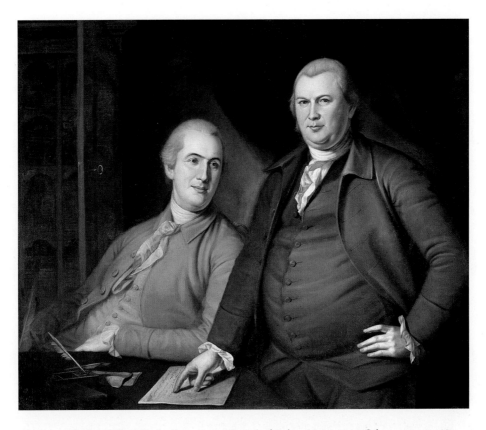

FIG. 2.10 Charles Willson Peale, *Gouverneur Morris and Robert Morris*, 1783. Oil on canvas, 43 ½ × 51 ¾ in. (110.5 × 131.4 cm). Courtesy of the Pennsylvania Academy of the Fine Arts, Philadelphia, Bequest of Richard Ashhurst, 1969.20.1.

Dyck portrait *Thomas Wentworth, First Earl of Strafford, and Sir Philip Mainwaring* (ca. 1639–40), Peale's painting, like Van Dyck's, documented a close and politically important working relationship between two men.[74] Robert Morris (1734–1806), who commissioned the portrait, was a financier of the Revolution, and Gouverneur Morris (1752–1816), who was not related, was his able assistant. Together they shared a herculean task and remained close friends and business partners after the war ended, despite their very different personalities, which Peale ably depicted in his portrait.

In June 1795, only weeks after the opening of the Columbianum exhibition and the presentation of Peale's "Portraits of two of his Sons on a stair case," Peale painted another family portrait. Like the earlier Morris double portrait, it had specific visual and thematic precedents. At the request of his eldest daughter, Angelica Kauffmann Peale (1775–1853), Peale traveled to Baltimore to paint her and her husband, the wealthy, Irish-born Alexander Robinson (1751–1845), shortly before she was due to give birth to the artist's first grandchild (fig. 2.11).[75] The portrait is clearly evocative of

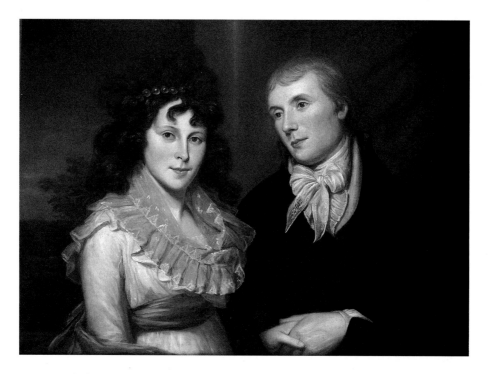

FIG. 2.11 Charles Willson Peale, *Portrait of Alexander and Angelica Kauffmann Peale Robinson*, 1795. Oil on canvas, 26 ¼ × 35 ¼ in. (66.7 × 89.5 cm). Philadelphia Museum of Art, Promised gift of the McNeil Americana Collection, x-8264.

the visual tradition used to commemorate or celebrate betrothals, marriages, or the imminent birth of a child. Models for the format, which date to antiquity, are found in Cesare Ripa's emblematic *Marital Concord* from his *Iconologia*, and in the portraiture of European artists as disparate as Anthony van Dyck and Lorenzo Lotto (ca. 1480–1556).⁷⁶

THE PORTRAIT IN THE DECEPTION

Painters may draw a considerable advantage from all the different manners of those that have gone before them, who are as so many flowers, from whence, like the bees, they may suck a juice, which incorporating with their proper substance, will bring forth such works as are useful and agreeable.

—Roger de Piles

Like the later texts of Pilkington and Palomino, Roger de Piles's recommendation of an eclectic method for creating useful and agreeable works of art gave artists the

freedom to pursue multiple choices of artistic inspiration.[77] In his bold and eclectic merger of trompe l'oeil style with grand-manner portraiture, Peale took full advantage of such license. Created in the context of the Columbianum's intense pre-exhibition controversy over the possibility of the organization's becoming a national institution modeled on England's Royal Academy, *The Staircase Group* may have been Peale's independent-minded, antimonarchical, anti-Federalist response to an idea he opposed.[78] Not only did the prospect of a national academy have the potential to minimize Peale's guiding hand, but it raised the specter of a highly defined hierarchical curriculum with concomitant aesthetic dictates. Rembrandt Peale's comment that the resignation of eight Englishmen from the organization was "occasioned by some republican sentiment uttered by an American" suggests that freedom of expression, if not political ideology, may have been an issue.[79] Peale had been in London when the Royal Academy was founded with the intention of superseding the Society of Artists. As Matthew Hargraves notes, "far from being a simple progressive move towards greater professionalization, or the inevitable outcome of several decades of pro-academic campaigning, or even a necessary step for the quality artists to cast off their inferior colleagues, the RA was created to cancel out the developments brought about by the recent exhibitions, to undermine the power of the new generation of influential artists and to return the political order to a largely pre-exhibition status quo. By protecting established authority, George III reversed the recent advances, and arbitrarily handed almost unassailable power to a small elite of artists."[80] If *The Staircase Group* was a response to the contentious situation at the Columbianum, it may not only have been about creating a deception as part of "anxieties over forms of deception," as has been suggested.[81] It also may have been a statement about artistic self-determination and the freedom to imagine a new order in a new way. Peale clearly did not envision European artists coming to American shores to reestablish foreign hierarchies. Rather, in 1771 he wrote to Benjamin Franklin, whom he had met in England, that he saw America as a refuge and new start for those who sought a better political and social order: "The people here have a growing taste for the arts, and are becoming more and more fond of encouraging their progress amongst them. I fondly flatter myself they will here find patronage, and an Assylum [sic], when oppression and tyranny shall perhaps banish them from seats where they now flourish."[82]

THE MODEL OF VAN DYCK

Although the particular scale and placement of Peale's figures of his sons on the staircase were carefully calibrated to ensure that his image produced a successful illusion, this precise orchestration did not preclude the adaptation of a formal and conceptual model in its composition.[83] With his long history and facility in crafting

grand-manner portraiture to meet the desires of his American clientele, Peale was well prepared to select an appropriate pictorial model to evoke the ideas he wished to engage. This model was one of the most celebrated, copied, and adapted portraits of the British nobility, and as such it embodied a reference to the great court portraiture of the past that no British, European, or American cognoscente in cosmopolitan Philadelphia could miss. It is thus ironic that twentieth-century commentary on the portrait readily accepted Charles Coleman Sellers's judgment that the composition of *The Staircase Group* was "wholly unportrait-like," when in fact its inspiration sprang from Anthony van Dyck's masterpiece of pictorial design, *Lord John Stuart and His Brother, Lord Bernard Stuart* (fig. 2.12).[84] Van Dyck was renowned for the inventiveness of his compositions, the elegance and grace of his figures, his incomparable depiction of fabrics, and his ability to imbue his sitters with the qualities of dignity and natural command. More important, Van Dyck was the consummate master of a portraiture of engagement and relationship. This prolific artist, who is credited with revolutionizing English portrait painting, was idolized in eighteenth-century Britain and was the namesake of Peale's infant son, Van Dyck, who died in 1794.[85] Peale had written Bordley in 1772 of "the perfection and the excellence that portrait painting could be carried to in a Van Dyck," and Sir Joshua Reynolds considered Van Dyck "the first of portrait painters."[86] According to de Piles, "Aside from Titian, Van Dyck surpassed all the painters that went before him, or have come after him, in Portraits."[87] Pilkington lauded him as an "incomparable painter" who created "portraits of sublime character" and whose best works were "noble, easy and natural." And for Pilkington and many others, there was no painter who better understood the principles or practice of chiaroscuro.[88] The importance of Van Dyck in late eighteenth-century Britain was attested to by Gainsborough's famous summoning of Reynolds to his death bed to settle their differences in the name of Van Dyck.[89] Gainsborough was among the many artists who replicated the Flemish master's work; he copied the portrait of the Stuarts at the London residence of the Stuart heirs.[90] If you were looking for a model for an important portrait, Van Dyck certainly was your man. James McArdell's mezzotint after the portrait retained its essential composition and offered the British public greater access to the image (fig. 2.13). A comparison of Van Dyck's portrait of John and Bernard Stuart with *The Staircase Group* illustrates the advice of Reynolds and other academic theorists, including de Piles, on how to transform an admired artistic precedent to suit one's own expressive needs. The idea was to adapt the conception, not copy the details of the work, and to assimilate a model so fully that the source was evoked but did not obscure the new creation.[91] Although the setting of *The Staircase Group* is more evocative of a domestic interior than of a palatial stairway, it echoes Van Dyck's location of a partially darkened interior and uses the image of an ascending figure to introduce movement and variety into the composition. Like the younger royal brother, Lord John, Titian Peale faces the viewer at a slight angle, with light falling more fully

FIG. 2.12 Sir Anthony van Dyck, *Lord John Stuart and His Brother, Lord Bernard Stuart*, ca. 1638.
Oil on canvas, 93 ½ × 57 ½ in. (237.5 × 146.1 cm). © The National Gallery, London, NG6518.
Bought, 1988.

70

FIG. 2.13 After Sir Anthony van Dyck, *Lord John and Lord Bernard Stuart,
Sons of Esme Duke of Lenox*, 1740–65. Mezzotint by James McArdell, 505 ×
355 mm. The British Museum, London, 1838,0420.182. © The Trustees of the
British Museum. All rights reserved.

on the right side of his face. The boys in both paintings act as stable elements, and their
figures are slightly elevated over those of their elder brothers, who project greater phys-
icality and movement. The authoritative stance of Lord Bernard, which was destined
to resonate through British portraiture in the works of Lely, Reynolds, and others, is
echoed in the vigorous athletic stride of Raphaelle.[92] Other elements of the portrait
differ, but the identical pose is seen in a mezzotint engraving of Lord John and Lord
Bernard Stuart, and in Van Dyck's similarly composed full-length double portrait of
George and Francis Villiers, praised by Pilkington.

Titian's gesture is a particularly interesting example of Peale's pictorial adaptations. While the boy's hand appears to be pointing up the staircase, its directional quality is largely the effect of the artist's fine handling of chiaroscuro. It is clear that Peale endeavored to retain the form and gesture of a canonical Van Dyck hand, which turns gracefully inward toward the subject's chest. A glance at Lord Bernard's hand reveals a match. Titian's gesture may be construed as inviting the viewer up to the exhibits he worked on with such diligence, "patience and perseverance" that his father feared that his "too great attention to such minute objects would injure his health," yet it also defines his role as the young naturalist whose Linnaean mission to construct natural classifications and search out new specimens placed him in the service not only of his father but also of a divine higher order.[93] Unlike the nonchalant Stuarts, Raphaelle and Titian meet the viewer with a polite, direct, and inquisitive gaze, acknowledging that they have been seen and welcoming the viewer to join them. In its descriptive precision and unpretentious setting, the portrait is evocative of Dutch genre painting, and, considering Peale's ambitions for this work, it ironically echoes Reynolds's quip about the "painters of the Dutch school," for whom *a history painting is a portrait of themselves.*"[94] In Peale's transformation of an image of European aristocratic ease into a vision of middle-class republican engagement, the splendid silks of the nobility are replaced by neat, form-fitting attire. Raphaelle and Titian are well dressed in striped vests and silk stockings, and Raphaelle's dark blue jacket, with its high collar, is particularly dashing. Fashionable and genteel, they are up-to-date but not foppish.[95] Similarly reimagined is the background of the figures, where patterned wallpaper of the type often found in enclosed stairways in domestic and institutional settings replaces a backdrop of grandiose architecture, clouds, or foliage. We do not know whether this wallpaper was specific to the site and decorated one of the stairwells at the American Philosophical Society, where the Peale family, its museum, and the newly installed double portrait of Raphaelle and Titian Ramsay all resided by the midsummer of 1795. But, aside from a possible documentary purpose, the wallpaper also may have manifested Philadelphia's industrial health and creativity, since the city was among the largest fabricators of wallpaper in the country and was proud of its domestic product.[96]

The parallel to the English nobility established by Peale's pictorial reference was as much a conceptual element as a compositional debt. Not only was Peale's artistic ambition made visible in his homage to Van Dyck, but his choice of an important example of aristocratic portraiture created a conceptual confrontation between his traditional source and his reimagining of that source in an American context. Peale—who was in this instance his own patron—adapted, energized, and naturalized the salient elements of his model and presented them in the style of trompe l'oeil illusionism to serve a new purpose in a new place. It is worth noting that as a Jeffersonian Republican in the early and mid-1790s, Peale undoubtedly was acutely aware of the monarchical policies and aristocratic behavior of the Federalist administration. Like others of his political

71

persuasion, he surely feared the destruction of "the integrity and independence of the republican citizenry," as Gordon Wood puts it, by "the creation of a hierarchical society, based on patronage connections and artificial privilege and supported by a bloated executive bureaucracy and a standing army."[97] This was the type of society Peale and many of his compatriots believed they had fought to destroy in the 1770s. Peale's sons on a stairway were young men meant to live their lives in sharp distinction to British sons of royal blood; they were aristocrats of another sort. Momentarily stopped on a steep and narrow stair rather than posing at their leisure on wide palatial steps, they were on a mission. Raphaelle's maulstick not only links him visually to his brother; it also puns upon the aristocratic accoutrements of swords or batons of command, traditionally seen in grand-manner portraiture. But Raphaelle's power lay not in the sword but in his command of art. Just as color and design both contribute to a work of art, the tasks of Raphaelle and Titian contributed to an accomplished display of the arts and sciences in the context of Peale's museum. In so doing, they helped advance the cultural life and educational resources of the new nation.

In 1795, Charles Willson Peale still hoped that his eldest son, Raphaelle, would become a leading figure in the fine arts, much as he hoped that Titian Ramsay would become a leader in the world of natural science and the museum. The boys' progress was a cultural ascent; they were young gentlemen of nature's making, presented as an arresting, true-to-life visualization of Jefferson's natural aristocracy of virtue and talent.[98] Jefferson's plans for universal education, like Peale's educational goals for his museum, were designed to discover and nurture this type of natural aristocracy for the good of democracy.

In 1786, the year that Peale founded his museum, Jefferson, who then was serving as American minister to France, wrote his friend and teacher, the distinguished Virginia jurist and signer George Wythe (1726–1806), from Paris about the educational plans he had drafted earlier and that he continued to hope the Virginia legislature would adopt.

> I think by far the most important bill in our whole code is that for the diffusion of knowledge among the people. No other sure foundation can be devised for the preservation of freedom, and happiness. If anybody thinks that kings, nobles or priests are good conservators of the public happiness, send them here. It is the best school in the universe to cure them of that folly. . . . Preach, my dear Sir, a crusade against ignorance; establish and improve the law for educating the common people. Let our countrymen know that the people alone can protect us against these evils, and that the tax which will be paid for this purpose is not more than the thousandth part of what will be paid to kings, priests and nobles who will rise up among us if we leave the people in ignorance.[99]

Jefferson maintained a lifelong commitment to education and to promoting what he called America's "natural aristocracy." In 1813 he wrote John Adams,

> I agree with you that there is a natural aristocracy among men. The grounds of this are virtue and talents. . . . There is also an artificial aristocracy, founded on wealth and birth without either virtue or talents. . . . The natural aristocracy I consider as the most precious gift of nature, for the instruction, the trusts, and government of society. And indeed, it would have been inconsistent in creation to have formed man for the social state, and not to have provided virtue and wisdom enough to manage the concerns of society.[100]

Charles Willson Peale's *Staircase Group* captures a fleeting moment when the viewer's glance is returned by two boys on a stairway, the most ephemeral and quotidian of human encounters and one well suited to trompe l'oeil presentation. But the painting was not meant to offer merely a fleeting experience; it also was intended as a solid statement of optimism about the Peales' participation in the future. The *Staircase Group* thus reconciled high and popular art, uniting the differing artistic traditions and modes of visual representation on which they were based. This unity of seeming opposites may have been a natural reflex for a man who in his own life straddled the worlds of the gentry and the populace, education and entertainment, culture and nature. Although both his painting and its message were ambitious, the image he presented to the public was slyly self-effacing. Peale had taken to heart Roger de Piles's advice to create a work that "strikes and attracts everyone, the ignorant, the lovers of painting, the judges, and even painters themselves."[101] He created a contemporary multivalent painting that not only impressed and entertained but also projected a serious message about the nation's responsibilities and cultural goals, and his ambitious hope that his family would be instrumental in realizing them.

NOTES

This chapter is an adaptation of the ideas presented in my doctoral dissertation, "'In Sympathy with the Heart': Rembrandt Peale; An American Artist and the Traditions of European Art" (University of Pennsylvania, 2000). A briefer version of this essay, which discusses Peale's grand-manner portraits in the collection of the Philadelphia Museum of Art, appears in Carol Eaton Soltis, *The Art of the Peales in the Philadelphia Museum of Art: Adaptations and Innovations* (Philadelphia: Philadelphia Museum of Art, 2017), chap. 2, 91–99. I would like to thank George Boudreau for asking me to contribute an essay on *The Staircase Group* so many years ago and to George and Margaretta Lovell for their fortitude and discernment in bringing this volume to fruition. I would also like to thank Rick Sieber, librarian for reader services at the Philadelphia Museum of Art, for assisting both me and George with issues of photo rights and access.

1. *Peale's Museum Gallery of Oil Paintings: Catalogue of the National Portrait and Historical Gallery, Illustrative of American History, Formerly Belonging to Peale's Museum, Philadelphia, Friday, 6th October, 1854, at 10 o'Clock, M. Thomas &*

Sons Auctioneers, 67 & 69 South Fourth Street (Philadelphia: Wm. T. Owen Printer, 1854), 6.

2. For Peale's Philadelphia Museum, see Charles Coleman Sellers, *Mr. Peale's Museum: Charles Willson Peale and the First Popular Museum of Natural Science and Art* (New York: W. W. Norton, 1980); David R. Brigham, *Public Culture in the Early Republic: Peale's Museum and Its Audience* (Washington, D.C.: Smithsonian Institution Press, 1995).

3. Harrison admired Rembrandt Peale and in 1859 he held a reception with two hundred guests to honor Peale and his colleague, Thomas Sully (1783–1872). James Freeman, "Sketchings," *Crayon* 6, no. 5 (1859): 161.

4. Sellers also quoted the 1854 catalogue entry in his text, along with Rembrandt Peale's comments in "Reminiscences: The Person and Mien of Washington," *Crayon* 3, no. 3 (1856): 100.

5. Charles Coleman Sellers, "Portraits and Miniatures by Charles Willson Peale," *Transactions of the American Philosophical Society*, new ser., 42, no. 1 (1952): 167.

6. Sir Joshua Reynolds, "Discourse III, Delivered to the Students of the Royal Academy, on the Distribution of the Prizes, December 14, 1770," in *Discourses on Art*, edited by Robert R. Wark (New Haven: Yale University Press for the Paul Mellon Centre for Studies in British Art, 1997), 44.

7. Peale, "Reminiscences," 100. Rembrandt also repeated and addressed the negative comments on the picture by C. R. Leslie, which reflected his academic perspective. See Leslie, *A Hand-Book for Young Painters* (London: John Murray, 1855), 3.

8. Phoebe Lloyd, "A Death in the Family," *Bulletin of the Philadelphia Museum of Art* 78 (Spring 1982): 2–13; Roger Stein, "Charles Willson Peale's Expressive Design: The Artist in His Museum," in *New Perspectives on Charles Willson Peale: A 250th Anniversary Celebration*, edited by Lillian Miller and David Ward (Pittsburgh: University of Pittsburgh Press, 1991), 167–218. Among the useful studies on the iconography and pictorial references in Peale's portraiture not specifically cited elsewhere in this essay are Charles Coleman Sellers, "The Jimson Weed Warning: Charles Willson Peale and John Beale Bordley," *Pharos* 7, nos. 2–3 (1969): 20–25; David Steinberg, "Charles Willson Peale: The Portraitist as Divine," in Miller and Ward, *New Perspectives*, 131–43; Brandon Braeme Fortune, "'From the World Escaped': Peale's Portrait of William Smith and His Grandson," *Eighteenth-Century Studies* 25, no. 4 (1992): 587–615; Karol Ann Peard Lawson, "Charles Willson Peale's 'John Dickinson': An American

Landscape as Political Allegory," *Transactions of the American Philosophical Society* 136, no. 4 (1992): 455–86; Joseph Manca, "Cicero in America: Civic Duty and Private Happiness in Charles Willson Peale's Portrait of 'William Paca,'" *American Art* 17, no. 1 (2003): 68–89.

9. The Peale literature and commentary is extensive, but the publications most relevant here are Sidney Hart, "'To Encrease the Comforts of Life': Charles Willson Peale and the Mechanical Arts," *Pennsylvania Magazine of History and Biography* 110, no. 3 (1986): 323–57; Sidney Hart and David C. Ward, "The Waning of an Enlightenment Ideal: Charles Willson Peale's Philadelphia Museum, 1790–1820," *Journal of the Early Republic* 8, no. 4 (1981): 389–418; David C. Ward and Sidney Hart, "Subversion and Illusion in the Life and Art of Raphaelle Peale," *American Art* 8, nos. 3–4 (1994): 96–121; David C. Ward, *Charles Willson Peale: Art and Selfhood in the Early Republic* (Berkeley: University of California Press, 2004).

10. Wendy Bellion, *Citizen Spectator: Art, Illusion, and Visual Perception in Early National America* (Chapel Hill: University of North Carolina Press for the Omohundro Institute of Early American History and Culture, 2011).

11. See Eric Jan Sluijter, *Seductress of Sight: Studies in Dutch Art of the Golden Age*, trans. Jennifer Kilian and Kathy Kist (Zwolle: Waanders, 2000).

12. Susan L. Feagin, "Presentation and Representation," *Journal of Aesthetics and Art Criticism* 56, no. 3 (1998): 237.

13. This notice ran in both *Dunlap and Claypoole's American Daily Advertiser* and the *Pennsylvania Packet* on April 24, 1794. See *The Selected Papers of Charles Willson Peale and His Family*, edited by Lillian B. Miller, Sidney Hart, and David C. Ward, 5 vols. (New Haven: Yale University Press, 1983–2014), 2.1:91.

14. Carol Eaton Hevner, *Rembrandt Peale, 1778–1860: A Life in the Arts* (Philadelphia: Historical Society of Pennsylvania, 1985), 30–35, 96.

15. Published in London in 1739, the book bears an advertisement for Dunlap's business on its inside front cover and a note by Peale saying that Dunlap had presented it to him in 1780. William Dunlap was the uncle of John Dunlap (1747–1812), who printed the first copies of the Declaration of Independence. John and Charles fought in the Revolution and had similar political leanings, and in 1778 Charles sold impressions of his first mezzotint engraving of Washington from Dunlap's shop. Rembrandt Peale inscribed his name and the date 1794 on the book's preface page when he received

the book. It is now in the library of the Philadelphia Museum of Art. Palomino told the story of Philip IV's being deceived by a portrait by Velasquez. "King Philip," he said, "was deceived by it, and took the picture for the Admiral himself." Much like Rembrandt Peale's description of Washington in "Reminiscences," Philip IV saw the picture from a distance, close enough to recognize the life-sized subject but far enough away to sustain the illusion. Antonio Palomino de Castro y Velasco, *An Account of the lives and works of the most eminent Spanish painters, sculptors and architects, and where their several performances are to be seen/translated from the Museum pictorium of Palomino Velasco* (London: Sam. Harding, 1749), 52.

16. *General Advertiser*, September 19, 1794, in *Selected Papers of Charles Willson Peale*, 2.1:98.

17. Brigham, *Public Culture in the Early Republic*, 15–16.

18. The board began with twenty-seven members but was expanded to thirty-six in 1792. For Peale's establishment of his board, see Sellers, *Mr. Peale's Museum*, 54–62.

19. The Swedish physician and scientist Carolus Linnaeus (1707–1778) created a highly influential system for naming, ranking, and classifying organisms used by scientists. His work was informed by natural theology, and he believed that it was possible to understand God by studying his creation. The first edition of his most famous work, *Systema Naturae*, was published in 1735.

20. Gilbert Stuart had recently relocated to Philadelphia and was invited to become a member. He accepted membership graciously but did not contribute work to the exhibition.

21. Rembrandt Peale noted that "the Columbianum died a natural death by schisms." Rembrandt Peale, "Reminiscences, Exhibitions, and Academies," *Crayon* 1, no. 19 (1855): 290. For documents on the Columbianum's founding, some of the published statements surrounding it, and an explanation of the political divisions they represented, see *Selected Papers of Charles Willson Peale*, 2.1:103–13; Wendy Bellion, "Illusion and Allusion: Charles Willson Peale's 'Staircase Group' at the Columbianum Exhibition," *American Art* 17, no. 2 (2003): 23.

22. *The Exhibition of the Columbianum or American Academy of Painting, Sculpture, Architecture, & Established at Philadelphia, 1795* (Philadelphia: Francis & Robert Bailey, 1795). In his "Reminiscences, Exhibitions, and Academies," Peale's noted additions were made to the exhibition after the catalogue was printed.

23. On display were architectural renderings and designs for ships and buildings by such notable practitioners as Robert Smith (1722–1777) and Joshua Humphrey (1751–1838). Similar works were displayed by Joseph Bowes, John Sproul, Abraham Collady, and William Williams. Similarly utilitarian pieces were three maps and a *Composition for a Card* by the cartographer and writing and drawing master Samuel Lewis (1753/54–1822). Sculpture was represented by visiting European artist Giuseppe Ceracchi (1751–1801) and the locally established artists Eckstein & Son. Frederick Eckstein (ca. 1775–1852) was the son of Johannes Eckstein (ca. 1736–1817), who had worked at the Prussian royal court. They advertised themselves as sculptors and painters with an exhibition room on High Street and were among the Columbianum's founders. The only recorded genre picture was Jeremiah Paul's (active 1791–1820) *A Boy Holding a Mouse to a Cat*, a work probably indebted to a print with a moralizing theme common in seventeenth-century Dutch painting. The only history painting was *A Scene from Shakespeare* by Robert Edge Pine (ca. 1730–1788).

24. For Lewis, see William H. Gerdts, "A Deception Unmasked: An Artist Uncovered," *American Art Journal* 18, no. 2 (1986): 5–23. The work Lewis displayed was a deception similar to the one illustrated in fig. 2.2.

25. This number does not include miniatures and may be slightly lower than the actual number, since there were probably last-minute additions to the exhibition that were never recorded. Oil portraits by Jeremiah Paul, Jacob Witman (Whitman, 1700–1798), Pierre Eugène du Simitière (ca. 1736–1784), Thomas Spence Duché (1763–1790), Samuel Jennings (ca. 1755–1834), and Robert Edge Pine were on display.

26. Peale described Wright as an artist who "made some interesting pictures, and without doubt, would have acquired excellence and celebrity had he lived to mature his talents, he died in Philada. of the yellow fever in 1793. He possessed excellent talents though he was of an eccentric character like others of his family." *The Autobiography of Charles Willson Peale*, in *Selected Papers of Charles Willson Peale*, 5:105. Joseph Wright was born in Bordentown, New Jersey, where his mother, at age four, had moved with her family. Raised in London, he returned to America in 1783 and settled in Philadelphia, where he painted several well-known sitters, including George Washington. His family lent six of his portraits to the Columbianum exhibition. Gainsborough's portrait is in the collection of the Huntington Library and Art Collections,

San Marino, California. See Monroe H. Fabian, *Joseph Wright: American Artist, 1756–1793*, exh. cat. (Washington, D.C.: Smithsonian Institution Press for the National Portrait Gallery, 1985), 114–15.

27. This is believed to be the picture by James Peale now referred to as the *Artist and His Family* that is in the collection of the Pennsylvania Academy of the Fine Arts. See https://www.pafa.org/collection/artist-and-his-family.

28. The works exhibited were an unidentified portrait pair and a portrait of Washington. See Helen A. Cooper, ed. with essays by Patricia Mullen Burnham, Martin Price, Jules David Prown, Oswaldo Rodriquez Roque, Egon Verhayen, and Bryan Wolf, *John Trumbull: The Hand and the Spirit of a Painter* (New Haven: Yale University Art Gallery, 1982), 125–47.

29. West had succeeded Sir Joshua Reynolds as president in 1792, and Philadelphia-born Samuel Jennings (ca. 1755–1834) sent his *Portrait of Benjamin West, President of the Royal Academy* to the exhibition. Jennings was active in Philadelphia prior to leaving for London in 1789. Although he remained in England, in 1792 he sent his monumental abolitionist allegory, *Liberty Displaying the Arts and Sciences*, to Philadelphia. This work, a commission from the Library Company of Philadelphia, remains in its collection.

30. Allen and Hamilton were among West's earliest and best patrons and launched his career by supporting his study in Italy. Hamilton served as lieutenant governor from 1748 to 1754 and again from 1759 to 1763. He was in London between November 1765 and November 1767. Peale arrived in February 1767. See Helmut von Erffa and Allen Staley, *The Paintings of Benjamin West* (New Haven: Yale University Press, 1986), 514–16.

31. Peale, "Reminiscences, Exhibitions, and Academies," 290.

32. Jules Prown, "Charles Willson Peale in London," in Miller and Ward, *New Perspectives*, 31; prior to London, Peale also benefited from the professional advice of the Maryland portraitist John Hesselius (1728–1778).

33. Quoted in Prown, 42, 44.

34. Quoted in Paul Staiti, "Mr. & Mrs. Thomas Mifflin," in Carrie Rebora, Paul Staiti, Erica E. Hirshler, Theodore E. Stebbins Jr., and Carol Troyen, *John Singleton Copley in America*, exh. cat. (New York: Metropolitan Museum of Art, 1995), 320.

35. Margaretta M. Lovell, *Art in a Season of Revolution: Painters, Artisans, and Patrons in Early America* (Philadelphia: University of Pennsylvania Press, 2005), 54.

36. The Mifflin picture is a rare example of the marital double portrait that appears only toward the end of Copley's American career. In 1774, he painted another such portrait, of Mr. and Mrs. Isaac Winslow. His compositions were surely derived from mezzotints after contemporary British portraits. For the rise of this type of portraiture in England and its popularity, see Kate Retford, "'Delicious Harmony': Marriage and the Double Portrait," in *The Art of Domestic Life: Family Portraiture in Eighteenth-Century England* (New Haven: Yale University Press for the Paul Mellon Centre for Studies in British Art, 2006), 48–82; Jules David Prown, *John Singleton Copley*, vol. 1, *Copley in America, 1738–1774* (Cambridge: Harvard University Press for the National Gallery of Art, 1966), 90–92.

37. This portrait's iconography is discussed in the online catalogue of the National Gallery of Art, Washington, D.C. https://www.nga.gov/collection/art-object-page.62968.html.

38. Charles Willson Peale to Rembrandt Peale, October 21, 1816, in *Selected Papers of Charles Willson Peale*, 3:456–58.

39. Staiti, "Mr. & Mrs. Thomas Mifflin," 320.

40. The tradition of trompe l'oeil painting can be traced to antiquity. Revived during the Renaissance, it remained a subgenre in European art, practiced with great skill by painters in the North as well as in Spain during the seventeenth century. It enjoyed a particular vogue in eighteenth-century France and Britain, and examples arrived in America as part of private collections as well as via artists and picture dealers. As Olaf Koester has noted, "The term *trompe l'oeil* (French, meaning 'deceive the eye') is used of a painting that has been made with the intention of tricking the viewer into believing for a brief moment that he is faced with a real object and not a two-dimensional image of it. The term was first used in 1800 in the catalogue of the Paris Salon to describe a picture exhibited by the French painter Louis-Leopold Boilly (1761–1845). The picture depicted a pile of drawings and sketches piled on top of one another under a piece of broken glass and it caused such a response from the viewers that the picture had to be roped off. The first trompe l'oeil painting is considered to be Jacopo de' Barbari's *Still life, Partridge, Iron Gloves and Crossbow Bolt* (1504; Alte Pinakothek, Munich), the establishment of deceptions as a separate genre occurred in Holland in the 1650s." Koester, "C. N. Gijsbrechts—An Introduction," in *Illusions: Gijsbrechts, Royal Master of Deception* (Copenhagen: Statens Museum for Kunst, 1999), 14–15.

41. For the development of Peale's style after 1795, see Carol Eaton Hevner, "Lessons from a Dutiful Son," in Miller and Ward, *New Perspectives*, 103–17.

42. Bellion, "Illusion and Allusion," 31.

43. Quoted in Sellers, *Mr. Peale's Museum*, 30–31.

44. Rembrandt Peale recalled that his father had learned to model in wax in London "from an Italian." Rembrandt Peale, "Reminiscences: Charles Willson Peale, a Sketch by His Son," *Crayon* 1, no. 6 (1855): 82. Charles also created wax figures on a large scale for his museum in the 1790s with his "Races of Mankind." See Charles Coleman Sellers, "Charles Willson Peale with Patron and Populace: A Supplement to Portraits and Miniatures by Charles Willson Peale, with a Survey of his Work in Other Genres," *Transactions of the American Philosophical Society*, new ser., 59, part 3 (1969): 32. Charles Willson Peale's forays into wax sculpture had ample precedent in Philadelphia. Not only were there wax modelers like Dr. Abraham Chovet, who arrived in Philadelphia in 1770 and set up an anatomical museum in 1774 where he delivered lectures, but there also were locally born, accomplished modelers such as Patience Wright (1725–1786) and Rachel Wells. Wells remained in Philadelphia, where she filled portrait commissions and set up a waxwork display with biblical "subject pieces," which were seen by both John Adams and Peale's sister in 1776. Diary of Charles Willson Peale, October 5, 1776, in *Selected Papers of Charles Willson Peale*, 1:66, 199–200. Patience Wright became a great success in Georgian London, where she modeled the rich and famous and dabbled in politics. See Charles Coleman Sellers, *Patience Wright: American Artist and Spy in George II's London* (Middletown: Wesleyan University Press, 1976). For a useful discussion of wax, wax statues and wax works see Catherine E. Kelly, *Republic of Taste. Art, Politics, and Everyday Life in Early America* (Philadelphia: University of Pennsylvania Press, 2016). See also Lloyd Haberly, "The Long Life of Daniel Bowen," *New England Quarterly* 32, no. 3 (1959): 320–32. The visual power of wax sculpture was enthusiastically praised by Roger de Piles in his *Cours de Peinture par Principes* (Paris, 1708), 284–93.

45. Charles Willson Peale to Rembrandt Peale, August 1823, in *Selected Papers of Charles Willson Peale*, 4:299. David R. Brigham, "'Ask the Beasts, and They Shall Teach Thee': The Human Lessons of Charles Willson Peale's Natural History Displays," in *Art and Science in America: Issues of Representation*, edited by Amy R. W. Meyers (San Marino, Calif.: Huntington Library, 1998), 17, 19, 21,

25. Peale told his board of visitors that he hoped at some point to be able to preserve a *Homo sapiens* to head the Linnaean order of his museum. Sellers, *Mr. Peale's Museum*, 60.

46. Koester, *Illusions*, 54.

47. Charles Willson Peale to George Walton, Esq., January 15, 1793, Peale-Sellers Family Collection, American Philosophical Society, Philadelphia.

48. Charles Willson Peale to A. M. F. J. Palisot de Beauvois, June 16, 1799, *Selected Papers of Charles Willson Peale*, 2.1:243–44. Beauvois (1752–1820) was an important French naturalist who traveled in parts of America and the Caribbean between 1786 and 1797.

49. For a discussion of Raphaelle's difficulties, see Lauren Lessing and Mary Schafer, "Unveiling Raphaelle Peale's *Venus Rising from the Sea—A Deception*," *Winterthur Portfolio* 43, nos. 2–3 (2009): 229–59.

50. In his autobiography, in which he consistently refers to himself in the third person, Charles wrote that the *Staircase Self-Portrait* commissioned by his son Rubens for his Baltimore museum in 1823 was to be done "in the manner of that which he painted many years past, with his Sons Raphaelle and Titians Portraits, which had long been admired for the deception produced." *Selected Papers of Charles Willson Peale*, 5:450.

51. Richard Leppert, *Art and the Committed Eye: The Cultural Functions of Imagery* (Boulder: Westview Press, 1996), 26.

52. *Selected Papers of Charles Willson Peale*, 5:327.

53. Palomino, *Most eminent Spanish painters*, 53, 55, 112, 117–19. To date, no reference to Diego Velázquez (1599–1660) has been found in Peale's writings, and it may be that he had little firsthand knowledge of this artist's work.

54. Palomino, 55. This picture was Velázquez's portrait of Juan de Pareja, now in the Metropolitan Museum of Art.

55. Charles Coleman Sellers referred to Pilkington's book as the Peale family bible. It was a frequently consulted resource in the Peale household and, much like a family bible, it had the birth and death dates of Peale's children recorded on the inside of its front cover. Matthew Pilkington, *The Gentleman's and Connoisseur's Dictionary of Painters* (London: printed by T. Cadell in the Strand, 1770). Peale's copy of the book is in the Peale-Sellers Family Collection, American Philosophical Society.

56. Quoted in Soltis, "'In Sympathy with the Heart,'" 123–24. For the divergence between critical esteem for Dutch and Flemish pictures and their popularity with the public, see Francis Haskell,

Rediscoveries in Art: Some Aspects of Taste, Fashion, and Collecting in England and France (Ithaca: Cornell University Press, 1976), 5. See also Gerald Reitlinger, *The Economics of Taste: The Rise and Fall of the Picture Market, 1760–1960* (New York: Holt, Rinehart & Winston, 1961), 12–13, 25; Stein, "Peale's Expressive Design," 200–201.

57. See Peale's copy of the book in the Peale-Sellers Family Collection, 186.

58. Pilkington listed the "Names of the Principle [sic] Authors" from whom he derived the ideas he presented in his text. These included such staples for eighteenth-century readers as Jonathan Richardson, Charles Alphonse du Fresnoy, Francesco Algarotti, Daniel Webb, Leonardo da Vinci, and Giorgio Vasari, along with all the writings of Roger de Piles and less frequently consulted works on Dutch and Flemish artists by Joachim von Sandrart, Karel van Mander, Arnold Houbraken, and Cornelis de Bie. He also consulted Francisco Pacheco for Spanish painting and listed in his bibliography a *Lives of Spanish Painters*, which was probably Palomino's text.

59. Thomas Puttfarken, *Roger de Piles' Theory of Art* (New Haven: Yale University Press, 1985), 46.

60. De Piles, "The Author's Preface on the Idea of Painting," in *The Principles of Painting*, English ed. (London, 1743), 3.

61. Puttfarken, *De Piles' Theory of Art*, 103–4.

62. De Piles, *Cours de Peinture*, quoted in Puttfarken, 103–4.

63. Leppert, *Art and the Committed Eye*, 23.

64. Leppert notes that "in this and other genres of painting the artist's identity was commonly confirmed by a signature, not merely as a sign of authentication but also as a form of self-advertising. Indeed, occasionally trompe-l'oeil paintings take this a step further by including on some painted scrap of paper not only the painter's name but also his studio's address. . . . One painting thereby becomes an advertisement for another" (23).

65. Ten of Peale's seventeen children, starting with his first surviving son, Raphaelle, in 1774, found their namesakes in this book. The children's names, in order of birth, were Raphaelle, Angelica Kauffmann, Rembrandt, Titian Ramsay, Rubens, Sophonisba Angusciola, Rosalba Carriera, Van Dyck, Sybilla Miriam, and a second Titian, named after his deceased elder brother. Long a figure of fun for naming so many of his children after great artists, Charles Willson Peale selected both male and female names to commemorate the artists he most admired.

66. Pilkington, *Dictionary of Painters*, 500–501, 649–51.

67. Peale's practice of grand-manner portraiture on American soil began with commissions from Edmund Jennings in 1770 for portraits of his friends John Beale Bordley and John Dickinson, which were impressive in their presentation and allusions. By 1779 Peale had been commissioned by the Supreme Executive Council of Pennsylvania to "perpetuate the resemblance" of General Washington. This 93 × 58 inch picture, *George Washington at the Battle of Princeton* (Pennsylvania Academy of the Fine Arts), won him fame and commissions for replicas in America and Europe. During the 1780s, Peale continued to receive large-scale Washington commissions, as well as commissions for multifigure family portraits such as *Robert Goldsborough and Family* (1789, Philadelphia Museum of Art, Promised Gift of the McNeil Americana Collection). In his stylish portrait *Benjamin and Eleanor Ridgely Laming* (National Gallery of Art, Washington, D.C.), painted in 1788, Peale conveys his message through a carefully constructed composition based on a visual tradition of amatory subject matter. See Ellen G. Miles and Leslie Reinhardt, "'Art Conceal'd': Peale's Double Portrait of Benjamin and Eleanor Ridgely Laming," *Art Bulletin* 78, no. 1 (1996): 56–74.

68. Charles Carroll to Charles Willson Peale, October 29, 1767, in *Selected Papers of Charles Willson Peale*, 1:70–71; Karol A. Schmiegel, "Encouragement Exceeding Expectation: The Lloyd-Cadwalader Patronage of Charles Willson Peale," *Winterthur Portfolio* 12 (1977): 87–102.

69. Werner Busch, "Copley, West, and the Tradition of European High Art," in *American Icons: Transatlantic Perspectives on Eighteenth- and Nineteenth-Century American Art*, edited by Thomas Gaehtgens and Heinz Ickstadt (Chicago: University of Chicago Press, 1992), 36.

70. See Christopher Looby, "The Constitution of Nature: Taxonomy as Politics in Jefferson, Peale, and Bartram," *American Literature* 22, no. 3 (1987): 252–73.

71. The subjects are Robert Auriol Drummond and his brother Thomas at ages sixteen and fifteen, respectively. Von Erffa and Staley, *Paintings of Benjamin West*, 47, 500. Engraved by Valentine Green in 1769, the painting was exhibited at London's Society of Artists in 1768. The original oil is in the collection of the Addison Gallery of American Art, Phillips Academy, Andover, Massachusetts.

72. Peale exhibited his miniature of Matthias and Thomas Bordley at the Society of Artists in 1768.

73. See Karen Hearn, ed., *Van Dyck and Britain*, exh. cat. (London: Tate Britain, 2009), 123.

74. Peale's image reverses Van Dyck's portrait of Wentworth and Mainwaring, which, in turn, had a pictorial precedent in a portrait by Titian. Hearn, 123.

75. Angelica was the namesake of Angelica Kauffmann (1741–1807), a Swiss artist active in London between 1766 and 1781, whom Peale met while abroad. Highly acclaimed, she was a founding member of the Royal Academy. Pressed for time, Peale began his daughter's sitting immediately on his arrival in Baltimore. The result was a lovely portrait of Angelica in a fine dress and beautifully embroidered scarf and a less satisfactory likeness of her husband. Peale attributed the lesser likeness to the fact that his son-in-law sat with "bad grace." Peale completed the original portrait and also made an unfinished copy in which he said that the face of Mr. Robinson was not quite equal to the first. He was "contented to have it so rather than plague a man who seemed to have so little disposition to give me a chance of doing justice to my reputation as a painter." Peale later retouched and improved the portrait before it was given to one of Angelica's daughters in 1822. Sellers, "Portraits and Miniatures," 183. This picture is now in the collection of Reynolda House, Winston-Salem, North Carolina. The child Peale's daughter was carrying was Alexander Robinson, who died in 1804.

76. Among Van Dyck's portraits in this format was his well-known portrait of Charles I and Queen Henrietta (ca. 1625, Her Majesty the Queen, the Royal Collection Trust), a composition that was often copied by his followers. See Hearn, *Van Dyck and Britain*, 173.

77. The epigraph is from Roger de Piles, "Of the usefulness and use of Prints," in *The art of painting and the lives of painters: containing, a compleat treatise of painting, designing, and the use of prints [. . .] Done from the French of Monsieur de Piles. To which is added, An essay towards an English-school, with the lives and characters of above 100 painters* (London: Printed for J. Nutt, 1706), 53.

78. Although Peale had purposely put aside active political engagement by 1795, he had prior affiliations with "radical politics" and an outspoken preference for a new political and social order. For Peale's politics, see Ward, *Charles Willson Peale*, 71–83; *Selected Papers of Charles Willson Peale*, 1:227–28. For the controversy in the press prior to the exhibition, see Bellion, "Illusion and Allusion," 20–24.

79. Rembrandt Peale, "Reminiscences, Exhibitions, and Academies," 290.

80. Matthew Hargraves, *Candidates for Fame: The Society of Artists of Great Britain, 1760–1791* (New Haven: Yale University Press for the Paul Mellon Centre for Studies in British Art, 2005), 169.

81. For "anxieties over forms of deception," see Bellion, "Illusion and Allusion," 24.

82. Charles Willson Peale to Benjamin Franklin, April 21, 1771, in *Selected Papers of Charles Willson Peale*, 1:98–99. As the editors' notes on this letter observe, Peale's statement reflected a growing belief that the arts were fostered by political liberty.

83. Trompe l'oeil pictures require tight and highly finished surfaces and a careful depiction of light and shadow. In this instance, the figures needed to be life-sized and carefully located spatially to create the illusion that they were part of the spectator's normal visual world when seen from a short distance. The door frame and step created an expected contextual element that reinforced their spatial placement.

84. Sellers, "Portraits and Miniatures," 167. The portrait has been categorized as "iconic." See Hearn, *Van Dyck and Britain*, 103.

85. Van Dyck Peale was around eighteen months old when he died.

86. Reynolds, "Discourse VI, Delivered to the Students of the Royal Academy on the Distribution of the Prizes, December 10, 1774," in *Discourses on Art*, 109.

87. De Piles, *Art of painting*, 269.

88. Pilkington, *Dictionary of Painters*, 628–30.

89. Edgar Wind, *Hume and the Heroic Portrait: Studies in Eighteenth-Century Imagery*, edited by Jaynie Anderson (Oxford: Clarendon Press, 1986), 17.

90. Henry Stuart, Lord Darnley was a descendant of the sitters. Gainsborough copied the portrait in full and in part. It was found in his studio after his death along with several other copies after Van Dyck. The full copy is now in the collection of the Saint Louis Art Museum. Its dimensions are 92 ½ × 57 ½ inches.

91. Although it is possible that Peale saw the original picture or even Gainsborough's copy while in London, we don't know how he encountered his famous model. He may have seen the painting and had recourse to a mezzotint as an aide-mémoire. In any case, he blended his life subjects with his source so well that its identity as a historical portrait eluded his descendant Charles Coleman Sellers, who had in fact written an article on the use of mezzotints in American colonial portraiture. See Sellers, "Mezzotint Prototypes of Colonial Portraiture: A Survey Based on the Research of Waldron Phoenix Belknap, Jr.," *Art Quarterly* (Winter 1957): 407–68.

92. Sir Peter Lely (1618–1680), a follower of Van Dyck, adapted the stepping pose for his *Portrait of a Young Boy, believed to be the second Earl of Carnarvon* (ca. 1647–48). As his young boy climbs, he leans on a baton of command that functions visually much like Raphaelle's maulstick. This portrait can be viewed in Hearn, *Van Dyck and Britain*, 189, fig. 102. One of Reynolds's several adaptations of this pose can be seen in his portrait *Thomas and Martha Neate, with His Tutor, Thomas Needham* (1748), now in the Metropolitan Museum of Art.

93. Charles Willson Peale to Etienne Geoffroy Saint-Hilaire, April 30, 1797, in *Selected Papers of Charles Willson Peale*, 2.1:200–201.

94. Reynolds, "Discourse IV, Delivered to the Students of the Royal Academy on the Distribution of the Prizes, December 10, 1771," in *Discourses on Art*, 69.

95. My thanks to my colleague H. Kristina Haugland, the LeVine associate curator of costumes and textiles, PMA, for sharing her expertise on eighteenth-century fashion.

96. Catherine Lynn, *Wallpaper in America: From the Seventeenth Century to World War I* (New York: W. W. Norton, 1980), 109–11. There were at least ten manufacturers of wallpaper in the city in 1795. My thanks to my colleague Alexandra Alevizatos Kirtley, the Montgomery-Garvan associate curator of American decorative arts, PMA, for sharing her expertise.

97. Gordon S. Wood, *Empire of Liberty: A History of the Early Republic, 1789–1815* (Oxford: Oxford University Press, 2009), 172.

98. See Gary Wills, *Inventing America: Jefferson's Declaration of Independence* (New York: Doubleday, 1978), 167–225.

99. *The Writings of Thomas Jefferson*, edited by Andrew A. Lipscomb and Albert Ellery Bergh, 20 vols. (Washington, D.C.: Thomas Jefferson Memorial Association, 1903–4), 5:396.

100. Ibid., 13:399.

101. De Piles quoted in Puttfarken, *De Piles' Theory of Art*, 47.

Objects with Meaning

Artists' Materials and the Transatlantic Craft Traditions of Eighteenth-Century American Portrait Painting

ELLEN G. MILES

AMERICAN EIGHTEENTH-CENTURY PORTRAITS are undergoing a revival of investigation and interpretation.[1] Many of the new approaches result from research concerning social, political, and personal contexts that allow us to better understand the purposes, uses, and settings for portraits painted in America during this period. And while the roles of the patron and the artist in defining context for the making of these portraits are important, the rarely discussed physical properties of an eighteenth-century painted portrait also played a highly important, and generally overlooked, role in the appearance of these portraits. An examination of the details of the craft also yields a wealth of information about the transfer of sophisticated portrait-painting practices from Europe to America during these years.

Stylistic descriptions of two portraits by John Singleton Copley provide good examples of the issues. The first is John Caldwell's interpretation of Copley's portrait of Samuel Verplanck (fig. 3.1) as an early example of the neoclassical style in America. "The composition of this portrait is radical in its simplicity, and the colors are extraordinarily muted, both characteristics that are usually thought of as neoclassical. . . . Even with Copley's unquestioned genius, one hesitates to credit him with the independent invention of the neoclassical style. Clearly, though, the characteristic qualities of this

and other Copley portraits of the period contradict the theory that neoclassicism emerged in America as a response to the Revolution."[2] More recently, Jennifer Roberts, analyzing Copley's *Boy with a Flying Squirrel (Henry Pelham)* (fig. 3.2), has observed that "here Copley drapes a flat and relatively symmetrical curtain behind the boy's head, blocking off the background rather than engineering a relation between the sitter and a larger setting," as he did in his larger portrait of Nicholas Boylston.[3] In both cases, these subtle differences in composition were not the invention of the individual artist. They instead indicate aspects of the craft of portrait painting that were communicated from artist to artist, which in turn suggests the high degree to which the traditional aspects of the profession of portrait painting crossed the Atlantic in the eighteenth century. In both examples, the use of a simplified background was part of what a professional portrait painter of the time would have considered "best practice." Rather than interpret the composition as having political or cultural meaning, we need to recognize that it is an indicator of the artist's knowledge of the craft aspects of European portrait painting.

Eighteenth-century European artists relied on formulas for sizing and pricing portrait paintings on canvas that had developed over two centuries of practice. Artists in Italy and Spain, and then in France, developed compositions that successfully represented the single figure in a variety of sizes and prices. The price paid for a portrait was directly tied to the amount of work that went into its completion in relationship to the size of the canvas. And the canvas size, in turn, governed the amount of figure to be shown on the canvas, along with the amount of background or foreground detail around the figure. These practices were brought to the American colonies and the early Republic by European artists who came here seeking new markets for their work. American-born artists imitated these European artists in creating their own work. British canvases were the ones most frequently used in the American colonies. There were four standard sizes of precut canvas in British practice at this time, termed the "whole-length," the "half-length," the "three-quarter," and the "kit-cat." When stretched prior to painting, these canvases measured approximately 80 to 90 × 50 inches ("whole-length"); 50 × 40 inches ("half-length"); 30 × 25 inches ("three-quarter," sometimes called a "quarter" or "bust" size in the early nineteenth century); and 36 × 28 inches ("kit-cat"). The first three sizes had a clear physical relationship to one another that is best understood if the dimensions are given in inches, the original means of measuring English canvas. Also, the terms for these three sizes relate directly to the amount of canvas used, not to the amount of figure shown on the canvas. The whole-length canvas set the standard: measuring about 80 to 90 inches × 50 inches, it was used to depict a full-length life-size figure, standing or seated. If that piece of canvas was cut in half, the two resulting canvases measured 50 × 40 inches each. Each piece was termed a "half-length" cloth, because it was exactly half of a full-length canvas. On a half-length canvas, a figure was normally depicted standing or seated, from the head only to the

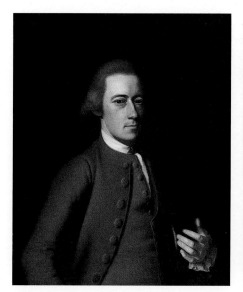

FIG. 3.1 John Singleton Copley, *Samuel Verplanck*, 1771. Oil on canvas, 30 × 25 in. (76.2 × 63.5 cm).
The Metropolitan Museum of Art, New York, gift of James De Lancey Verplanck, 1939 (39.173). Image
copyright © The Metropolitan Museum of Art. Image source: Art Resource, New York. Termed "rad-
ical" in its neoclassical simplicity, this portrait more accurately exemplifies the transatlantic transfer of
eighteenth-century English portrait practices to colonial America. In English practice at the time, the
complexity of a portrait's composition was directly related to its size and price.

FIG. 3.2 John Singleton Copley, *A Boy with a Flying Squirrel (Henry Pelham)*, 1765. Oil on canvas, 30 ⅜
× 25 ⅛ in. (77.15 × 63.82 cm). Museum of Fine Arts, Boston, gift of the artist's great-granddaughter,
1978.297. Photograph © 2018 Museum of Fine Arts, Boston. Copley's knowledge of the craft of
English portrait painting led him to limit the physical space depicted around and behind the figure in
this portrait of his half brother, Henry Pelham.

knees, that is, three-quarters of his or her full-length image at about the same scale. The
name of the next size down, the "three-quarter" canvas of 30 × 25 inches, was probably
derived from the fact that one dimension of the canvas, after it was cut but before it
was stretched, was three-quarters of a yard, or 27 inches. On a three-quarter canvas,
a person was typically depicted to the waist, usually without inclusion of the hands.
Finally, the "kit-cat" canvas, measuring 36 × 28 inches, was used to depict a figure to the
waist with one or both hands included. It became known as the "kit-cat" size because
Godfrey Kneller used it for a series of portraits of members of the Kit-Cat Club, a
London political and literary society, that he painted for Jacob Tonson, a London pub-
lisher, between about 1700 and 1721.[4] Kneller, a German artist who settled in England
in 1676, introduced the size, which was already in use in Holland.

In 1817, Henry Pickering of Salem, Massachusetts, recorded Gilbert Stuart's
description of the British system of using precut canvases for specific compositional

choices. Pickering made several visits to Stuart's Boston studio that year and took notes on their conversations. Stuart by that time was firmly established as a portrait painter in Boston, having returned in 1793 from eighteen years in England and Ireland. Settling first in New York City, he continued to use English linen canvases, preferring their rough weave. He obtained them from Thomas Barrow, an English artist who had settled in New York and opened a shop selling artists' supplies.[5] In 1794, Stuart moved on to Philadelphia, where he worked until 1803. He then moved to Washington, D.C. (1803–5), before settling in Boston. Pickering noted Stuart's comments on the sizes of canvases and their prices: "I saw a head of Mr. Jeffersons at Mr. Stuart's today for the first time. Mr. S. told me it was executed at one sitting. It appears to be a fine likeness. It is intended to be a *three-quarters*. For this size his price is $300. I observed to Mr. S. that I should not know precisely what size a picture would be, from the terms used by painters. He immediately took a piece of chalk & described the different sizes as follows—the smallest compartment being first delineated, & the other lines added."[6]

Pickering made a set of sketches describing these terms (fig. 3.3). The top sketch shows a whole-length canvas. On it he indicated the proportions of the smaller canvases. In the four sketches beneath, he showed the various canvas sizes and the amount of the figure shown on them, together with Stuart's price for each. "The smallest compartments," he wrote, "are *Heads*—Both together form a *Kitcat*—Two *Kitkats* [*sic*] make a *Three-Quarters*—& two Three Quarters constitute a whole length Portrait."[7] Although Pickering confused the names of the sizes, his drawings clarify the amount of figure shown and its relationship to the next-larger portrait. Thus, for a 30 × 25, on the left, Stuart charged $100; this is the price he asked for his portraits of George Washington, calling them his one-hundred-dollar bills. The next-largest size, for $150, was a kit-cat. Stuart painted several portraits in New York of this size, including that of Catherine Yates Pollock, 1793–94 (National Gallery of Art), but in general he used it infrequently in his American work. The third size shows a seated figure on a half-length canvas, for which the price was $300. And finally, the full-length, the most expensive; Pickering doesn't note its price, perhaps because by this time Stuart was no longer painting whole-lengths. In 1796 he charged $1,000 for the original full-length "Lansdowne" portrait of Washington (Smithsonian National Portrait Gallery), which is a typical whole-length, life-size portrait in the English tradition. The painting measures 97 ½ × 62 ½ inches. Stuart charged $500 for the same-size copy that he painted for William Constable, while charging half, or $250, for a seated portrait of Washington on a canvas that measures 50 × 40 inches. Constable commissioned this second portrait, described as a "half-length" in the receipt for payment, as a gift for Alexander Hamilton.[8]

The use of these canvas sizes was well documented a century earlier in the records kept by Scottish portrait painter John Smibert, who settled in Boston in 1729 and enjoyed a seventeen-year career there as a portrait painter.[9] Trained in England and

FIG. 3.3 Henry Pickering, diagrams of painting sizes and prices, 1817. Ink on paper. The Pickering Foundation, Salem, Massachusetts. Photo: Peabody Essex Museum, Salem, Massachusetts. Salem resident Henry Pickering drew this series of sketches to record Gilbert Stuart's explanation of the terms used by portrait painters to describe the sizes, prices, and compositions of their work.

Italy, Smibert was the earliest European artist whose use of English canvases in America is well documented in written records. His notebook, which includes his lists of commissioned portraits, refers consistently to these standardized sizes and prices, with entries recording the name of the sitter, the size and price of the portrait, and the amount paid. Smibert began to record his portrait commissions in the notebook in 1722 in London and continued to record these commissions through 1746, the last year that he painted portraits in Boston. In 1734, for example, he was commissioned to paint a full-length portrait of William Browne of Salem (fig. 3.4). The April 1734 entry in the notebook reads, "William Browne Esqr. whole Lenth [*sic*] H.P. 100–0–0." This means that he was commissioned to paint the life-size, whole-length portrait of Browne at the price of £100, half of which was the down payment ("H.P.").[10] Half of the price was normally paid at the first sitting, with the balance due when the portrait was finished. That same year, he painted several half-length portraits, including one of William Browne's brother Samuel Browne (fig. 3.5) and one of Samuel's wife, Katherine Winthrop Browne (both owned by the Rhode Island Historical Society), for £50 each.[11] He also painted several three-quarter-length portraits, including those of the children of James and Hannah Pemberton of Boston, Hannah Pemberton (Metropolitan Museum of Art), her sister Mary (Bayou Bend Collection, Museum of Fine Arts, Houston), and their brother, Samuel Pemberton (fig. 3.6). Each measures about 30 × 25 inches and was priced at £25.[12] Kit-cat portraits that Smibert painted that year included one of William Lambert (fig. 3.7), whose portrait was recorded as a "K.K. 37–10–00." The following spring, Smibert painted Mrs. Lambert's portrait (Bayou Bend Collection), by which time he had converted to using guineas for payment, and charged nine guineas for her kit-cat portrait.[13]

Joseph Blackburn and John Wollaston, two English artists who came to the North American colonies to paint portraits in the 1750s and early 1760s, also used canvases in the British sizes. Blackburn, who arrived in Newport, Rhode Island, in 1753 after spending more than a year in Bermuda, painted portraits in Newport, Boston, and Portsmouth, New Hampshire, for about a decade, returning to England sometime between July 1762 and January 1764. Wollaston arrived from London in 1749 and painted in the colonies until 1767. Since only a few invoices have survived for Blackburn and Wollaston, and no other papers or accounts are known, their terms for these sizes, and their prices, are not as well documented. Nor do we know where or how they actually obtained precut and primed English canvases during their years in America. But their surviving portraits, which number in the hundreds, are the same sizes as the canvases Smibert used.[14] Typical examples of Wollaston's work include his portraits of William Axtell (50 × 40 inches, 1749–52, Metropolitan Museum of Art), Cadwallader Colden (30 × 25 inches, 1749–52, Metropolitan Museum of Art,), and Captain John Waddell (36 × 28 ½ inches, ca. 1750, New-York Historical Society). One portrait by Wollaston, titled *Young Lady* (Colonial Williamsburg Foundation, formerly called

FIG. 3.4 John Smibert, *William Browne*, 1734. Oil on canvas, 92 ½ × 57 in. (234.9 × 144.8 cm). Courtesy of the Alan Mason Chesney Medical Archives of The Johns Hopkins Medical Institutions. When Scottish artist John Smibert arrived in Boston in 1729, he introduced the English practice of portrait painting to his New England patrons. His American portraits are documented in his account book, which provides clear evidence of the direct connection between canvas size, figure size, and price in the craft of portrait painting.

FIG. 3.5 John Smibert, *Samuel Browne Jr.*, 1734. Oil on canvas, 50 × 40 in. (127 × 101.6 cm). Courtesy of the Rhode Island Historical Society, RHi X17 1127. William Browne's brother Samuel Browne is represented on a half-length canvas size, a term derived from the dimensions of the canvas, 50 × 40 in., or about half the size of the canvas used for a full-length portrait. The price for this size portrait was half that of a whole-length.

FIG. 3.6 John Smibert, *Portrait of Samuel Pemberton*, 1734. Oil on canvas, 30 ⅛ × 25 ½ in. (76.5 × 64.8 cm). The Museum of Fine Arts, Houston, The Bayou Bend Collection, museum purchase funded by Miss Ima Hogg, B.72.7. In English practice, this canvas size, used for the most limited compositions, was called a three-quarter. The price for a portrait this size was typically half that of a half-length.

FIG. 3.7 John Smibert, *William Lambert*, 1734. Oil on canvas, 35 ⅞ × 28 ⅛ in. (91.12 × 71.44 cm). Addison Gallery of American Art, Phillips Academy, Andover, Massachusetts, Museum purchase, 1958.55. Photo: Addison Gallery of American Art, Phillips Academy, Andover, Massachusetts / Art Resource, New York. The "kit-cat" size canvas used for this portrait is slightly larger than the three-quarter size and could include the sitter's hands. Its price was slightly higher than that of a portrait painted in the three-quarter format.

Mary Brooke Prentis), which measures 29 ⅞ × 24 ¾ inches, has been described as painted on prepared English canvas. Evidence seen in the edges of the canvas, which was still on its original stretcher, showed that the fabric had been cut from "one end of a length prepared specifically for standard size 30 inch by 25 inch portraits."[15] Among Blackburn's portraits are the 1760 full-length of Governor Benning Wentworth (93 ½ × 58 inches, New Hampshire Historical Society), the 1754 half-length of Mary Sylvester (50 × 40 inches, Metropolitan Museum of Art), and his 1756 portrait *A Military Officer* (30 × 25 inches, National Gallery of Art).

Artists who came to America from continental Europe also used canvases in these sizes. This suggests that they didn't bring the materials with them but used local or possibly British suppliers. Jeremiah Theus, a Swiss-born artist working in Charleston, produced portraits primarily in the small 30 × 25 inch size. He painted only three larger (50 × 40 inch) portraits, including that of Elizabeth Wragg Manigault in 1757 (Charleston Museum), the pendant to the portrait of her husband, Peter Manigault, painted as a 50 × 40 portrait in England in 1751 by Allan Ramsay (whereabouts now unknown).[16] John Valentine Haidt, a German artist who was trained as a goldsmith, emigrated from Berlin to London in the 1720s. There he joined a Moravian religious community and devoted many hours to creating religious paintings. In 1754, he emigrated with members of that community to settle in Bethlehem, Pennsylvania, where he continued as the community's painter. His work included not only biblical scenes but a series of portraits of members of the community. For these he used primarily two sizes of canvas, measuring either about 30 × 25 or about 25 × 20 inches. One of the

larger portraits is his *Young Moravian Girl*, painted around 1755–1760 (Smithsonian American Art Museum). The sources of his materials have not been studied. Most of his portraits are still owned by the Moravian Archives in Bethlehem.[17]

Most of the artists born in the British colonies used the same English canvas dimensions. John Singleton Copley and Charles Willson Peale were the most talented and productive. Virtually all of their colonial-era portraits were made in these sizes. For example, Copley's full-length portrait of Nathaniel Sparhawk (1764, Museum of Fine Arts, Boston) was one of the single-figure portraits that he made as a life-size whole-length. It measured 90 × 57 ½ inches. Copley's paired portraits of Katherine Greene Amory (1763) and her husband, John Amory (1768, Museum of Fine Arts, Boston), were both painted on a "half-length" canvas and show the sitter to about the knees. His 1771 portrait of Samuel Verplanck (fig. 3.1), is a good example of the three-quarter size (30 × 25 inches), while a "kit-cat" canvas, measuring about 36 × 28 inches, was used for each of his portraits of Samuel Quincy and his wife, Hannah Hill Quincy (Museum of Fine Arts, Boston). He used this size to great effect in the late 1760s and early 1770s, notably for his very well-known image of Paul Revere (Museum of Fine Arts, Boston). Surviving invoices, such as that for a pair of portraits of Mr. and Mrs. Ezekiel Goldthwait, painted in 1771, document Copley's familiarity with the terms describing these English canvas sizes. The invoice reads in part, "To his Lady's portrait half length 14 Guis [guineas] £19–12–0. To his own Do [Ditto] 19–12–0." The two carved gold frames cost £9 each.[18] Copley's trip to New York City in 1771 at the request of British army captain Stephen Kemble provided the most complete statement that he made concerning these canvas sizes. While planning the trip, Copley told Kemble how many painted portraits of the different sizes he could complete in New York, depending on the length of his stay: "I may be able to engage 12 or 15 half Lengths, or in proportion to that, reckoning whole Length as two half Lengths, and half length Double the busts. More I could not engage without a Longer stay." Copley also sent Captain Kemble the prices for the various sizes, which clearly reflect the physical relationship of the canvas sizes: "The price of Whole Lengths 40 Guineas, half Length 20, ¼ peices [*sic*] or Busts 10."[19]

Maryland artist Charles Willson Peale studied in London in 1767–69. After his return, he began making lists of the portraits he had painted, specifying the sizes and prices. The first of these lists, made in about 1772, begins with his portrait of one of his earliest patrons, Anne Catharine Hoof Green (fig. 3.8), the Annapolis widow who was publisher of the *Maryland Gazette* and official printer for the colony of Maryland. The listing for her portrait reads "Mrs. Grien Kitcat £6–6–0." The list includes portraits in all the sizes Peale had become accustomed to in England, whole-lengths, half-lengths, three-quarter lengths, and miniatures. The prices were reduced in proportion. For example, his life-size whole-length of John Beale Bordley (National Gallery of Art) was priced at £22 1s. The half-length of Samuel Chase (Maryland Historical Society) cost

FIG. 3.8 Charles Willson Peale, *Anne Catharine Hoof Green*, 1769. Oil on canvas, 36 × 28 in. (91.4 × 71.1 cm). National Portrait Gallery, Smithsonian Institution, partial gift with funding from the Smithsonian Collections Acquisitions Program and the Governor's Mansion Foundation of Maryland. Peale was one of many artists in colonial America who used English canvases and portrait sizes. Mrs. Green's portrait was one of the first that he painted on returning from London in 1769, and is documented as a "Kitcat" in his portrait list of circa 1772.

£10 10s., or half the price of the full-length. A three-quarter portrait of Mrs. Thomas Harwood (Metropolitan Museum of Art), who is listed by her maiden name as "M. Peggy Streacshorn" (Strachan), which measured about 30 × 25 inches, was priced at £5 5s.[20] Peale continued to use these sizes after the Revolutionary War, into the 1790s. The artist's handbill of October 19, 1786, listed the sizes he was used to. "Head size, 23 × 19 inches. Five guineas. Kitcat, 36 × 27 inches. Eight guineas. Half-length, 50 × 40 inches. Sixteen guineas. Whole-length, 84 to 96 × 63 inches. Thirty guineas." The head size was the one that he frequently used for his museum portraits.[21] Other artists born in colonial America, including Robert Feke, John Hesselius, and Joseph Badger, used the same sizes. After the Revolution, many artists continued to use these formulas, among them Lewis Clephan, an artist whose work is almost unknown today; he advertised in New York in 1787 that he painted "Likenesses, whole, half and quarter Lengths, on the lowest and most reasonable Terms."[22] A decade later, in 1797, Raphaelle Peale advertised in Baltimore: "Portraits, Price of head size, which is two feet one inch, by two feet five inches, four guineas," and in Philadelphia in 1800: "A head size portrait in oil, Twenty; half-length, fifty dollars, &c."[23] Late eighteenth-century artists who used these canvas sizes included Ralph Earl, his brother James Earl, and Joseph Wright, all three with training in England.

There is little evidence concerning how artists in North America acquired their painting materials. Because firms that sold art supplies were not established in American cities until the early nineteenth century, and the manufacture of artists' materials in America also didn't begin until that time, the artists themselves often imported and sold painters' supplies.[24] There are some records of Smibert's orders for canvases and other materials that were prepared in London and shipped to him in Boston. In 1734, Smibert opened a shop that sold artists' materials, including brushes, colors, and canvas, along with engravings and frames. The shop was managed by his nephew, John Moffatt. By 1743, his London supplier was the British artist Arthur Pond, to whom he wrote on July 1 to arrange for the shipment of many painting supplies, including "3 doz ¾ Cloaths strained, & two whole Length Cloaths which pray order to be good and carefully rolled up & put in a Case." This order specifies that the smaller, three-quarter-length (head-and-shoulder size) canvases be shipped stretched on strainers and ready to use, and that the two larger whole-length canvases be rolled up and packed in a case, no doubt because they would have been too large—roughly seven feet long—to ship stretched. In the same letter, Smibert ordered pigments: "Lake of the Common midling [*sic*] sort about two Guineas and of good Lake about two Guineas more. Prussian Blew 50 1 2 shillings per pound." The following March, 1744, Smibert and Moffatt ordered a dozen "half length Cloaths primed, kit kat do 1 doz. ½ to be rolled up as the last," pallet knives, lead pencils, and a set of prints of ships. In 1745 and 1749, Smibert ordered more canvases, pigments, and some small picture frames. After Smibert's death in 1751, John Moffatt continued in this exchange with Pond until Pond's death in 1758.[25] Some of his canvases have retained evidence of the commercial preparation, including the whole-length portrait of William Browne (fig. 3.4). When it was restored and lined in 1970, its original tacking edges provided evidence that it was a "commercially prepared London canvas."[26] There is also some evidence of how Copley obtained precut canvases. While he was in New York, his half brother, Henry Pelham, ordered "12 half Length Cloths. 6 Kitkat Ditto" through his brother-in-law, the London merchant Henry Bromfield.[27] The accounts of Charles Willson Peale, on his arrival in London in 1767, note the purchase of painting supplies, including "Pensils [brushes], Tools & Cloaths," a "Piece of canvis H L [half-length]," and supplies for painting miniatures, which would provide some income for him while he was in London.[28] But after his return to Maryland, there are few references to how or from whom he bought his canvas and painting supplies. In 1780, he wrote to Henry Laurens in London to accept Laurens's offer to send "some Materials for My profession." He was running low because of the war: "I fear that I shall be out before I can get any of the kind, my last large Canvis is now before me with the [first] outlines of Genl Washington traced on it. Mr. Carmichael promised to send me of the same articles which I now wish to trouble you for." (The ship carrying Carmichael to London had been disabled in a storm.) Peale asked Laurens to send brushes, mezzotint plates,

pigments, and "6 whole length Canvas's 1 Doz half Length Do. [Ditto] 2 Doz. Three quarter Do."[29] After the war, in the 1780s, he was able to buy canvases and paint supplies from the Philadelphia drug and paint merchants Christopher Marshall Jr. and Charles Marshall.[30]

For other artists, the supply path is unknown. Less successful artists often augmented their incomes by selling supplies. New York City painter Gerardus Duyckinck II advertised in 1754 for sale, "just imported in the last Ships from London," a number of colors, including Prussian blue and vermilion that could be had "whole ground in Powder or in Oil," along with "Limner's and Japanner's Colours . . . Painters Brushes and Pensils . . . and sundry other Things too tedious to mention." Portrait painter Lawrence Kilburn offered "paints and painter's materials. . . . Portrait Painter's Colours; Canvas, Hair and Fitch Pencils, Tools, and gilt carv'd Frames for Portraits" in New York City in 1764.[31] And Thomas McIlworth, a Scottish painter who was in New York by 1757 and worked there and in Montreal for about ten years, bought canvases and frames from a New York merchant named Samuel Deall. Deall's account book lists a purchase by McIlworth on April 7, 1760, for "5 doz. Picture cloths" for £5 12s. McIlworth also ordered frames from Deall, and these remain on the portraits that he painted of Elizabeth Becker Curzon (Baltimore Museum of Art), David Edgar (private collection), and Major General John Bradstreet (Smithsonian National Portrait Gallery).[32]

Using the supplied canvases, artists also followed unwritten formulas about figural proportions that no doubt were communicated from one artist to another. Copley probably came to use these sizes early in his career as a result of the influence of the works by John Smibert, the training of his own stepfather, the English engraver Peter Pelham, and especially the example of Joseph Blackburn, whose arrival in Boston in 1755 had important consequences for Copley's career. Blackburn's impact on Copley merits closer study. Copley's early work mirrors Blackburn's in figural proportion, amount of background, and canvas size. Blackburn's influence on Copley can be seen in the younger artist's imitation of the Englishman's compositions, colors, renditions of fabric, and portrait settings. Copley's portrait of Jane Browne (National Gallery of Art) shows Blackburn's influence in the treatment of the figure, the painted oval framing device, the use of light colors, and attention to the minute details of the white lace and the picot edging on the bows of her dress. Even the signature, including the word "pinx," an abbreviation of "pinxit," or "[he] painted it," recalls Blackburn's signatures.[33] The practice of using certain sizes of canvas for specific compositions, however, is not often described in Copley's correspondence. A rare example is from 1770, when the American artist John Greenwood, living in London, requested that Copley paint a portrait of his mother, Mrs. Humphrey Devereux (fig. 3.9). He had not seen his mother since 1752, when he left Boston, and wrote to Copley, "I am very desirous of seeing the good Lady's Face as she now appears, with old age creeping upon her. I

FIG. 3.9 John Singleton Copley, *Mrs. Humphrey Devereux*, 1771. Oil on canvas, 40 ½ × 32 in. (103 × 81.3 cm). Museum of New Zealand Te Papa Tongarewa, Wellington, gift of the Greenwood Family, 1965, 1965-0013-1. Artist John Greenwood commissioned Copley to paint this portrait of his mother on a canvas "a little broader than a Kitt Katt, sitting in as natural a posture as possible."

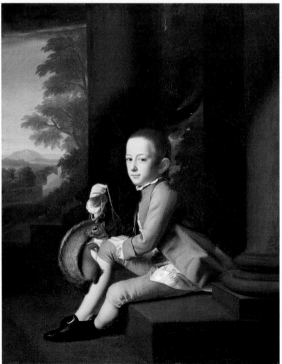

FIG. 3.10 John Singleton Copley, *Daniel Crommelin Verplanck*, 1771. Oil on canvas, 49 ½ × 40 in. (125.7 × 101.6 cm.). The Metropolitan Museum of Art, New York, gift of Bayard Verplanck, 1949 (49.12). Image copyright © The Metropolitan Museum of Art. Image source: Art Resource, New York. Before going to New York City to paint portraits on commission, Copley explained the relationship of canvas size, image, and price to his patron, Stephen Kemble. He also explained that because a child was smaller than an adult sitter, more of his or her figure could be depicted on a canvas than would be appropriate if the same size canvas was used for a portrait of an adult.

shoud chuse her painted on a small half length or a size a little broader than Kitt Katt, sitting in as natural a posture as possible. I leave the pictoresque disposition intirely to your self and I shall only observe that gravity is my choice of Dress."[34] The result was the very fine portrait of Mrs. Devereux seated at a table, looking into the distance; the painting measures 40 ½ × 32 inches, showing that Copley followed Greenwood's direction and painted her on a canvas smaller than the typical 50 × 40 half-length. The following year, the British army captain Stephen Kemble invited Copley to travel to New York to paint portraits. Kemble arranged the commissions in advance of Copley's departure from Boston, and wrote that "twelve ½ lengths are subscribed to (two Busts to a half Length), and I make no doubt as many more will be had as your time will permit you to take." Copley told him that when painting an adult's portrait on a three-quarter, or 30 × 25, canvas, such as that of Samuel Verplanck (Metropolitan Museum of Art), he charged ten guineas. "Weither [sic] Men or Weomen [sic] makes no difference in the price nor does the Dress." He also explained a variation: "Children in the ¼ peaces will be more, because of the addition of hands, which there must be when a Child is put in that size; but should the hands be omitted, the picture may be smaller and than [sic] the price will be the same as for a Mans or Womans without hands. But if hands they will be something more tho the price will be not exceeding 15 [guineas]."[35] An example of a child's portrait by Copley that would have been priced differently according to this description is that of Daniel Crommelin Verplanck (fig. 3.10), which shows him full-size, seated, on a canvas measuring 49 ½ × 40 inches. This use of a 50 × 40 canvas for a full-length image of a child was in practice as early as the 1720s, as seen in the portrait *De Peyster Boy with a Deer*, circa 1730 (New-York Historical Society).[36]

Another artist who documented the sizes and prices of his portraits in relation to their composition was Swedish artist Adolph Ulrich Wertmüller, a painter of historical subjects as well as portraits. Wertmüller studied painting in Stockholm and Paris, and he worked in Lyon, Paris, Bordeaux, Madrid, and Cádiz before coming to Philadelphia in 1794. His careful record of commissions shows that Wertmüller used the canvases made according to French practice, which differed from the English system in proportions and dimensions and was more closely codified, with a greater variety of sizes.[37] Wertmüller included the portraits that he painted in America in his "Notte de tous mes ouvrages . . . pour les années 1780–1801." In 1794, he painted a portrait of George Washington that he described as a "buste quaré toile de 15," or a bust-size portrait on a rectangular "size fifteen" canvas. Later that year and in 1795, he recorded three copies in the same size for specific patrons.[38] The versions at the Philadelphia Museum of Art (fig. 3.11) and the Metropolitan Museum of Art measure about 25 × 21 inches, which is slightly smaller than the English bust size of 30 × 25 inches. They depict Washington to the waist, with no hands shown. Premeasured canvases of these and other sizes were available in Paris by the mid-1750s. In a listing

FIG. 3.11 Adolph Ulrich
Wertmüller, *Portrait of George
Washington*, 1794. Oil on canvas,
25 ⅜ × 21 ⅛ in. (64.4 × 53.7 cm).
Philadelphia Museum of Art,
gift of Mr. and Mrs. John Wagner,
1986, 1986-100-1. Wertmüller, a
Swedish artist trained in France,
used canvases in formats that
were more closely codified than
English canvases. The head-
and-shoulders canvas that he
used for his portraits of George
Washington was slightly
smaller than a typical English
three-quarter size, and was
termed a size 15, its price in
French sous.

of such canvases published in Paris in 1757, the size fifteen measured 2 feet (pied) × 1 foot, 8 inches, or 24 × 20 inches.[39] Wertmüller also documented a copy of a portrait of a Quaker with one hand in his waistcoat ("copie d'un Quaker avec une main enfoncée dans la veste"), painted on a rectangular canvas "size twenty" ("toile de 20, quaré"). This may be the *Portrait of a Quaker* (National Gallery of Art), which measures about 28 × 22 inches. While still painting in France, Wertmüller had used this canvas size only for portraits of sitters shown "with one hand."[40]

The size of the portrait also led to noticeable differences in the amount and complexity or plainness of the background. This is implied in Gilbert Stuart's remarks to another visitor to his studio. In 1816, the young Kentucky artist Matthew Harris Jouett studied with Stuart for three months. Jouett kept careful notes of Stuart's remarks as he watched the master paint portraits. He noted that the smaller the canvas, the less detail was placed around the figure to divert the attention. According to Jouett, Stuart taught that backgrounds

should contain whatever is necessary to illustrate the character of the person. The eye should see the application of the parts to the illustrate [*sic*] of the whole, but without seperating [*sic*] or attracting the attention from the main point. Back

grounds point to dates and circumstances peculiarly of employment or profession, but the person should be so portray'd as to be read like the bible without notes, which in books are likened unto back grounds in painting. Too much parade in the background, like notes with a book to it, and as verry [sic] apt to fatigue by the constant shifting of the attention &c.[41]

99

Examples of these differences abound in the portraits themselves, those by both Stuart and his predecessors. A comparison of Stuart's portrait of Catherine Brass Yates (National Gallery of Art), as an example of a 30 × 25 canvas, with the contemporary portrait of Matilda Stoughton de Jaudenes y Nebot (Metropolitan Museum of Art), a half-length portrait measuring about 50 × 40 inches, shows how the choice of a smaller canvas size resulted in a simpler image. Mrs. Yates's portrait has often been described as essentially American. Frederic Fairchild Sherman wrote in 1932 that it showed "how powerfully the native influence in art moved [Stuart] at times."[42] A comparison with the picture of Señora de Jaudenes, a larger painting, shows that much of the impact of the smaller portrait is its focus on the sitter. In the portrait of Mrs. Yates, Stuart has not included what he called "parade in the background," which would detract from the image of the sitter. By comparison, Señora de Jaudenes, the daughter of John Stoughton of Boston and the wife of the Spanish chargé d'affaires Josef de Jaudenes y Nebot, is dressed in white silk with gold embroidery, with a feathered coronet in her hair. The larger composition allows for the inclusion of a table with books, a masonry wall or column, a curtain, and blue sky. Copley's two portraits of John Hancock, and a third that he commissioned of his uncle, Thomas Hancock, also show how the setting differs on the three different sizes of canvas. The whole-length of Thomas Hancock (about 95 × 60 inches; Harvard University Portrait Collection), which was painted for Harvard College in about 1764, after Hancock's death, shows the merchant in full figure in an elaborately detailed setting that includes a colonnade, a sweeping drapery, a large chair, and an ornate table. The larger of the two portraits of John Hancock, measuring about 50 × 40 inches and painted in 1765 (Museum of Fine Arts, Boston), shows the merchant seated at a desk in a Queen Anne–style chair, holding a pen. The background is limited to a flat wall and a small piece of red drapery to the right. The smaller portrait, of about 1770–72 (Massachusetts Historical Society), shows John Hancock in a similar blue coat with gold braid, but no hands are shown, there is no setting indicated, and the background is only a flat wall.[43]

Painters did not follow these single-figure canvas sizes when painting multifigure compositions. Peale used irregular sizes for what he termed "conversations," which showed more than one figure. One example is his *Portrait of the Edward Lloyd Family* (1771) (Winterthur Museum), a painting measuring 48 × 57 ½ inches, which represents Lloyd, of Talbot County, Maryland, his wife, and their eldest child, Anne. Peale described it in his list as "3 Mr Loydd a co[n]versation," for which the price was

£36 15s.[44] This amount was the highest in his early listing of portrait commissions, more than one and a half times the price of a life-size whole-length like that of John Beale Bordley, no doubt because, although the canvas was not as large, the painting represented three figures. An English painter named John Stevenson, whose work we have no examples of, offered in 1773 in Charleston to paint "Family and Conversation Pieces, either the size of nature, or small whole Lengths, in the Stile of Zoffani," a reference to Swiss painter Johan Zoffany.[45] Other artists used their own variations on these sizes. At times, artists used substitute fabrics for canvas because of the unusual size of the portrait that was commissioned, sometimes because of disruption in trade. Ralph Earl used canvases with a fine texture when painting in England and New York City, where manufactured materials could be obtained. But he had to resort to using mattress ticking or other coarse fabrics when painting outside cosmopolitan areas, where he could not easily obtain canvases. In his New England portraits, he occasionally used fabrics that were only a yard wide, and therefore had to piece two sections of canvas together when painting large portraits.[46] Charles Willson Peale at times used mattress ticking, which is the support for his whole-length of William Paca (Maryland State Archives, Annapolis).[47] Stuart turned to the use of wood panels in 1800 and continued to use them for about twenty years. While it has been believed for some time that his use of wood panels instead of imported canvas was a result of the Embargo Act of 1807, which disrupted trade with Britain, this may not have been the initial reason. Paintings on wood panel begin to appear in his work in 1800 and continue through at least 1818.[48]

Studies of these materials, especially the prices and sizes, and what they tell us about portraiture and social status are rare. Only the works of John Singleton Copley have been thoroughly studied from this viewpoint. For his study of the artist's work, Jules Prown examined the way in which these sizes and prices might correlate with the sitter's social status, religion, education, and income. The results of the analysis were published in *Copley in America*, the first volume of Prown's two-volume study *John Singleton Copley*. Prown described this survey as "a rare opportunity to study the relationship between an artist and his clients." He described as "endless" the list of questions that could be based on a statistical analysis of the sitters, their place of residence, age, religious affiliation, education, income, and the sizes of the portraits they ordered. Entering as much data as he had for 240 American portraits, he tabulated the results in terms of Copley's career in six distinct time periods between 1753 and 1774, when the artist left Boston for England. For example, merchants outnumbered other men as sitters and also monopolized the whole-length commissions. Ministers preferred the smaller portraits. And although there seemed to be no correlation between church affiliation or political position and picture size, "all of the provincial elective officials ordered portraits of the 50 inch by 40 inch or larger size." And of course the very wealthy ordered most of the large canvases.[49] While Charles Willson Peale's

career has also been studied in depth, only Charles Coleman Sellers wrote specifically about his materials, technical procedure, and the prices and sizes of his portraits.[50] But there has been no statistical study of Peale's sizes and prices in social terms.

What difference does all of this make in our interpretation of these portraits? It reminds us to be wary of interpretations of the visual material in an individual painting that might lead to personal or political generalizations about the meaning of its style or composition. Rather than study the unique qualities of one portrait, it is perhaps appropriate first to study the similarities between portraits by the same or different artists to establish the shared practices that in fact are striking evidence of the transatlantic importation to America of the European profession of portrait painting. For the work of Copley and other American eighteenth-century portrait painters, this information helps modern viewers understand the degree to which they were able to emulate or imitate European standards for portraits that would satisfy their American clients.

NOTES

In addition to thanking my many curatorial colleagues over the years, I would particularly like to acknowledge the many instructive and enlightening conversations I have had with painting conservators during my career. My opportunities to observe them at work and discuss their observations began in the 1960s with Russell Quandt at the Corcoran Gallery of Art and continue to this day at the Smithsonian National Portrait Gallery, the National Gallery of Art, and in many other museum and private conservation studios. I especially thank Erin Beasley, Smithsonian National Portrait Gallery, for her continued assistance with the images for this chapter. I also thank Meghan Gross, Baltimore Museum of Art; Andy Harrison, Alan Mason Chesney Medical Archives, the Johns Hopkins Medical Institution; Linda Jenkins, executive director of the Pickering Foundation; Jennifer Hornsby, Phillips Library, Peabody Essex Museum; J. D. Kay, Rhode Island Historical Society; Carolyn Cruthirds, Museum of Fine Arts, Boston; the staff of Art Resource, Inc., New York; and Shelby Rodriguez, Museum of Fine Arts, Houston, for their assistance with specific reproductions.

1. Margaretta M. Lovell has transformed the study of American portraiture of this period with her book *Art in a Season of Revolution: Painters, Artisans, and Patrons in Early America* (Philadelphia: University of Pennsylvania Press, 2005). Recent articles that also seek to study the social contexts or social meanings of portraiture include Leslie K. Reinhardt, "Serious Daughters: Dolls, Dress, and Female Virtue in the Eighteenth Century," *American Art* 20, no. 2 (2006): 32–55; and Jennifer Van Horn, "The Mask of Civility: Portraits of Colonial Women and the Transatlantic Masquerade," *American Art* 23, no. 3 (2009): 8–35. Exhibition catalogues that have sought to better analyze the contexts for portraits include Carrie Rebora, Paul Staiti, Erica E. Hirshler, Theodore E. Stebbins Jr., and Carol Troyen, *John Singleton Copley in America*, exh. cat. (New York: Metropolitan Museum of Art, 1995); and Carrie Rebora Barratt and Ellen G. Miles, *Gilbert Stuart*, exh. cat. (New York: Metropolitan Museum of Art, 2004). Most recently, Zara Anishanslin, in *Portrait of a Woman in Silk: Hidden Histories of the British Atlantic World* (New Haven: Yale University Press, 2016), elaborates on one portrait's many contextual roles.

2. John Caldwell and Oswaldo Rodriguez Roque, *American Paintings in the Metropolitan Museum of Art*, vol. 1, *A Catalogue of Works by Artists Born by 1815* (New York: Metropolitan Museum of Art, 1994), 95.

3. Jennifer L. Roberts, *Transporting Visions: The Movement of Images in Early America* (Berkeley: University of California Press, 2014), 17.

4. Canvas sizes and their uses in English portraiture are discussed in Christina Young, "Canvas Suppliers in London and Early Evidence of Colourmen Firms," in *The Conservation of Easel Paintings*, edited by Joyce Hill Stoner

and Rebecca Anne Rushfield (New York: Routledge, 2012), 133–35. Their history, terminology, and usage are analyzed in greater detail in Jacob Simon, "'Three-Quarters, Kit-Cats, and Half-Lengths': British Portrait Painters and Their Canvas Sizes, 1625–1850," available on the website of the National Portrait Gallery, London, at www.npg.org.uk/research/programmes/artists-their-materials-and-suppliers; see especially parts 1 and 2. On Kneller's Kit-Cat Club series, see J. Douglas Stewart, "The Kit-Cat Club Portraits," in *Sir Godfrey Kneller*, exh. cat. (London: National Portrait Gallery, 1971), appendix, i–xviii.

5. On Barrow, see Charles Merrill Mount, *Gilbert Stuart: A Biography* (New York: W. W. Norton, 1964), 166, 185, 190. He is listed in Alexander W. Katlan's "Checklist of Carvers, Gilders, and Related Craftsmen in New York City: 1786–1799," in *American Artists' Materials: A Guide to Stretchers, Panels, Millboards, and Stencil Marks* (Madison, Conn.: Sound View Press, 1992), 399. It was in Barrow's shop that John Vanderlyn received his first introduction to painting and met Gilbert Stuart, which led to his apprenticeship with Stuart in Philadelphia.

6. Henry Pickering, "Interview," November 4, 1817, in "Interviews with Mr. Stuart in 1810 and 1817," manuscript, Pickering Foundation, Salem, Massachusetts, quoted in Barratt and Miles, *Gilbert Stuart*, 278, 280.

7. Quoted in Barratt and Miles, 278, 280.

8. On the payments for the Lansdowne portraits of Washington referred to here, see Barratt and Miles, 170, 178n6, and 183. The Constable-Hamilton portrait of Washington now belongs to the Crystal Bridges Museum of American Art in Bentonville, Arkansas.

9. On Smibert, see *The Notebook of John Smibert*, with essays by Sir David Evans, John Kerslake, and Andrew Oliver (Boston: Massachusetts Historical Society, 1969); and Richard H. Saunders, *John Smibert: Colonial America's First Portrait Painter* (New Haven: Yale University Press, 1995).

10. *Notebook of John Smibert*, 92, no. 92; Saunders, *John Smibert*, 183, no. 94, and plate 16.

11. *Notebook of John Smibert*, 92, nos. 97 and 100; Saunders, *John Smibert*, 186–88.

12. These three portraits are listed in *Notebook of John Smibert*, 92, nos. 94, 98, and 99, and in Saunders, *John Smibert*, 184, no. 96, and 187, nos. 100 and 101.

13. On the portraits of the Lamberts, see *Notebook of John Smibert*, 92, no. 89, and 93, no. 110; Saunders, *John Smibert*, 182, no. 92, and 191, no. 109.

14. Blackburn's work was catalogued in 1922 and 1936; see Lawrence Park, *Joseph Blackburn: A Colonial Portrait Painter, with a Descriptive List of His Works* (Worcester, Mass.: American Antiquarian Society, 1923) (reprinted from the *Proceedings of the American Antiquarian Society* for October 1922); and John Hill Morgan and Henry Wilder Foote, "An Extension of Lawrence Park's Descriptive List of the Works of Joseph Blackburn," *Proceedings of the American Antiquarian Society*, new ser., 46 (April 1936): 15–81. Recent studies focus on his work in specific locations; see William B. Stevens Jr., "Joseph Blackburn and His Newport Sitters, 1754–1746," *Newport History* 40 (Summer 1967): 95–107; and Elizabeth Ackroyd, "Joseph Blackburn, Limner in Portsmouth," *Historical New Hampshire* 30 (Winter 1975): 231–43. Wollaston's work was documented first in 1931 by Theodore Bolton and Harry Lorin Binsse, "Wollaston: An Early American Portrait Manufacturer," *Antiquarian* 16 (June 1931): 30–33, 50, 52. Later authors, including Wayne Craven and Carolyn J. Weekley, focused on specific geographical areas; see Craven, "John Wollaston: His Career in England and New York City," *American Art Journal* 7, no. 2 (1975): 19–31; and Weekley, "John Wollaston, Portrait Painter: His Career in Virginia, 1754–1758" (master's thesis, University of Delaware, 1976). Weekley recently summed up his American career in *Painters and Paintings in the Early American South* (New Haven: Yale University Press, 2013), 226–47. Individual portraits are also documented in the databases of the Catalog of American Portraits at the National Portrait Gallery (http://www.npg.si.edu/portraits/research) and the Inventory of American Painting, established and maintained by the Smithsonian American Art Museum (http://siris-artinventories.si.edu).

15. Eleanor S. Quandt, "Technical Examination of Eighteenth-Century Paintings," in *American Painting to 1776: A Reappraisal*, edited by Ian M. G. Quimby (Charlottesville: University Press of Virginia, 1971), 358.

16. On Theus, see Margaret Simons Middleton, *Jeremiah Theus, Colonial Artist of Charles Town* (Columbia: University of South Carolina Press, 1953); and Weekley, *Painters and Paintings*, 193–208. On this portrait, see also Angela D. Mack and J. Thomas Savage, "Reflections of Refinement: Portraits of Charlestonians at Home and Abroad," in *In Pursuit of Refinement: Charlestonians Abroad, 1740–1860*, Maurie D. McInnis in collaboration with Angela D. Mack, with essays by J. Thomas Savage, Robert A. Leath, and Susan Ricci Stebbins, exh. cat. (Columbia: University of South Carolina Press for the Gibbes Museum of Art, 1999), 25–27.

17. On Haidt, the teacher of Benjamin West, see Vernon Nelson, *John Valentine Haidt* (Williamsburg, Va.: Abby Aldrich Rockefeller Folk Art Museum, 1966); and Richard H. Saunders and Ellen G. Miles, *American Colonial Portraits, 1700–1776*, exh. cat. (Washington, D.C.: National Portrait Gallery, 1987), 248–49, no. 80.

18. Rebora et al., *Copley in America*, 154.

19. *Letters and Papers of John Singleton Copley and Henry Pelham, 1739–1776* (Boston: Massachusetts Historical Society, 1914; reprint, New York: Da Capo Press, 1970), 112. The letter is not dated.

20. *The Selected Papers of Charles Willson Peale and His Family*, edited by Lillian B. Miller, Sidney Hart, and David C. Ward, 5 vols. (New Haven: Yale University Press, 1983–2000), 1:631–33, Appendix I, A.

21. Charles Coleman Sellers, "Portraits and Miniatures by Charles Willson Peale," *Transactions of the American Philosophical Society*, new ser., 42, no. 1 (1952): 18–19; *Selected Papers of Charles Willson Peale*, 1:458n3, Appendix I, B–H.

22. Quoted in Rita Susswein Gottesman, ed., *The Arts and Crafts in New York, 1777–1799: Advertisements and News Items from New York City Newspapers* (New York: New-York Historical Society, 1954), 4.

23. Alfred Coxe Prime, ed., *The Arts and Crafts in Philadelphia, Maryland, and South Carolina: Gleanings from Newspapers*, 2 vols. (1929–33; reprint, New York: Da Capo Press, 1969), 2:24–25.

24. For a study of artists' supply firms and manufacturers in America, see Alexander W. Katlan, *American Artists' Materials Suppliers Directory* (Park Ridge, N.J.: Noyes Press, 1987); Katlan describes the early years of artists' supply firms on 5–17. Lance Mayer and Gay Myers discuss eighteenth-century American artists' painting techniques and materials in *American Painters on Technique: The Colonial Period to 1860* (Los Angeles: J. Paul Getty Museum, 2011), 1–58.

25. On the color shop in Boston, see Saunders, *John Smibert*, 100–102; for the letters, see Appendix 2, 257–61. On Pond, see Louise Lippincott, *Selling Art in Georgian London: The Rise of Arthur Pond* (New Haven: Yale University Press, 1983).

26. See Saunders, *John Smibert*, 183; and Quandt, "Technical Examination," 358, 368n12.

27. *Papers of John Singleton Copley*, 115 (letter dated June 6, 1771).

28. *Selected Papers of Charles Willson Peale*, 1:60, 63.

29. Ibid., 1:341 (letter dated March 6, 1780).

30. Ibid., 1:443.

31. Duyckinck's advertisement in the *New-York Gazette or the Weekly Post-Boy* of November 18,

1754, is quoted in Rita Susswein Gottesman, ed., *The Arts and Crafts in New York, 1726–1776: Advertisements and News Items from New York City Newspapers* (New York: New-York Historical Society, 1938), 354; Kilburn's is quoted on p. 5.

32. Ona Curran, *Thomas McIlworth: Colonial New York Portrait Painter* (Esperance, N.Y.: Art Books Press, 2007).

33. On Blackburn's influence on the young Copley, see the discussion of Copley's portraits of Ann Tyng (1756) (Museum of Fine Arts, Boston), Theodore Atkinson Jr. (ca. 1757–58) (Museum of Art, Rhode Island School of Design, Providence), and Mrs. George Watson (Elizabeth Oliver) (1765) (Smithsonian American Art Museum), in Rebora et al., *Copley in America*, 176–81, 206–8.

34. *Papers of John Singleton Copley*, 81–82 (letter dated March 23, 1770); the painting is discussed in Rebora et al., *Copley in America*, 269–71 (no. 59).

35. *Papers of John Singleton Copley*, 112–13.

36. On these two portraits, see Rebora et al., *Copley in America*, 292–95 (*Daniel Crommelin Verplanck*) and fig. 214 (*De Peyster Boy with a Deer*).

37. On French-manufactured canvas sizes, in use for more than two hundred years, see David Bomford, John Leighton, Jo Kirby, and Ashok Roy, "Canvases and Primings for Impressionist Paintings," in *Impressionism*, exh. cat. (London: National Gallery of Art, 1990), 44–45; Christina Young, "Nineteenth-Century French Suppliers and Artists' Choices," in Stoner and Rushfield, *Conservation of Easel Paintings*, 139–40; and Simon, "'Three-Quarters, Kit-Cats,'" part 5, "Britain and the Continent."

38. Michel Benisovich, "Wertmüller et son livre de raison intitulé la 'Notte,'" *Gazette des Beaux-Arts*, 6th ser., 48 (July–August 1956): 58–59.

39. Antoine Joseph Pernety, *Dictionnaire portative de peinture, sculpture et gravure* (Paris, 1757; reprint, Geneva: Minkoff, 1972), s.v. "toile" (canvas).

40. See *Portrait of a Quaker*, attributed to Adolph Ulrich Wertmüller, in *American Paintings of the Eighteenth Century: The Collections of the National Gallery of Art Systematic Catalogue*, edited by Ellen G. Miles (Washington: National Gallery of Art, 1995), 312–16.

41. Matthew Harris Jouett, "Notes Taken by M. H. Jouett While in Boston from Conve[r]sations on painting with Gilbert Stuart Esqr.," in John Hill Morgan, *Gilbert Stuart and His Pupils* (New York: New-York Historical Society, 1939), 84–85.

42. Frederic Fairchild Sherman, *Early American Painting* (New York: Century Library of American Antiques, 1932), 28.

43. For these portraits, see Barratt and Miles, *Gilbert Stuart*, 108–12, cat. no. 28 (Mrs. Yates), and

124–27, cat. no. 33 (Señora de Jaudenes); Rebora et al., *Copley in America*, 211–14, cat. nos. 22 and 23 (both entries are for portraits of John Hancock), and 4, fig. 1 (Thomas Hancock).

44. Sellers, "Portraits and Miniatures," 28, no. 486; Charles Coleman Sellers, "Charles Willson Peale with Patron and Populace: A Supplement to Portraits and Miniatures by Charles Willson Peale, with a Survey of his Work in Other Genres," *Transactions of the American Philosophical Society*, new ser., 59, part 3 (1969): 69, no. SP 77; *Selected Papers of Charles Willson Peale*, 1:632–33, Appendix I, A.

45. Prime, *Arts and Crafts in Philadelphia*, 1:9.

46. For a discussion of this and other physical aspects of Earl's work, see Stephen H. Kornhauser, "Ralph Earl's Working Methods and Materials," in Elizabeth Mankin Kornhauser, with Richard L. Bushman, Stephen H. Kornhauser, and Aileen Ribeiro, *Ralph Earl: The Face of the Young Republic*, exh. cat. (New Haven: Yale University Press, 1991), 85–91.

47. The painting was conserved at Winterthur under the direction of Dr. Joyce Hill Stoner, Edward F. and Elizabeth Goodman Rosenberg Professor of Material Culture, University of Delaware, who generously sent me a copy of the report.

48. On Stuart's use of wood panels, see Marcia Goldberg, "Textured Panels in Nineteenth-Century American Painting," *Journal of the American Institute for Conservation* 32, no. 1 (1993): 33–42. Although Goldberg described Stuart's five presidential portraits at the National Gallery of Art as scored in the ground (36, 41n4), examination of the paintings for the systematic catalogue published in 1995 determined that the scoring is in the wood panels themselves. See Miles, *American Paintings of the Eighteenth Century*, 265.

49. For this study and its findings, see Jules David Prown, *John Singleton Copley*, vol. 1, *Copley in America, 1738–1774* (Cambridge: Harvard University Press for the National Gallery of Art, 1966), appendices, 97–137 ("Statistical Data for 240 Portraits," "Categorical Listings," and "Analysis of Data").

50. Sellers, "Portraits and Miniatures," 11 ("Technical Procedure"), 18–19 ("Sizes and Prices").

Clock Making in Southwestern Connecticut, 1760–1820

PAUL G. E. CLEMENS AND EDWARD S. COOKE JR.

CLOCKS WERE AMONG THE most inspiring, ingenious, complicated, and expensive consumer goods of the revolutionary and early national period in American history. Early Americans bought clocks as markers of status, as tools to organize and measure activities in an increasingly time-aware culture, and as local products. Over time, they bought an increasingly large number of them. Before the mid-eighteenth century, very few Americans, other than the wealthiest, most genteel inhabitants of the colonies, owned clocks. Following the Revolution, as the American economy recovered from the aftershocks of a destructive war, clock ownership would become more common. This story unfolds by looking at Fairfield County, Connecticut, a prosperous agricultural county nestled in the southwestern part of the state. A border with New York and an extended Atlantic coastline ensured that Fairfield had access to regional and international markets, but the county also had a long tradition of skilled artisans embedded within the local mixed agricultural economy. In this chapter we examine both the production of and the demand for clocks in southwestern Connecticut in an era before most clocks were manufactured with machine tools. The production story is one that depends on a careful analysis of material culture—what was built by whom, and how. The story of consumption is reconstructed from probate inventories and tax lists that allow us to gauge who owned clocks and how patterns of ownership changed chronologically and geographically.[1]

PRODUCTION

Contrary to popular belief, Connecticut towns in the early national period did not have a standard complement of craftsmen. The only universal artisans were joiners/carpenters, blacksmiths, and shoemakers, all of whom could be found in every town.[2] Clockmakers tended to work in regional territories, often determined by the early establishment of a shop (such as the East Hartford shop of Benjamin Cheney) or by the density and wealth of the population.[3] In Fairfield County, clock production can be split into a southern metal tradition, centered in Fairfield, and a northern wood tradition, centered in Plymouth in the southeastern corner of neighboring Litchfield County, but with a growing impact on clock ownership in Fairfield County. Both traditions were based on artisanal skill, but the former made use of intensive traditional application of knowledge within single shops, while the latter made use of mechanical expertise extensively deployed throughout a region of shops.

The founder of the Fairfield tradition was John Whitear (d. 1762), a clockmaker and bell founder who first appeared in Fairfield in 1736. A skilled metalworker, Whitear fabricated complex works made from cast brass plates and wheels with offset riveted brass plate posts (figs. 4.1 and 4.2). Possession of a complex and expensive wheel-cutting engine to index the wheels for his works established his as the leading shop in southwestern Connecticut and permitted him to gain a significant regional market, often, it seems, facilitated by the bell commissions of the Anglican Church. Based upon the numbers that were engraved on the dials made by Whitear and his son, John Jr. (1738–1773), it appears that the Whitear shop made at least 172 clocks over the careers of father and son. This meant that the Whitears averaged slightly fewer than five clocks a year. Their works have several diagnostic elements that differentiate Fairfield works from those of other colonial craftsmen and from English imported movements of the same period, including the tendency to leave the front plate pitted, the high-arched brass rack hook, the straight-sided and uniform-width brass rack, and the offset plate posts. Such features can also be found in works made by Joseph Bulkley (1755–1815), William Burr Jr. (working ca. 1782–1800), and Whiting and Marquand (a brief partnership formed by Bradford Whiting and Isaac Marquand in 1787) of Fairfield, as well as in mechanisms by Richardson Miner (1736–1797) of Stratford, and suggest the persistence of a strong and relatively unchallenged apprenticeship network. Bulkley inherited the Whitear family tools and succeeded them as the dominant shop in the region, but there was apparently sufficient demand for clocks, repair work, and related metalwork that the other shops found customers as well.[4]

In Newtown, the clockmaker and bell founder Ziba Blakslee (w. 1791–1834) also provided church bells and brass clockworks, although no surviving examples have been identified. In addition to the local craftsmen who made brass works and faces, there is also evidence that other Fairfield County clockmakers or cabinetmakers used imported

FIG. 4.1 John Whitear Sr., tall
case clock, Fairfield, Connecticut,
ca. 1750. Cherry, brass, white
pine, iron, and glass. Courtesy
Winterthur Museum, gift of
Henry Francis du Pont, 1958.2430.

FIG. 4.2a, b John Whitear Sr.,
details of the dial and works of
the tall case clock in figure 4.1,
Fairfield, Connecticut, ca. 1750.
Cherry, brass, white pine, iron,
and glass. Courtesy Winterthur
Museum, gift of Henry Francis du
Pont, 1958.2430.

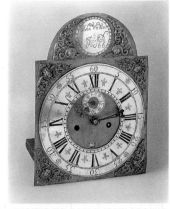

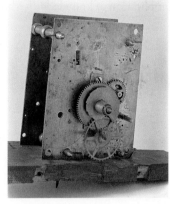

British works and dials. John Benjamin (1730–1796), a silversmith in Stratford, appears
to have provided silvered brass dials for English works that were then housed in a
locally made case. The Danbury cabinetmaker William Chappel (w. 1790–1825) used
an imported Birmingham painted iron dial on a clock case he made.[5] The concentration
of clockmakers in southern Fairfield County resulted in unusually high ownership
of tall case clocks with brass works in these nonurban areas. In the Newtown tax list
of 1798, sixteen out of 495 houses had steel- or brass-wheeled clocks and only two
had wooden-wheeled clocks. Similarly, a tax list from Fairfield in 1805 lists sixty-three
out of a total of 537 households as having brass-wheeled clocks, and only four with
wooden-wheeled clocks.[6] In each town, the presence of a metalworking clockmaker
within the local social economy had a direct impact upon the ownership of these expen-
sive furniture/instrument hybrids. Both the Whitear/Bulkley shop and the Blakslee
shop seem to have parlayed a small-shop expertise—grounded in metallurgical knowl-
edge, access to traded-in imported brass alloys, and specific clock-making machinery
like the engine—to develop a niche in the regional economy and supply metal clock-
works that were housed in cases made by a number of woodworkers.

The intensive use of small-shop expertise and imported materials that character-ized clock making in southern Fairfield County was challenged by more extensive use of artisanal skill and local materials in Litchfield County (see table 4.1). Clockmakers there substituted riven oak for brass plates; cherry wheels, maple arbors, and maple pinions for brass and steel elements; and painted wood or paper dials for single-sheet brass or painted iron dials to produce less expensive works. The tall cases remained the same in terms of parts (a hood with architectural pediment and glazed door in front of a dial, a long, thinner waist with door, and a wider base with bracket feet) and dimensions; the major differences were the dials and works. The substitution of wooden works did not seem to dramatically affect performance, either. Timothy Dwight, writing about clock making in Waterbury in 1798, commented that local clocks made from "a particular species of wood" were "considered as keeping time with nearly as much regularity, as those which are made of customary materials. They also last long."[7] While the visual distinctions between these clocks were minimal and while their performance was within acceptable boundaries, the price differential was significant. In the Waterbury area in the early 1790s, wooden works cost from $13.33 for those with paper faces to $25 for those with sheet-brass faces. Brass mechanisms cost from $33.33 to $50. Cases varied in cost from $5 to $30 depending not on the works within but on the type of wood and decoration. Thus a plain tall case clock with wooden works might cost $18, whereas the plainest example with brass works might sell for $38 and the most elaborate for $80.[8]

In Fairfield County, the craftsman who dominated the production of wooden-works clocks was Eli Terry (1772–1852). Terry had learned the craft from Daniel Burnap of East Windsor—arguably the most entrepreneurial and successful of all eighteenth-century Connecticut clockmakers (more than a fifth of surviving clocks from the Connecticut Valley region were made in his shop)—and gained an additional year's experience with wooden works in the shop of Timothy Cheney of

TABLE 4.1 Comparison of wood and brass clockworks

	Wood works	Brass works
Materials		
Wheels	Local cherry	Imported or recycled brass
Plates	Local oak	Imported or recycled brass
Hands	Readily available pewter	Imported steel or sheet iron
Face	Paper on white pine	Imported or recycled brass, silver, imported painted iron
Processes	Turning, riving, sawing, filing	Casting, milling, threading, filing, engraving
Tools	Lathes, jigs, files	Molds, patterns, clock wheels engines, metal lathes,
	Standard woodworking tools	files, metalworking tools, buffing pads, and polishing compounds
Skill level	Broad-based, low to midlevel	Narrowly based, highly specialized

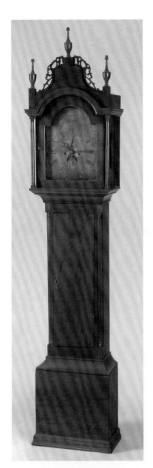
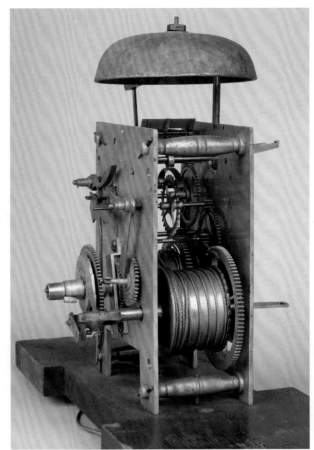

FIG. 4.3 Eli Terry, tall case clock, Plymouth, Connecticut, ca. 1800. Cherry, brass, iron, and glass. The Connecticut Historical Society, gift of Kenneth D. Roberts, 1980-55-0dt1. Photo: David Stansbury.

FIG. 4.4 Eli Terry, brass works of tall case clock in figure 4.3, Plymouth, Connecticut, ca. 1800. Cherry, brass, iron, and glass. The Connecticut Historical Society, gift of Kenneth D. Roberts, 1980-55-0dt2. Photo: David Stansbury.

East Hartford, the acknowledged master of such mechanisms in the last quarter of the eighteenth century. Terry thus had a solid command of both types of works. Facing stiff competition in the Hartford/East Windsor area, Terry moved away from the valley and settled in 1793 along the Naugatuck River, in a part of Watertown that became Plymouth. From 1793 until about 1800, Terry worked in a typical small-shop manner: he made both eight-day brass (figs. 4.3 and 4.4) and thirty-hour wooden mechanisms (figs. 4.5 and 4.6). For his wooden works, he used an engine to lay out his wheels and a backsaw and edge tool to cut them; turned his arbors, posts, and wheels

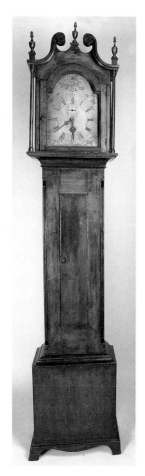
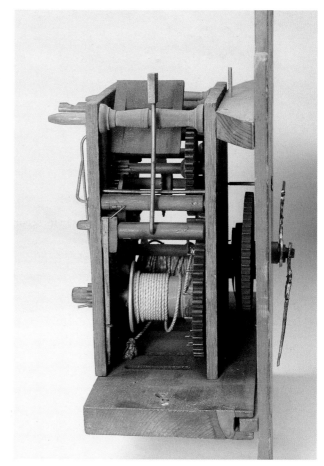

FIG. 4.5 Eli Terry, tall case clock, Plymouth, Connecticut, 1802–6. Cherry, oak, and paper. Collection of the Mattatuck Museum, Waterbury, Connecticut.

FIG. 4.6 Eli Terry, wooden works of tall case clock in figure 4.5, Plymouth, Connecticut, 1802–6. Cherry, oak, and paper. Collection of the Mattatuck Museum, Waterbury, Connecticut.

on a foot-powered lathe; and made small batches of three or four clockworks, which he then peddled throughout the region.[9] Around the turn of the century, based on feedback he received when trying to sell clocks in an agricultural region, Terry began to focus on wooden clockworks and efficiency in production. He turned to water power for his saws and lathes and, judging from the artifactual evidence, may even have begun to use water power to cut the teeth of his wooden wheels with a milling cutter. He also began to take advantage of pieceworkers, such as the dial painter Candace Roberts, outside his shop. These steps allowed him to increase production to about two hundred clocks a year.[10]

Demand for and ownership of brass-wheeled and wooden-wheeled clocks greatly expanded in Connecticut between 1802 and 1806, but it was the Embargo Act of 1807, which brought the import trade to a standstill, that provided an ideal opportunity for Terry to take the next step in reorganizing his shop.[11] Two Waterbury businessmen, Levi Porter and Edward Porter, contracted with Terry to make four thousand wooden works for tall case clocks. To fill this massive order, Terry began to fit out a recently purchased old gristmill site to establish a new shop with sufficient water power. He invested in new lathes and a circular saw and hired Seth Thomas and Silas Hoadley to set up new machinery and develop jigs to ensure consistent production. Neither Thomas nor Hoadley was a trained clockmaker, but both men were skilled woodworking machinists who fabricated and oversaw what Terry desired. The Terry shop took one year to set up, produced a thousand clocks in its second year, and then hit its stride in the third year, producing three thousand clocks and fulfilling the Porter contract (fig. 4.7 and 4.8). Having completed the task, Terry sold the manufactory to his two assistants, Thomas and Hoadley, who continued producing wooden mechanisms for tall case clocks for another three years. During the same years, other clockmakers in the region quickly adopted Terry's improvements, spurred on by businessmen like the Porters, who fronted materials or provided a contract with advance payments linked to specified production schedules. Ephraim Downs and Heman Clark produced thousands of mechanisms for Lemuel Harrison & Co., and the shops of Gideon Roberts and Joseph and Ira Ives in Bristol, Asa Hopkins in Litchfield, and William Leavenworth in Waterbury (figs. 4.9 and 4.10) all eagerly increased production and distribution of wooden works for tall case clocks. The expansion was enabled by the capital and schedules of businessmen and their contracts, but it was mainly driven by the use of water power for saws and lathes and of jigs to ensure the consistent shaping and cutting of wheels; the coordination of pieceworkers who provided parts or decorated elements; the training of local woodworkers to make carcasses; and the hiring of family members or neighbors as peddlers to sell the final product, not only locally but throughout the Northwest Territory and the South. The region became so well known for clock making that a new 1811 map included clock manufactories.[12]

After selling his manufactory to Thomas and Hoadley, Terry retreated to his own small shop to work on a related idea, a small clock with wooden works. He developed the simple rectangular shelf clock between 1814 and 1816 and patented it in 1816 (fig. 4.11). He then served as his own entrepreneur, contracting with Seth Thomas to make the cases, install Terry's works, and sell the finished product. By 1818 he had developed a more stylish case, the pillar scroll top, which resembled the hood of a tall case clock set upon scaled-down bracket feet. Such packaging made the shelf clock more closely approximate the look of a more traditional and expensive tall case clock (fig. 4.12). Such clocks sold wholesale for $9 and retail for $15. The 1820 manufacturing census listed the major clockmakers in southern Litchfield, revealing the significant

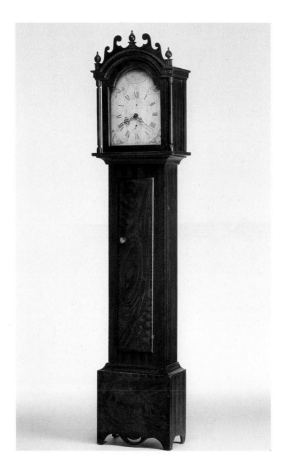

FIG. 4.7 Eli Terry, tall case clock, Plymouth, Connecticut, 1807–9. White pine, cherry, oak, and paper. Courtesy Old Sturbridge Village, 57.1.221.

FIG. 4.8 Eli Terry, wooden works of tall case clock in figure 4.7, Plymouth, Connecticut, 1807–9. Cherry, oak, and paper. Courtesy Old Sturbridge Village, 57.1.221.

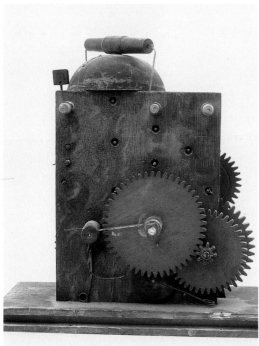

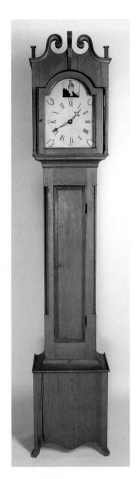 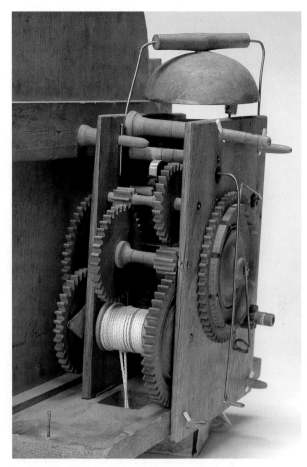

FIG. 4.9 William Leavenworth, tall case clock, Waterbury, Connecticut, 1806–15. Cherry, oak, and paper. Collection of the Mattatuck Museum, Waterbury, Connecticut.

FIG. 4.10 William Leavenworth, wooden works of tall case clock in figure 4.9, Waterbury, Connecticut, 1806–15. Cherry, oak, and paper. Collection of the Mattatuck Museum, Waterbury, Connecticut.

number of clocks being made (8,450 in Plymouth and Litchfield alone) and the mix of wooden tall case mechanisms and shelf clocks. Silas Hoadley was making fifteen hundred wooden mechanisms for tall case clocks per year ($4.50 each), Seth Thomas was producing about four thousand tall case works ($4.50 each) and five hundred "Terry patent clocks" with wood and brass elements ($14 each), Eli Terry was making eleven hundred shelf clocks ($14), and Asa Hopkins of Litchfield was manufacturing five thousand tall case works ($5). All of these operations employed men to fabricate the parts and women to paint the dials or glass doors; Hopkins's operation appears to have been the most mechanized, as it had the fewest number of male workers (six

FIG. 4.11 Seth Thomas, box clock, Plymouth, Connecticut, 1816–18. Cherry, oak, and brass. Courtesy Old Sturbridge Village, 57.1.116.

as compared to ten for Terry and Hoadley and thirty for Thomas). Heman Clark specialized in brass works for shelf clocks ($30 each) but used only male workers and sold his works to others who made cases.[13]

Terry and the other clockmakers in the Plymouth/Waterbury region had a profound effect upon both the production and the consumption of clocks. Linking local capital and initiative with a skilled labor pool, ample supplies of cherry and water power, the division of production, and a peddling system, they stimulated both local and extralocal demand for clocks. It was not a shop-based mode of production but rather a regional one that drew on extensive webs of craftsmen.[14]

CONSUMPTION

When Samuel Beers Jr. died in 1820 in Newtown, he was among Fairfield County's richest inhabitants. He had a prosperous farm, a six-acre homestead, more than 160 additional acres of land, a dwelling house valued at $550, and a substantial interest in textile manufactory. He ate off japanned ware, kept silverware, and had a small collection of practical and religious books, a valuable looking glass, a mahogany table,

FIG. 4.12 Mark Leavenworth, pillar and scroll shelf clock, Waterbury, Connecticut, 1818–25. Cherry, oak, and steel. Collection of the Mattatuck Museum, Waterbury, Connecticut.

and—perhaps his most valuable household possession—a clock and case, appraised at $6. The death the next year of Beers's neighbor, Benjamin Hawley, brought his estate into probate court as well. Hawley was also a farmer and had also amassed a fair amount of land, but much of his personal estate had probably already passed to his children and grandchildren. He still had his farm animals, but there was no other indication that he still worked the land. All he had in the way of household possessions were his bed linens, some old pewter, his clothing, a kitchen table worth twelve cents, and a brass-wheeled clock valued at $3. For both men, ownership of a clock mattered; it marked their status and, strikingly, in a way that mere wealth did not, as Beers was far wealthier than Hawley. But Hawley's possession of a clock also suggests how the ownership of such a timepiece had become far more general by the 1820s than it had been in the late colonial era.[15]

For a long view of clock ownership, we must use the probate inventories. They tell us that very few, some 2 percent, of the inventoried population of Fairfield County died with clocks in their possession in the late colonial period. Even among the wealthiest inhabitants, clock ownership was unusual, and clocks were clearly a unique marker of status and wealth (comparable to watches and riding coaches).

TABLE 4.2 Ownership of clocks, organized by inventoried decedents' wealth categories, in percentages, for Fairfield County, Connecticut, 1760s–1820s

	Poor	Middling	Wealthy	Average
1760s	0	4	7	2
1790s	1	5	45	7
1820s	7	38	83	33
Average	3	18	56	16

Source: Connecticut Probate Records, Connecticut State Library, Hartford. Probate records were used from Danbury, Fairfield, Newtown, Stamford, and Stratford probate districts. A total of 621 inventories were analyzed: 163 from the 1760s, 210 from the 1790s, and 248 from the late 1810s and early 1820s. Column and row averages were calculated by multiplying each percentage in the column or row by the number of inventories in a particular category, adding the results, and dividing by the total number of inventories in that column or row.

After the Revolution, clock ownership became much more common among the wealthy (almost half of wealthy decedents owned a clock), but ownership remained extremely limited among middling and poorer folk. By 1820 this situation had changed significantly. Now, virtually everyone of wealth owned a clock (or if they did not, a watch), but ownership had spread to the middling sort as well. Moreover, people were now far more likely to own clocks than watches, so that a watch still remained something of a "gentleman's possession," while clocks had found their way into the homes of far more people than ever before. The figures suggest that, although Fairfield's economy did not rebound quickly after the incursions the region suffered during the Revolution, by the early nineteenth century a modest consumer revolution was under way, at least when it came to clocks. Even some of the poorer residents of the county now owned what in earlier years had been a hallmark of gentility (see table 4.2).[16]

We can further trace the changes in clock ownership in the post-1790 era by looking at summary statistics by county from the Connecticut grand lists for 1796–1818. The ownership of clocks has been charted for 1796, 1808, 1815, and 1817, and statistics have been compared for Fairfield and Litchfield Counties. Fairfield's location between Litchfield, the new center of clock production in southern New England, and New York City, a supplier of high-end imports from Great Britain and continental Europe, meant that as production accelerated and distribution improved, the results would ripple through the county's consumer economy.

The data demonstrate that between 1796 and 1815, clock ownership increased dramatically in both Litchfield and Fairfield, and, not surprisingly, that Litchfield led the way. Between 1796 and 1808, ownership increased approximately fourfold in Fairfield but sevenfold in Litchfield, and then approximately doubled in both counties by 1815. In both counties it was the availability of less expensive wooden-wheeled

TABLE 4.3 Clock ownership in Fairfield and Litchfield Counties, Connecticut, 1796–1817

	Number of clocks	Ratio of clocks (× 100) to polls	Ratio of wooden clocks to brass clocks
Fairfield County			
1796	205	3.8	0.12
1808	794	16.9	0.52
1815	1,519	33.9	2.11
1817	1,755	34.4	2.48
Litchfield County			
1796	263	4.6	1.44
1808	1,166	27.8	4.45
1815	2,099	50.8	12.99
1817	2,293	56.1	14.40

Source: Connecticut grand lists, 1797–1825 (but including data for 1796; the list for any given year records tax data for the previous year), Connecticut State Library, Hartford. After 1817, clocks and watches were still taxed as luxury goods, but they were lumped together and designated only by their value.

tall case clocks that fueled the expansion. The figures suggest, without proving, that wooden-wheeled clockworks manufactured in Litchfield were being used in other counties, including Fairfield, to increase cabinetmakers' production of finished clocks for local consumption (table 4.3).

The transformation of clocks from precious luxuries of the genteel into every-day household possessions of the middling sort did not occur evenly across Fairfield County (table 4.4). While clock ownership became more common in virtually every township in the first decade of the nineteenth century, ownership spread most broadly in Fairfield, Newtown, Redding, and Trumbull, and in the latter three towns, the introduction of less expensive wooden-wheeled clocks explains most of the change. Particularly striking is the situation in Newtown, long an important woodworking center and the home of the brass-works clockmaker Ziba Blakslee. In 1808, the township had the second-highest number of clocks in the county and the third-highest ratio of clocks to taxable polls. It also outranked eleven of the other sixteen townships in the ratio of wooden- to brass-wheeled clocks. By contrast, in Fairfield, the wealthiest and most populous township in the county, while clock ownership was not as common as in Newtown, most people who owned clocks owned the traditional and more expensive brass-wheeled clocks. Most of these were presumably made by local makers such as Bulkley.[17]

TABLE 4.4 Clock ownership in Fairfield County, Connecticut, 1808

Town	Number of clocks	Ratio of clocks (× 100) to polls	Ratio of wooden clocks to brass clocks
Brookfield	36	28.5	0.38
Danbury	75	17.9	0.27
Fairfield	106	19.9	0.20
Greenwich	65	15.5	0.48
Huntington	36	13.4	2.6
New Canaan	24	14.5	0.09
New Fairfield	20	22.2	3.0
Newtown	89	25.3	0.78
Norwalk	55	18.3	0.25
Redding	42	19.8	0.91
Ridgefield	39	15.5	1.05
Sherman	13	14.2	0.63
Stamford	59	10.6	0.02
Stratford	52	17.4	0.37
Trumbull	44	36.7	10
Weston	20	6.3	0.43
Wilton	19	9.7	0.46

Source: Connecticut grand lists, 1797–1825, Connecticut State Library, Hartford. The number of polls ages 21–70 has been used as a proxy for population.

The sale of cheaper wooden-wheeled clocks undercut the role that their brass-wheeled counterparts had played as markers of status, but without eliminating that role entirely. The "democratization" of timekeeping was an incomplete revolution. For one thing, watches continued to be far more often the possession of the richest inhabitants (see the statistics for Newtown in 1808 in table 4.5), while clock ownership, which spread throughout the middling ranks, did so mostly through purchases of wooden-wheeled clocks. The distinction, of course, between a wooden-wheeled and a brass-wheeled tall case clock was more price than appearance. For those who saw and used the clocks, the more important distinction was between tall case clocks and the newly introduced shelf clocks. Finally, the very few people who owned both clocks and watches were disproportionately to be found among the wealthy.

By the early 1820s, inhabitants of Fairfield County had experienced a dramatic change in the ownership of clocks. Recent interpretations of clocks and clock making in the early national period have tended either to focus upon the horological revolution brought about by the shelf clock or to follow the disciplinary model of E. P.

TABLE 4.5 Ownership of clocks and watches in Newtown, Fairfield County, Connecticut, 1808

Taxable wealth (in dollars)	Number (percentage) in category	Percentage with watches	Percentage with clocks	Percentage of clock owners with wooden clocks	Number with both clocks and watches
0–49	106 (19.4)	6	2	50	-
50–99	169 (31.1)	5	9	50	-
100–149	91 (16.7)	14	13	58	2
150–199	84 (15.4)	15	26	45	3
200–249	46 (8.5)	13	39	56	2
250–299	29 (5.3)	17	45	23	4
300 and above	19 (3.5)	32	32	33	3
Total	544 (99.9)				14
Average		11	16	46	

Source: Newtown grand list, 1808, Newtown Town Hall, Connecticut.
Note: 58 of the 544 taxpayers owned watches, 89 owned clocks, and 14 owned both clocks and watches or more than one watch. Overall, 24 percent owned either a clock or a watch (that is, [89 + 58 − 14] ÷ 544 × 100).

Thompson, who emphasized the effect of merchant and industrial capitalism. For the new professional classes, timekeeping was more important than agricultural rhythms, and the purchase of a clock was essential. Their purchases set off a wave of emulation that was only satisfied by the production of shelf clocks that were aggressively distributed by entrepreneurial peddlers.[18]

However, such an explanation does not seem to hold in southwestern Connecticut, a region where shifts in clock consumption predated the development of shelf clocks in the late 1810s and where industrialized production did not really take hold until the 1840s. Rather, it is important to recognize that notions of "clock time" were evident even in the seventeenth century, and that "communities of practice" grew over the course of the eighteenth century. Various notions of timekeeping coexisted, and even people who lacked their own clock still organized their activities by hours of the day or thought in terms of hours. Such a different way of thinking of time within social networks and situational meanings allows one to conceive of a growing demand for clocks for any number of reasons, from marking personal or religious time, to a fascination with scientific instruments, to appreciating and desiring a case clock as a sensory or aesthetic object.[19] In southern Fairfield County, metal clocks may have remained prevalent owing to strong apprenticeship patterns and traditional notions of consumption. The sheer expense of a clock may have been offset by its advantages as a locally produced object that was distributed through local networks of exchange. In northern Fairfield County, innovative technologies unleashed a demand that had been held in check in that region by the cost of brass-wheeled clocks.

The shift in clock consumption in southwestern Connecticut can also be understood in the language of basic economics. In the 1760s, metal clocks were dominant while wooden clocks were relegated to a minor role. Over time, however, and as the manufacture of wooden clocks improved, particularly in southern Litchfield County, this dynamic evolved in accordance with the economic concept of "the substitution effect." This effect holds that with changes in price, quantity, or quality of a good, individuals will shift their consumption toward the newly favorable good and away from the other, older good. Litchfield County and northern Fairfield County demonstrate this concept: the cheaper and more readily available wooden clocks caused an increase in their consumption and prevented any real increase in the purchase of clocks with brass works. Yet the wooden clock was not a "perfect" substitute—a good that is identical to another except in price and/or quantity—as demonstrated by the failure of wooden clocks to catch on in southern Fairfield County. There, the barrier to entry for makers of wooden clocks posed by the established tradition of metal clockmakers prevented wooden manufacture from ever becoming fully established, and thus the availability and relative price of wooden clocks were too low and high, respectively, for them to become the popular good they were in Litchfield.

In southwestern Connecticut, the community of practice was inextricably connected to the community of production and contributed to a specific geography of clock time. The catalyst for the initial changes was an artisanal one, as the recollections of Chauncey Jerome reveal. He remembered an 1805 conversation about Eli Terry in which two older men talked about Terry's foolishness in undertaking to make two hundred tall case clocks with wooden works: "One said he would never live long enough to finish them; another remarked that if he did he never would, nor could possibly sell so many, and ridiculed the idea."[20] Craftsmen who used and intensified familiar woodworking techniques produced traditional-looking clocks that satisfied a broad-based demand. As Timothy Dwight remarked in 1798, these clocks, "being sold at a very moderate price, are spread over a prodigious extent of the country, to the great convenience of a vast number of people who otherwise have no means of regulating correctly their various business."[21] Dwight fully understood that clocks with wooden works were sufficiently regular and durable that they satisfied a deep-seated demand for the various notions of clock time prevalent in the late eighteenth and early nineteenth centuries.

NOTES

For their assistance in developing the ideas in this essay, the authors would like to thank Charles Hummel, Giorgio Riello, Benjamin Cooke, Albert LeCoff, John Edwards, David Lindow, Jon Sauer, and Gorst duPlessis. For gathering images, we would like to acknowledge the help of Rich Malley of the Connecticut Historical Society, Jeannette Robichaud of Old Sturbridge Village,

Susan Newton of the Winterthur Museum, Suzie Fateh and Ann Smith of the Mattatuck Museum, Adrienne Saint-Pierre of the Fairfield Museum and History Center, and Diana DeLucca of the National Association of Watch and Clock Collectors.

1. For our earlier work on the material culture of Fairfield County, see Paul G. E. Clemens, "The Consumer Culture of the Middle Atlantic, 1760–1820," *William and Mary Quarterly*, 3rd ser., 62 (October 2005): 577–624 (on clocks, 593–97); and Edward S. Cooke Jr., *Making Furniture in Preindustrial America: The Social Economy of Newtown and Woodbury, Connecticut* (Baltimore: Johns Hopkins University Press, 1996), 88, 105. On the increasing number of clocks and timepieces throughout Connecticut, see Lee Soltow, "Watches and Clocks in Connecticut, 1800: A Symbol of Socioeconomic Status," *Connecticut Historical Society Bulletin* 45, no. 4 (1980): 115–22. While Soltow assumes that clocks were luxury goods purchased by the wealthy citizens of Connecticut, Charles Hummel has found that wealth did not necessarily predict clock ownership in East Hampton, Long Island. See Hummel, "The Dominys of East Hampton, Long Island, and Their Furniture," in *Country Cabinetwork and Simple City Furniture*, edited by John D. Morse (Charlottesville: University Press of Virginia, 1970), esp. 41, 66, and 102–6.

2. On the craft topography of Connecticut at this time, see Edward S. Cooke Jr., "The Embedded Nature of Artisanal Activity in Connecticut, ca. 1800," in *Voices of the New Republic: Connecticut Towns, 1800–1832*, vol. 2, *What We Think*, edited by Howard Lamar (New Haven: Connecticut Academy of Arts and Sciences, 2003), 141–48.

3. A good overview of the craft is Philip Zea and Robert Cheney, *Clock Making in New England, 1725–1825* (Sturbridge, Mass.: Old Sturbridge Village, 1992), esp. 11–28.

4. On Whitear and the Fairfield school, see Winthrop Warren and Christopher Nevins, *Clocks and Clockmakers of Colonial Fairfield, 1736–1813* (Fairfield, Conn.: Fairfield Historical Society, 1993). On the importance of a clockmaker's possession of an engine, see Charles Hummel, *With Hammer in Hand* (Charlottesville: University Press of Virginia, 1968), 169–70. John Whitear Jr.'s engine was valued at £7 in 1773. It was by far the most expensive tool in his shop, with a higher value even than a high chest of drawers in a bedchamber (appraised at £5). This engine, along with many of his lathe parts, files, pinchers, and die cutters, was probably imported from Lancashire, England, the center for the production of clock-making tools in the second half of the eighteenth century. Alan Smith, ed., *A Catalogue of Tools for Watch and Clock Makers by John Wycke of Liverpool* (Charlottesville: University Press of Virginia, 1978).

5. On Blakslee, see Penrose Hoopes, *Connecticut Clockmakers of the Eighteenth Century* (1930; reprint, New York: Dover Publications, 1974), 37, 53. On Benjamin, see Warren and Nevins, *Clocks and Clockmakers*, 691–93; and on Chappel, see David Thomas and MaryLou Thomas, "A Tall Clock by William Chappel, Cabinetmaker of Danbury," *Connecticut Historical Society Bulletin* 31, no. 2 (1966): 55–57. Hoopes also lists several other clockmakers in Fairfield County, including Joseph Clark (a New York–trained craftsmen working in Danbury from 1777 to 1811), Comfort Starr Mygatt (working in Danbury 1783–1807), Isaac Reed (who worked in Stamford 1763–90), Nathaniel Wade (a Norwich craftsman who worked in Stratford 1793–1821), Noble Spencer (a London-trained craftsman who worked in Stratford beginning in 1797), Wooster Harrison (trained in Litchfield or Waterbury but working in Trumbull from 1795 on), and Jared Brace of Newtown.

6. The data on Newtown are drawn from Cooke, *Making Furniture in Preindustrial America*, 78–79, and on Fairfield from Warren and Nevins, *Clocks and Clockmakers*, 694–95.

7. Dwight quoted in Paul Hensley, "Time, Work, and Social Context in New England," *New England Quarterly* 65, no. 4 (1992): 549. Zea and Cheney point out that wooden works were not durable in the long run, but in the early national period they were deemed acceptable.

8. These prices are derived from Henry Terry's 1853 recollections as published in the *Waterbury Republican*, reproduced in Kenneth Roberts, *Eli Terry and the Connecticut Shelf Clock* (Bristol, Conn.: Ken Roberts Publishing, 1973), 35–38. See also Hoopes, *Connecticut Clockmakers*, 88, though he mistakenly identifies James Harrison's clocks as examples with brass works. See also Zea and Cheney, *Clock Making in New England*, 23–25.

9. On Terry's early career, see Roberts, *Eli Terry*, 9–23, 35–36; Zea and Cheney, *Clock Making in New England*, 121. A valuable source on Burnap is Penrose Hoopes, *The Shop Records of Daniel Burnap, Clockmaker* (Hartford: Connecticut Historical Society, 1958). On Burnap and Cheney, see William Hosley and Gerald Ward, eds., *The Great River: Art and Society of the Connecticut Valley, 1635–1820* (Hartford: Wadsworth Atheneum, 1985), 342–43, 356–62. For the smaller gears, Terry appears to have turned a cylinder, hobbed the teeth lengthwise along the cylinder, and then cut off the discs. For larger wheels, where shrinkage posed a

122

greater problem, Terry cut individual discs from the plank or tangential face of the log to minimize shrinkage, stacked them up, and then hobbed them on a lathe bed. Hobbing with a milling machine had been pioneered by Eli Whitney in producing interchangeable parts for guns. Cherry, abundant in the region at that time, was the preferred wood for gears since it was hard, tight-grained, and uniform in structure. Our thanks to John Edwards and David Lindow for sharing their knowledge of the production of wooden gears.

10. Terry's use of water power for something other than up-and-down saws was unusually early in western Connecticut. See Cooke, *Making Furniture in Preindustrial America*, 29–30.

11. Soltow reported that Connecticut citizens owned 1,606 brass or steel clocks and 1,694 wooden clocks in 1802, and 2,159 and 2,630, respectively, in 1806.

12. On the Porter contract and its influence, see Roberts, *Eli Terry*, 27–36; Zea and Cheney, *Clock Making in New England*, 121–27; Chauncey Jerome, *History of the American Clock Business* (New Haven: F. C. Dayton, 1860), 35–39; and David Skokol, "Marketing Time Measurement and Visual Culture in the Era of Eli Terry" (seminar paper, Yale University, 2001). The 1796 Carl Ernst Bohn map of Connecticut includes the standard list of mills, furnaces, and distilleries, but the 1811 Moses Warren and George Gillette map adds cloth manufactories, metal manufactories, and clock manufactories, underscoring the importance of these new enterprises.

13. Roberts, *Eli Terry*, 41–89; Zea and Cheney, *Clock Making in New England*, 119–30; Jerome, *American Clock Business*, 39–40; records of the 1820 "Census of Manufactures: Schedules for Connecticut," National Archives Microfilm Publications, no. 279, roll 4, 422.

14. On the regional basis of protoindustrialization, see Charles Sabel and Jonathan Zeitlin, "Historical Alternatives to Mass Production," *Past and Present* 108 (August 1985): 133–76; and Jean Quataert, "A New View of Industrialization: 'Protoindustry' or the Role of Small-Scale Labor-Intensive Manufacture in the Capitalist Environment," *International Labor and Working-Class History* 33 (Spring 1988): 3–22. For more on the furniture makers of southwestern Connecticut, see Cooke, *Making Furniture in Preindustrial America*, 190–99.

15. Samuel Beers Jr. inventory, Newtown Probate Records, 1:37 (March 9, 1821); Benjamin Hawley inventory, Newtown Probate Records, 1:41 (March 15, 1821), microfilm copies of originals in the Connecticut State Library, Hartford. The date of Beers's inventory is not given; the March 1821 date, when it was entered in the probate records, suggests that Beers died in 1820. More than half the Newtown probate records from this period were recorded in the Danbury probate district.

16. Only 2 percent of the 163 inventoried decedents from the 1760s and early 1770s examined in this study included watches—the same figure as for clocks. Only one person owned both a watch and a clock. In the years around 1820, almost 90 percent of those with wealth, and 45 percent of those in the middling ranks of society, had either a clock or a watch. Overall, 2 percent of the decedents had watches in the 1760s, 9 percent in the 1790s, and 12 percent around 1820.

17. This paragraph is based on the summary statistics for Fairfield County in 1808 in the Connecticut grand lists.

18. See E. P. Thompson, "Time, Work-Discipline, and Industrial Capitalism," *Past and Present* 38 (1967): 56–97. For an American application of this model, see David Jaffe, *A New Nation of Goods: The Material Culture of Early America* (Philadelphia: University of Pennsylvania Press, 2010).

19. On different ways of thinking about clocks, particularly the notions of "clock time" and "communities of practice," see two essays by Paul Glennie and Nigel Thrift: "The Spaces of Clock Time," in *The Social in Question: New Bearings in History and the Social Sciences*, edited by Patrick Joyce (London: Routledge, 2002), 151–74; and "Revolutions in the Times: Clocks and the Temporal Structures of Everyday Life," in *Geography and Revolution*, edited by David Livingstone and Charles W. J. Withers (Chicago: University of Chicago Press, 2005), 160–98. For American notions of clock time, see Hensley, "Time, Work, and Social Context."

20. Jerome, *American Clock Business*, 17.

21. Dwight quoted in Hensley, "Time, Work, and Social Context," 549.

PART III

Spaces of Power

HOUSES AND OBJECTS

Face, Place, and Power

JAMES LOGAN, STENTON, AND THE
ANGLO-AMERICAN GENTLEMAN'S HOUSE

STEPHEN G. HAGUE

IN 1714, JAMES LOGAN of Pennsylvania wrote, "I am about purchasing a planta-
tion to retire to for I am heartily out of love with the world."[1] This sentiment suggests
that Logan, the secretary to William Penn and one of the most influential people in
the colony, hoped to take a natural course open to him as a member of the wealthy
elite in purchasing a plantation, building a country house, and retiring to a life of
gentlemanly scholarship. In the first half of the eighteenth century, people in Britain
and North America like Logan grappled with rising status, accumulated wealth,
increased power, and what to do with the resulting material outcomes. The brick,
hipped-roof, two-and-a-half-story, small classical house he constructed between 1723
and 1730 outside Philadelphia, called Stenton, is a superb artifact of a genteel culture
that existed on both sides of the Atlantic. The material culture of the colonial gentry
clearly expressed their position in society, yet their objects—houses, furnishings, land-
scapes—are often seen as unexceptional, even quaint, remnants. Of course, we know
that rich people build big houses; naturally, they collect tables and chairs and dishes
and precious metals. Like any historical evidence, however, these objects are all subtle
and complex signifiers of the world in which they were created and put to use.

The elite material culture of colonial North America symbolically and physi-
cally expressed power and identity. During the eighteenth century, this expression
increasingly resembled forms found in England, creating a genteel material culture
that spanned the Atlantic world. Identity theory holds that people are culturally

FIG. 5.1 Portrait of James Logan (1674–1751), nineteenth-century copy from an engraving, 30 × 26 in. Courtesy of The National Society of The Colonial Dames of America in the Commonwealth of Pennsylvania at Stenton, Philadelphia, gift of Logan Fox, 1965, 69.011.

structured. The interplay of a variety of forces generates our identity and worldview, which encourage us to interpret experiences on the basis of our relationship to specific situations, not exclusively economic stimuli. Seventeenth- and eighteenth-century people thought about their society in terms of "orders," a way of thinking about status that transcended the socioeconomic. For members of the gentry in Britain and colonial North America, objects like houses and furnishings helped significantly to construct personal identity, and to demonstrate it across time and space.

James Logan, colonial grandee of Pennsylvania, was one imperious local face of this Anglo-American genteel culture (fig. 5.1), and Stenton was the place where he most overtly displayed his status (fig. 5.2). Now a publicly accessible historic house museum, Stenton allows us to mine the material culture of early colonial America for its social, political, economic, and cultural meaning. In order to do this, this chapter first defines the gentleman's house, identifies examples of it in Britain and North America, and explores its architectural and cultural language. It then examines Stenton as a representative gentleman's house unique in the depth and authenticity of its documentary and material culture evidence. James Logan and Stenton offer a clear and compelling example of the close Atlantic world connections in the architecture and furnishings of eighteenth-century houses of the gentry and the complex process of Anglo-American identity formation for the genteel between 1680 and 1760.

Material culture studies have much to say about these gentry houses and their contexts and contents. Historians and material culture scholars have continued to examine

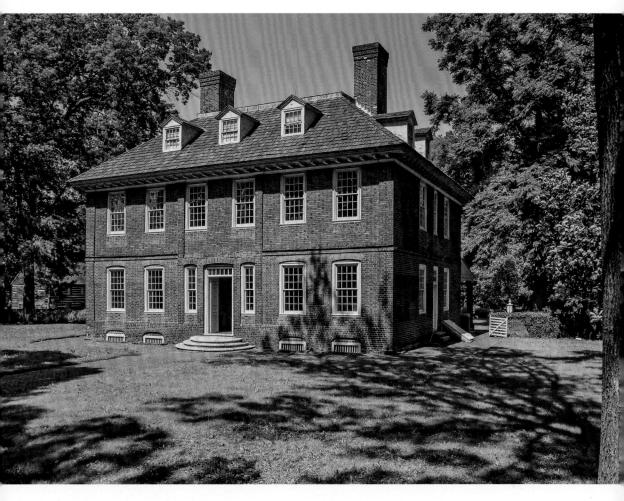

FIG. 5.2 Stenton, built for James Logan, 1723–30, Philadelphia, Pennsylvania. Courtesy of The National Society of The Colonial Dames of America in the Commonwealth of Pennsylvania at Stenton, Philadelphia. Photo: Jim Garrison.

elites in British North America.[2] People in the colonial world had much of their mindset shaped by being members of colonial societies that were part of a larger imperial endeavor. Historian Huw Bowen has commented that the British Empire "provided colonists, especially colonial elites, with a sense of belonging, identity and order."[3] In evaluating elite culture on the American side of the Atlantic, there is sometimes a lack of clarity about the interplay between material culture and social status, reflecting in many respects the contested, uncertain status of colonial elites.[4] This lack of clarity is quite natural given the ambiguity of these groups, but it strongly suggests the need for further definition and evaluation of how material culture served as one

specific form of elite cultural transmission. Lawrence and Jeanne Stone have argued that access to elite status in Britain was narrowly restricted, and that most men of business and commerce in London and provincial England thus made no effort to join the landed elite by acquiring an estate and country house. Their analysis, however, consciously ignores the lesser gentry and the many smaller country houses that were the settings for movement between urban merchants, professional men, and landed elites. Although this was an intentional omission, for some historians it undermined the Stones's basic argument and conclusions.[5]

The confusion about social status and material culture in the eighteenth century, and recent scholarship on elites, makes it both useful and timely to examine the gentry and their material culture in the Atlantic world. In 1696, Gregory King identified fifteen thousand families in England with incomes of less than £500 per year who were the lesser members of the ruling elite.[6] The characteristic that distinguished the gentry from smaller landowners and farmers was unearned income from rents, mortgages, or investments, supplemented perhaps by the profits of office or profession. This income enabled them to live the comfortable and more leisured life of a gentleman.[7] In turn, mercantile elites often entered the ranks of the gentry, or held gentry status. Although King's analysis remains controversial, his statistics still form the basis for assessing the England that James Logan of Stenton grew up in, and help define who wielded political, social, cultural, and economic power.[8]

A key feature of gentlemanly living was the acquisition of a country house. Mark Girouard has argued that these were "power houses" of the ruling class, acquired as a bid to claim power.[9] But what constitutes a country house in physical terms? The term "country house" typically suggests a house in the country supported by a significant amount of land, usually at least one thousand acres.[10] But not all houses in the Atlantic world built and occupied by genteel families were supported by a landed estate. Genteel houses can perhaps be most usefully defined not by what they were but by what they were used for.

Such a house did not need to be large or situated on a substantial estate. The gentry frequently overlapped with nonlanded levels of society. This social and cultural exchange between wealth based on land and income from trade and commerce was characteristic of genteel families across the Atlantic world.[11] As a result, houses, particularly at this contested level of society, functioned as nuanced statements about position and aspiration. As Rhys Isaac has further suggested, "Those who continuously exercise power must *always* construct 'theaters' for their enactments."[12]

In Britain, the construction of these "theaters" has focused largely on the stately home and larger country houses. Palatial buildings like Blenheim Palace or Chatsworth House are important as a representation of the great elites in Britain, awe-inspiring as works of art and places of power, and can be appreciated on a number of levels. But they are insufficient to understand fully the cultural transmission of the English country house to the shores of colonial British America. By looking closely at the

permeable boundary between the great commercial elite and the lesser landed gentry, we can gain a better understanding of the gentry culture so critical to the Atlantic world, as physically represented by houses, landscapes, and other material possessions. To position Stenton and other North American houses in the context of British cultural transmission between 1680 and 1775, our gaze must be directed not at first-rank aristocratic country houses, or even, for the most part, at the second-rank structures of the greater gentry, but instead at the third rank—those polite houses that can most accurately be called gentlemen's houses.[13]

As a costly, fixed, and visible expression of material culture, architecture enables us to tease out important social and cultural forces, and these smaller but still substantial houses reflect a more appropriate level for comparison between Britain and its American colonies. Many of the houses constructed after 1680 in England and subsequently North America were an outgrowth of the movement toward classical architectural forms during the seventeenth century.[14] During the second quarter of that century, the general architectural form recognizable as a precursor to the gentry houses of eighteenth-century North America began to appear. One of the earliest examples, designed in 1629 by Inigo Jones, is Chevening in Kent, a seven-bay-wide brick house, slightly larger than most American colonial mansions. On a grander scale, Coleshill in Berkshire, built in about 1650, represented a prototype for what was to be the standard house for the greater gentry and lesser aristocracy for the remainder of the seventeenth century. The formula that developed from these architectural initiatives is two and one-half stories high, with a hipped roof, often of brick, with quoins and a wooden modillion cornice, surmounted by dormers and sometimes a cupola, with a double-pile (or two-rooms-deep) floor plan. Coleshill has a horizontal orientation that was later modified in other houses to create more verticality, a design goal achieved by adding a pediment to elevate the status of the house, such as at William Talman's Stansted Park in Sussex, depicted in *Britannia Illustrata* in 1707.

A simplified version of this form, without the pediment and generally only five bays wide, served as an architectural form flexible enough to suit lesser gentry and rising commercial elites in country, suburban, and even urban settings for more than a century.[15] Related to these larger houses but more directly antecedent to gentry houses in America is Maltravers House (1638), which Jones designed for Lord Maltravers as a London house (fig. 5.3). This house introduced all the elements of the style that was to become common in England and America: rectangular form with five bays, two and one-half stories, hipped roof, dormers, and relatively unornamented façade.

Teasing out the differences between lesser gentry houses and those of the mercantile elite can be difficult, and there was much crossover, as seen in a rural retreat near a city like Pendell House, built by Richard Glyd, a London merchant, in 1636 about twenty miles from London. Glyd, the younger son of minor gentry who had been apprenticed to a tallow chandler, began speculating in property in 1617 as an investment, and purchased the Pendell estate in 1633. He remained active in London

FIG. 5.3 Maltravers House, by Inigo Jones, 1638. The Provost and Fellows of Worcester College, Oxford.

political and commercial affairs, however, and Pendell House is typical of the type of new building in and around London seen by the mid-seventeenth century. Certainly, by the 1630s this compact form, later to be replicated so often, was becoming "well established as the appropriate mode for the suburban gentry house." Interestingly, however, Melton Constable Hall, a house of the rectangular, hipped-roof form but on quite a grand scale, was criticized as being unsuitable as the principal seat of a large landed estate. By the late seventeenth century it was clear what sort of status was suggested by the level of architectural design language.[16]

One benchmark for comparing Atlantic world gentry houses is their size. The hearth tax, a crude property tax introduced in 1662, provides a sense of the relative dimensions of the houses associated with the different social categories outlined by Gregory King. For example, the great country house Chatsworth in Derbyshire had seventy-nine hearths, while Roger Pratt's nine-bay Coleshill in Berkshire had fifty-six. Contemporaries considered these very large houses indeed. Houses inhabited by genteel families more typically contained between eight and fifteen hearths. Although most members of the gentry in England continued to occupy older-style houses, there was enough construction of classically inspired country houses, or remodeling of

older houses following the Restoration in 1660, to make the hearth tax a worthwhile indicator of the size of houses and the status attached to them. Stenton, with twelve hearths, would have qualified as a fairly typical gentry house on either side of the Atlantic.[17]

Although some historians have argued that English and colonial houses differed in scale, claims about relative size and construction warrant some qualification.[18] Among the colonial elite, the Maltravers-style house remained standard until the 1750s, and this small, compact house set a standard for numerous small classical houses across the Atlantic world.[19] The dimensions and scale of English and American houses were not substantially different.[20] As an expression of status, elites throughout the American colonies began building houses inspired by "small, vernacular brick houses built in provincial England in the late 1600s and early 1700s."[21] Even these modest houses nevertheless represented a type befitting both the lesser landed gentry and wealthy men of commerce and the professions. Such houses demonstrated localized building characteristics, at the same time that most expressed a level of architectural sophistication that readily communicated their owners' efforts to construct social status in accord with the skills and capabilities of their master builders. Building materials offered a local inflection that differentiated structures across the Atlantic world. Brick was commonly used on both sides of the Atlantic, but many brick houses also used stone, while wood-frame American examples can be found that used paint, scoring, and sand to replicate dressed stone.[22]

Throughout England, classical houses comparable in size to colonial gentry houses used a range of building materials and exhibited vernacular design vocabulary. Owletts (1684) in Cobham, Kent, is one small early example, while the Rectory at Stanton Harcourt (1669), not far from Oxford, and Poulton Manor (ca. 1680) in Gloucestershire are slightly larger, on a scale with genteel houses that would be built in North America. A series of sketches of Yorkshire houses made by Samuel Bucks about 1720 illustrate more than twenty examples of the classical form on this scale, such as Bell Hall (1684), making it by far the most popular type of new house in Yorkshire at this time.[23]

In the county of Gloucestershire alone, nearly eighty houses built or extensively remodeled in the century or so after 1660 conform to the classical, double-pile type with dimensions comparable to those found in British North America. Frampton Court (1731–33), the home of the Clifford and Clutterbuck families, has a width of fifty-seven feet for the main block, similar in size and scale to the finest mansions of colonial America (fig. 5.4). With a projecting pedimented frontispiece, ionic pilasters, quoining at the corners, a solid parapet, rusticated window framing, and basement, Frampton Court is stylistically more innovative than similar houses in America. A scaled-down version of some of the larger houses influenced by the work of Sir John Vanbrugh, it also looked toward a more restrained Palladian style. Frampton Court

FIG. 5.4 Frampton Court, built for Richard Clutterbuck, 1731–33, Gloucestershire, England. Photo: author.

is important, however, not only to make the point about architectural similarity or difference, but also to illustrate the social and economic origins that its owners shared with other elites in England and its colonies. Richard Clutterbuck (1703–1775) built Frampton Court at roughly the same time that James Logan constructed Stenton in Pennsylvania. The Clutterbucks were a family of clothiers in Gloucestershire and came into possession of the estate through marriage to a descendant of the original owners, the Cliffords. Richard Clutterbuck's father, William, was a merchant who made money in commerce and government service, inherited estates, and took up residence at a small country seat. William and Richard Clutterbuck prospered as customs officials in nearby Bristol. The last male Clifford died in 1684, and subsequent Clutterbucks maintained an interest in the weaving industry, which helped to infuse the property with enough cash to tear down the old house and build a new one beginning in 1731.[24]

In its architectural scale and in the socioeconomic background of its builder, Frampton Court reflects the contested status of gentlemanly owners in England and North America. In similar houses, genteel families fulfilled an important role in exercising and exhibiting power. It may not have been the national domination of the aristocracy, but the "polite" collaboration between the landed gentry and the

upper elements of bourgeois society formed "the closest thing to a governing class in Georgian England."[25] The gentry, and those rising into it, used their newly erected or modernized houses as the backdrops for their more localized power.

It is in the form, size, and sociocultural background of the inhabitants of such genteel houses that we can most readily see parallels in British North America, at places like Westover Plantation, Stratford Hall, Sabine Hall, and others in Virginia, and in Pennsbury Manor, Fairhill, and James Logan's Stenton in Pennsylvania. Classical, compact, double-pile houses like Stenton served as domestic settings for a large section of the lesser ruling elite in Britain and its colonies. What is more, the periphery of society, in places like the American colonies, offered an ideal environment for establishing a gentry lifestyle. In England, the urban middle classes started to build stylish town houses in provincial cities, while the minor rural gentry remodeled their manor houses or built new ones according to current fashion. Across the Atlantic, gentrified British colonials sought to approximate, if not to reproduce exactly, the social, economic, architectural, and cultural milieu of the small English landed estates, albeit conforming to the specific circumstances in North America. Significant differences existed between the colonies and the metropole: the institution of slavery underpinned some economies and not others, while the role of religion, political culture, and demographic patterns also varied. The patterns of wealth distribution and the social structure in the American colonies—important topics that are more fully explored elsewhere—were, of course, not identical to those found in Britain. For example, whereas the proportions of freeholders and great landed (i.e., tenanted) estates in Britain were 30 percent and 70 percent, respectively, in the American colonies this proportion was reversed.[26] Nevertheless, many similar impulses drove those who came to the colonies, made fortunes, and set about ruling the new land.

Historians, even when emphasizing difference, have tended to treat elites in a monolithic way that supports an argument for Anglicization and the prevalence of enhanced cultural ties and social practices between mother country and colonies. Indeed, there was a "feudal revival" in the middle and southern colonies in the late colonial period; between 1730 and 1745, "the descendants of seventeenth-century proprietors successfully revived long-dormant claims to land and quitrents," one example being the Walking Purchase of 1737, involving the sons of William Penn and their chief agent, James Logan.[27] Cary Carson has highlighted the similarities between the wealthy colonist and the well-off Briton, a process he calls "international gentrification." Studies of consumption, material life, and manners have suggested such a close connection, and yet "international gentry culture has figured curiously little in the long-running historical debates about the influence of America's European antecedents."[28]

This spread of culture beyond Britain points to important ideas about imperial development in the eighteenth century, and to how exactly and in what form cultural transmission took place within the British Empire. Almost as soon as parts of the

landscapes of North America were settled, those with the means to do so began building small polite houses that resembled those found in England. In America a similar pattern developed, where town houses in places like Philadelphia were followed by country houses a few miles outside cities, and mansions on large rural estates built by southern planters and landholders in the middle and northern colonies.[29] There were few mansions in the North American colonies prior to the 1690s, but, especially after 1720, two- and three-story elite houses sprang up along the Eastern Seaboard.[30] These developments were an attempt by North American colonists to transform themselves and their environment in a cultivated and refined way.

It is useful to recall that most dwellings in British North America were small one- or two-room houses, only as large as perhaps one public space in the largest mansions. A survey of Delaware for the period 1760–1830 documents that 67 percent of the houses had fewer than 450 square feet on the first floor. Another 22 percent had between 450 and 600 square feet, while only 11 percent had more than 600, modest, to say the least, when compared with Stenton's 2,040 square feet per floor.[31] Evaluating housing in this way helps reinforce the substantial size of these gentry houses, at least to the mind of the eighteenth-century colonist. They were the crème de la crème of colonial architecture, as impressive in many ways in their own locale as the great country houses of England were in theirs.

Thus when James Logan traded "the town for the country" and went to live at Stenton in 1730, he followed a seemingly natural trajectory as a wealthy, socially prominent, and politically powerful Englishman. Gentility in the form of a country house confirmed status and visibly expressed the social class of those set off by their wealth, authority in government, and learning.[32] How, then, did James Logan and other members of the colonial elite think about their plantation houses and other significant structures? What were they attempting to achieve with their houses and the spaces around and within them? What messages did they wish to convey with their furnishings and possessions? And what activities took place in the houses that further reinforced the statement that one was a member of the international gentry?

Early country houses in America, though few and far between, reflected the English Jacobean style, as typified by Bacon's Castle in Virginia: diamond shaped chimney stacks, curved gables, and a projecting front porch. By the 1680s, the construction of Pennsylvania proprietor William Penn's Pennsbury highlighted the appearance of the classical gentry house in North America. William Penn preferred life in the country and, as a result, he looked to establish a country estate.[33] A survey in 1700 outlined the 8,431 acres of Penn's landholdings, including a fine mansion house. Several plans show sketches of Pennsbury, all of them reflecting—although some are more difficult to make out than others—a symmetrical design.[34]

Because of the checkered history of reconstruction in the 1930s, the physical evidence at Pennsbury needs to be treated gingerly. The exact architectural configuration

is somewhat in question, as documentary evidence may suggest the double-pile plan seen in the reconstruction today, while archaeological work indicated a T-shaped floor plan.[35] This uncertainty notwithstanding, it seems clear that Penn favored the balance and symmetry of the classical architecture increasingly predominant toward the end of the seventeenth century, and the façade almost certainly reflected a brick five-bay arrangement. Penn also intended to create a garden and landscape suited to his status, although the result was, like many other genteel houses, fairly restrained.[36] References from around 1700 speak to its status and elegance; John Oldmixon called it "a very fine seat . . . both in its nature and Situation, as well as its improvement." Oldmixon noted that Lord Cornbury, governor of New York, was "extremely pleas'd with the House, Orchards and Gardens."[37] Particularly intriguing are architectural fragments said to come from the original door surround at Pennsbury. These pieces of carved capital, probably from a column or pilaster, clearly suggest an impressive classical entrance to the house.[38] From about 1700 onward, Pennsbury, and later James Logan's Stenton, hosted large gatherings of Native Americans, complete with exchanges of wampum and other goods, an indication of these houses' role in impressing the native populace and projecting the new power of the English colonial elite.

In Virginia, classical forms became prominent through three public buildings in Williamsburg—the Main Building (renamed the Wren Building in 1931, after Sir Christopher Wren, to whom the design has been attributed) at the College of William and Mary (originally built 1705, burned, reconstructed 1710–16), the State House (1701–1705 but later reconstructed), and the Governor's Palace (1706, but later burned and reconstructed). One especially wonders about the balustrade and cupola on the Governor's Palace, a high-style feature replicated nowhere else in Virginia. This may have been on account of fashion, the cupola being considered too ostentatious for anything more than an official governor's residence.[39] Ironically, in the purportedly staid Quaker Delaware Valley, cupolas or roof lanterns are evident by 1730 on at least three domestic buildings—Fairhill, the Trent House, and Stenton, all homes of members of the ruling elite. It seems therefore that Quaker elites favored an architectural style at least as impressive as the Anglican cavaliers of Virginia did.[40]

The classical five-bay form suited other grand planters and became increasingly standard for country house architecture. Subsequent examples of the brick, hipped-roof design exist at single-pile houses such as Indian Banks and Ampthill. But by 1730, Virginia planters had begun to construct double-pile, hipped-roof brick houses as a matter of course. William Byrd II (1674–1744), who rivaled Philadelphia's James Logan in taste, erudition, and pretension to power and surpassed him in wealth, inherited a total of 26,321 acres in 1704. In 1729 he wrote that in "a year or 2 I intend to set about building a very good house."[41] Clearly, he achieved this with one of the most impressive Virginia plantation houses, Westover, completed by the early 1750s. Another example, Wilton, now moved to Richmond, originally stood in Henrico

135

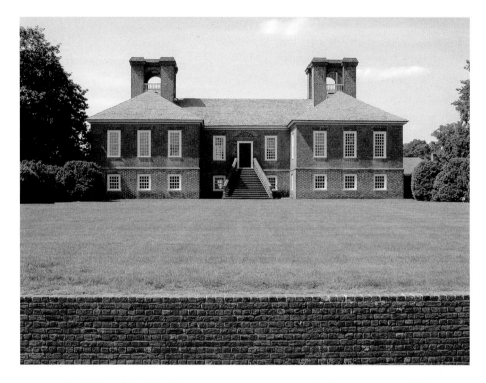

FIG. 5.5 Stratford Hall, built for Thomas Lee, ca. 1738, Westmoreland County, Virginia. Photo: author.

County outside the city. It was the country seat of William Randolph III, another extremely wealthy Virginia planter who had the means and taste to build a large country house on some two thousand acres that he acquired in 1747. Sumptuous interior paneling at Wilton is suggestive of attempts to introduce further elements of show into the American country house as the eighteenth century unfolded. As in England, however, this adaptable architectural style could be used and was considered appropriate for both country and town dwellings. Philip Ludwell III, a member of the Virginia Governor's Council, built the Ludwell House in Williamsburg, which reflected the fashion for hipped-roof brick. He died in 1767, leaving an estate valued at £11,442, making him one of the richest men in Virginia, and one who was pleased to build and own a house in the prevailing gentry style of the day.[42]

Perhaps the most unorthodox example of a colonial gentry house was Thomas Lee's Stratford Hall (fig. 5.5). Lee was a prominent planter and was actively involved in public life as a local magistrate. He served on the Governor's Council from 1732, was its president from 1748, and became acting governor in 1749. As a result, "Stratford was intended to be a grand and impressive dwelling for a man of importance."[43] Its H-plan is unusual for a house built in the late 1730s, and its size and its main floor, towering

over a basement level, are unique. No English model exists—indeed, nothing else like it exists—but it stands as a striking and creative adaptation of the classical country house. In 1744, when Thomas Lee visited Philadelphia, his secretary William Black described James Logan's Stenton as a "beautiful house."[44] His experience of Stratford Hall gave him an eye for fine architecture across colonial borders.

By the second quarter of the eighteenth century, the classical house form had become the choice for some leading members of the gentry in the mid-Atlantic region as well.[45] Significant early buildings in the Delaware Valley include the cupola-surmounted William Trent House (1719). William Trent was a leading figure with widespread commercial connections throughout the Atlantic world. He served in the Pennsylvania Assembly, as a colonel of militia, and as New Jersey's first resident chief justice. As a merchant, shipper, and importer/exporter, he dealt in a range of goods. He shared with many provincial and colonial merchants trading interests that included enslaved Africans and West Indians. His complicity in slavery, while not unusual, helped to provide the means to purchase eight hundred acres of land in New Jersey and construct a large brick dwelling house overlooking the falls of the Delaware River, in modern-day Trenton. In late 1721, the Trent family left Philadelphia to take up permanent residence in their new country house, which confirmed their status among the colonial elite.[46]

One of the earliest country seats in the region for which much evidence survives is Fairhill (1712–17), which belonged to the Norris family, prominent Quakers in Philadelphia. Fairhill was a significant real estate investment of more than eight hundred acres for Isaac Norris Sr. (1671–1735), who was born in Surrey, England, emigrated to Jamaica, and eventually became a wealthy merchant and member of Pennsylvania's ruling elite. Fairhill's H-plan marked it as a somewhat old-fashioned design, but in most ways Fairhill resembled the small gentry houses of England. A sketch of the house dated 1777 provides a view of the sort of country houses being built in the eighteenth century in America, and includes the physical context of the shaped landscape and ancillary buildings, and the setting of the mansion house.[47] Although the pious Norris struggled with his worldly achievements at Fairhill, he was not above some considerable expenditure, especially when it came to the symbolic act of crowning his grand house with a suitable display: "Another thing is a whim, but thou must get it for me. That is a weather-cock for the top of my turret." Not only did Norris have a turret, or cupola—something perhaps thought too grand save for the governor's mansion in Virginia—but he also further ornamented his house with an ostentatious weather vane, clearly visible in the drawing of sixty years later.[48]

In building Stenton in the 1720s, James Logan may have been attempting to rival his friend Norris's Fairhill, completed in 1717.[49] Developing a plantation or estate was a sensible investment strategy, as land had the principal economic advantage of security. Overseas trade or business was always risky, while land offered a less profitable

but more stable investment. It was no surprise that James Logan, following a string of disastrous or nearly disastrous investments in shipping and overseas trade, elected to begin acquiring land in Pennsylvania and engaging in commerce close to home through the Indian trade.[50]

An estate was also a social investment, and Logan's land acquisitions eventually led to the construction of Stenton near Philadelphia. Today, this remarkably preserved structure draws together not only outstanding architecture representative of the Anglo-American gentleman's house but substantial documentation and period collections directly associated with the Logan family as well. This combination provides a unique perspective on architectural style and function, and on the possessions that populated the domestic spaces and how rooms were used and to what end. In few other gentry houses on either side of the Atlantic can we survey a similar range of material remains. Although it is possible to reconstruct evidence for other gentry houses, Stenton serves as a tangible, extant opportunity to evaluate the totality of material life for one of the most influential figures in early colonial America.

James Logan originally came to the American colonies in 1699 as secretary to William Penn. Over the course of his first decade there, he made a prominent place for himself in the affairs of Pennsylvania. Although he had once remarked that he was "firmly resolved never to set up a gentleman," and was prepared to "sit down and be content with ease and happiness instead of show and greatness," as Logan became more prominent and increasingly rich, he began to talk of building a country house, or plantation, as he often called it.[51] Through savvy investments, Logan acquired a considerable fortune, and soon set about putting his riches to work. Soon after his "never set up a gentleman" remark, he wrote about "purchasing a plantation to retire to." He began to purchase land in 1714, and over the next fifteen years or so, as he remained active in colonial administration and trade, he began to plot the construction of his house.[52]

By November 1727, after long years in colonial government and as work continued on Stenton, Logan decided to "change the town for the country." An obituary of Logan, probably written by Benjamin Franklin, referred to Stenton as "a country seat," an important conceptual point that reinforces Logan's successful establishment of an appropriate country house and estate.[53] This act physically and symbolically set Logan apart from other people, confirming in a literal way that he held a special place in colonial Pennsylvania. There were five hundred acres in the immediately contiguous estate at Stenton, but landholdings that totaled about eighteen thousand acres in Pennsylvania and New Jersey by the time of Logan's death supported his impressive gentry lifestyle.[54] Even the name he chose for his house was from an ancient village in Scotland where his father had been born and connected Logan to gentrified ancestors.

Logan initially talked of building a "plain, cheap stone farmer's house," but he claimed that his "quarries failed him entirely" and he was forced to build in brick.[55] One wonders whether this more elegant building material did not suit Logan better than

stone. Although Logan owned several books on architecture, including Vitruvius's *Ten Books of Architecture* (1649) and *The Theory and Practice of Architecture; or Vitruvius and Vignola Abridged* (1702–3), edited by Claude Perrault and Joseph Moxon, there is no indication that any of them inspired the construction of the house. His books also included Richard Neve's *City and Country Purchaser, and Builder's Dictionary* (1726), acquired by August 1729, probably too late to be of much use in the completion of Stenton.[56]

139

Because of its unadorned façade and simple classical lines, scholars have sometimes described Stenton as a work of Quaker simplicity.[57] Given its relationship to other houses in the cultural milieu of the British Empire, however, it can more usefully be interpreted as an English gentleman's house in North America.[58] It is little surprise that Stenton's construction coincided with the increasing frequency with which Logan appeared in Pennsylvania tax records and deeds, especially after 1727, as "gentleman" or "esquire."[59] This indication of elevated status after setting up his country seat reinforced that Stenton was a conscious expression of Logan's self-image. It was not a city house transplanted, nor was it a plain, unexceptional structure reflecting Quaker ideals; it was another thing altogether, the material representation of Logan's successful rise as a colonial grandee.

The exercise of political authority was inherent in building a country house, and Stenton dramatically reinforced Logan's social and political power. The Whig government during Queen Anne's reign, closely tied to the "moneyed interest," appealed to the young James Logan visiting from North America; the Whig ministers were, Logan said, "the most able ministry that England had ever been blessed with."[60] In Pennsylvania, where there were constant problems between the popularly elected Assembly, the governor, and the Provincial Council, Logan's ideal government balanced three elements: the monarchical (the Penn family as proprietors), the aristocratic (the Provincial Council), and the democratic (the Assembly). As a member of the Provincial Council, Logan played, in his own mind and in the view of many contemporaries, the part of the educated (if irascible) gentleman who tempered the wilder ideas of the popular Assembly.

The design of his country house underpinned Logan's political ideas and important position in colonial affairs. In keeping with the layout of similar double-pile houses, Stenton's floor plan is compact but suggests a clear, hierarchical segregation of space, allowing it to function almost as a public building. This is a role for which Logan may have intended it and that it often filled during his residence, when he held meetings there (figs. 5.6 and 5.7). Two rooms, the stair hall and the parlor, were important components of the grandest colonial architecture and governed social behavior. Stairs particularly "played a part in the ascent from a ground floor to the more formal apartments above," and dictated movement into different regions of the house.[61] Stenton's stair hall is separated from the entry hall by the only set of arched double doors in the

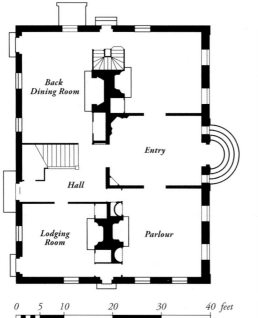

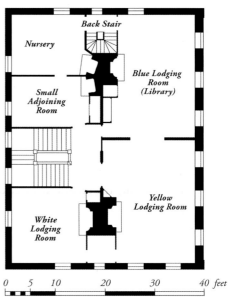

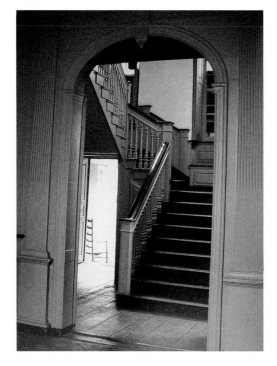

FIG. 5.6 (above left) Stenton, first-floor plan. Drawn by Mary Agnes Leonard.

FIG. 5.7 (above right) Stenton, second-floor plan. Drawn by Mary Agnes Leonard.

FIG. 5.8 Arched passage and double-arched doors leading from the Stenton entry hall into the stair hall. Courtesy of The National Society of The Colonial Dames of America in the Commonwealth of Pennsylvania at Stenton, Philadelphia.

house, indicating the importance attached to moving from entry to stair and on to the rooms above (fig. 5.8). The entry hall, a brick-floored space monitored by a servant, offered access to the house itself, while also serving as the nexus for individuals moving to different rooms for varying purposes. The members of the family or their servants, however, never needed to enter this space, as they could reach all the other rooms in the house through a series of cleverly designed side passages. Thus the hierarchically lower-status entry hall formed an important link between interior and exterior spaces, while specifically and simultaneously designed to impress and to segregate.

An important and greatly understudied aspect of gentry culture has been the furnishing of houses, especially how those furnishings interacted with and reinforced the messages conveyed by the architecture. Upon entering such a house, visitors experienced not only the spaces themselves but also the accumulated possessions of the owner, carefully arranged to communicate coded cultural meanings that allowed viewers to appreciate the intended statement of status. Here again, Stenton has much to say. In Pennsylvania, Logan's country seat was furnished predominantly with English pieces, with some of the finest and most fashionable objects made in Philadelphia, and with a library of staggering size and quality. Ledgers and account books document that Logan had a predilection for English goods, while the surviving material culture is a mix of British and Philadelphia wares. Perhaps most usefully, a 1752 inventory taken after Logan's death records the house's standard of furnishing. Specific objects and room arrangements at Stenton in the second quarter of the eighteenth century further suggest a lifestyle closely in line with that experienced in gentry houses in England and elsewhere in British North America.[62]

Household furnishings reveal a great deal about genteel people. Although not necessarily acquiring the most magnificent, most beautiful, or most costly objects, members of the gentry purchased to the level that they could. Increasingly, these objects were made in North America, but imports from Britain found a market in America until well after the American Revolution.[63] Families like the Logans obtained numerous fine new furnishings while continuing to use older, less stylish objects, often in back rooms. The 1752 Stenton inventory lists such items as "3 old Cane Chairs" and "1 pr of old Walnutt Drawers" in "ye Nursery and Small adjoining Room," a reference to a style of chair that was out-of-date and unfashionable by the 1750s and a chest of drawers made from a wood that had been largely superseded by mahogany for the finest cabinetmaking and joinery in urban centers like Philadelphia.[64]

The furniture, silver, ceramics, and glass in gentry houses largely reflected British tastes, with obvious albeit relatively minor variations over time and according to place. Hence Queen Anne–style chairs made in Philadelphia have their own specific construction details and proportion. These details are critical to the understanding of regional design and consumption; chairs in this style could send complex signals through the wood used in their construction, their level of craftsmanship, and design

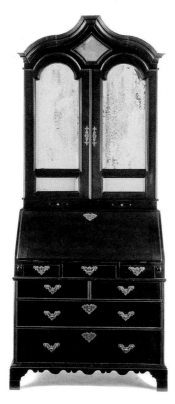

FIG. 5.9 Desk and bookcase, Philadelphia, ca. 1730. Mahogany, cedar, oak, poplar, and exotic wood inlay, 93 × 39 ½ × 22 ¾ in. Probably owned by James Logan. Courtesy of The National Society of The Colonial Dames of America in the Commonwealth of Pennsylvania at Stenton, Philadelphia, 71.7.

FIG. 5.10 Settee, Philadelphia, ca. 1730–40. Walnut and yellow pine, 45 ¾ × 62 × 26 ¼ in. (116.2 × 157.5 × 66.7 cm). From the Logan family and probably at Stenton. The Metropolitan Museum of Art, New York, Rogers Fund, 1925, 25.115.1. Photo: www.metmuseum.org.

features like the type of foot, the presence of any surface decoration such as paint-
ing, carving, or gilding, and the quality of textile used in the upholstery. At the same
time, they reflect an overall sense of the curvilinear and elegant Queen Anne form.
Examining these objects in detail—a task often neglected by traditional historians—
provides yet another complex layer of analysis for these gentry houses.

The parlor at Stenton, which played an important function in genteel houses as
a place of civility, allowed owners like the Logans to set themselves apart from their
social inferiors by the architecture of approach, the architectural finish, and the level
of furnishing. James Logan's 329 ounces of silver, including a fine London-made tea
service, were ceremonially housed in an elaborate shell-work cupboard in the fully pan-
eled parlor, highlighting the importance of precious metals. A desk and bookcase (or
"scrutore," as it is called in the Logan inventory), probably the one in the parlor valued
at £7 in 1752, exhibits distinctive Philadelphia form and craftsmanship (fig. 5.9). Yet,
with its ogee top, mahogany primary wood, mirrored door panels, and sophisticated
interior, the desk/bookcase closely resembles similar objects seen in contemporary
interior domestic scenes of the British gentry. The overall value of the goods in the
Stenton parlor, £185, represented the most expensively equipped space in the house.

The second-floor Yellow Lodging Room, the grandest bedchamber in the house,
functioned in both public and private ways. Approached via the entry hall and the main
staircase, the spatial arrangement restricted access to the Yellow Lodging Room to
select family, friends, and visitors. In the room, people encountered a "Yellow Worsted
Damask Bed with curtain, Window Curtains & bed cloths, &ca." Embedded hooks
in the ceiling suggest that the bed had a suspended tester (or "flying tester"), much
in keeping with significant beds of the early eighteenth century.[65] Certainly, this was
not the finest bed available in the Atlantic world, but valued at £30, it was an impres-
sive object displaying textiles similar to those found in genteel houses in England.[66]
Contemporaries would have recognized it as an elaborate centerpiece consuming yards
of costly and colorful fabric. The Yellow Lodging Room also contained two "Sconce
glasses with Brass Arms," valued at £10, which would have created a dazzling setting
with the yellow wool damask and warm color of the maple furnishings. If this room
also contained a fully upholstered Queen Anne–style settee (fig. 5.10), now in the
Metropolitan Museum of Art, the Yellow Lodging Room at Stenton was a magnifi-
cently furnished room indeed, more than a match for genteel houses in England.[67]

The house also contained a range of upholstered pieces of furniture such as a set
of "10 leather chairs" listed at 8s. apiece in the back dining room, and a £3 fully uphol-
stered easy chair.[68] Logan's 1752 inventory lists a total of seventy-four chairs, ranging
in value from 27s. 6d. in the Yellow Lodging Room—these had worsted damask
seats—to 12s. 6d. for leather-bottomed chairs in the parlor, to "3 old cane chairs" at
3s. in the nursery. Again, the Yellow Lodging Room, its chairs far exceeding the value
of any other chairs in the house, took pride of place. The value of the furnishings in

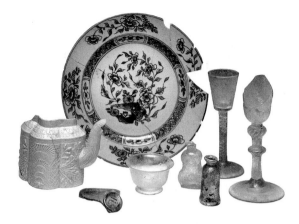

FIG. 5.11 Ceramics and glass from the Stenton archaeological collection, showing the range of goods in a genteel household. Courtesy of The National Society of The Colonial Dames of America in the Commonwealth of Pennsylvania at Stenton, Philadelphia.

the Yellow Lodging Room, £66 2s. 6d., record the second-highest value in 1752, and if we remove the eminently portable commodity of silver from storage in the parlor, the Yellow Lodging Room was the most expensively furnished room at Stenton.[69] It served as a great chamber on the second floor, reached only after traversing several other spaces, and furnished to the highest standard.

The numbers of objects owned is another indicator of sociability and efforts to display status. Stenton contained numerous chairs in various forms, providing ample seating for large numbers of potential visitors, and the range and quality of dishes and serving pieces suggested by the inventory, surviving objects, and archaeological collections indicate a well-equipped genteel household. Archeological investigations at Stenton have yielded an extraordinary cache of material dating from about the time the house was completed until no later than 1760, with examples of the range of ceramics and glass expected of the Atlantic world gentry (fig. 5.11). These objects found in situ at Stenton offer a time capsule of consumption practices throughout the Atlantic world.[70]

Stenton helped James Logan put not only his social and political power on display but his intellectual prowess as well. If we accept the old adage that knowledge is power, then Logan certainly wielded it in considerable measure, and his library formed an important material and symbolic embodiment of that knowledge. For comfort, Logan often retreated to books, saying, "Books are my disease."[71] Benjamin Franklin, a generation younger and a frequent visitor to Stenton, recounted that Logan had "for the most part a life of business, tho' he was passionately fond of study."[72] It was this life of the mind that transfixed Logan in his years at Stenton, as he continued to collect books actively. Although Logan harbored some resentment against the intellectual elites of the Royal Society in London, he nevertheless corresponded regularly with the great minds of Britain and Europe. In doing so, he helped define himself as a member of the educated elite of the British Empire. Logan ordered books in many languages—Greek,

Latin, German, Italian, Spanish, French, Hebrew, and Arabic—and read them all. His later correspondence is filled with orders for books and discussions of the merits of particular editions and the ideas contained therein. He made extensive notes in some volumes that display his wide-ranging knowledge and intellectual sophistication, a form of identity creation that was clear to anyone who visited or corresponded with this leading colonial grandee. In 1708, Logan became the first documented American to acquire Sir Isaac Newton's *Principia Mathematica*, a tremendously influential book that Logan spent long hours studying. Few people understood Newton's ideas, but Logan made lengthy pages of notes about the mathematical equations and arguments formulated by Newton. Notes in another book, Euclid's classic work on geometry, are translations into Latin from Arabic. He also understood several Native American dialects, and made notes on one translation into Algonquin. In 1711, he bought a Bible in Algonquin of which he complained, "not one word agrees with any of our Indian."[73]

Logan wrote works of his own and conducted scientific experiments. He produced an original essay on corn, and, for his friend Isaac Norris of Fairhill, he translated Cicero's essay on old age, *Cato Major*, which Benjamin Franklin printed in 1744. Logan wrote an extensive series of footnotes to this essay, citing all manner of classical works, and even offering amusing translations: "Old Cato would, 'tis said, with wine / Make his reverend face to Shine."[74]

In Gawen Hamilton's circa 1732 painting *Nicol Graham of Gartmore and Two Friends Seated in a Library*, three men sit and discuss books, a scene repeated in genteel houses throughout the American colonies with any pretension to learning (fig. 5.12).[75] James Logan's library at Stenton must have taken up several rooms, including the Yellow and Blue Lodging Rooms on the second floor. Objects are most effective when used to illustrate people and their actions, and one of the most striking pieces at Stenton is an original bookcase, simple and unfinished, designed to fit exactly the size books that Logan possessed. The library was a highlight of any visit to Stenton. When Benjamin Franklin first visited in March 1732, it was to ask Logan—"a Gentleman of universal learning, and the best Judge of Books in these parts," as Franklin called him—about book choices for the new Library Company of Philadelphia.[76] It is interesting to contemplate the scene of a young, clearly impressed Franklin first encountering the tremendous holdings of the Stenton library. William Black, Thomas Lee of Stratford Hall's secretary, also remarked on the library at Stenton that Logan had a custom of showing it to "any persons of account." Black judged the book collection "very fine" and noted that Logan intended it as a legacy to Philadelphia.[77] The Virginia gentleman finally complimented Logan on his "fine taste" and left Stenton, having participated in a genteel ritual that mixed learning and conviviality.

Not only were important visitors to Stenton treated to the de rigueur tour of the library, but Logan also reached out to assert his intellectual power. One letter recounts Logan's displeasure with Josiah Martin, a longtime correspondent and bookseller in

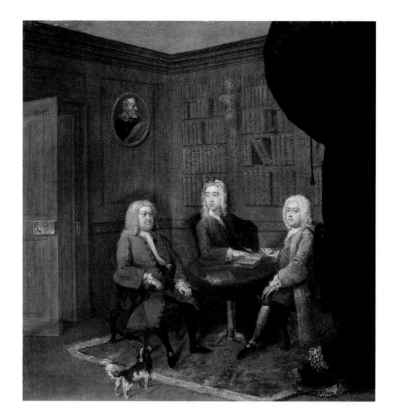

FIG. 5.12 Gawen Hamilton (1697–1737), *Nicol Graham of Gartmore and Two Friends Seated in a Library*, ca. 1732. Oil on canvas, 63.5 × 60.5 cm (framed: 79.10 × 77.80 × 7.20 cm). The National Galleries of Scotland, NG 2464.

London who had considerable influence in intellectual circles there. In August 1745 Logan drafted a letter accusing Martin of being a charlatan: "In two of thy letters [you] wrote such absurdities," he told Martin, and "I plainly discovered thy unacquaintedness with the Greek tongue." Logan proceeded to correct Martin's mistaken translation from the Greek, first translating from Greek to English and then, when he wished to make himself entirely clear, from Greek to Latin. In the end, it seems that the letter was never sent, and Martin died only a few years later. Still, it provides a glimpse of Logan's brilliance, his asperity, and his exacting high standards, as well as the sort of learned authority emanating from this country seat in Pennsylvania.[78]

By the mid-eighteenth century, James Logan owned one of the largest and most scholarly libraries in North America. Ownership of more than twenty-five hundred books valued at £900 Pennsylvania was remarkable for any gentleman. A few others, including William Byrd at Westover and Thomas Lee at Stratford Hall, had libraries similar in size and scope.[79] The sheer volume of books in these gentry houses might

overwhelm the typical eighteenth-century mind, with shelf after shelf of this comparatively rare possession. Many, although certainly not all, gentry houses on both sides of the Atlantic reflected this learned link. But most genteel families had far fewer books. The Stenton library was considerable even by European standards, and very few there were as good. At the end of his life, Logan decided to give his library away, in order that others might enjoy its many scholarly fruits, a symbolic gesture intended to reaffirm his rank among the great and the good of colonial America. Logan's model in this was, unsurprisingly, an English example—that of Thomas Bodley, benefactor of one of the world's greatest libraries, the Bodleian at the University of Oxford.[80] Here is a key to Logan's entire personality, to his position within colonial society, and indeed to his status in the British Empire's gentry culture. Although the figure of the ignorant squire existed, it was countered among the Anglo-American gentry by the character of the scholarly country gentleman.

Until the American Revolution, many colonial American elites continued to consume goods in a way similar to lesser gentry across the Atlantic. In certain key behaviors— the construction of their country houses, how they used their houses, and the objects with which they furnished them—colonial elites approximated their British equivalents. Gentrified colonials like Logan sought to define themselves as learned and refined by acquiring estates, building polite mansions, accumulating impressive libraries, and purchasing sophisticated furnishings.

These new houses, possessions, and landscapes were fitting accessories to their drama of power and pleasure. In 1755, Thomas Graeme wrote to proprietor Thomas Penn that his estate of Graeme Park near Philadelphia was "a piece of beauty and ornament to a dwelling I dare venture to say that no nobleman in England but would be proud to have it on his seat or by his house."[81] The same might have been said about Stenton, or various other houses in British North America. Yet lesser elites in both Britain and its colonies existed in a contested social space. In 1721, Logan wrote to Johann Albrecht Fabricius, the great classical scholar of Hamburg, "Therefore, allow me . . . to address you from the wilds of Pennsylvania," and he later told a London bookseller he was not to be put off "as a common American."[82] Despite his trappings of wealth and influence, Logan was conscious of his uncertain status.

In 1741, William Verelst painted a conversation piece of the Gough family. In the picture, Sir Henry Gough, a lawyer and director of the East India Company from 1735 to 1751, sits in a paneled parlor at a "scrutore," with Queen Anne–style side chairs, a cabriole-leg tea table, a silver tea kettle, and Chinese export dishes. There is even a glimpse through the windows of the assumed country landscape.[83] The space, objects, and situation, however, suggest that this could just as easily be the parlor at Westover in Virginia or Stenton in Pennsylvania. For James Logan or Sir Henry Gough, with connections ranging from India to the Indian frontier in

America, their lives shared similarities in material ways as cultural intermediaries in the British Empire.

 Stenton's importance is best understood within this context. James Logan's country seat formed a definitive statement of his position in the British Atlantic world. Simply put, from the moment a visitor approached one of the gentry houses in colonial America, everything he or she encountered—the setting, the genteel architecture, the segregated spaces, people serving the owner, the tables, chairs, china, silver, and textiles, even the very way he or she moved through the space—spoke in nuanced terms to the level of power resident at these places of authority. By studying the material culture of this important stratum of the ruling elite in the British Empire, we can develop a clearer sense of how they conducted their lives, authored their identity, projected their power, and appreciably shaped the eighteenth century.

NOTES

1. James Logan to Thomas Story, Philadelphia, June 26, 1714, James Logan Letterbook, 1712–1715, 199, Historical Society of Pennsylvania (HSP).

2. Classic works on the Delaware Valley are Carl Bridenbaugh and Jessica Bridenbaugh, *Rebels and Gentlemen: Philadelphia in the Age of Franklin* (New York: Oxford University Press, 1942); and Frederick Tolles, *Meeting House and Counting House: The Quaker Merchants of Colonial Philadelphia* (Chapel Hill: University of North Carolina Press, 1948). Tolles comments, "On the basis of fortunes accumulated in overseas trade, the Quaker merchants reared a structure of aristocratic living comparable to that of the Virginia planters, the landed gentry of the Hudson Valley, and the Puritan merchant princes of Boston" (109). On Virginia, see T. H. Breen, *Tobacco Culture: The Mentality of the Great Tidewater Planters on the Eve of Revolution*, 2nd ed. (Princeton: Princeton University Press, 1985), and Michal J. Rozbicki, *The Complete Colonial Gentleman: Cultural Legitimacy in Plantation America* (Charlottesville: University Press of Virginia, 1998); on Maryland, Ronald Hoffman, *Princes of Ireland, Planters of Maryland: A Carroll Saga, 1500–1782* (Chapel Hill: University of North Carolina Press, 2000), and Trevor Burnard, *Creole Gentleman: The Maryland Elite, 1691–1776* (New York: Routledge, 2002). Additional works touching on the gentry and cultural formation in England and America include Felicity Heal and Clive Holmes, *The Gentry in England and Wales, 1500–1700* (Stanford: Stanford University Press, 1994); Amanda Vickery, *The Gentleman's Daughter: Women's Lives in Georgian England* (New Haven: Yale University Press, 1998);

Jack P. Greene, *Pursuits of Happiness: The Social Development of Early Modern British Colonies and the Formations of American Culture* (Chapel Hill: University of North Carolina Press, 1988); David Hancock, *Citizens of the World: London Merchants and the Integration of the British Atlantic Community, 1735–1785* (New York: Cambridge University Press, 1995); T. H. Breen, "An Empire of Goods: The Anglicization of Colonial America, 1690–1776," *Journal of British Studies* 25 (1986): 467–99. Richard L. Bushman, *The Refinement of America: Persons, Houses, Cities* (New York: Knopf, 1992) is an excellent contribution to the literature and has a great deal to say about genteel culture and how it developed during the eighteenth century.

3. H. V. Bowen, *Elites, Enterprise, and the Making of the British Overseas Empire, 1688–1775* (London: Macmillan, 1996), 103.

4. Kevin M. Sweeney, "High Style Vernacular: Lifestyles of the Colonial Elite," in *Of Consuming Interests: The Style of Life in the Eighteenth Century*, edited by Cary Carson, Ronald Hoffman, and Peter J. Albert (Charlottesville: University Press of Virginia, 1994), 1–58. Sweeney's essay contains some uncertain language related to social structure, employing at various points the broad and somewhat anachronistic term *middle class*, the highly charged adjective form *aggressively aristocratic*, and the descriptor *minor gentry*.

5. Lawrence Stone and Jeanne Fawtier Stone, *An Open Elite? England, 1540–1880* (Oxford: Oxford University Press, 1984), x. The Stones examined Hertfordshire, Northamptonshire, and Northumberland and found that between 1700

and 1749 somewhere between 12 and 40 percent of landed elites had business connections. As might be expected, Hertfordshire, one of the home counties outside London, exhibited by far the highest percentage of landowners tied to business. In turn, many more such landowners were involved in government service and the professions (mostly law and the army)—somewhere between 30 and 40 percent from 1700 to 1749 and rising steeply thereafter (144–47). See also tables 2.6 and 2.7.

6. Gregory King, *Natural and Political Observations and Conclusions upon the State and Condition of England* (1696).

7. G. E. Mingay, *English Landed Society in the Eighteenth Century* (London: Routledge and Kegan Paul, 1963), 6.

8. On King and England's social structure, see Peter Mathias, "The Social Structure in the Eighteenth Century," *Economic History Review*, 2nd ser., 10, no. 1 (1957): 30–45; G. Holmes, "Gregory King and the Social Structure of Pre-Industrial England," *Transactions of the Royal Historical Society*, 5th ser., 27 (1977): 41–68; and P. H. Lindert and J. G. Williamson, "Revising the Social Tables for England and Wales, 1688–1812," *Explorations in Economic History* 19 (1982): 385–408.

9. Mark Girouard, *Life in the English Country House: A Social and Architectural History* (New Haven: Yale University Press, 1978).

10. Richard Wilson and Alan Mackley, *Creating Paradise: The Building of the English Country House, 1660–1880* (London: Hambledon and London, 2000), 7.

11. See Vickery, *Gentleman's Daughter*.

12. Rhys Isaac, *The Transformation of Virginia, 1740–1790*, new ed. (Chapel Hill: University of North Carolina, 1999), xxxi.

13. See Stephen Hague, *The Gentleman's House in the British Atlantic World, 1680–1780* (Basingstoke: Palgrave Macmillan, 2015).

14. On classical architectural development in the seventeenth and eighteenth centuries, see John Summerson, *Architecture in Britain, 1530–1830* (Harmondsworth: Penguin, 1954), with many subsequent editions; Giles Worsley, *Classical Architecture in Britain: The Heroic Age* (New Haven: Yale University Press, 1995); a useful group of essays can be found in Barbara Arciszewska and Elizabeth McKellar, eds. *Articulating British Classicism: New Approaches to Eighteenth-Century Architecture* (Aldershot: Ashgate, 2004); also helpful is Paul Hunneyball, *Architecture and Image-Building in Seventeenth-Century Hertfordshire* (Oxford: Clarendon Press, 2004). For North America, see Hugh Morrison, *Early American Architecture* (Oxford: Oxford University Press, 1952).

15. Hague, *Gentleman's House*, 48–52.

16. Nicholas Cooper, *The Houses of the Gentry, 1480–1680* (New Haven: Yale University Press, 1999), 154. On Pendell House, see 152–54; on Melton Constable Hall, 246.

17. Cooper, 349.

18. Worsley contends that "even where such houses were only five bays wide the scale on which they were built [in America] was much more substantial than equivalent houses in England." *Classical Architecture in Britain*, 171–72. Similarly, Daniel Reiff suggests that the dimensions of many examples in southeastern England are considerably smaller than those of the hipped-roof country house of colonial British America, ranging between thirty and fifty feet in the width of their front elevation, and often having an L shape, with only one room on the shortest depth. Daniel D. Reiff, *Small Georgian Houses in England and Virginia: Origins and Development Through the 1750s* (London: Associated University Presses, 1986), appendix 2, table 6, 323.

19. Worsley, *Classical Architecture in Britain*, 171.

20. Stephen Hague, "Historiography and the Origins of the Gentleman's House in the British Atlantic World," in *"The Mirror of Great Britain": National Identity in Seventeenth-Century British Architecture*, edited by Olivia Horsfall Turner (Reading: Spire Books, 2012), 233–60, esp. table 1, 254.

21. Sweeney, "High Style Vernacular," 11.

22. For example, Sir William Johnson's Johnson Hall in Johnstown, New York.

23. Despite its current name, the Rectory at Stanton Harcourt had no association with the Anglican Church or its clergy but was the home of minor landowning gentry. *Samuel Buck's Yorkshire Sketchbook* (Wakefield, UK: Wakefield Historical Publications, 1979) reproduces the original manuscript in the British Library.

24. Clifford Papers, D149, Gloucestershire Archives. See also Nicholas Kingsley, *The Country Houses of Gloucestershire*, vol. 2, *1660–1830* (Chichester, Sussex: Phillimore, 1992), 144–48; and "Frampton Court I and II" in *Country Life*, October 8 and 15, 1927.

25. Paul Langford, *A Polite and Commercial People: England, 1727–1783* (Oxford: Oxford University Press, 1989), 76.

26. James A. Henretta, "Wealth and Social Structure," in *Colonial British America: Essays in the New History of the Early Modern Era*, edited by Jack P. Greene and J. R. Pole (Baltimore: Johns Hopkins University Press, 1984), 281.

27. Rowland Berthoff and John M. Murrin, "Feudalism, Communalism, and the Yeoman

Freeholder: The American Revolution Considered as a Social Accident," in *Essays on the American Revolution*, edited by Stephen G. Kurtz and James H. Hutson (Chapel Hill: University of North Carolina Press for the Omohundro Institute of Early American History and Culture, 1973), 264. See also Henretta, "Wealth and Social Structure," 280.

28. Cary Carson, "The Consumer Revolution in Colonial America: Why Demand?," in Carson, Hoffman, and Albert, *Of Consuming Interests*, 687, 690–91. See also C. Dallett Hemphill, "Manners and Class in the Revolutionary Era: A Transatlantic Comparison," *William and Mary Quarterly* 63, no. 2 (2006): 345–72.

29. Bushman, *Refinement of America*, xi–xii, 5.

30. Hague, *Gentleman's House*, 12–17.

31. See, all by Bernard L. Herman, *Architecture and Rural Life in Central Delaware, 1700–1900* (Knoxville: University of Tennessee Press, 1987), 15; *The Stolen House* (Charlottesville: University Press of Virginia, 1992), 183, 208; and "Delaware's Orphans Court Valuations and the Reconstitution of Historic Landscapes, 1785–1830," in *Early American Probate Inventories*, edited by Peter Benes (Boston: Boston University Press, 1987), 121–39.

32. Bushman, *Refinement of America*, 5.

33. William Penn, *Some Fruits of Solitude, in Reflections and Maxims* (1693) (New York: Scott-Thaw, 1903), 49.

34. See Clare Lisa Cavicchi, "Pennsbury Manor Furnishing Plan" (manuscript, 1988), figs. 2–5, 58ff.

35. The argument for a T-shaped plan has been made recently by Mark Reinberger and Elizabeth McLean, in "Pennsbury Manor: Reconstruction and Reality," *Pennsylvania Magazine of History and Biography* 131, no. 3 (2007): 263–306. This essay raises important questions about the reliability of the Pennsbury reconstruction and Penn's effort to live in a lordly fashion. Reinberger and McLean also discuss Pennsbury in *The Philadelphia Country House: Architecture and Landscape in Colonial America* (Baltimore: Johns Hopkins University Press, 2015), 53–60.

36. William Penn to James Harrison, 25 October 1685, in *The Papers of William Penn*, edited by Richard S. Dunn and Mary Maples Dunn, 4 vols. (Philadelphia: University of Pennsylvania Press, 1981–87), 3:65–68; Reinberger and McLean, *Philadelphia Country House*, 59.

37. John Oldmixon, *The British Empire in North America*, 2 vols. (London: printed for John Nicholson, 1708), 1:176.

38. After Penn's departure in 1701, Pennsbury fell into disrepair, although Penn always planned to return there. This was not to be, however, and others began to negotiate for rental of the property. One letter from James Logan to Penn mentions "some of the gentry of Burlington and elsewhere, who hoped to have some advantage or pleasure from having such a country house." James Logan to William Penn, June 28, 1707, *Papers of William Penn*, 4:601n25, quoted in Cavicchi, "Pennsbury Manor Furnishing Plan." Note the use of the terms *gentry* and *country house*, a clear indication of status and symbolism as early as 1707.

39. Reiff, *Small Georgian Houses*, 230.

40. Although he does not mention the issue of cupolas, Bernard L. Herman discusses notions of Quaker aesthetics in eighteenth-century building in "Eighteenth-Century Quaker Houses in the Delaware Valley and the Aesthetics of Practice," in *Quaker Aesthetics: Reflections on a Quaker Ethic in American Design and Consumption*, edited by Emma Jones Lapsansky and Anne A. Verplanck (Philadelphia: University of Pennsylvania Press, 2003), 188–211.

41. William Byrd to Mr. Spencer, May 28, 1729, in *The Correspondence of the Three William Byrds of Westover, Virginia, 1684–1776*, edited by Marion Tinling, 2 vols. (Charlottesville: University Press of Virginia, 1977), 1:399.

42. See Reiff, *Small Georgian Houses*, 238–40 (Indian Banks and Ampthill), 253–55 (Wilton), 248 (Ludwell House). Frederick Tolles briefly but somewhat ineffectively compares Westover and Stenton in *Meeting House and Counting House*, 127n47.

43. Reiff, *Small Georgian Houses*, 284.

44. "The Journal of William Black," *Pennsylvania Magazine of History and Biography* 1, no. 4 (1877): 406 (June 1, 1744).

45. The standard work is now Reinberger and McLean, *Philadelphia Country House*.

46. Roger W. Moss, *Historic Houses of Philadelphia* (Philadelphia: University of Pennsylvania Press, 1998), 166–68.

47. The Fairhill sketch is in Reinberger and McLean, *Philadelphia Country House*, 118.

48. See the discussion of Fairhill in Mark Reinberger and Elizabeth McLean, "Isaac Norris's Fairhill: Architecture, Landscape, and Quaker Ideals in a Philadelphia Colonial Country Seat," *Winterthur Portfolio* 32, no. 4 (1997): 243–74.

49. The two great architectural features that originally existed but are now missing from Stenton are a balustrade and cupola similar to the ones shown in the Fairhill sketch. Stylistically, the houses differ—Stenton was a double-pile rectangle with a more fashionable hipped roof—but both were intended to convey similar messages about the status of their occupants.

50. Stone and Stone, *Open Elite*, 11; Albright G. Zimmerman, "James Logan, Proprietary Agent," *Pennsylvania Magazine of History and Biography* 78, no. 2 (1954): 143–76.

51. Quoted in Frederick Tolles, *James Logan and the Culture of Provincial America* (Boston: Little, Brown, 1957), 93.

52. See the detailed analysis of Stenton's construction in Reed Engle, "Historic Structure Report: Stenton" (manuscript prepared for the National Society of the Colonial Dames of America in the Commonwealth of Pennsylvania, 1982). Many historic sites in America have historic structure reports (HSRs) that assess the architectural and historical background of the buildings and their inhabitants. Mostly unpublished, they are a valuable resource underused by historians.

53. *Pennsylvania Gazette*, November 7, 1751, in *The Papers of Benjamin Franklin*, edited by Leonard W. Labaree, Whitfield J. Bell Jr., Helen C. Boatfield, and Helene H. Fineman, vol. 4 (New Haven: Yale University Press, 1961), 207.

54. Much of Logan's accumulated wealth was invested in land, although he began to divest himself of some of this property to buy English securities. He had sent nearly £1,000 to his brother in Bristol for this purpose by September 1733. His will of 1749 suggests that he owned nearly eighteen thousand acres in Pennsylvania and New Jersey and had an estate valued at £8,500. James Logan will, photocopy on file at Stenton.

55. Quoted in Engle, "Historic Structure Report: Stenton," 10.

56. Edwin Wolf, *The Library of James Logan of Philadelphia, 1674–1751* (Philadelphia: Library Company of Philadelphia, 1974), 336.

57. See, for example, Raymond V. Shepherd, "James Logan's Stenton: Grand Simplicity in Quaker Philadelphia" (master's thesis, Winterthur Museum, 1968).

58. Hague, *Gentleman's House*, 2–3.

59. "Guide to the Philadelphia Exemption Series, Being True Copies of Philadelphia County Land Records in the Master of Rolls Office and Its Successors, 1669–1838" (typescript compiled by James Duffin for the National Society of the Colonial Dames of America in the Commonwealth of Pennsylvania, 1994), 238–39. Of the forty-three times James Logan is listed in the guide, he appears twenty-four times with no occupation, eight times as "gentleman," four times as "merchant" (three of these are recorded on the same day, December 1, 1711), three times as "esquire" (including the two final listings, dated 1727 and 1736), three times as "proprietary secretary," and once as "attorney." Interestingly,

Logan's colleague and relation Isaac Norris is generally listed throughout as merchant, until his place of residence changes to Fairhill, at which time he is recorded as either "gentleman" or "esquire."

60. Quoted in Tolles, *Logan and the Culture*, 82.

61. See the discussion of parlors and stair halls in Bushman, *Refinement of America*, 114–22 (quotation on 119).

62. The Logan ledgers and account books are at the HSP and have been most usefully analyzed in Shepherd, "James Logan's Stenton," still a reliable guide to Logan's furnishing of Stenton, although it overemphasizes the idea of Quaker plainness somewhat. This has been supplemented and corrected in part by recent research on the Stenton collection, especially the furniture. See Laura Keim, "Stenton Room Furnishings Study" (manuscript, 2010, on file at Stenton); and Philip D. Zimmerman's articles "Philadelphia Case Furniture at Stenton," *Magazine Antiques*, May 2002, 94–101; "Eighteenth-Century Chairs at Stenton," *Magazine Antiques*, May 2003, 122–29; and "Early American Tables and Other Furniture at Stenton," *Magazine Antiques*, May 2004, 102–9.

63. Maxine Berg, *Luxury and Pleasure in Eighteenth-Century Britain* (Oxford: Oxford University Press, 2005), chap. 8.

64. Transcript of James Logan inventory, 1752, on file at Stenton.

65. In 2017, staff at Stenton completed a major project to reconstruct the flying tester bed and refurnish the Yellow Lodging Room, meticulously documenting restoration choices and research. Oliver Bradbury, "Handel at Home," *Country Life*, December 15, 2005, discusses the re-creation of a similar bed at a London house museum.

66. For comparative costs for beds, see John Cornforth, *Early Georgian Interiors* (New Haven: Yale University Press, 2004), 83–95. See also Hague, *Gentleman's House*, chap. 6.

67. Laura Keim makes this argument in "Stenton Room Furnishings Study," 45. Although there is no documentary evidence to substantiate a Logan provenance for the settee before ownership by James Logan's daughter Hannah, the circumstantial evidence, taking account of style and physical construction, is compelling. Weighing evidence related to this object highlights the different methodologies employed by material culture scholars and historians.

68. John Cornforth points out that around 1700 chairs made of walnut for great country houses cost £1 or £2, becoming more expensive only with the addition of fine upholstery. *Early Georgian Interiors*, 100.

151

152

69. That is, unless we consider the room at Stenton that housed Logan's books. These were valued at £900 Pennsylvania currency, making the Blue Lodging Room—the most likely space to have served as Logan's library during his lifetime—far and away the most valuable room monetarily, not to mention intellectually.

70. Archaeologist Barbara Liggett conducted several archaeological investigations at Stenton between 1968 and 1983; see especially her "Archeological Notes on Stenton" (manuscript, 1983[?], on file at Stenton). Artifacts unearthed during the early 1980s have been most usefully catalogued and evaluated in Deborah Miller, "'Just Imported from London': The Archaeology and Material Culture of Stenton's Feature 14" (master's thesis, Pennsylvania State University, Harrisburg, 2006), and further analyzed in Dennis Stephen Pickeral, "The Proper Équipage: Tea and Tea Ware at James Logan's Stenton," (master's thesis, Pennsylvania State University, Harrisburg, 2008). See also John L. Cotter, Daniel G. Roberts, and Michael Parrington, *The Buried Past: An Archaeological History of Philadelphia* (Philadelphia: University of Pennsylvania Press, 1993), 332–36. Many thanks to Leslie Grigsby, curator of ceramics and glass at the Winterthur Museum and Library, for her very helpful remarks about the ceramic and glass collection at Stenton.

71. James Logan to James Steel, 3 December 1729, Correspondence of James Logan, 1683–1730, 1:93, HSP.

72. See n. 53.

73. Quoted in Wolf, *Library of James Logan*, 53. Wolf's volume is an exceptional guide to Logan's library, book-collecting habits, and intellectual interests. A further contribution is James N. Green, "Ben Franklin in Logan's Library" (paper delivered at Stenton, March 25, 2006).

74. *Cato Major, or His Discourse of Old-Age: With Explanatory Notes*, trans. James Logan (Philadelphia: Benjamin Franklin, 1744), 99.

75. Charles Saumarez Smith, *Eighteenth-Century Decoration: Design and the Domestic Interior in England* (New York: Harry N. Abrams, 1993), 107, plate 91.

76. Minutes of the Library Company of Philadelphia, March 29, 1732, LCP.

77. "Journal of William Black," 407.

78. James Logan to Josiah Martin, August 1745, Stenton Collection.

79. Kevin T. Hayes, *The Library of William Byrd of Westover* (Madison, Wisc.: Madison House, 1997); Thomas Lee inventory, recorded August 29, 1758, http://www.gunstonhall.org/library/probate/LEE58.PDF; *Stratford Hall Plantation and the Lees of Virginia: A Stratford Handbook* (Stratford, Va.: Robert E. Lee Memorial Association, n.d.), 18.

80. Wolf, *Library of James Logan*, xxxviii, 361.

81. Thomas Graeme to Thomas Penn, July 1, 1755, Penn Manuscripts, Official Correspondence, 7:67, HSP.

82. James Logan to Johann Fabricius, November 11, 1721, James Logan Letterbook, 1717–1731, 20–22, HSP. "Common American" quoted in *James Logan, 1674–1751: Bookman Extraordinary* (Philadelphia: Library Company of Philadelphia, 1971), 3.

83. Smith, *Eighteenth-Century Decoration*, 171, plate 157.

Trophy Heads at Monticello

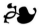

MARGARETTA MARKLE LOVELL

THOMAS JEFFERSON AT MONTICELLO was surrounded by heads (fig. 6.1). Here at the house he designed for himself on top of a small mountain in central Virginia, the animate figures in his household (family members, slaves, guests, business partners, Native Americans, political allies) occupied the *center* of the rooms—here they dined and held conversations, exchanged information, and moved in a hierarchical set of socially prescribed, choreographed steps.[1] But against the walls there were *heads*. These heads were the material result of conversations and correspondence that extended throughout Jefferson's life. They are the object residue of his reading in, investigations of, and correspondence about the Western scholarly tradition, the political and natural history of the New World, the lives of notable contemporaries, fossilized remnants from prehistory, and astonishing evidence sent back to Charlottesville from distant corners of the trans-Mississippi West.[2]

The three rooms in which Jefferson located his heads were the hall, the drawing room (parlor), and the tea room (fig. 6.2).[3] These heads were of four kinds. First were the painted portraits of notable friends and contemporaries such as George Washington and Benjamin Franklin—the latter, in Jefferson's opinion "the greatest man & ornament of the age and country in which he lived"—and of historical figures he admired, such as John Locke.[4] Locke, together with Francis Bacon and Isaac Newton, constituted the "trinity of the three greatest men the world had [has] ever produced," as he put it.[5] This triumvirate was copied at his direction from originals in London, and their portraits were hung together in his parlor.[6] Other canvases in the upper tier of Jefferson's parlor represented Christopher Columbus, Ferdinand

FIG. 6.1 Entrance Hall, Monticello, Charlottesville, Virginia (this current installation includes Jefferson-acquired objects where he placed them and also appropriate substitute objects for those currently unlocated). © Thomas Jefferson Foundation at Monticello. Photo: Robert Lautman.

Magellan, and Amerigo Vespucci, copied from originals in the Uffizi ("the gallery of the Medicis") by Jefferson's order in 1788.[7]

Second, there were sculptural busts, of marble and patinated plaster, of remarkable contemporaries, such as the group by the French sculptor Jean-Antoine Houdon on consoles installed between windows and on pedestals against window walls (figs. 6.1, 6.3). Seven of these busts Jefferson acquired in Paris directly from the sculptor.[8] Most of the Americans and the Marquis de Lafayette were installed in the tea room.[9]

Busts of two French intellectual figures, Voltaire (François-Marie Arouet) and Anne-Robert-Jacques Turgot, were located in the entrance hall, with Jefferson's own portrait by Houdon (fig. 6.3).[10] The heads of these and other modern worthies, perched on pedestals or consoles, greeted visitors in this, the most public room at Monticello. Nearby, two New World heads represented, for Jefferson, Native American translations of individuals or types into stone.[11]

Third, there were animal heads—the skulls and antlers of remarkable specimens of natural history such as magisterial moose antlers—thirty-nine inches from tip to tip—collected for Jefferson in New England or the upper Midwest (fig. 6.4).[12] These trophies included fossil remains of extinct creatures, including the bones of a mastodon (*Mammut americanum*) and the fossilized skull of a Harlan's muskox excavated

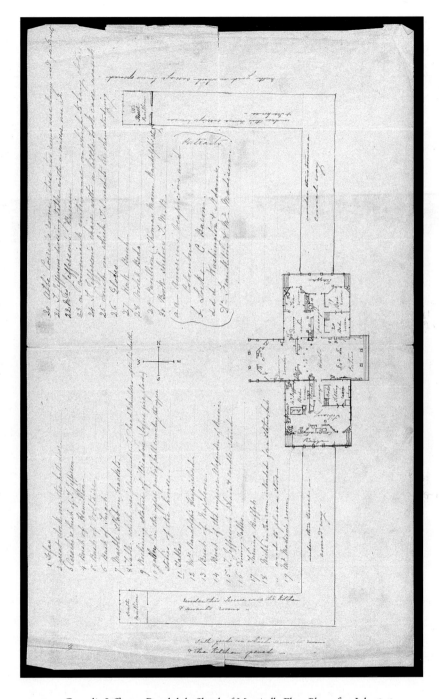

FIG. 6.2 Cornelia Jefferson Randolph, *Sketch of Monticello Floor Plan*, after July 1826. Ink on paper, 10 × 16 in. (25.1 × 40 cm). Jefferson, Randolph, and Trist Family Papers, 1791–1874, N-563, University of Virginia Library, Charlottesville, Virginia. Albert and Shirley Small Special Collections Library.

FIG. 6.3 Tea Room, Monticello (this current installation includes objects Jefferson acquired, placed where he placed them, and also appropriate substitute objects for those unlocated). © Thomas Jefferson Foundation at Monticello. Photo: Jack Looney.

in a dig financed by Jefferson at Big Bone Lick in Kentucky.[13] Perhaps most startling to Jefferson's visitors were the taxidermied severed heads of such noble beasts as a bighorn sheep and a buffalo, for this was a novel head type in Jefferson's generation.[14] The hunter's triumph (or scientist's specimen) could, with the newly developed techniques of preservation, remain both immediate and permanent, as the exterior parts of the head were preserved and mounted as sculpture. All of Jefferson's taxidermied beasts were exhibited in the entrance hall. This was the era of the guillotine, that machine of death that removed immediate human agency from the act of execution but, significantly, preserved the visage for the moment in which the severed head could be raised aloft as a trophy of a different kind, as proof of the state's triumph over an individual whose face and identity were yet vivid.[15]

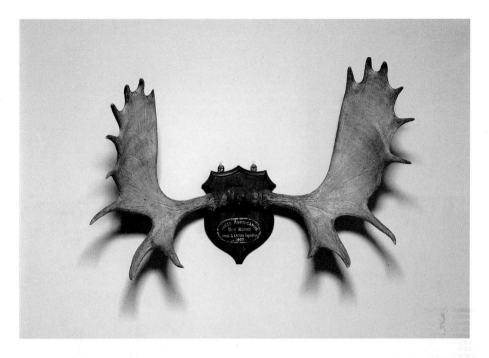

FIG. 6.4 Moose antlers (*Alces alces americana*), 39 in. (99 cm), acquired by Jefferson for Monticello either from New England by William Whipple or John Sullivan, ca. 1784–86, or from Meriwether Lewis, ca. 1803. University of Virginia, on loan to Thomas Jefferson Memorial Foundation, Monticello. © Thomas Jefferson Foundation at Monticello.

Fourth, there were the severed heads of long-dead biblical figures, including, in the parlor, the recognizably saintly features of John the Baptist laid on a platter in a copy of a Guido Reni in the Galleria Nazionale d'Arte Antica in Rome, which Jefferson purchased at auction in Paris in 1785 (fig. 6.5).[16] Nearby, in the hall, David held aloft the head of Goliath in triumph. Although scholars have made much of Jefferson's quick education in ancient and modern French architecture during the five years, 1784 to 1789, that he served as minister of the young United States to France, he was equally busy during these years assembling heads for Monticello.[17] What was the function of Jefferson's assemblage of beasts, saints, and exemplary men? How did he and his guests read these disembodied heads and faces? In what ways did art intersect in these rooms with the real, with memory, and with the future?

Jefferson was by no means unique in hanging his reception hall, parlor, and breakfast room with this—to us, heterogeneous—set of heads. Indeed, galleries of worthies and cabinets of curiosities were very much part of the European humanist tradition from at least the fifteenth century. But he was unique in the young United States in the breadth of his reach in selecting, collecting, commissioning, and exhibiting these

158

FIG. 6.5 *Herodias Bearing the Head of Saint John*, unknown copyist, ca. 1692, after ca. 1631 original by Guido Reni. Oil on canvas, 56 ½ × 40 ½ in. (143.5 × 102.9 cm). Purchased at auction by Thomas Jefferson in 1785 in Paris. © Thomas Jefferson Foundation at Monticello.

trophies in the public rooms of his domestic sphere. These were not accidental or haphazard acquisitions—Jefferson received some of these objects as gifts, but most were deliberately commissioned, excavated at his behest, purchased at auction, or acquired by exchange.

If we think of this assemblage as the end product of Jefferson's education and epistolary networks, if we think of the boxes and crates that arrived with these objects as containing condensed messages, vehicles of knowledge, and singular ideas, we can begin to read Jefferson's intellectual reach and personal identity. The argument of this chapter is that Jefferson was very much a man of his era in his enthusiasm for heads and in his understanding of them as metonymically signaling remarkable persons, whole creatures, and complex ideas. They were not just fractional aesthetic, historical, and scientific exempla; their importance lay in their role as prompts for "offstage" wholes and truths. Like others in his era, Jefferson understood the head not only as singularly recognizable but also as the seat of reason and virtue in humans, and as displaying the most recognizable, humanlike features in creatures. The point was not flattery or amusement but accuracy and truth.

For Jefferson and his peers, domestic material culture—and especially the assemblage of heads—was socially active, reminding and instructing viewers, for instance, about character and citizenship. The realm of reference was personal (Jefferson's contemporaries), national (the thread of New World history from Columbus to the Revolution, as well as biblical prehistory), and universal (the Linnaean orders of flora and fauna). Above all, Jefferson's assemblage was mnemonic and political. It was not, moreover, just a straightforward gallery of worthies, faces of those whose lives presented models of statesmanship, manhood, creativity, and courage (although it was indeed that, in large part). In some cases, the meaning was contained not in the individual head but in juxtapositions: a pedestaled pair of marble busts of Jefferson and Alexander Hamilton by Giuseppe Ceracchi, for instance, flanked Monticello's entrance hall, the two men, as Jefferson put it "with a pensive smile," "'opposed in death as in life,'" in physical space as in political sentiments.[18] Similarly, marble busts of Napoleon Bonaparte and Tsar Alexander I flanked the entry to the parlor from the west portico, alternative reigning emperors with opposing characters, the first "a cold-blooded, calculating, unprincipled usurper, without a virtue . . . a great scoundrel," and the second, newly ascended to the throne of Russia, "a sovereign whose ruling passion is the advancement of the happiness and prosperity of his people, and not of his own people only."[19]

Not just for "background" or his own contemplation, Jefferson's heads participated actively in his social and political life. In a long letter to Benjamin Rush in January 1811, he described an after-dinner conversation with John Adams and Alexander Hamilton, "the room being hung around with a collection of the portraits of remarkable men, among them . . . those of Bacon, Newton and Locke"; a discussion ensued sparked

159

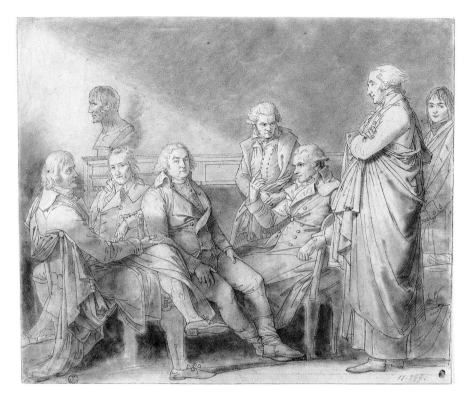

FIG. 6.6 French unknown, *Seven Men in Conversation Before the Bust of Brutus*, ca. 1787. Ink on paper, 12 × 14 ½ in. (30.4 × 36.8 cm). Department of Drawings and Prints, Gallerie degli Uffizi, Florence. Figures from left: Thomas Jefferson, unidentified, John Adams, unidentified, Jacques-Louis David, Philip Mazzei, and William Short. Courtesy of Gallerie degli Uffizi.

by those portraits. The conversation—which focused on "remarkable" men and the virtues of different forms of constitutional government—clarified for him, he told Rush, the disparate political characters of his two guests.[20] In order to effect their purpose—"to transmit to posterity the form of the person whose actions will be delivered to them by history"—it was important that the portraits be as accurate as possible, involving, in the case of Houdon's busts of Jefferson and Washington, the taking of life masks.[21] The point of portraiture in this portrait-rich era was to transmit to posterity a past that might otherwise be invisible. And, secondarily, the work was understood to be more powerful if executed in an engaging way. As theorized by the Roman poet Horace and his eighteenth-century followers, "He who instruction and delight can blend, / Please with his fancy, with his moral mend, / Hits the nice point, and every vote obtains."[22] A similar conversation of which we have a pictorial but not a written account is recorded in a drawing by an unknown French artist, *Seven Men in Conversation Before the Bust of Brutus*, in which Thomas Jefferson (far left),

Jacques-Louis David, John Adams (who considered Julius Caesar the greatest man who had ever lived), and others discuss the half-averted bust of Caesar's assassin (fig. 6.6).[23] The slouching artist David makes a rhetorical gesture echoing that of Socrates in his painting *Death of Socrates*, the work Jefferson singled out at the Salon of 1787 as "the best thing" among the 330 works on view.[24] Not just a conceit, such social and conversational "uses" of material culture objects—where a bust, a conversational group, and an "offstage" painting are linked in multimedia intertextuality—were characteristic of the age.

Objects like the assemblage Jefferson staged at Monticello can also be read as a kind of portrait of their owners. George Washington, for instance, appears to have shared Jefferson's taste in interior decoration to some degree, and, as in so many other things, preceded Jefferson. In 1759, when he was ordering clothing for himself and his bride, Washington also ordered "Busts ... one of Alexr the Great ... another of Julius Caesar. ... not to exceed 15 inches in height ... and the Duke of Marlborh—somewht smallr. [and] 2 [Furious] Wild Beasts not to exceed 12 inches in height nor 18 in length." These were to be made of "Copper, Enamel or Glazed" and were to "fill up broken pediments over doors."[25] They were interior architectural ornaments intended to provide specific models of bellicose masculinity—men and beasts equally—for Washington (a retired colonel at the time) and his guests at Mt. Vernon. After the Revolution, Washington conspicuously hung trophies of war in the form of flags captured in sea and land battles in the principal rooms of his home; he also hung the key to the Bastille, sent to him by Lafayette as a trophy of that other, subsequent revolution.[26]

The head, as the seat of reason, and *the face*, as the locus of unique identity, are privileged sites of aesthetic display. The portrait genre may include many elements, but its single desideratum and raison d'être is to capture the recognizable, unique, and possibly character-revealing individual face.[27] And no period in the history of American art saw a greater flourishing of painted and sculpted portraits than the early national period. This chapter investigates the reasons for this florescence and some of the disparate cultural threads that crossed in this movement of heads from the centers of rooms (on live bodies) to the periphery (on walls); from the changing, aging, and dying bodies of history's participants to the fixity of taxidermy and art.

Such collections of memorable actors of the Revolution as Gilbert Stuart's portraits, Jefferson's domestic assemblage, John Trumbull's precise miniature likenesses, and Charles Willson Peale's ambitious public museum in Philadelphia show the eagerness with which this generation sought to record and preserve the faces of those who witnessed the triumphant birth of the nation in immemorial rhetoric, political invention, and decisive deeds.

Identity, the portrait project argues, survives the death and decay of the body only in the memory of those living, and only if that memory is triggered, reinforced, and instructed by the continuing presence of eyewitness accounts (including, prominently,

painted and sculpted "eyewitness" portraits) long after the actors themselves have vanished. But the effort to memorialize specific physiognomies went beyond this grand campaign to hold up to future generations the model of their soon-to-be-dead forefathers; it included deliberate and systematic efforts on the part of some, such as George Catlin, to fix on canvas the "unique and imperishable" portrait record of what they understood to be a dying race.[28] These were understood to be pressing national, scientific, and ethnographic projects intended to rescue individual noble presence from the finality of death and the anonymity to which death reduces all heads and faces.

What other projects intersect with the early national period's enthusiasm to fix in memory, to fix in all *future* memories, the deeds, words, and persons who catapulted the country to nationhood, and to fix the faces of indigenous notables whose nations were summarily incorporated into that larger nation? Among the novelties Jefferson brought back from France to Monticello was his collection of life-sized sculptural busts, including a bust of the notable French friend of the Revolution the Marquis de Lafayette, by Houdon. The form is an old one. In ancient Rome, elite households kept their senatorial progenitors "alive" and present to them in the form of wax masks (and later, by the reign of Augustus, marble busts). In this practice, the Romans of the republic foregrounded the concept of the family line, with its inherited privileges and responsibilities, and in this they gave the dead a presence among, and surveillance over, the living. The *imago* (a mask that was also an "exact copy" portrait) was created for a man upon his election to the Roman Senate. It was stored with the carefully labeled *imagos* of his ancestors in labeled cupboards in the atrium, the most public part of the Roman house, and worn by actors impersonating those ancestors in the family's funeral processions. From the practice of making, wearing, and keeping these wax masks, the marble bust portraits evolved. Both the masks and the busts were associated with republican mores and values, with distinguished service, political legitimacy, and the continuing active role of illustrious ancestors within the household.[29] It was logical that Jefferson and his generation would appropriate this tradition, expanding the concept of genetic ancestor to include moral, political, and military models of exemplary citizenship.

As in the case of the newly elevated Roman statesmen, for whom the fidelity of the portrait mask to truth was of supreme importance, the concept of "exact copy" was similarly important to the sculptors, and the distinguished men who were their subjects, in the early national period. To achieve precision in depicting facial features (and the insight those features were thought to yield into the sources and nature of greatness), life masks such as that of the Marquis de Lafayette (taken by Houdon in 1785) were often made, either as ends in themselves or as a step in producing the most recognizable portrait bust possible. Thomas Jefferson had a life mask cast in 1825 by John Henri Isaac Browere, and his account is one of a near-death experience in which the sculptor had to resort to the mallet and chisel to free Jefferson's head from

FIG. 6.7 Jean-Antoine Houdon, *Bust of Thomas Jefferson*, 1789. Terra-cotta patinated plaster, 28 ¾ in. (73 cm). Monticello, gift of Richard Gilder and Lewis E. Lehrman. © Thomas Jefferson Foundation at Monticello.

163

the hardened plaster.[30] That Jefferson would submit to such an operation (and to the tedium of sitting for twenty-six portraits in a wide variety of media over the course of his public life) attests to the importance he ascribed not only to the record of his own features but to the fidelity of those portraits to his physiognomy, for the benefit of the future's memory (fig. 6.7).

While the wax, terra-cotta, plaster, or marble bust can be said to represent the Mediterranean tradition imported to the New World, a second tradition crossed paths with that ancient practice in the hall at Monticello. In northern Europe, long before canvas was stretched on wood, painted with pigments suspended in oil, framed in gilt and tacked onto walls, those walls were covered with other ornaments: trophies of war and trophies of the hunt. Hung high above the hall where the baron reveled with his knights, weapons and flags captured in battle were assembled in symmetrical and aesthetic arrangements—like steel and fabric bouquets—to bring to memory the tales of ancestral victories that gave the family and the tribe its booty, its territory, and its identity. Hung there as well were the trophies of the hunt, as the hunt was not only a quest for food and a ritual foray into nature; it was a rehearsal for battle. In the hunt, cunning and courage, teamwork and violence were practiced weekly, preparing the community for those less frequent occasions on which these skills would be tested, with much higher stakes, on humans. To memorialize these adventures and triumphs, and their rewards, the heads of particularly large and difficult kills were hung—their skulls and elegant antlers presiding over the feasting on lesser beasts that took place in

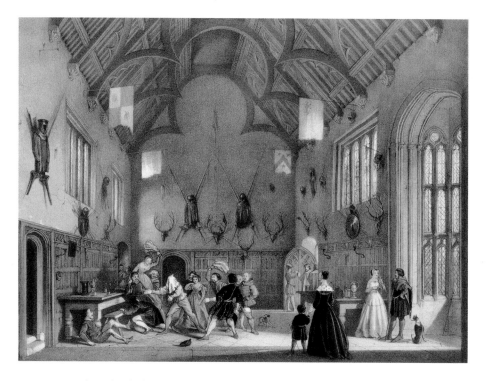

FIG. 6.8 Joseph Nash, *Blind Man's Buff, Played in The Great Hall, Athelhampton, Dorset, 15th-Century,* in Joseph Nash, *Architecture of the Middle Ages: Drawn from Nature and on Stone* (London: T. S. MacLean, 1838), plate XX. Colored lithograph, 11 ¾ × 16 in. Private collection / The Stapleton Collection / Bridgeman Images.

that venue nightly. So we can think of the medieval hall as the site of cooking, eating, and sleeping, but it was—as the upper walls in a nineteenth-century depiction of fifteenth-century Athelhampton Hall tell us—prominently a site of tale telling and memory, a place where these questions were posed and partially answered: what are the memorable events in our history? What are our rights to this place? Who are we as a family, a tribe, a community, a people (fig. 6.8)?

Thomas Jefferson's Monticello draws together all these usages concerning trophy heads. We find there the marblelike busts of worthies—including Jefferson's trans-atlantic contemporaries Lafayette and Voltaire—whose deeds and wisdom the third president wished to keep visible before him every day. We also find the heads of great beasts that Meriwether Lewis and William Clark sent back from their explorations in the western territories—in part to help Jefferson refute the claims of Georges-Louis Leclerc, Comte de Buffon, the prominent French naturalist who advanced a theory of American degeneracy—that is, the proposition that all species in the New World were smaller than and inferior to those of Europe. Jefferson exerted himself to refute

Buffon, including writing *Notes on the State of Virginia*, and, in 1787, sending to France the skeleton of an American moose in what was clearly a "my moose is bigger than your moose" gesture. (The American moose proved to be thirteen inches taller at the withers than its European counterpart.)[31]

Lewis and Clark's survey of the West and the exhibition of trophies from the expedition at Monticello signaled metonymically to Jefferson and his visitors not only the riches and abundance of natural resources in that distant region but also Jefferson's and the nation's mastery of that landscape and those regions by proxy (figs. 6.1, 6.4). Napoleon Bonaparte, having surrendered Haiti after fruitlessly attempting to regain control of that lucrative island, had no need for the vast Louisiana territories, kept, in his model of political economy, primarily as a breadbasket to feed the island populations, and in 1803 he offered this land to the young United States.[32]

Before he sent them west to survey his purchase of the vast Louisiana territories, Jefferson sent Meriwether Lewis to Philadelphia to study modern scientific methods of recording natural history phenomena.[33] In Philadelphia, Lewis saw Charles W. Peale's museum, housed in the long gallery in the State House, where Peale had assembled the bones of a mastodon, the taxidermied, animated bodies of 760 New World birds, arranged in Linnaean classifications, and other exhibits (fig. 6.9).[34] "Over the Birds, in handsome gilt frames," an 1807 "Guide to the Philadelphia Museum" notes, "are two rows of Portraits of distinguished Personages, painted from the life, by C. W. Peale and his son Rembrandt ... [a] collection ... begun in 1779 and including 70 paintings" (by 1823 it would grow to include 240 portraits).[35] To Peale's mind, these accurate images, "painted from the life," were not discontinuous with the natural history taxonomies among which they were hung but rather, in his words, represented "the animal man" in his most exemplary form. Among birds, the raptors occupy the prime rank along the top of the boxed dioramas—with the national symbol, the bald eagle, in pride of place at the top left corner. Humans—notables from his generation—were hung high above these cases not because Peale did not want viewers to see the details of their faces but because, in the Linnaean system, humans are "above" other creatures. In Peale's words, "In the animal kingdom, man is placed in first class and first order, called *primates*. ... [And, he continues, quoting Linnaeus] 'he nevertheless stands as *an animal*, in the system of nature, at the head of this order.'"[36]

In Jefferson's generation, the commissioning, making, hanging, observing, and preserving of portraits, which had been largely a private family matter in the colonial period, became a public and political matter.[37] Peale's self-commissioned gallery of the faces of 240 members of the founding generation signaled (among other innovations) an important and inventive shift in the relationship between artist, audience, and money. He banked on public interest and anticipated that visitors' modest admission fees would recoup his considerable personal investment. This new kind of made-for-exhibit portrait included not only kit-cat-format portraits of statesmen but also the

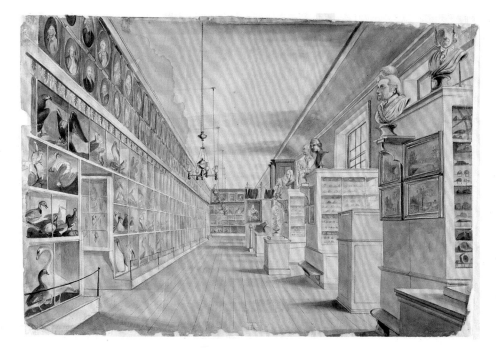

FIG. 6.9 Charles Willson Peale, *The Long Room (Interior of Front Room in Peale's Museum)*, 1822. Watercolor over graphite pencil on paper, 14 × 20 ¾ in. (35.6 × 52.7 cm). Detroit Institute of Arts, USA Founders Society Purchase, Director's Discretionary Fund (57.261). Photo © 2016 Detroit Institute of Arts / Bridgeman Images.

heads of remarkable Native American warriors like Joseph Brant and distinguished Europeans who rallied to the American cause, most notably the Marquis de Lafayette, the visionary French teenage orphan who showed up at Washington's door in 1777 to lend his considerable talents and money to the patriot cause. Peale, echoing Horace, understood the object of his remarkable undertaking to be "the improvement and the pleasure" of a broad public—a better-informed, happier, more prosperous republican citizenry.[38]

At the same time, both the young national and local civic governments took on the role of patron and commissioned—at considerable expense—full-length imposing portraits of national heroes and celebrities, including Conrad Alexandre Gérard, the first foreign ambassador sent by France, the novice nation's critically important ally, to recognize and assist the United States.[39] These life-sized celebrated personages too were placed on public view in Peale's museum.

Peale's assemblage of heads and creatures echoed Jefferson's project and, as an institution open to the public, it dwarfed Monticello in its more ambitious scale. Like Jefferson, Peale valued accuracy in collecting his set of portraits of the revolutionary generation. He and his audience were so intent on recognizability that the

ingenious artist and museum impresario improved a new machine, the physiognotrace, that would inexpensively and quickly "take" the precise (profile) features of museum visitors, democratizing the portrait project and preserving for posterity the precise features of many, including those of visiting Native Americans from the far West.[40] Peale was similarly innovative in his efforts to retain the lifelikeness of his birds and other creatures. His project emerged out of the same cultural forces that set John James Audubon on his quest to record and engrave with painstaking accuracy the color, movement, habitat, and correct scale of the birds of America, but Peale sought to take accuracy one step further than even the best two-dimensional records.[41] While paintings, life masks, sculpted busts, and silhouettes could be very accurate and provide many of the precise characteristics of their subjects, they were nevertheless all substitutes, simulacra. When visitors at the outset of the nineteenth century saw Peale's gallery, they saw not only portraits of worthy men held up to the future's emulation and an orderly system of natural specimens arranged to educate viewers in the order of nature; they also saw real bird specimens arranged in dioramas, stuffed and animated to resemble life. Taxidermy was a new practice that preserved not just the skull and horns of trophy animals but also their heads and hides (and in some cases skeletons and other body parts), so that they could be displayed as almost-animate sculptural creatures, as we see in Peale's birds and Jefferson's buffalo and bighorn sheep (mounted by Peale for Jefferson in 1804) at Monticello.[42]

For Jefferson and Peale's generation, the desire to bequeath to the future precise and accurate records—even, ideally, the irrefutable thing itself—encouraged the development of taxidermy, the translation of a living thing into sculpture. Eighteenth-century attempts to preserve the heads and bodies of mammals, birds, and fish had been thwarted by the inevitable destructive work of moths, mice, rats, and beetles. In the 1770s, a French apothecary devised a successful technique using arsenic, and Peale had perfected the method in the United States by 1788. He partnered with Philadelphia's eminent sculptor, William Rush, who created wooden forms (sculptures) mimicking lifelike postures and musculature on which to mount the skins, and pioneered the practice of placing his reanimated creatures in diorama boxes painted to resemble appropriate habitats.[43] His techniques have resulted in many specimens—including a pair of unusually well provenanced golden pheasants given by the emperor of China to Louis XVI, by the king to Lafayette, and by Lafayette to George Washington, who, when they died, gave them to Peale to mount. They survive to the present undiminished, the female deferentially bowing in acknowledgment of eighteenth-century systems of patriarchy, extended here to the animal kingdom (fig. 6.10).[44]

Because it answered pressing culturally specific desires for arresting time and defying decay, taxidermy became widespread in Peale's generation. In 1824, in a kind of homage to a fellow artist, Peale painted a portrait of an important visiting English taxidermist, Charles Waterton, with two examples of his work, a bird and a cat's

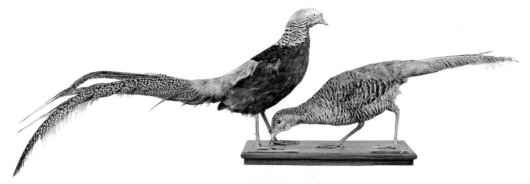

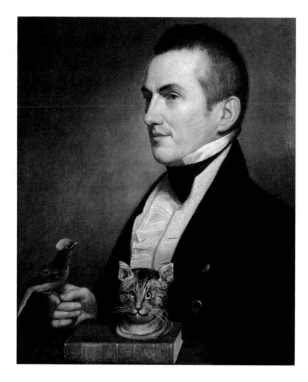

FIG. 6.10 Golden pheasants
(*Chrysolophus pictus*) from China,
presented to Louis XVI, who
gave them to Lafayette, who gave
them to George Washington in
1786, who, when they died in 1787,
gave them to Charles W. Peale,
who taxidermied them. 12 × 46
× 12 in. Museum of Comparative
Zoology, Harvard University.
Photo © President and Fellows of
Harvard College.

FIG. 6.11 Charles Willson Peale,
Charles Waterton, 1824. Oil on
canvas, 24 ⅛ × 20 ¼ in. (61.3
× 51.4 cm). National Portrait
Gallery, London, NPG 2014.
© National Portrait Gallery,
London.

head; arguably, the feline—who engages the viewer directly—looks more alive than its (former) owner (fig. 6.11).[45] The lifelikeness possible with these new preservation techniques permeated unforeseen and surprising corners of early Republican culture, including suggesting a new way of picturing the (chatty) heads of Bluebeard's beheaded wives in illustrations of Charles Perrault's tale. In a print accompanying an edition published in Philadelphia in 1815, their heads, like Waterton's cat's, seemingly animated by taxidermy, are mounted and set flat on a tabletop.[46] Taxidermy, over the course of the past two centuries, has developed its own conventions and practices. As Waterton's cat (a head type that startles most people today) makes clear, we do not usually taxidermize pets, animals with names; the practice is reserved for wild creatures like Jefferson's buffalo and bighorn sheep. For herbivores, they look alert; and carnivore trophy animals are usually scripted as savage, enacting a moment of aggression; in both cases, the killing of the animal, the hunter's or scientist's triumph over the specific creature, is muted and invisible as the animal is positioned as very much alive and intact, noble, a worthy competitor in its "contest" with man, frozen in seemingly animate sculpture.

Peale was proud of his accomplishments in portraiture as a vehicle of memory: "By good and faithful paintings the likeness of man is perhaps with the greatest precision handed down to posterity," he said. But he hoped for more; he had a vision of "hand[ing] down to succeeding generations, the relicks of such great men by . . . preserving their bodies from corruption . . . the *actual remains* of such men." That is, he sought to preserve humans through taxidermy. Specifically, he lamented that he had lacked the forethought to "propose the means of such preservation to that distinguished patriot and worthy philosopher, Doctor Franklin . . . [so that] the remains of his body [would] be now in our view."[47] Peale clearly hoped that some resonance of Franklin's remarkable aura—"his patient and thoughtful Industry; his matchless prudence; his judicious seizure of opportunities; his careful investigation of all that invited his attention"—could be visible in the authenticity of the taxidermied body of this astonishingly accomplished autodidact.[48] It did not happen, and it is probably just as well. The one human body so preserved from the period, that of Jeremy Bentham, has not been an unalloyed success in giving successive generations a sense of his genius, or in receiving the sort of veneration that Bentham surely trusted would ensue.[49]

The theory at the base of this enthusiasm for true, accurate portraits of notable humans was the belief that character is legible in face, features, and deportment, and that it was the artist's duty to discover and reveal, through material form, abstract qualities of character. One critic of the period felt, for instance, that Peale had captured George Washington's character in his 1779 portrait, "the countenance open and manly, the mild blue eye, the whole bespeaking intelligence, and dominion of lofty feelings, and the passions at rest."[50] But deciphering the sitter's character from an artist's clues was apparently not always straightforward; indeed, those clues were evidently

sometimes subjectively misread, as when one visitor to Peale's museum decried the placement of "the mild and philosophic [David] Rittenhouse, directly *over* whom was placed Thomas Paine. . . . The countenance of the one was softened by philanthropy; that of the other manifested . . . depravity of heart . . . [and a] smile of malignant cunning."[51] Overall, of course, this enthusiasm for fixing faces and reading character within a public and political framework points to an ideology of individual causality in the formation of history's watershed events and, in this case, on the part of actors focused on a common good larger than personal self-interest.[52] However true and objective (or accidentally open to misreading) the painted and marble faces, they represented together a very specific period narrative about historical process in general and 1776 in particular.

This push toward fixing the facts and authenticating details of specific faces bled over into history painting when John Singleton Copley and John Trumbull (see, for instance, *The Death of General Warren at the Battle of Bunker's Hill*) revolutionized that genre by painting true and accurate faces into their complex historical tableaux. Trumbull was encouraged in this injection of portraiture into history painting by Jefferson and took the likenesses of many of the French officers who participated in the Revolution in Jefferson's house in Paris in 1789.[53] The attempt was to memorialize—beyond the faintest possibility of forgetting—those faces and those deeds. In this move to combine the genre of history painting and portraiture, a particularly American innovation was created. The project was both to depict heroic and decisive battles—long a staple of Native American as well as European art—and to record the specific physiognomies of the actors in those battles. To underline a relationship between the two kinds of history painting, Jefferson hung a particularly splendid buffalo-hide record of a Native American battle near a print of Trumbull's *Declaration of Independence* in his entrance hall.[54]

Jefferson at Monticello and Peale in Philadelphia hung portraits of those of their generation they sought to hold up to themselves, to their families, to the public, and to the future as models of human ingenuity, courage, originality, and civic virtue. But it is important to remember that both hung them among heads of very different sorts. Together, this disparate assemblage of heads provides us with a portrait of Jefferson, Peale, and their compatriots as exemplary of that ingenious generation in their understanding of the legibility of personal character and their understanding of the role of the individual in historical change.

But there were substantial differences. Peale's project was to explain nature's order in encyclopedic synchronic completeness, preserve the faces of the revolutionary generation, and demonstrate the principles of hierarchy, harmony, and interdependence that, in his view, governed both the animal kingdom and republican society.[55] Jefferson's was a more diachronic project, animating the long history of European settlement of North America, the intellectual roots of that settlement (including philosophical

predecessors and biblical narratives), and a sketch of the future of the nation in the territories to the west. The surprisingly religious (and Roman Catholic) nature of two dozen of Jefferson's most prominently hung oil paintings is perhaps a testament to his aesthetic appreciation of Renaissance and baroque art, but it was also a way for him to bring biblical history into the narrative of the progress of civilization up to the (republican) present. Jefferson's carefully commissioned, purchased, and catalogued material culture assemblage was not the illogical, heterogeneous accumulation that some have described; it was an object-based narrative of history as he understood it.[56]

In the fall of 1806, when Jefferson was in Washington serving as president, he wrote a letter to Meriwether Lewis, who was en route—together with a Mandan chief and his family—to Charlottesville on the last leg of the journey east from the voyage of exploration that took Lewis and Clark seven thousand miles through the territories (and Native American nations) of the West.[57] Jefferson urged Lewis to take his visitors to Monticello to show them "in what manner I have arranged the tokens of friendship I have received from his country particularly, as well as from other Indian friends." What—beyond viewing these "tokens of friendship"—did Jefferson expect these Native Americans to see, understand, and learn at Monticello? It is likely that his pedagogy was in part directed at informing them about the absent host they would soon meet in person; it is probable that it was directed at giving them a précis—in the shorthand of art and material culture—of the history of Western civilization, converging purposely with their own history in his entrance hall.

One of the most noticeable aspects of the heads gathered by Jefferson and Peale is that, like others of their generation, their efforts were focused on capturing and preserving exact likenesses. Life masks, the reanimation of taxidermied specimens, the precision of the physiognotrace machine, the population of historical tableaux with recognizable faces—all these developments and usages point to a generation preoccupied with the contribution of specific, recognizable, accurately recorded individuals to history's narrative, and the power of empirical experience to instruct their successors. This attention to the uniqueness of humans (juxtaposed with the presumed sameness of natural history specimens) and the necessary absolute truth of rendering led to the development of photography in the decade following the deaths of Jefferson and Peale in 1826 and 1827, respectively. Both were intent on gathering accurate assemblages of material culture texts with moral, social, and intellectual intentions. Their goal was permanence, a kind of material triumph over death that would assure the immortality of a vision of the revolutionary generation and of scientific truth that would become a past permanently coexisting with the future's present.

Unlike the generally private role of the hanging of heads—to use the period term for fixing portraits to a wall—in the colonial period, when portraiture was about the family as a diachronic entity, portraiture in the early national period took on these much more public functions. This period saw the integration of portraiture

into history painting, the integration of portraits and natural history specimens, and the introduction of portraiture into the functioning (and expenses) of republican government, as both individual states and Congress—following the lead of Jefferson and Peale—invested in sculpture and paintings of exemplary men for public display.[58] Artists were eager to oblige. Houdon, for instance, acknowledged to be the very best sculptor in Europe, according to Jefferson, "offered to leave statues of kings unfinished to go to America to take the true figure" of Washington.[59] Portraits in the early national period helped citizens understand the order of nature, recall memorable public events, and see with eyewitness authenticity the potential for human virtue to instruct the future. Portraiture's new public role was to "excite others to tread the same glorious and disinterested steps which lead to public happiness and private honors."[60] Painters like Charles Willson Peale and collection gatherers like Thomas Jefferson created a corpus of works, like those ancient Roman masks, in which the dead were intended to remain active among the living, instructing and communicating across generations.

NOTES

I would like to thank the American Antiquarian Society for the Mellon Fellowship that gave me the opportunity to develop this essay, Christopher Hallett and Andrew Stewart for their advice concerning antique portraiture and trophies, Edwin Harvey and Mary Okin for their resourceful work as research assistants, and the Berkeley Americanist group for their helpful feedback on an early draft. Preliminary versions of this essay were given as talks at the Louvre, at the Smithsonian American Art Museum, at the Redwood Library in Newport, Rhode Island, and at the Huntington Library.

1. Concerning Native Americans at Monticello, see the reference to the visit of the family of Mandan chief Shahaka in Thomas Jefferson to Meriwether Lewis, October 20, 1806, in Reuben Gold Thwaites, ed., *Original Journals of the Lewis and Clark Expedition, 1804–1806*, 7 vols. (New York: Dodd, Mead, 1904–5), 7:345.

2. For Jefferson's collection of objects at Monticello, see Anna O. Marley, "Landscapes of the New Republic at Thomas Jefferson's Monticello," in *Building the British Atlantic World: Spaces, Places, and Material Culture, 1600–1850*, edited by Daniel Maudlin and Bernard L. Herman (Chapel Hill: University of North Carolina Press, 2016), 78–99; Susan R. Stein, *The Worlds of Thomas Jefferson at Monticello* (New York: Harry N. Abrams, 1993); Joyce Henri Robinson, "An American Cabinet of Curiosities: Thomas Jefferson's Indian Hall at

Monticello," *Winterthur Portfolio* 30, no. 1 (1995): 41–58; William Howard Adams, ed., *The Eye of Thomas Jefferson* (Charlottesville: University Press of Virginia, 1976); William Howard Adams, ed., *Jefferson and the Arts: An Extended View*, exh. cat. (Washington, D.C.: National Gallery of Art, 1976); Eleanor Davidson Berman, *Thomas Jefferson Among the Arts: An Essay in Early American Esthetics* (New York: Philosophical Library, 1947); Fiske Kimball, "Jefferson and the Arts," *Proceedings of the American Philosophical Society* 87, no. 3 (1943): 238–45; and "Recreating the Indian Hall: The Monticello-Peabody Native Arts Project," https://www.monticello.org/site/jefferson/recreating-india n-hall-monticello-peabody-native-arts-project. Jefferson used the term "head" in his notebook of 1784 listing purchases: "Two pictures of heads, 7 livres . . . five paintings (heads)." Quoted in Adams, *Jefferson and the Arts*, 111. For a brief history of the house and site at Monticello, see Jack Sexton, "Monticello: The Invention of an American Place," *Common-Place* 8, no. 4 (2008), http://www.common-place-archives.org/vol-08/no-04/sexton/; for early national eyewitness descriptions of Monticello, see Merrill Peterson, ed., *Visitors to Monticello* (Charlottesville: University Press of Virginia, 1989).

3. There are three sources that together give us a good idea about what paintings, sculptures, prints, and artifacts Jefferson owned and where he

displayed them: the Kirk-Jefferson list of fifty-eight paintings (undated but probably before 1803 [in private hands])—see Harold E. Dickson, "Jefferson as Art Collector," in Adams, *Jefferson and the Arts*, 104–32, esp. 131n74; Jefferson's manuscript "Catalogue of Paintings &c. at Monticello," undated but probably between 1803 and 1815 (Thomas Jefferson Papers, #2958-b, Special Collections Department, University of Virginia Library), transcribed in Stein, *Worlds of Thomas Jefferson*, Appendix 2, 434–36; and Cornelia Jefferson Randolph's *Sketch of Monticello Floor Plan*, drawn after the death of Jefferson on July 4, 1826, but before the beginning of the dispersal sales in 1827 (see fig. 6.2). There are also epistolary comments by visitors and records of the dispersals at Monticello (January 15, 1827), the Boston Athenaeum (1828), and Chester Harding's Gallery in Boston (1833); see Dickson, "Jefferson as Art Collector," 122–28, 130, 132, and nn. 49 and 91. Jefferson's "Catalogue of Paintings &c." places the portraits, sculptures, and artifacts in the hall, the parlor, and the tea room, while history paintings and prints—chiefly of landscape subjects—were hung in the dining room. Randolph's sketch concurs. Copies of biblical subjects by Old Masters shared the walls in the more public rooms at Monticello. As early as 1771 Jefferson made notes about the copies of important classical statues that he, ambitiously, hoped to acquire, and in 1782 he penned a similar list of Old Master paintings. Kimball, "Jefferson and the Arts," 241, 242; Dickson, "Jefferson as Art Collector," 109–10.

4. Thomas Jefferson to Samuel Smith, August 22, 1798, in *The Works of Thomas Jefferson*, edited by Paul Leicester Ford, 12 vols. (New York: G. P. Putnam's Sons, 1904–5), 8:443–47. The Franklin portrait was probably by Jean Valade, a copy of that painted by Joseph Duplessis in 1778. Dickson, "Jefferson as Art Collector," 114.

5. Thomas Jefferson to Benjamin Rush, January 16, 1811, in *Works of Thomas Jefferson*, 11:168.

6. These copies, after Sir Godfrey Kneller and others, were ordered for Jefferson by John Trumbull in London—see Jefferson to Trumbull, January 12 and 18, February 15, and March 15, 1789, and Trumbull to Jefferson, February 5 and March 10, 1789, in *The Papers of Thomas Jefferson*, edited by Julian P. Boyd, 41 vols. (Princeton: Princeton University Press, 1950–2014), 14:440–41, 467–69, 524–25, 561, 634–35, 663.

7. The copyist was Giuseppi Calendi; they were delivered in January 1789. Dickson, "Jefferson as Art Collector," 115.

8. Jefferson, "Catalogue of Paintings &c.," in Stein, *Worlds of Thomas Jefferson*, 215, 434, 436.

9. Randolph, *Sketch of Monticello*, fig. 2; Stein, *Worlds of Thomas Jefferson*, 88–90, 230.

10. Houdon exhibited his head of Jefferson at the Salon in 1789. Stein, *Worlds of Thomas Jefferson*, 216–17, 230–31. Jefferson's own copy of this bust is now lost; the painting by Louis-Léopold Boiley of Houdon's studio prominently includes the busts of Jefferson and Franklin. *The Studio of Houdon*, Musée Thomas Henry, Cherbourg, illustrated in Adams, *Eye of Thomas Jefferson*, 136; Randolph, *Sketch of Monticello*. For an account of the life portraits of Jefferson, see Alfred L. Bush, "The Life Portraits of Thomas Jefferson," in Adams, *Jefferson and the Arts*, 9–99 (see 14 for a list of these life portraits). Those at Monticello included paintings, sculptural busts, cut silhouettes, watercolors, and profiles struck on medals.

11. Two of these Late Mississippian soapstone heads (ca. 1250–1350 C.E.), now in the collection of the Smithsonian (currently on long-term loan to Monticello), were collected in Palmyra, Tennessee, in the late eighteenth century; Morgan Brown sent them as a gift to Jefferson in 1799. See Kristine K. Ronan, "'Kicked About': Native Culture at Thomas Jefferson's Monticello," *Panorama: Journal of the Association of Historians of American Art* 3, no. 2 (2017), http://journalpanorama.org/native-culture-at-monticello/; see also Stein, *Worlds of Thomas Jefferson*, 410, 434.

12. Stein believes that these antlers of an eastern moose (*Alces alces americana*) were procured for Jefferson circa 1784–86 by William Whipple or John Sullivan, citing Sullivan's June 1784 letter to Jefferson, which reads in part, "I have procured . . . a Large pair of Mooses horns." *Worlds of Thomas Jefferson*, 394–95. There is evidence, however, recorded on the apparently period plaque that this "rack" was sent back to Jefferson by Lewis and Clark during their exploration of the trans-Mississippi West two decades later. Sullivan did succeed in procuring, at Jefferson's request, the whole skeleton of a Vermont moose, which Jefferson presented to Buffon in Paris in 1787 in an attempt to correct that savant's theory of the degeneracy of New World fauna. See Jefferson to Buffon, October 1, 1787, in *Works of Thomas Jefferson*, 5:352.

13. The mastodon's cranium was particularly sought to complete the skeleton Peale was reconstructing in Philadelphia. Stein, *Worlds of Thomas Jefferson*, 398–403.

14. George Ticknor remarked on the buffalo head in 1815; the bighorn sheep (*Ovis canadensis*) was taxidermied in Philadelphia by Charles Willson Peale and is now lost. Stein, 64, 66–67, 397.

15. See Linda Nochlin's provocative *The Body in Pieces: The Fragment as a Metaphor of Modernity*

173

(London: Thames and Hudson, 1994); I argue that the head is not a fragment but rather a metonymic projection that stands for the whole, not a triumph of modernity over the past but a mnemonic collapsing of past into the present, signifying both the classification of all creation and the uniqueness of individuals.

16. Jefferson's "Catalogue of Paintings &c." (ca. 1809–15) describes fig. 6.5 as "Herodiade bearing the head of St. John in a platter ¾ length of full size canvas, copied from Simon Vouett [now known to be copied from Guido Reni], purchased from St. Severin's collection . . . the subject Matt. 14.11. Mark 6.28." Here as elsewhere, Jefferson is careful to give the biblical source text, the artist of the original composition (noting also whether his object is an original or a copy), the size of the canvas and, often, the size of the figures with respect to life size, the disposition of the figure(s), and sometimes the provenance. Other paintings Jefferson purchased from the Saint Severin sale include *St. Peter Weeping*; *Democritus and Heraclitus*; *The Prodigal Son*; and *The Penitent Magdalen*. Stein, *Worlds of Thomas Jefferson*, Appendix 2, 434–36.

17. For a summary of Jefferson's knowledge of European art, see chap. 5, "Jefferson's Ideas About Painting," 74–93, and chap. 6, "Jefferson on the Uses of Sculpture," 94–112, in Berman, *Jefferson Among the Arts*; and Dickson, "Jefferson as Art Collector." Jefferson's were not the first copies of Old Masters in Virginia; Matthew Pratt exhibited a group he had copied in London in a Williamsburg tavern in March 1773. W. H. Adams, "Land of Promise," 1–27, in Adams, *Eye of Thomas Jefferson*, 14–15.

18. As reported and quoted in Henry S. Randall, *The Life of Thomas Jefferson*, 3 vols. (New York: Derby and Jackson, 1858), 3:336.

19. Jefferson to John Adams, 5 July, 1814, in *Works of Thomas Jefferson*, 11:394–95; Jefferson to Levett Harris, 18 April, 1806, and Jefferson to Tsar Alexander, April 19, 1806, both in *The Writings of Thomas Jefferson*, edited by Andrew A. Lipscomb and Albert Ellery Bergh, 20 vols. (Washington, D.C.: Thomas Jefferson Memorial Association, 1903–4), 11:101–3 and 11:103–6, respectively.

20. Jefferson to Rush, January 16, 1811, *Works of Thomas Jefferson*, 11:167–72.

21. Jefferson to George Washington, December 10, 1784, in Gilbert Chinard, ed., *Houdon in America: A Collection of Documents in the Jefferson Papers of the Library of Congress* (Baltimore: Johns Hopkins University Press, 1950), 5. For the life mask of Jefferson taken by John Henri Isaac Browere, see Bush, "Life Portraits of Thomas Jefferson," 95–98.

22. Horace (Quintus Horatius Flaccus), *Epistola ad Pisones: De Arte Poetica*, translated by George Colman (London: T. Cadell, 1783), 67–68.

23. Jefferson to Rush, January 16, 1811, 165–73, *Works of Thomas Jefferson*, 11:168.

24. Jefferson to John Trumbull, August 30, 1787, *Papers of Thomas Jefferson*, 12:69.

25. George Washington to Robert Cary & Co., September 20, 1759, in *The Papers of George Washington*, edited by William Wright Abbot, 10 vols. (Charlottesville: University Press of Virginia, 1983–95), 6:348–58; see also Carol B. Cadou, *The George Washington Collection: Fine and Decorative Arts at Mount Vernon* (Manchester, Vt.: Hudson Hills Press, 2006), 355, 358.

26. Jean B. Lee, ed., *Experiencing Mount Vernon: Eyewitness Accounts, 1784–1865* (Charlottesville: University of Virginia Press, 2006), 1, 101.

27. See Johann Kaspar Lavater, *Essays on Physiognomy: For the Promotion of the Knowledge and the Love of Mankind* (1750), translated by Thomas Holcroft, 4 vols. (London: C. Whittingham, 1804).

28. George Catlin, "To the Reader," in *A Descriptive Catalogue of Catlin's Indian Gallery* (London: C. Adlard, 1840), quoted in George Gurney and Therese Thau Heyman, *George Catlin and His Indian Gallery* (Washington, D.C.: Smithsonian American Art Museum, 2004), 29.

29. Harriet I. Flower, *Ancestor Masks and Aristocratic Power in Roman Culture* (New York: Oxford University Press, 1996), 32–35, 59, 189, 222–23, 270–80. I thank Christopher Hallett for his useful discussion of this tradition.

30. See Jefferson to James Madison, October 18, 1825, quoted in Bush, "Life Portraits of Thomas Jefferson," 95.

31. Joyce Elizabeth Chaplin, "Nature and Nation in Context," in *Stuffing Birds, Pressing Plants, Shaping Knowledge*, edited by Sue Ann Prince (Philadelphia: American Philosophical Society, 2003), 88; Buffon's multivolume *Histoire Naturelle, générale et particulière, avec la description du Cabinet du Roi* was published over the period 1749–1804; Jefferson included on the title page of his *Notes on the State of Virginia* (Paris: Philippe-Denis Pierres, 1784) the statement that it had been "written in the year 1781, somewhat corrected and enlarged in the winter of 1782, for the use of a foreigner of distinction, in answer to certain queries proposed by him." Jefferson's was not the first American moose in Europe: the duke of Richmond had imported several live moose, including a young bull painted by George Stubbs in 1770. See Judy Egerton, *George Stubbs, Painter: Catalogue Raisonné* (New Haven: Yale University Press, 2007), 283; see also

Lee Alan Dugatkin, *Mr. Jefferson and the Giant Moose: Natural History in Early America* (Chicago: University of Chicago Press, 2009).

32. Peter S. Onuf, "Prologue: Jefferson, Louisiana, and American Nationhood," in *Empires of the Imagination: Transatlantic Histories of the Louisiana Purchase*, edited by Peter J. Kastor and François Weil (Charlottesville: University of Virginia Press, 2009), 23–33; and Jessie Poesch, "New Orleans—Site of the Transfer—Prize of the Purchase," and Patrice Higonnet, "France, Slavery, and the Louisiana Purchase," both in *Jefferson's America and Napoleon's France: An Exhibition for the Louisiana Purchase Bicentennial*, edited by Victoria Cooke, exh. cat. (New Orleans: New Orleans Museum of Art, 2003), 224–55 and 256–82, respectively.

33. James P. Ronda, "Introduction: The Objects of Our Journey," in Carolyn Gilman, *Lewis and Clark: Across the Divide*, exh. cat. (Washington, D.C.: Smithsonian Institution Press, 2004), 15–49. Lewis learned collection protocols from William Barton, and at the conclusion of the expedition, Jefferson deposited its plant materials at the American Philosophical Society in Philadelphia. Peck, "Alcohol and Arsenic," 48. Peale and Jefferson exchanged animal pelts, skeletons, and recipes for specimen preservation. *The Selected Papers of Charles Willson Peale and His Family*, edited by Lillian B. Miller, Sidney Hart, and David C. Ward, 5 vols. (New Haven: Yale University Press, 1983–2014), 4:893–95, 929–31.

34. See David R. Brigham, *Public Culture in the Early Republic: Peale's Museum and Its Audience* (Washington, D.C.: Smithsonian Institution Press, 1995), 1–12, 34–50. For the prehistory of Peale's collection, see his account of Pierre Eugène du Simitière's collection in prerevolutionary Philadelphia, in Charles Willson Peale to Rembrandt Peale, October 28, 1812, in *Selected Papers of Charles Willson Peale*, 3:175.

35. "A Guide to the Philadelphia Museum," *Port-Folio* 4, no. 19 (1807): 293. Peale's Museum was in Philosophical Hall from 1794 to 1802; before 1794 the collection was at his home on Lombard Street (where a sixty-six-foot-long structure was built for it in 1782), and after 1802 it was in the Long Room of the State House. Robert McCracken Peck, "Preserving Nature for Study and Display," in Prince, *Stuffing Birds, Pressing Plants*, 11–12; Sue Ann Prince, "Introduction," in Prince, 9n1. For an account of the 1784, 1795, 1804, 1813, 1854, and 1855 catalogues of Peale's portraits, see Charles Coleman Sellers, "Portraits and Miniatures by Charles Willson Peale," *Transactions of the American Philosophical Society*, new ser., 42, no. 1 (1952): 16, 17.

36. Charles Willson Peale, "My Design in Forming This Museum," Philadelphia, 1792 (broadside), in *Selected Papers of Charles Willson Peale*, 2.1:12–19 (quotation on 14); see also David R. Brigham, "'Ask the Beasts, and They Shall Teach Thee': The Human Lessons of Charles Willson Peale's Natural History Displays," *Huntington Library Quarterly* 59, nos. 2–3 (1996): 182–206.

37. Margaretta M. Lovell, "Painters and Their Customers," in *Art in a Season of Revolution: Painters, Artisans, and Patrons in Early America* (Philadelphia: University of Pennsylvania Press, 2005), 8–25.

38. Quoted in Brigham, *Public Culture in the Early Republic*, 2.

39. Edgar P. Richardson, "Charles Willson Peale and His World," in *Charles Willson Peale and His World*, edited by Edgar P. Richardson, Brooke Hindle, and Lillian B. Miller (New York: Harry N. Abrams, 1983), 58. Unlike Peale's "political" oval heads of notable participants in the events of 1776, this portrait type—full-length portraits of public figures—had been known in the colonies before the Revolution in the portraits of sovereigns distributed to seats of government as proxies for and expressions of royal authority in this distant place. Peale's gallery also included his full-length portrait of Washington and Sully's full-length of Lafayette. Doris Devine Fanelli and Karie Diethorn, *History of the Portrait Collection, Independence National Historical Park* (Philadelphia: American Philosophical Society, 2001), 16–22.

40. Peale began offering physiognotrace portraits in 1802. Brigham, *Public Culture in the Early Republic*, 11. See also Wendy Bellion, "Heads of State: Profiles and Politics in Jeffersonian America," in *New Media, 1740–1915*, edited by Lisa Gitelman and Geoffrey B. Pingree (Cambridge: MIT Press, 2003), 31–59.

41. Jennifer L. Roberts, *Transporting Visions: The Movement of Images in Early America* (Berkeley: University of California Press, 2014), chap. 2, "Audubon's Burden: Materiality and Transmission in *The Birds of America*," 69–115.

42. Peck, "Preserving Nature," 14. For Peale's public announcement of a "proper method of preserving dead animals from the ravage of moths and worms," see "To the Citizens of the United States of America," *Dunlap's American Daily Advertiser*, January 13, 1792, in *Selected Papers of Charles Willson Peale*, 2.1:9–10. Jefferson and Peale were frequent correspondents in 1804 and 1805 (2.2:711–40, 893–931).

43. Peck, "Preserving Nature," 15–17n24, 24. For Peale's taxidermy technique, see "My Design in

Forming This Museum," 2.1:9, 14–15; Brigham, "'Ask the Beasts,'" 189–96. See also Paul Lawrence Farber, "The Development of Taxidermy and the History of Ornithology," *Isis* 68, no. 4 (1977): 550–66.

44. For the golden pheasants' provenance, see Peck, "Preserving Nature," 19. These pheasants (or perhaps their progenitors) were originally Chinese, a gift to the French king from China's Qianlong emperor, who himself may have received them as a tribute from the western provinces in which they are native.

45. Charles Waterton preferred turpentine to arsenic and disapproved of competing methods. His and Peale's are among the oldest and best-preserved surviving taxidermied specimens, Waterton's at the museum in Wakefield, West Yorkshire, and Peale's at the Museum of Comparative Zoology at Harvard. Peck, "Preserving Nature," 18–19; Christopher C. Frost, *A History of British Taxidermy* (Long Melford, Suffolk, UK: self-published, 1987), 1–2, 117–21.

46. Charles Perrault, *Blue Beard, or The Fatal Effect of Curiosity and Disobedience* (Philadelphia: Wm. Charles, 1815), unpaginated. Originally "collected" and published in the late seventeenth century, this folktale was translated into English in 1729 and was first published in the United States in 1794. See Susan Scott Parrish, *American Curiosity: Cultures of Natural History in the Colonial British Atlantic World* (Williamsburg: Omohundro Institute, 2006), 178–83.

47. Peale, "My Design in Forming This Museum," 2.1:14, 24n4.

48. Stein, *Worlds of Thomas Jefferson*, 73; "A Sketch of the History of the Museum," *Philadelphia Museum, or Register of Natural History and the Arts* 1, no. 1 (1824): 1.

49. Tom Flynn, *The Body in Three Dimensions* (New York: Harry N. Abrams, 1998), 102–21; "Auto-Icon," University College London Bentham Project, http://www.ucl.ac.uk/Bentham-Project /who/autoicon, accessed September 7, 2015.

50. "The Historian," *New-York Mirror: A Weekly Gazette of Literature and the Fine Arts*, December 9, 1826.

51. A., "Mr. Oldschool," *Port-folio* 3, no. 19 (1803).

52. Scott Casper, *Constructing American Lives: Biography and Culture in Nineteenth-Century America* (Chapel Hill: University of North Carolina Press, 1999), 40.

53. Trumbull to Jefferson, June 11, 1789, in *The Autobiography of Colonel John Trumbull: Patriot-Artist, 1756–1843*, edited by Theodore Sizer (New Haven: Yale University Press, 1953), 152, 158–62; Maura Lyons, *William Dunlap and the Construction of an American Art History* (Amherst: University of Massachusetts Press, 2005), 84n7, 107–8. Concerning the introduction of authenticating details in history painting, see Wendy Wassyng Roworth, "The Evolution of History Painting: Masaniello's Revolt and Other Disasters in Seventeenth-Century Naples," *Art Bulletin* 75, no. 2 (1993): 219–22; Edgar Wind, "The Revolution of History Painting," *Journal of the Warburg Institute* 2, no. 2 (1938): 116–27; and Patricia M. Burnham, "John Trumbull, Historian: The Case of the Battle of Bunker's Hill" in *Redefining American History Painting*, edited by Patricia M. Burnham and Lucretia Hoover Giese (Cambridge: Cambridge University Press, 1995), 37–53.

54. In 1815, a visitor remarked on the proximity of the hide painting to Jefferson's copy of Carlo Lotti's *St. Peter Weeping*. Stein, *Worlds of Thomas Jefferson*, 67, 68, 409. The downstream provenance of Jefferson's buffalo-hide battle scene has been obscured. See Castle McLaughlin, *Arts of Diplomacy: Lewis and Clark's Indian Collection* (Cambridge: Peabody Museum of Archaeology and Ethnology, Harvard University, 2003), 146–51.

55. Peale, "To the Citizens," 2.1:9–11.

56. Anthony F. C. Wallace, *Jefferson and the Indians: The Tragic Fate of the First Americans* (Cambridge: Harvard University Press, 1999), 104–7, 264–67.

57. Jefferson to Lewis, October 20, 1806, in Thwaites, *Lewis and Clark Expedition*, 7:345. See also Donald Jackson, ed., *Letters of the Lewis and Clark Expedition with Related Documents, 1783–1854*, 2nd ed., 2 vols. (Urbana: University of Illinois Press, 1978), 2:351.

58. Jefferson to Benjamin Harrison, January 12, 1785, in *Papers of Thomas Jefferson*, 7:599–601; see also Jefferson to Patrick Henry, January 12, 1785, in *Works of Thomas Jefferson*, 4:392–95.

59. Thomas Jefferson to governor of Virginia (Patrick Henry), January 12, 1785, in *Works of Thomas Jefferson*, 4:393.

60. Supreme Executive Council of Pennsylvania, resolution to commission a portrait of Washington, January 18, 1779, quoted in Richardson, "Peale and His World," 58.

"Painting" Faces and "Dressing" Tables

CONCEALMENT IN COLONIAL DRESSING FURNITURE

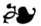

JENNIFER VAN HORN

CHARLESTON, SOUTH CAROLINA, CABINETMAKER William Jones's 1785–90 dressing chest is one of the most luxurious pieces of furniture crafted in early America (fig. 7.1). The quality of the chest's materials and craftsmanship is immediately apparent on its serpentine façade, from the dynamic sweep of the grain in the book-matched, mahogany-veneered drawer fronts to the rosewood bands and fan inlays that frame each drawer. Yet, surprisingly, the expense and attention lavished on the chest's *interior* surpasses that visible on its *exterior*. The top drawer opens to reveal a sophisticated dressing drawer equipped with a ratcheting looking glass, twelve rosewood-lidded compartments, and two sets of partitioned openings, lavish fitments intended to house "combs, powders, essences ... and other necessary equipage" (fig. 7.2).[1]

While sumptuous, Jones's is only one example of the high-style dressing chests and tables with equipment concealed in their interiors that gained popularity throughout the British Atlantic world in the second half of the eighteenth century. Such intricate dressing furniture proved especially desirable in the southern colonies, where most elaborate dressing furniture was produced and used in early America. Indeed, by midcentury, Charlestonians had already adopted the outfitted chest of drawers as the most popular type of toilette furniture; a group of dressing chests produced by an unknown Charleston craftsman in the 1750s contain dressing drawers with ratcheting mirrors and lidded

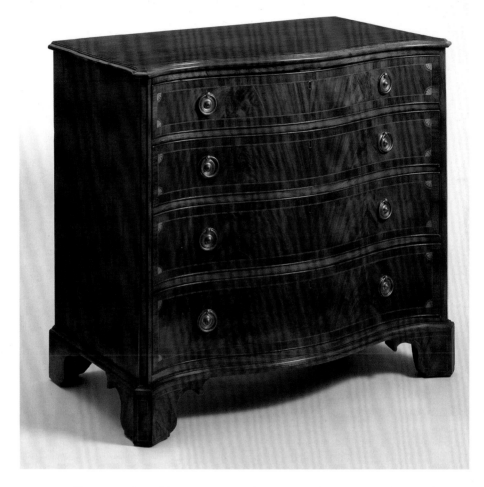

FIG. 7.1 William Jones, chest of drawers, 1785–90, Charleston, South Carolina. Mahogany, white pine, cedar. Courtesy Winterthur Museum, gift of Commander and Mrs. Duncan I. Selfridge, 1957.32.2. Charleston cabinetmaker William Jones constructed this elaborate serpentine-front dressing chest for an unknown purchaser. He embellished the drawer fronts with two matched mahogany-veneer panels surrounded by rosewood bands and fan inlays at each corner.

mahogany compartments similar to those in the later Jones chest. Given elite southerners' adherence to metropolitan taste, it is not surprising that they quickly embraced the newest forms of English dressing furniture. Many of the dressing chests used and sold in Charleston were imported directly from London, as were the "mahogany . . . bureaus with the furniture of a toylet" advertised by one of the city's merchants in 1766. Charleston's craftsmen also constructed complex dressing chests and tables by adapting the patterns published in English cabinetmaking manuals. For example, a dressing chest

FIG. 7.2 William Jones, dressing drawer from chest of drawers, 1785–90, Charleston, South Carolina (detail). Mahogany, white pine, cedar. Courtesy Winterthur Museum, gift of Commander and Mrs. Duncan I. Selfridge, 1957.32.2. The interior of this chest contains a dressing drawer outfitted with a mirror that can be raised and lowered. Surrounding the central mirror are several moveable partitions and twelve compartments with rosewood-veneer lids, outlined with bright polychrome stringing and topped by ivory finials.

with cabinet (fig. 7.3), constructed in the city around 1750–60 with a history of ownership in Virginia, is modeled on a pattern included in Thomas Chippendale's famous *Gentleman and Cabinet-Maker's Director*. It originally had an outfitted top drawer below a complex upper case with shelves and drawers hidden behind the hinged looking glass, and more compartments housed within its flanking side panels (fig. 7.4).[2]

Such elaborate dressing furniture suggests an efflorescence of the toilette ritual, an activity performed daily by elites throughout the Atlantic world, which was critical for early Americans' self-fashioning into civil beings—people who exhibited "politeness" and maintained a "freedom from barbarity" through bodily control and the embrace of refined objects. Although the washing of bodies and the donning of wigs contributed to genteel appearance, the application of cosmetics was the most transformative element of the toilette, and the most controversial. Cosmetics, understood to be "any [substance made] . . . to beautify and embellish the face or preserve or improve the

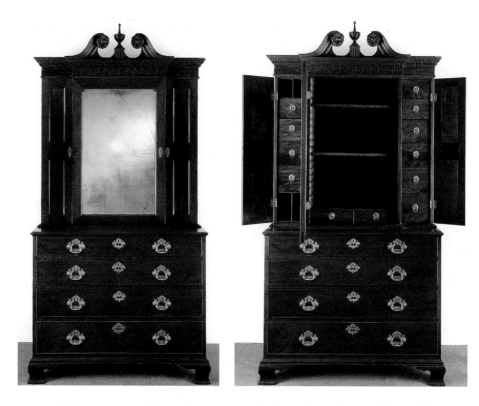

FIG. 7.3 Unknown maker, cabinet on chest, 1750–60, Charleston, South Carolina. Private collection. Photograph courtesy of Old Salem Museums & Gardens, Museum of Early Southern Decorative Arts (MESDA) Object Database File s-7418. An unknown Charleston cabinetmaker added a cabinet or press to a dressing chest to create this unique piece of mahogany dressing furniture. Below an imposing pediment, the upper case features a mirrored door flanked by two paneled doors. The overall format is adapted from a pattern in Thomas Chippendale's *The Gentleman and Cabinet-Maker's Director*.

FIG. 7.4 Unknown maker, cabinet on chest, 1750–60, Charleston, South Carolina. Private collection. Photograph courtesy of Old Salem Museums & Gardens, Museum of Early Southern Decorative Arts (MESDA) Object Database File s-7418. When opened, the central mirrored door of the cabinet reveals a series of shelves with two small drawers below. The two paneled side doors similarly disclose drawers in vertical rows. Although manufactured in Charleston, this piece descended in the Custis and Washington families of Virginia.

complexion," were sometimes used by men, particularly London's dandies, but were more commonly associated with women. Dressing furniture, too, was used by both sexes, but the most heavily outfitted chests were identified as women's in cabinetmakers' accounts and merchants' advertisements. For instance, Charleston cabinetmaker Thomas Elfe distinguished "Lady's dressing drawers" from the less expensive "dressing drawers" also noted in his account book, and Charleston merchant Thomas Woodin

advertised for imported "Ladies Dressing-Tables, with all the useful apparatus" in the *South Carolina Gazette and Country Journal* in 1767.[3]

The toilette, a place where identity was remade and civility enhanced, was also a site of potential counterfeit, where a user crafted a new appearance that many feared might bear no relation to his or her true virtue. Analysis of the dressing furniture and cosmetics used by elite colonial women, particularly those in Charleston, provides new insight into the realignment of the complicated relationship between people and objects that took place throughout the British Atlantic world in the eighteenth century, as consumers turned increasingly to new types of material goods to express their civility. Attention to the material culture of elite southern women's toilette rituals reveals that colonists perceived dressing furniture as a unique type of object that enjoyed a distinctive bond with female users. I argue in this chapter that it was dressing furniture's special status that enabled it to both spur and ultimately help allay fears about authenticity and deception that threatened to undermine early Americans' faith in civility as a system for structuring individual behavior and social progress.

In order to understand the form and function of dressing chests like Jones's, we must first resituate them within the toilette ritual. This task is made difficult by the secrecy surrounding colonial women's toilettes. In England, the dressing ritual was often a sociable occasion and a means of asserting class or rank. Elite English women modeled their toilettes on the French *levee*, where royal and eventually aristocratic women invited guests into their private chambers to view their rouging and powdering. Such public toilettes were fictive performances (the real work of grooming and cosmetic application had been done prior to the event) designed to demonstrate a woman's graceful demeanor and showcase her expensive dressing accoutrements. Unlike their English counterparts, American colonists considered the dressing ritual a private ablution that should be hidden from the eyes of genteel peers rather than publicly celebrated. Whereas many French and English women elected to have themselves depicted at their toilettes, no representation of any colonial woman at her dressing table is known to have been created, nor have any written descriptions of a colonial woman's toilette been discovered. This paucity of early American sources renders the furniture used during the dressing ritual the primary body of evidence for study of the toilette's social meaning in early America. It also encourages scholars to situate these objects within the rich literary and visual culture that spanned the Atlantic rim and bound North American colonists to the metropole. Elite southerners' taste for British goods extended beyond furniture to encompass the satirical prints—manufactured in London—that they imported in large numbers, the novels and periodicals, published in the metropole, that wealthy Charlestonians purchased for their libraries, and the London-made powders, rouges, pomades, and cosmetic manuals that were widely available throughout the colonies.[4]

Advertisements in colonial newspapers indicate that elite southern women, like their metropolitan counterparts, filled the drawers of their dressing chests with imported cosmetics purchased from local merchants, such as the "honey and orange water . . . court plaister, Italian wash . . . puffs . . . and washballs" that Balfour and Barroud advertised in the *Virginia Gazette* as "Just Imported" from London in 1766. Colonial women also used washes, pomatums, and powders that they manufactured themselves from popular recipes, including one for a "French pomatum," recorded in Charlestonian Harriott Pinckney Horry's receipt book of circa 1770. Both cosmetic manuals and books on housewifery contained recipes for cosmetics, and the necessary ingredients could be assembled from plantation resources coupled with items sold by local apothecaries or supplied by merchants. Cosmetics commonly included animal fat (in Pinckney's recipe, "one pound Beef marrow [and] one pound of hogs lard"), small amounts of beeswax or spermaceti, sweet-smelling floral essences, and often lead-based whitening agents, known as "ceruse" or "white loaf," or red pigments, such as "Cochineal" or "red Sanders."[5]

Cultural critics in the eighteenth century argued that by lathering their faces with white pomade, dabbing their cheeks with carmine or rouge, and rubbing red salve onto their lips, women did more than simply enhance their beauty. They made new faces, literally "painting"—the popular term for cosmetic use in the period—different "Lips, Cheeks, and Eyebrows, by their own Industry." The many physical similarities between the act of portrait painting and the application of cosmetics probably sparked the association between makeup and art production, one that was strong in Europe as well as in Great Britain and its colonies. Not only did the small brushes women used to apply cosmetics resemble those employed by a painter, but their ratcheting mirrors—such as that in Jones's chest—also looked like miniature painters' easels, which consisted of a similar wooden "frame" that could be "set either the more sloping or more upright" to suit the artist as he or she worked. Finally, the same colored pigments and lead-based paints were used in both activities. In the colonies, merchants even offered identical supplies to artists and to women. James Peters, a "Druggist & Chymist" in Lancaster, advertised in the *Pennsylvania Journal* in 1764 "all sorts of colours neatly prepared for either house or face painting *viz*. White lead ground in oil, red Lead . . . verdegrease . . . carmine, flake white . . . together with brushes, camel hair pencils, gally-pots, bottles, [and] viols." Peters's pigments, "just imported in the last vessels in Philadelphia from London," could be used by any sort of painter to cover a house, a canvas, or a face.[6]

Equating a woman's toilette with an artist's creation of a portrait called attention to the dressing ritual as a productive action by which a facsimile was created. As artists produced likenesses of their sitters, so too did women at their dressing tables paint second faces that were related to but recognizably different from the originals. The London print *The Toilet* from 1780 (fig. 7.5) depicts the ritual as an act comparable to self-portraiture. The printmaker shows a woman in profile seated in front of her

FIG. 7.5 Robert Sayer and John Bennett, *The Toilet*, 1780. Ink, watercolor, laid paper. London, England. Courtesy Winterthur Museum, Museum purchase, 1955.14.2. This hand-colored mezzotint, produced in London, depicts a woman seated before a well-appointed dressing table spread with pins and toiletries.

dressing table. The reflection in the woman's looking glass is not what she would see when seated in front of her table but appears to be a bust-length portrait in a gilt oval frame, suggesting that she did not merely supplement her face but "painted" a copy of her visage similar to an artist's depiction. The linkage of women's reflections in their mirrors with artists' portraits enabled those around the British Atlantic world to understand the mysterious transformations that occurred at the dressing table by analogy to another system in which the body was similarly improved and represented. Because applying cosmetics entailed the alteration of the body's surface, what might today be seen as a subtle enhancement was thought in the period to be a radical improvement that could dramatically change bodies and alter identity.[7]

An eighteenth-century viewer perceived any modification of the skin to have tremendous significance because of the important role that anatomical and aesthetic treatises afforded the organ. If the skin was a veil that concealed the mysterious inner workings of the body, it was also a screen, or what Diderot labeled a "living canvas," that signaled the physical and moral state of the body it covered. Physicians and natural historians argued that the skin, especially that of the face, registered "the expressions of every passion by greater or less[er] suffusions of colour," as Thomas Jefferson put it in his *Notes on the State of Virginia*. The awakening heat of base passions such as anger or sexual arousal appeared on the face as a momentary blush or flush. If a person experienced such dangerous desires consistently, manuals warned, a "shameless Bronce [*sic*]" would "invade each Feature," reddening the skin permanently. In addition to changing the skin's hue, hedonistic pursuits also marred its surface, causing sores and pimples, thought to be the result of an overabundance of certain humors.[8]

A person's skin thus testified to the state of his or her virtue: those who were civilized, meaning able to subdue their base passions, had "smooth," "white," and "polish[ed]" skin that was "properly," rather than excessively, "tinged with red." Those ruled by their animal urges, by contrast, could be recognized by their rough, blemished, or darkened skin, reinforcing contemporary understandings of racial characteristics. Cosmetics, however, offered an opportunity to protect, "maintain," or "improve" a civil exterior. Just as a portrait painter regularized and perfected his sitter's physiognomy with paints, women used pigments "to whiten the complexion and hide . . . defects," subduing their exteriors into a state of harmonious regularity. Like portraitists preparing a canvas by "fill[ing] the little holes" and making "the field very equal and smooth," women filled in scars and pitted skin with pastes and pomades, and then, as an artist would, they augmented the surface with ground pigments that added a finishing layer of color to an otherwise white appearance.[9]

While performing their toilettes, colonial women became civilizers of their own unruly bodies. Smoothing away moral imperfections by disguising bodily ones, they diminished both the evidence and the effect of the dangerous desires that threatened their civility. Advertisements and manuals on cosmetics promised that their products

could counteract the visible effects of ill behavior, "repair[ing] the Wastes of Languor," "brac[ing] up the skin from relaxed habits," and helping control the passions internally. "Cooling" creams contained "cold, viscid" ingredients like milk, cucumbers, melons, and beans that aimed to dampen the humors and dispel hot desires, thus reducing "unnatural Heats in the face" and "rendering the Skin perfectly white and smooth." White lead, a common ingredient in many pomatums, was also believed to have a cooling effect and was even used as an ingredient in salves for burns, as it could "effectually take out the Fire." An advertisement for a "beautifying Lotion" printed in the *New York Gazette* in 1763 maintained that the cream had a direct effect upon the body's humors and would eliminate "Pimples . . . Carbuncles, and all other Cutaneous Deformities" by "exud[ing] . . . and correct[ing]" the "obstructed Humours" that "occasion these Maladies."[10]

Cosmetics' ability to heighten civility was important for all polite Britons, but it was especially critical for southern colonists who needed to counteract the dangerous effects of a brutal climate in a land peopled with "savages," both indigenous and African American. If the skin was a barrier, it was also a conduit through which external stimuli could affect the body's humors and complexion. As George-Louis Leclerc, Comte de Buffon argued in his *Natural History* (1749), "Man, white in Europe, black in Africa . . . and red in America, is the same animal [only] tinctured with the colour peculiar to the climate." Many scientists and explorers hypothesized that Africans' and Native Americans' skin colors, and in part their "savagery," stemmed from prolonged exposure to the hot sun, for, to the eighteenth-century British mind, climate was in large part responsible for "forming . . . Complexion, Temper, and consequently the Manner of Mankind." Africans were thus "scorched" with both sun and sin, with "the colour of hell set upon their faces." On the other hand, civil behaviors were thought to enhance the skin's fairness, so that "the Ways of Living, in Use among most Nations of white People, make their Colours whiter, than they were originally."[11]

Southern colonists worried especially about the effect on their civility of the blistering sun combined with the passions that were believed to increase in hot and humid conditions. South Carolina governor William Bull, for example, attributed the "languid" habits "acquired in the warm months of June through September" to the "genial warmth of the sun" and the absence of the "purifying cold winds" that "invigorated" them in the winter. Determined to avoid giving in to their base desires and darkening their skin, elite southerners turned to cosmetics that promised "to prevent" or to "clear a Sun-burnt Complexion," such as the "cold cream for sun burning" just "imported from London" advertised by Charleston milliner Agnes Lind in the *South Carolina Gazette* in 1766. A recipe for a wash "to cure red or pimpled faces" caused by heat or sunburn was also included in *The Compleat Housewife, or Accomplish'd Gentlewoman's Companion*, published in Williamsburg in 1742. The author, Eliza Smith, not only recommended applying a solution of lemon, vinegar, and "cooling" bean flowers to the

face but also prescribed a strict diet of cucumber, mutton, and oatmeal, "Morning, Noon, and Night, without Intermission, for three Weeks." The extremity of such beauty regimens and the frequency of cosmetic advertisements and printed materials intended for a female audience suggest colonial women's desperation to maintain and preserve their "clear complexion." In an American environment, their white faces were critical for visually asserting their "freedom from Barbarity" by contrasting their whiteness with the darker skins of the "savage" others who surrounded them.[12]

Analyzing early American dressing chests' construction and mode of use reveals the furniture's active and equal participation in elite women's crafting of civil exteriors through cosmetics. Because each step of the toilette required the user to manipulate her dressing chest, every stage of the ritual was accompanied by a concurrent alteration of the object. Accessing and applying the makeup housed within a dressing drawer, such as that of the Jones chest, required constant maneuvering: first, a user unlocked and opened the top drawer; then she ratcheted up the mirror before removing the lids from individual compartments to access the bottles, vials, or gallipots inside. After applying pomades and powders, she repeated the entire process in reverse: capping boxes and bottles, reaching back into the drawer to fit them into their containers, replacing lids, pushing down the mirror, and finally closing and locking the drawer. The changes the toilette wrought upon the user's body were paralleled by the effects it had upon her dressing chest, making the ritual a process of mutual and concurrent change for both woman and object.[13]

At their toilettes, women engaged with furniture in a way that was more bodily, personal, and individuated than in their interactions with objects during other polite rituals, promoting an especially close relationship between dressing chests and their female users. By design, a piece of dressing furniture and its component looking glass can be used by only one person at a time, and, where economically possible, they were designated for use by only one person within a household. Moreover, dressing chests and mirrors could be arranged to conform to a specific body in a way that other furniture could not; any ratcheting or "swinging" glass allowed the woman to adjust the looking glass for her own use. Along with the sustained bodily contact between user and furniture, the corporeal nature of the goods stored within dressing tables and chests strengthened the connection between woman and object. In addition to cosmetics, dressing tables also typically housed jewelry, combs and brushes, hairpins, and straight pins. That dressing furniture's role in storing and protecting objects closely associated with the user's body helped to imbue it with a special status is evident in the 1782 will of Betty Randolph, wife of Virginia planter and Speaker of the House of Burgesses, Peyton Randolph. Betty Randolph made special provision for her dressing objects, instructing that "my dressing Table and Glass that stands in my Chamber and the Cabinet on the Top of the Desk" should be given to niece Elizabeth Harrison, along with "all my wearing Cloth[e]s . . . my miniature picture of my dear Husband,

[and] my watch." Randolph grouped her dressing furniture with objects worn on or close to her person: her clothing, a watch that she would have pinned to her costume, and a miniature portrait of her husband, typically worn either as a pin or on a necklace or bracelet. Given Randolph's evident emotional association with her husband's miniature, a form of portrait that facilitated private contemplation, it is not surprising that, as the Randolphs had no children, she chose to bequeath it to the niece who lived with her and would value it as she did. Her decision to leave Elizabeth her dressing furniture as well speaks of a similar desire to bestow possessions to which she had a personal attachment upon someone whom she knew well.[14]

The intimate connections forged during the toilette between makeup, furniture, and the painted face bound dressing chests and women's bodies together, both literally through the repetitive touching of cosmetics, skin, and mahogany surfaces, and in the larger British Atlantic cultural imagination, where dressing furniture and women's faces appeared as part of the same material continuum. If the colorful interior of the dressing drawer in the Jones chest—which features bright red, yellow, and black stringing around each compartment lid—appears to have been tinted with the pigments kept within it, then the vibrant inlays, painted ornaments, and japanned surfaces that cabinetmakers recommended to enhance the "beauty and elegance" of a dressing chest's exterior also recalled women's embellished faces. Thomas Chippendale recommended japanning—the application of a chinoiserie scene that was then covered by layers of lacquer or varnish—as the best way to finish his "Dressing-Table for a Lady," while Hepplewhite's cabinetmaking manual suggested veneer and inlay as the appropriate way to embellish the "Tops of Dressing Tables and Commodes." Japanning and veneering paralleled the act of making up a woman's face, dividing the exterior of the piece from the interior by enhancing its visible surface. Contemporary authors looked to such dressing furniture for metaphors for women's painted skin, describing cosmetic application as the "lacquer[ing of a] face with many varnishes," and promising that "Beautifying Wash" would render the complexion "as clear and glossy as a looking glass."[15]

The blurring of the boundary between a woman's body and her dressing furniture is especially visible in the practice of costuming dressing tables. The English print *The Toilet* (fig. 7.5) illustrates the appropriate types of covering for a dressing table, which included a fabric drape or hood placed over the looking glass, a ruffled dressing table cover, and a floor-length skirt. Chippendale's *Director* identifies this skirt as a "Petticoat," a reference to women's clothing that is not coincidental; probate inventories from Virginia and Maryland indicate that elite colonists commonly selected "Marseilles"—a white quilted fabric with a raised decorative pattern—for their dressing table covers, and that they purchased the same material for their petticoats. Inventory takers' notations of "a muslin twilite [toilette]," a "diaper Cover," and two "small worked [i.e., embroidered] Toilettes" indicate the use of "Marseilles" at the

colonial toilette, while the frequent appearance of "Marseilles" in southern merchants' advertisements and observers' accounts attests to the fabric's popularity for women's petticoats. Virginia tutor Phillip Fithian, for example, noted a Miss Hale who wore a "white Holland gown, with cotton diaper quilt very fine, lawn apron [and] a small tuft of ribbon for a cap." Women not only used "Marseilles" for both costume and dressing covers; sometimes they even reused a piece of "Marseilles," moving it from their bodies to their tables. The central portion of a dressing table cover now in the Winterthur Museum's collection is a piece of an eighteenth-century "Marseilles" petticoat that originally covered a woman's body.[16]

A woman and her toilette furniture were so closely aligned that a dressing table could be represented as a kind of facsimile or three-dimensional portrait of its user, linked through the similar textiles that covered furniture and woman. In the print *The Toilet*, for example, the woman's and table's matched costumes create a visual equivalency, as the figure's ruffled skirt recalls the ruched edge of her dressing table cover, while her white bonnet is echoed by the tuft of fabric above her mirror. Woman and table appear to be an original and her copy, so that the furniture becomes a kind of body double in its own right. Phillip Fithian's description of Miss Hale's white gown, quilted petticoat, and white bonnet adorned with ribbon would equally suit the costumed table in *The Toilet*, with its similar quilted petticoat, white cover, and white hood accentuated with ribbons. The reflected face in the table's looking glass only heightens the viewer's impression that the dressing furniture replicates the female user.[17]

This perceived connection between a woman and her dressing furniture extended to the belief that the moral character of the user could be mirrored by her dressing table. In a set of prints by William Hogarth, a woman and her dressing glass are so thoroughly enmeshed that a threat to the civility of one has a destructive impact on the other. Hogarth's engravings, *Before* and *After*, circa 1736, portray a scene of seduction set in a woman's bedchamber (figs. 7.6 and 7.7). In the first print, the woman resists, pushing against her lover's head with one arm as she grabs onto her dressing table with the other, causing the furniture to tip forward and its drawer to fall open. In the second print, we see the moment after sexual intercourse. As the man pulls up his breeches, the woman clings to him beseechingly, wiping perspiration from her face with a handkerchief. Her dressing table lies overturned in front of her, its swinging glass smashed and her cosmetics crushed. The contents of the dressing table have tumbled out just as the base passions erupted, the furniture's shattered mirror paralleling the destruction of the woman's painted face, which has melted from the heat of awakening desires. Though Hogarth's prints may initially appear to be a scene of forced sexual intimacy, details in the engravings suggest that the woman's resistance, and by extension her appearance of politeness, is a charade. Her stays are prominently displayed on the chair in the foreground of both prints, indicating that she has removed them in anticipation of her lover's arrival and received him "en dishabille" in her chamber, hinting at her

FIG. 7.6 William Hogarth, *Before*, ca. 1736. Etching with engraving. London, England (lwlpr22250). Courtesy of The Lewis Walpole Library, Yale University. Hogarth portrays a seduction, set in a woman's bedchamber, which has disastrous consequences for her dressing table and dressing glass, seen teetering precariously at the left of the print.

FIG. 7.7 William Hogarth, *After*, ca. 1736. Etching with engraving. London, England (lwlpr22251). Courtesy of The Lewis Walpole Library, Yale University. In this pendant print, Hogarth depicts the negative results of awakened passions, both for the unhappy couple and for the woman's dressing glass, which lies shattered on the floor before them.

FIG. 7.8 Thomas Rowlandson, *Six Stages of Mending a Face, Dedicated with respect to the Right Hon-ble. Lady Archer*, 1792. Hand-colored etching. London, England. The Elisha Whittelsey Collection, The Elisha Whittelsey Fund, 1959, 59.533.463. The Metropolitan Museum of Art, New York. Photo: www.metmuseum.org. In this hand-colored etching, Rowlandson lampoons the transformations made possible by cosmetics. Rouge and paint, along with dentures and a wig, are powerful enough to transform an old bald woman into one who appears to be young and beautiful.

amenability to a sexual relationship. A set of books, labeled "NOVELS" and "ROCHESTER POEMS" spill out of the dressing drawer along with a collection of sermons titled "THE PRACTICE OF PIETY," implying that while the woman wishes to appear virtuous, she has amorous intentions.[18]

Hogarth's *Before* and *After* address a question that abounded in the satirical texts and popular engravings that circulated through the British Atlantic world: if a woman's civil exterior could be assumed and then removed so easily, what relationship did her appearance bear to her inner morality? Did women use cosmetics to "improve" their characters, or did makeup merely "conceal" their base natures? Thomas Rowlandson's *Six Stages of Mending a Face* from 1792 (fig. 7.8) equates a woman's toilette ritual with the donning of a mask, a disguise that conceals her physical and moral decrepitude. In the print, a grotesque woman applies a wig, false teeth, and makeup to transform herself into a sexually desirable beauty. The engraving's final stage, at the bottom left, shows the now attractive woman comparing a black mask, ostensibly a powder mask, with her own entirely "artificial" visage. The driving force behind the tremendously popular cosmetic manual *Abdeker, or The Art of Preserving Beauty*, first published in 1754, was to create makeup that could conceal a woman's emotions and act as a kind of

mask, a "Covering or Sheath" under which "the Passions might have their Play without being perceived." The guide purports to be the work of the Arabian physician Abdeker, who is in love with Fatima, a member of a sultan's harem, and develops cosmetics to allow his lover to conceal her desire for him. By rouging Fatima's cheeks Abdeker gives her "Face a fix'd Colour, instead of that Paleness and Redness" that "necessarily accompanied her Passions." He thus prevents Fatima's waxing and waning base desires from being discovered by producing "a different Countenance from what she had naturally." Thomas Jefferson used similar language to describe what he perceived as "that immovable veil of black which covers all the emotions of the other race" and prevented viewers from perceiving African Americans' true feelings. He preferred instead "the fine mixtures of red and white," which he believed to be the purview of the white race. For Jefferson, the opacity of black skin was a permanent mask or "veil," like Fatima's cosmetically produced flush, which denied the spectator a chance to know the other race's emotions.[19]

191

As Rowlandson's print suggests, the use of cosmetics posed a direct threat to the legibility of civility by enabling users to keep their passions from becoming visible on their skin. Cultural commentators condemned face painting for its deceptive capabilities, reminding readers of the *London Magazine* that "all deceit is criminal, and painting is no better than looking a lye," a woman's "painted" face "all counterfeit." Just as a counterfeit bill resembled actual currency but was not backed by specie, so might a "painted" face duplicate the appearance of civility but not reflect a woman's true virtue. In monetary counterfeit, a forgery could be detected through careful scrutiny of the paper money, bond, or bill of exchange, since the counterfeiter always left a trace of his or her crime on the falsified document. With cosmetic face painting, the task was more difficult. Although Doctor Anthony Fothergill, contributor to London's *Universal Magazine*, threatened that upon "exposure to the sun, [or] a hot fire" the "roses soon fade," the "whiteness contracts a dingy brown," and "when the mask falls off, . . . the spectre stands confessed," in reality pomades and rouges melded imperceptibly with a woman's face to fool even the "most discerning eye," as an advertisement for "vinaigre de rouge" assured the "*Ladies of Charles-ton*" in the *City Gazette and Daily Advertiser*. Cosmetic manuals and advertisements routinely promised that women could use their powders and rouges "without any Danger of being suspected," as the cosmetics would not "come off by perspiration, or the use of a handkerchief," nor could they "be distinguished from the natural bloom of youth."[20]

Despite the constant repetition of the toilette at elite households across the Atlantic world, the ritual's potential for disguise engendered tremendous cultural anxiety. In satirical literature, the fear that one could no longer distinguish between counterfeit and genuine identity was manifested in the common trope of a man falling in love with, and sometimes even marrying, a woman who appeared youthful and demure but was really ugly, diseased, old, or lascivious. This allegedly happened to

an unfortunate husband who wrote to the *Spectator* after discovering that his wife's features "were all Effects of Art"; in the morning, "she scarce seems young enough to be the Mother of her whom I carried to Bed the Night before." In 1770, a member of Parliament jokingly proposed an act that "prohibited every woman [from] . . . trying to entrap any of His Majesty's subjects by . . . scents, paints, cosmetic washes, artificial teeth, [and] false hair," warning that any woman who used these substances "shall incur the penalty of the law now in force against witchcraft" and that their "marriage upon conviction shall be null and void." Like counterfeiters who created false notes, women who used cosmetics deliberately crafted exterior appearances that did not rightfully belong to them and entrapped men foolish enough to be taken in. The humorous proposal to legally prosecute such women for witchcraft satirically adopted a legal solution similar to the serious legal penalties for counterfeiting currency.[21]

As a site dedicated to the construction of external appearance through the application and manipulation of material goods, the toilette became the focus of both Britons' and Americans' fears about the malleability of identity made possible by the consumer revolution. The rise of consumerism posited that identity was not only external, expressed through material possessions, but could also be changed through the purchase and use of certain goods. This belief in exteriority was critical for the creation of the British Empire, as it allowed identity to be communicated by sight rather than through long-standing community knowledge. Yet Britons and colonists alike struggled to reconcile themselves to the contradictions in a system of identity that depended upon the use and display of material objects. What exactly was the relationship between civility and external appearance? Were there any permanent markers of politeness that could not be altered? How did one, or even could one, distinguish between the appearance of virtue crafted at the dressing table and the attainment of politeness through appropriate action? As women's civility was deemed more precarious, and their identities less fixed than those of men, female consumers bore the brunt of much of the fear over the new ability to shape identity simply by changing costume or painting the face. Projecting such anxiety onto women enabled men to dismiss their own immersion in and reliance upon consumer goods even as it bolstered their ideas about women's inherent lack of morality and overwhelming desires.[22]

Given the perceived bodily connection between a woman and her dressing furniture, anxious viewers wondered if they could scrutinize the site of the toilette in order to deduce what cosmetics a woman used and, by extension, what passions she concealed. Jonathan Swift's famous poem "The Lady's Dressing Room" (1732) details the disastrous consequences of such an attempt. Swift's verse narrates the trials of Strephon, who is enamored of Celia and curious to see what she does during the "Five Hours" she spends dressing. Strephon waits until Celia leaves and sneaks into her chamber. He is dismayed by what he finds: "a dirty Smock . . . / Beneath the Arm-pits

well besmear'd" and a "Forehead Cloth with Oyl upon't," along with the cosmetics she uses to craft her appearance, "Gallypots and Vials" filled "with Washes, some with Paste, / Some with Pomatum, Paints and Slops." His final revelation, however, is the most traumatic. "Resolv'd to go thro' thick and thin" to discover the mysteries behind his beloved's exterior, Strephon approaches a piece of furniture in the corner of the room that appears to be a cabinet. Ignoring the ominous "Vapours [that] flew from out the Vent," he begins "lifting up the Lid, / To view what in the Chest was hid." To his horror, he discovers neither expensive jewelry nor love letters but Celia's chamber pot. After groping "The Bottom of the Pan" and "fowl[ing] his Hands," the "Disgusted" Strephon steals away, "Repeating in his amorous Fits, / Oh! *Celia, Celia, Celia* shits!"[23]

The poem connects the deceit perpetrated by Celia to the fraud performed by her so-called cabinet. Swift's description—"In vain, the Workman shew'd his Wit / With Rings and Hinges counterfeit / To make it seem in this Disguise, / A Cabinet to vulgar Eyes"—uses the language of deception to describe Celia's dressing furniture. The poet implies that Strephon should have known the truth about Celia's nature as well as the real function of her cabinet but instead is fooled by the "counterfeit" furniture just as he has been duped by his lover's "Ointments, Daubs, and Paints and Creams." In Swift's poem, woman and furniture perform the same deception; Celia masquerades as "sweet and cleanly," hiding her humoral extrusions under a cosmetically enhanced appearance, just as her dressing furniture conceals bodily waste by pretending to be a genteel cabinet. Once Strephon pierces the illusion of Celia's toilette, he becomes "blind / To all the Charms of Female Kind" and can no longer be deceived by any woman's pleasing exterior.

Both Swift's poem and Hogarth's prints so closely connect a woman's façade—her appearance of civility—with her dressing furniture that in exposing the fraudulence of one the viewer is able to pierce the deception of the other. Anxieties over women's ability to alter their skin to create fraudulent selves warred with the hope that by solving a piece of furniture's inner mysteries one could, like Strephon, know the true character of the person who used it. Yet dressing furniture like Celia's "cabinet" resisted attempts to reveal owners' secrets. Perhaps the best example of this potent mixture of furniture, woman, and deception comes from the famous Rudd-Perreau scandal that dominated newspapers in Britain and America in 1775 and even influenced furniture design.

Hepplewhite's cabinetmaking guide contains a pattern for a mysterious "Rudd's Table" (fig. 7.9), which, he informs the reader, "derives its name from a once popular character, for whom . . . it was first invented." His audience would have recognized the namesake immediately as the infamous Margaret Rudd, the key character in a counterfeiting case that culminated in two executions. Rudd, her common-law husband, Daniel Perreau, and his twin brother, Robert, were accused of forging bonds from wealthy Londoner William Adair and using them to defraud lenders out of tens of

thousands of pounds. Rudd testified against the Perreaus in exchange for immunity, winning the support of the public by her "very elegant appearance" and the seemingly "artless manner in which she told her story." Although Rudd maintained her innocence in the affair, the Perreaus claimed that she, a former courtesan, was the mastermind behind the scheme. They testified that Rudd herself forged the bonds and then duped the brothers into passing the counterfeits by claiming that Adair was her biological father and had given the bonds to her as gifts. Rudd, they testified, was "the most artful of impostors" and had donned a "mask of . . . faithful friendship" in order to cover "the most wicked and treacherous artifice."[24]

In order to perpetrate the scheme, Rudd and/or the Perreaus not only forged bonds, counterfeiting Adair's signature, but, more important, they developed counterfeit identities that fooled those around them into accepting their dubious forgeries. Bonds, like bills of exchange and promissory notes, depended for their value on the reputation of the person who issued them, and in accepting them the creditor, whether a bank or an individual, assumed the risk that the issuer could provide the funds they represented. The material possessions of Margaret Rudd and Daniel Perreau were a critical component of the counterfeiting scheme's success. In the years leading up to their arrests, Margaret and Daniel consumed lavishly and visibly, renting and furnishing a town house in the fashionable Pall Mall district, purchasing a carriage, and outfitting themselves with new clothes and jewelry valued at roughly £3,000. Their heightened level of consumption enabled them to enter London's fashionable society and reassured friends and business associates that the family had already begun to benefit from their relationship to Adair, enabling the pair to pass more counterfeited bonds.[25]

The story of Rudd's counterfeiting and impersonation held a particular fascination for American colonists, who faced constant threats of forged currency and imposters. Owing to the endemic lack of specie in America, colonists developed many types of paper currency, and as a result faced frequent incursions by counterfeiters who could pass forged bills in distant locations where merchants and shopkeepers were unfamiliar with the correct appearance of a note. The transitory nature of colonial life also helped counterfeiters and con men to craft fictitious identities and elude authorities. The famous colonial confidence man Tom Bell used tactics similar to those employed by Margaret Rudd and the Perreau brothers to pass forgeries. Dressed in expensive clothing and exhibiting a genteel demeanor, he moved throughout the North American colonies and the West Indies between 1733 and 1750, forging bills of exchange and letters of credit and claiming to be related to persons of good standing in order to swindle his marks. Bell used at least nineteen different false names, posing at various times as a minister, a schoolteacher, a surveyor, and the son of a colonial governor. Though Bell achieved celebrity status thanks to the coverage of colonial newspapers, countless less-well-known chiselers operated throughout North America.

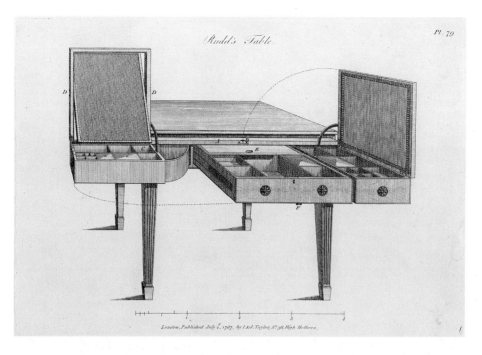

FIG. 7.9 "Rudd's Table," from A. Hepplewhite and Co., *The Cabinet-Maker and Upholsterer's Guide* (London: I. and J. Taylor, 1789). Courtesy The Winterthur Library: Printed Book and Periodical Collection, RBR NK2542 H51*. Hepplewhite has designed an extremely intricate dressing table that includes not only a fully fitted dressing drawer in the center but two additional dressing drawers, one on either side, with adjustable mirrors that swing up. The table is named after Margaret Rudd, a Londoner infamous for her involvement in a counterfeiting scheme and the ensuing legal trial.

Whether men who deluded communities into accepting them as ministers despite their lack of credentials, or women with no formal education who pretended to be schoolmistresses, such tricksters used purchased goods and carefully crafted appearances to counterfeit vocations, reputations, and familial connections.[26]

While the Perreaus' damaging claims compelled the court to try Margaret Rudd in spite of her plea agreement, she was found innocent. Ultimately, the court could not believe that she was anything other than what she appeared to be, a genteel woman and a victim of the Perreaus' machinations. Members of the public held contradictory views, but after the Perreau brothers' executions in 1776, opinion turned forcefully against Rudd. The Rudd/Perreau trial, with its interlinked counterfeiting of bonds and identities, shocked Britons and Americans alike, proof of the potentially deadly consequences of women's ability to manipulate their appearances. By naming his most complex piece of dressing furniture after Rudd, Hepplewhite connected his furniture design with Rudd's infamous fraud and with her own dressing table; supposedly of "curious construction," it had been made especially for her. Hepplewhite's

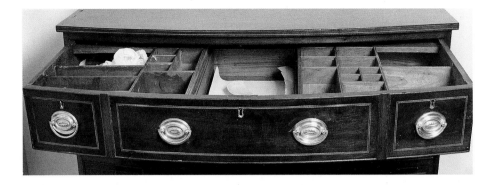

FIG. 7.10 Dressing drawer from chest of drawers, 1795–1805, Charleston, South Carolina. Private collection. Photograph courtesy of Old Salem Museums & Gardens, Museum of Early Southern Decorative Arts (MESDA) Object Database File s-900. An unidentified Charleston cabinetmaker cleverly disguised a dressing drawer by adding unnecessary handles, cock beading, and fake stiles to the exterior of the mahogany chest in order to make the top drawer appear to be three separate drawers.

"Rudd's Table," touted as "the most complete dressing table made, possessing every convenience . . . mechanism and ingenuity supply," features a capacious central drawer flanked by dual dressing drawers that swing out from the table, each with its own looking glass that rises into a vertical position when the drawer is opened. Not only do the table's multiple looking glasses and extensive fitments seem appropriate for a woman who counterfeited an appearance of civility so convincing that it protected her from execution, but its bifurcated design (it is split in half, with complete and identical dressing drawers on either side) suggests that two different people had performed their toilette rituals there, evoking Rudd's irreconcilable personas of victim and villainess. The sense of discrepancy continues in the table's overall appearance; when closed, its austere form gives no indication of the apparatuses that slide, swing, and spring from its interior, misleading the viewer about its contents just as the "decency" of Rudd's "whole deportment" kept the public from discerning her real character.[27]

Although "Rudd's Table" is the most extreme example of dressing furniture's potential for deception, colonial and early American dressing chests worked in a similar fashion to shield the site of the toilette from view by concealing the existence of functional elements within their cases, divorcing surface ornament from interior arrangement and camouflaging the means of access to dressing equipment. With its top drawer closed, Jones's dressing chest gives no visual clues about the array of dressing elements contained within but appears to be a conventional chest of drawers (fig. 7.1). Indeed, unless it is opened, it remains indistinguishable from a regular chest. The chest with cabinet, produced in Charleston around 1750–60 (figs. 7.3 and 7.4), also hides its dressing elements behind a seemingly substantial façade. Yet the hinged panels that flank the central mirror open to reveal two sets of small vertical drawers,

and the central looking glass has a set of shelves secreted behind its mirrored surface. A later group of dressing chests, produced in Charleston around 1795–1805, are even more disorienting, providing the viewer with false indicators about how to access their interiors (fig. 7.10). The chests appear to have three drawers across, and this is true for most of the case, but the uppermost drawer consists of one long opening that has been disguised by "sham" drawers—complete with cock beading, locks, and handles.[28]

The same sense of secrecy continues inside early American dressing furniture such as the Jones chest. In Swift's poem, Strephon ferrets out Celia's fraudulence through careful scrutiny of her "cabinet," but the labyrinthine interior of the dressing drawer renders such a search futile. Not only is the drawer partitioned into a warren of compartments (fig. 7.10), but layers of barriers prevent access to the items within. The chest is equipped with a writing slide, a leather-covered piece of wood that could be extended over the drawer and used as a writing surface. When closed, it functions as a lid or screen that hides the contents below. When the slide is pushed back to access the dressing drawer, however, another series of wooden compartment covers await, and nested within those were originally still more lids, resting atop the pomatum jars and gallipots that housed women's cosmetics. Dressing furniture not only kept the details of a woman's toilette ritual in the strictest confidence; it even denied that the user applied cosmetics at all, closing back up to present an embellished façade that, like a woman's painted face, betrayed nothing.[29]

Beyond the furniture form itself, showy textiles also concealed the site of the toilette by calling attention to the furniture's exterior surface while keeping viewers from seeing the dressing implements used or the means of accessing them. In his cabinetmaking manual, Thomas Chippendale instructed that the "Drapery" placed on dressing furniture should "be Silk Damask, with Gold Fringes and Tassels," and the probate inventory of Maryland planter Daniel Dulany of Annapolis, taken in 1754, suggests that elite southern colonists embellished their dressing tables with equally lavish textiles. Among the contents of the house's best chamber are listed a mahogany dressing table and "One Toylet with Silk Quilt and . . . Callico Muslin Covering." Dulany's "Toylet" was probably a floor-length piece of yellow silk damask made en suite with the bed hangings, window curtains, and twelve chair bottoms also noted in the inventory. It was valued at a staggering £6 (more than the mahogany dressing table it covered), which explains why the yellow silk toilette was covered by a dressing table cover made of a less expensive piece of calico.[30]

Such layers of fabric fulfilled a practical function by protecting mahogany surfaces from damaging grease, oil, and water and cushioning dropped pomatum jars and essence bottles. More metaphorically, these textiles recall Abdeker's cosmetic veil, a kind of fabric skin that extended over the table, obscuring drawer placement and protecting the items used at the toilette from detection. Thus, with the addition of textiles, even relatively common and straightforward dressing tables, such as one made

FIG. 7.11 Unknown maker, dressing table, 1755–70, southeastern Virginia. Black walnut with yellow pine, red cedar, white oak, and cypress. The Colonial Williamsburg Foundation, Museum purchase, acc. no. 1968-734, image no. TC1996-114. Constructed primarily of black walnut, this dressing table is a typical example of the simplified tripartite format that was extremely common throughout the northern and southern American colonies. It consists of two deeper drawers, one on either side of a longer shallow central drawer.

by an unknown cabinetmaker in southeastern Virginia between 1755 and 1770 (fig. 7.11), could hide the exact nature of a woman's toilette ritual. In the eighteenth century, dressing tables like this one rarely functioned alone but served as a base for the "whole dressing apparatus," a larger functional unit that consisted of "Dressing Table, Coverings & [looking] glass," as described in the inventory of Jesse Ball of Lancaster County, Virginia, taken in 1747. Most Chesapeake inventory takers valued dressing tables along with the covers and looking glasses that adorned them, indicating that they conceived of these objects as components of the same set. Decorating tables with such long textiles may have required the user to move fabric aside to access the drawers below, but it afforded women valuable privacy that enabled their toilettes to remain in view in the family's best bedchamber while simultaneously protecting their cosmetics from sight.[31]

Unlike Margaret Rudd, elite southern women did not need their dressing furniture or dressing table covers to conceal acts of criminal counterfeit. If anything, however, cosmetic face painting in the colonies had more dangerous consequences, conjuring fears that cosmetics could blur the line not only between internal state and external appearance but also between civilized self and "savage" other. For North Americans, altering the skin with cosmetics recalled indigenous peoples' and Africans' practices of painting the body with "crimson," "blue," and "black" pigments and oils. Such bodily adornments are visible in the earliest representations of Native Americans,

such as John White's watercolor *Indian in Body Paint* (fig. 7.12), which depicts warriors' "manner of their attire and painting them selves when they goe to their generall huntings" or to their councils. The artist shows red and blue lines and circles painted across the Native American's arms, torso, face, and legs. Such depictions of Indians' painted bodies substantiated claims that natives were in reality fair-skinned but dyed their hair black and made their skin darker by rubbing themselves with vegetable dyes and bear grease. In his 1775 *History of the American Indians*, British author James Adair assured readers that "the Indian colour is not natural" but "merely . . . artificial," achieved by painting "their faces with vermilion." Many Britons believed that Africans also used "dirt and black paints" to darken their skin, as Buffon repeated in his *Natural History*. Although ideas of racial characteristics were becoming more fixed by the end of the eighteenth century, cosmetic manuals still maintained that "black" skin could be made fair, promising "Brown ladies" that their "detersive penetrating applications" would "by degrees remove the . . . varnish that covers the skin" to "chang[e] the Tawyny Colour of the Face" and "whiten a dark Skin."[32]

An article from a London newspaper, reprinted in the *Boston Gazette* in 1763, warned that cosmetic use had the potential to break down racialized distinctions between civil and "savage" in North America. The author wondered "what demands there will be for all our [English] cosmetics" until "the Ladies of North America, erroneously called Savages, have entirely purified their complexions." He then imagined "the [future] people of taste throughout that country," a group that would include "Creolians, Canadians, Philadelphians [and] Mississippians," a combination of white, Native American, and mixed-race peoples. Advising colonists "to be careful who . . . you admit among you," he warned that the English, "flushed with success," had been ruined by their "open houses." In this cosmetically enriched future, Philadelphians, "flushed" with the passions, would no longer be distinguishable from Creoles and Mississippians—mixed-race and Native American people—who have "purified their complexions." Cosmetic use, along with the dangers of the North American climate, had compromised the civilizing project, so that the British Empire had failed to refine the "savage" others and had instead led Britons to become like them.[33]

For their part, elite American colonists complained that "the common people of England foolishly imagine" that they were a "compound mongrel . . . of *English, Indian, and Negro*" rather than "freeborn *British white subjects*." Even elite southerners faced assumptions in England that their skin had darkened as a result of their climate and contact with indigenous tribes and African Americans. When Charlestonian Eliza Lucas Pinckney, for example, introduced her daughter Harriott to Princess Augusta at Kew, the princess exclaimed in surprise at the white color of Harriott's cheeks after learning that an enslaved African had been her wet nurse. Claims that Americans were becoming dark-skinned reinforced the fears of colonial elites that indigenous peoples and African Americans could use cosmetics to make their complexions

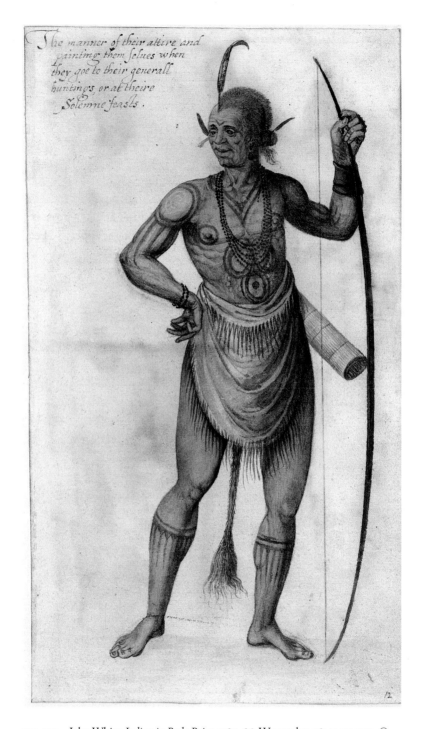

FIG. 7.12 John White, *Indian in Body Paint*, 1585–86. Watercolor, 263 × 150 mm. © The Trustees of the British Museum. All rights reserved. In this watercolor, English artist John White, one of the first artists to depict the inhabitants of North America, presents an Algonquin chief. The watercolor was subsequently engraved by Theodor de Bry and included in Thomas Harriot's *A briefe and true report of the new found land of Virginia*, published in 1588.

indistinguishable from those of whites. Colonial women's red cheeks, "under which the Passions might have their Play," might not be so different from what Jefferson labeled that "immovable veil of black which covers all the emotions of the other race," and Americans worried that eventually they would be unable to distinguish the counterfeited complexion of a "savage" from their own darkened cheeks.[34]

As a tool of disguise, cosmetics inherently contained the potential to break the bond between internal reality and external appearance. In the southern colonies, a place where cosmetics were doubly necessary to maintain a civil state, they further threatened to undermine the racialized system of civility. Because cosmetics prevented viewers from determining whether a woman's appearance was genuine or forged, any woman who "painted" faced the suspicion that she did not actually possess the level of civility that her complexion claimed. Worse still, she might appear to be a "savage" counterfeiter who only masqueraded as civil. In this context, deceptive dressing furniture became an essential means by which elite southern women prevented others from learning the details of their toilette rituals. It enabled women to negotiate dangerous ground by counteracting the effects of the American environment, while allowing them to deny their need for cosmetics' help. Dressing chests like Jones's thus allowed colonial and early American elites to maintain the counterfeit at the heart of the toilette ritual. To become civil required an act of repression and substitution, suppressing bodily urges beneath a pleasing front that denied the existence of an impolite self within. Being civil can be seen as an act of concealment, the assumption of a mask of politeness that could be achieved only for short periods, never permanently. William Jones's dressing chest and other pieces of dressing furniture used by elite southerners give us a greater understanding of furniture's role, not only in creating civil bodies but in perpetuating the deception necessary to maintain civility.

NOTES

The research and writing of this essay began during a fellowship at the Winterthur Museum and Library and continued during a Terra Foundation Fellowship at the Smithsonian American Art Museum, a Gilder Lehrman Short-Term Residential Fellowship at the John D. Rockefeller Jr. Library, Colonial Williamsburg, and a Henry Luce/ACLS Dissertation Fellowship in American Art. The essay benefitted substantially from Fredrika Teute's and Nadine Zimmerli's insights and Kathy Burdettte's editing at the Omohundro Institute of Early American History and Culture, and became a chapter in my book *The Power of Objects in Eighteenth-Century British America.* I am grateful for the generosity of the Omohundro Institute

and the University of North Carolina Press in allowing me to republish portions of that book chapter in this volume. I would also like to thank Linda Baumgarten, Edward Cooke, Linda Eaton, Brock Jobe, Christian J. Koot, Maurie McInnis, and Katherine Rieder for their contributions.

1. For Jones's dressing table, see Bradford L. Rauschenberg and John Bivins Jr., *The Furniture of Charleston, 1680–1820,* 3 vols. (Winston-Salem: Museum of Early Southern Decorative Arts, 2003), 2:486–90. The description of the drawer interior is from A. Hepplewhite, *The Cabinet Maker and Upholsterer's Guide* (London: I. and J. Taylor, 1789; reprint, New York: Dover Publications, 1969), 13–15.

2. The ad, for the merchant Reeve, Cochran & Poole, appeared in the *South Carolina and American General Gazette*, November 7, 1766, 6. For the popularity of the dressing chest in Charleston, see Rauschenberg and Bivins, *Furniture of Charleston*, 1:105–7; for the dressing chest with cabinet, see 1:92–95, and Thomas Chippendale, *The Gentleman and Cabinet-Maker's Director* (1762; reprint, New York: Dover Publications, 1966), plate 114. For the use of English cabinetmaking directories in the colonies, see Morrison H. Heckscher, "English Furniture Pattern Books in Eighteenth-Century America," *American Furniture* 2 (1994):173–205.

3. Samuel Johnson, *A Dictionary of the English Language: In Which Words are Deduced from Their Originals*, 2nd ed. (London, 1755–56), s.v. "civility." On the understanding and practice of civility in this period, see especially Norbert Elias, *The Civilizing Process*, trans. Edmund Jephcott (New York: Urizen Books, 1978); Richard L. Bushman, *The Refinement of America: Persons, Houses, Cities* (New York: Knopf, 1992); Woodruff D. Smith, *Consumption and the Making of Respectability, 1600–1800* (New York: Routledge, 2002), 179. For an overview of dressing forms, see especially Benno Forman, "Furniture for Dressing in Early America, 1650–1730: Forms, Nomenclature, and Use," *Winterthur Portfolio* 22, nos. 2–3 (1987): 149–64. For Elfe's dressing chests, see Mabel L. Weber and Elizabeth H. Jervey, eds., "The Thomas Elfe Account Book, 1765–1775 (Continued)," *South Carolina Historical and Genealogical Magazine* 40 (1939): 81–86, esp. 81, 82; Rauschenberg and Bivins, *Furniture of Charleston*, 1:105. Thomas Woodin advertisement appeared in the *South Carolina Gazette and Country Journal*, September 8, 1767. James Stewart defines "cosmetic" in *Plocacosmos, or The whole art of hairdressing* (London: printed for the author, 1782), 315. For the gendering of furniture, see Amanda Vickery, *Behind Closed Doors: At Home in Georgian England* (New Haven: Yale University Press, 2009), 279–90.

4. For the public performance of the *levee*, see Mimi Hellman, "The Levee," in *Dangerous Liaisons: Fashion and Furniture in the Eighteenth Century*, edited by Harold Koda and Andrew Bolton (New Haven: Yale University Press for the Metropolitan Museum of Art, 2006), 35–44; Tita Chico, *Designing Women: The Dressing Room in Eighteenth-Century English Literature and Culture* (Lewisburg: Bucknell University Press, 2005), 55–59. For portraits of English women at the toilette, see Marcia Pointon, *Hanging the Head: Portraiture and Social Formation in Eighteenth-Century England* (New Haven: Yale University Press, 1993), 162–64. For the increasing

popularity of cosmetics and cosmetic manuals at midcentury, see Aimee Marcereau Degalan, "'Dangerous Beauty': Painted Canvases and Painted Faces in Eighteenth-Century Britain" (PhD diss., Case Western Reserve University, 2007), 56–65.

5. For the types of cosmetics women applied in the eighteenth century, see Tassie Gwilliam, "Cosmetic Poetics: Coloring Faces in the Eighteenth Century," in *Body and Text in the Eighteenth Century*, edited by Veronica Kelly and Dorothea von Mucke (Stanford: Stanford University Press, 1994), 144–59. Examples of London-printed cosmetic manuals include Pierre-Joseph Buchoz, *The Toilet of Flora* (London: printed for J. Murray and W. Nicholl, 1772); *The New London Toilet, or A Compleat Collection of the Most simple and useful Receipts for preserving and improving Beauty, either by outward Application or internal Use* (London: printed for Richardson and Urquhart, 1778); Antoine Le Camus, *Abdeker, or The Art of Preserving Beauty*, translated from an Arabic Manuscript (London: A. Millar, 1754). For cosmetics imported into the colonies, see Richard Corson, *Fashions in Makeup: From Ancient to Modern Times* (New York: Universe Books, 1972), 237, 241, 254. The Balfour and Barroud ad appeared in the *Virginia Gazette*, July 25, 1766, 2. For Harriott Pinckney Horry's recipe, see *A Colonial Plantation Cookbook: The Receipt Book of Harriott Pinckney Horry, 1770*, edited by Richard J. Hooker (Columbia: University of South Carolina Press, 1984), 115.

6. The quotation about "painting" is from the *Spectator*, April 17, 1711; that about painters' easels is from the *Universal Magazine of Knowledge and Pleasure*, November 1748, 226–27. For the ingredients commonly used in cosmetics, see Degalan, "'Dangerous Beauty,'" 100–124. James Peters's advertisement appeared in the *Pennsylvania Journal*, March 29, 1764. See also Janice H. Carlson and John Krill, "Pigment Analysis of Early American Watercolors and Fraktur," *Journal of the American Institute for Conservation* 18, no. 1 (1978): 19–32. Arguments about cosmetics and their relationship to portraiture abound. See especially Melissa Hyde, "The 'Make-Up' of the Marquise: Boucher's Portrait of Pompadour at Her Toilette," *Art Bulletin* 82, no. 3 (2000): 453–75; Caroline Palmer, "Brazen Cheek: Face Painters in Late Eighteenth-Century England," *Oxford Art Journal* 31, no. 2 (2008): 195–213.

7. Diana Donald, *The Age of Caricature: Satirical Prints in the Reign of George III* (New Haven: Yale University Press, 1996), esp. 87.

8. For the skin, see Mechthild Fend, "Bodily and Pictorial Surfaces: Skin in French Art and Medicine, 1790–1860," *Art History* 28, no.

3 (2005): 311–39; Angela Rosenthal, "Visceral Culture: Blushing the Legibility of Whiteness in Eighteenth-Century British Portraiture," *Art History* 27, no. 4 (2004): 563–92; Claudia Benthien, *Skin: On the Cultural Border Between Self and World*, trans. Thomas Dunlop (New York: Columbia University Press, 2002); Barbara Maria Stafford, *Body Criticism: Imaging the Unseen in Enlightenment Art and Medicine* (Cambridge: MIT Press, 1991). For medical understanding of the humors and illness, see Roy Porter and Dorothy Porter, *In Sickness and in Health: The British Experience, 1650–1850* (London: Fourth Estate, 1988), 44–50, 64–65, 142–49. Quotations are from *Historical and Literary Memoirs and Anecdotes Selected from the Correspondence of Baron de Grimm and Diderot*, 2nd ed. (London: H. Colburn, 1815), 4:140; Fend, "Bodily and Pictorial Surfaces," 313; Thomas Jefferson, *Notes on the State of Virginia* (written 1782, published 1787), in *The Portable Thomas Jefferson*, edited by Merrill D. Peterson (New York: Penguin, 1975), 186–87; Thomas Marriott, *Female Conduct: Being an Essay on the Art of Pleasing; to be Practised by the Fair Sex, before, and after Marriage* (London: W. Owen, 1759), 178.

9. Quotation about the skin's color from Joseph Spence [Sir Henry Beaumont], *Crito, or A Dialogue on Beauty* (Dublin: R. Dodsley, 1752), 13. Quotations about portrait painting are from the *Universal Magazine of Knowledge and Pleasure*, November 1748, 225–33. For cosmetics' ability to "preserve" and "improve," see *New London Toilet*. For the statement about cosmetics' ability to "whiten the complexion," see Stewart, *Plocacosmos*, 317.

10. Buchoz, *Toilet of Flora*, 3, 54–55, 164–65; *New London Toilet*, 13; Mary Kettilby, *A Collection of Receipts in Cookery, Physick, and Surgery Taken from the 1746 Edition* (Nashville: Vanderbilt University Medical Center for the Canby Robinson Society, 1985), 45. For the humoral properties of food, see Thomas Hayles (attr.), *Concise Observations on the Nature of our common food, so far as it tends to promote or injure health* (New York: T. and J. Swords for Berry and Rogers, 1790). For salves, see Eliza Smith, *The Compleat Housewife, or Accomplish'd Gentlewoman's Companion* (Williamsburg: Printed and Sold by William Parks, 1742), 209. Advertisements for the cosmetic lotion, "or Beautifying Wash," appeared in the *New York Mercury*, February 21, 1763, 3, and November 23, 1767, 4, and in the *New York Gazette*, February 28, 1763.

11. For notions of "savagery" in North America, see especially Bernard W. Sheehan, *Savagism and Civility: Indians and Englishmen in Colonial Virginia* (Cambridge: Cambridge University Press, 1980); Alden T. Vaughan, "From White Man to Redskin: Changing Anglo-American Perceptions of the American Indian," *American Historical Review* 87, no. 4 (1982): 917–53, esp. 920. See also Georges-Louis Leclerc, Comte de Buffon, *Natural History, General and Particular*, 9 vols. (Edinburgh: William Creech, 1780), 5:64; [Robert Wilkinson], *Lot's Wife: A Sermon Preached at Paules Crosse* (London: Felix Kyngston for John Flasket, 1607), 42; John Arbuthnot quoted in Dror Wharman, *The Making of the Modern Self: Identity and Culture in Eighteenth-Century England* (New Haven: Yale University Press, 2004), 88; John Mitchell and Peter Collinson, "An Essay upon the Causes of the Different Colours of People in Different Climates," *Philosophical Transactions* 43 (1744): 131. For Mitchell, see Edmund Berkeley and Dorothy Smith Berkeley, *Dr. John Mitchell: The Man Who Made the Map of North America* (Chapel Hill: University of North Carolina Press, 1974), 45. For early modern ideas about race and climate, see Roxann Wheeler, *The Complexion of Race: Categories of Difference in Eighteenth-Century British Culture* (Philadelphia: University of Pennsylvania Press, 2000); Wharman, *Making of the Modern Self*, 83–126; Joyce E. Chaplin, "Natural Philosophy and an Early Racial Idiom in North America: Comparing English and Indian Bodies," *William and Mary Quarterly*, 3rd ser., 54, no. 1 (1997): 229–52.

12. William Bull, "Representation of the Colony," reproduced in H. Roy Merrens, ed., *The Colonial South Carolina Scene: Contemporary Views, 1697–1774* (Columbia: University of South Carolina Press, 1977), 269. For the dangers of southern climate and ideas about race, see Wheeler, *Complexion of Race*, 4–6, 23–26; S. Max Edelson, "The Nature of Slavery: Environmental Disorder and Slave Agency in Colonial South Carolina," in *Cultures and Identities in Colonial British America*, edited by Robert Olwell and Alan Tully (Baltimore: Johns Hopkins University Press, 2006), 21–44. See also advertisement in the *South Carolina Gazette and County Journal*, June 10, 1766, 3; Buchoz, *Toilet of Flora*, 79–81, 132; *New London Toilet*, 6–8; Smith, *Compleat Housewife*, 209. For the importance of women's skin in asserting racial identity, see Deidre Coleman, "Janet Schaw and the Complexion of Empire," *Eighteenth-Century Studies* 36, no. 2 (2003): 169–93; Mary Cathryn Cain, "The Art and Politics of Looking White: Beauty Practice Among White Women in Antebellum America," *Winterthur Portfolio* 42, no. 1 (2008): 27–50.

13. Mimi Hellman has similarly analyzed the process of using French dressing furniture,

204

although she stresses its performative nature, in "Furniture, Sociability, and the Work of Leisure," *Eighteenth-Century Studies* 32, no. 4 (1999): 415–45, esp. 425–28. See also Dena Goodman, "The Secretaire and the Integration of the Eighteenth-Century Self," and Carolyn Sargentson, "Looking at Furniture Inside Out: Strategies of Secrecy and Security in Eighteenth-Century France," both in *Furnishing the Eighteenth Century: What Furniture Can Tell Us About the European and American Past*, edited by Dena Goodman and Kathryn Norberg (New York: Routledge, 2007), 183–203 and 205–36, respectively.

14. Betty Randolph (d. 1783), "Last Will and Testament of Betty Randolph," and "20 July 1782 A Codicil to the above Will," Colonial Williamsburg Foundation, http://www.history.org/Amanack /people/bios, accessed December 4, 2008. For portrait miniatures, see especially Marcia Pointon, "'Surrounded with Brilliants': Miniature Portraits in Eighteenth-Century England," *Art Bulletin* 83, no. 1 (2001): 48–71.

15. The idea of a "material continuum" comes from Ewa Lajer-Burcharth, "Pompadour's Touch: Difference in Representation," *Representations* 73 (Winter 2001): 54–88, esp. 68. Caroline Palmer discusses the intimacy of cosmetics, bodies, and portraits in "Brazen Cheek," 195. For recommendations about how best to finish a dressing chest, table, or bureau, see Chippendale, *Gentleman and Cabinet-Maker's Director*, 14; Thomas Sheraton, *The Cabinet-Maker & Upholsterer's Drawing Book* (1793–1802; reprint, New York: Dover Publications, 1972), 101; Hepplewhite, *Cabinet Maker and Upholsterer's Guide*, 13–14. For lacquering and varnishing, see Buchoz, *Toilet of Flora*, 86, 140, 230; *London Toilet*, 84; [George Coleman], *The Connoisseur By Mr. Town Critic and Censor General*, 2 vols. (London: R. Baldwin, 1755), 1:123, 396. For the relationship between japanning and cosmetics, see also Susan M. Stabile, *Memory's Daughters: The Material Culture of Remembrance in Eighteenth-Century America* (Ithaca: Cornell University Press, 2004), 137–39.

16. Chippendale, *Gentleman and Cabinet-Maker's Director*, 14; Phillip Fithian, *Journals and Letters of Phillip Vickers Fithian: A Plantation Tutor of the Old Dominion, 1773–1774*, edited by Hunter Dickinson Farish (Charlottesville: University Press of Virginia, 1957), 131. Probate inventories found through the Gunston Hall Probate Inventory Index at http://chnm.gmu .edu/probateinventory/, accessed November 2, 2008. For a list of inventories that mention dressing table covers, see Van Horn, *Power of Objects*, 310. For "Marseilles," see especially Kathryn

Berenson, "Origins and Traditions of Marseilles Needlework," *Uncoverings* 16 (1995): 7–32. For the use of "Marseilles" in dressing table covers and petticoats, see Linda Eaton, *Quilts in a Material World: Selections from the Winterthur Collection* (New York: Harry N. Abrams for the Winterthur Museum, 2007), 126–28; Linda Baumgarten and John Watson, with Florine Carr, *Costume Close-Up: Clothing Construction and Pattern, 1750–1790* (New York: Quite Specific Media Group for the Colonial Williamsburg Foundation, 1999), 29–40. For the common practice of recycling costumes, see Linda Baumgarten, "Altered Historical Clothing," *Dress* 25 (1998): 42–57, esp. 44. For a similar account of recycling a "Marseilles" petticoat, see Elizabeth Garratt, *At Home: The American Family, 1750–1870* (New York: Harry N. Abrams, 1989), 28.

17. For ideas of the identity of a woman's body at the toilette and the material objects around her, see Lajer-Burcharth, "Pompadour's Touch," 68. For fears of the blurring of the body's boundaries with objects, see Barbara M. Benedict, "The Spirit of Things," in *The Secret Life of Things: Animals, Objects, and It-Narratives in Eighteenth-Century England*, edited by Mark Blackwell (Lewisburg: Bucknell University Press, 2007), 19–40, esp. 20, 39. My reading of the personlike qualities of dressing furniture has been influenced by Jonathan Prown and Richard Miller's argument for the anthropomorphism of the high chest in "The Rococo, the Grotto, and the Philadelphia High Chest," *American Furniture* 4 (1996): 105–36, esp. 116–18.

18. For Hogarth's *Before* and *After*, see Ronald Paulson, *Hogarth's Graphic Works* (London: Print Room, 1989), 99–100.

19. Camus, *Abdeker*, 146–47. See also Gwilliam's analysis in "Cosmetic Poetics," 148–51; Jefferson, *Notes on the State of Virginia*, 186–87.

20. Roy Porter, "Making Faces: Physiognomy and Fashion in Eighteenth-Century England," *Etudes Anglaises* 38, no. 4 (1985): 385–96, esp. 389; Karen Halttunen, *Confidence Men and Painted Women: A Study of Middle-Class Culture in America, 1830–1870* (New Haven: Yale University Press, 1982); "Ladies Painting an Unnatural Practice," *London Magazine*, December 1754, 558–59; A. Fothergill, "On the Poison of Lead," *Universal Magazine of Knowledge and Pleasure*, October 1790, 191; A. Fothergill, *Cautions to the Heads of Families in Three Essays* (Bath: R. Crutwell, 1790), 56; *Charleston City Gazette and Daily Advertiser*, March 10, 1798; Buchoz, *Toilet of Flora*, 82–83, 215, 227. For counterfeiting in early modern England, see Paul Baines, *The House of Forgery in Eighteenth-Century Britain* (London: Ashgate, 1999).

21. *Spectator*, April 17, 1711. The proposed legislation is quoted in Charles John Samuel Thompson, *The Mystery and Lure of Perfume* (London: John Lane, 1927), 151–52. Fears about women who used cosmetics to disguise ill health often concentrated on prostitutes. See Sophie Carter, "'This Female Proteus': Representing Prostitution and Masquerade in Eighteenth-Century English Popular Print Culture," *Oxford Art Journal* 22, no. 1 (1999): 57–79.

22. Cary Carson, "The Consumer Revolution in Colonial America: Why Demand?," in *Of Consuming Interests: The Style of Life in the Eighteenth Century*, edited by Cary Carson, Ronald Hoffman, and Peter J. Albert (Charlottesville: University Press of Virginia, 1994), 483–697, esp. 542–48; Kathleen Wilson, *The Island Race: Englishness, Empire, and Gender in the Eighteenth Century* (London: Routledge, 2003); Elizabeth Kowaleski-Wallace, *Consuming Subjects: Women, Shopping, and Business in the Eighteenth Century* (New York: Columbia University Press, 1997).

23. Jonathan Swift, "The Lady's Dressing Room (1732)," in *Eighteenth-Century Poetry: An Annotated Anthology*, 2nd ed., edited by David Fairer and Christine Gerrard (London: Wiley, 2004), 81–85; see also Tita Chico, "Privacy and Speculation in Early Eighteenth-Century Britain," *Cultural Critique* 52 (Autumn 2002): 40–60.

24. Hepplewhite, *Cabinet Maker and Upholsterer's Guide*, 13–15. Allen Wardwell identifies Hepplewhite's reference to Mrs. Rudd in "Hepplewhite Dressing Table (Chicago Art Institute)," *Burlington Magazine* 110, no. 782 (1968): 277, 280. For the Perreau-Rudd case and its surrounding frenzy, see Donna T. Andrew and Randall McGowen, *The Perreaus and Mrs. Rudd: Forgery and Betrayal in Eighteenth-Century London* (Berkeley: University of California Press, 2001); for contemporary descriptions of Rudd, see 33–47. Quotation from *The Trials of Robert and Daniel Perreau* (London: T. Bell, 1755), 18–25.

25. Andrew and McGowen, *Perreaus and Mrs. Rudd*, 70, 112–16, 126, 228, 298.

26. For the American newspapers that covered the Rudd-Perreau trial, see Van Horn, *Power of Objects*, 326. For counterfeiting in early America, see especially Steven Mihm, *A Nation of Counterfeiters: Capitalists, Con Men, and the Making of the United States* (Cambridge: Harvard University Press, 2007); Margaret Ellen Newell, *From Dependence to Independence: Economic Revolution in Colonial New England* (Ithaca: Cornell University Press, 1998), esp. 117. For colonial imposters like Tom Bell, see Steven C. Bullock, "A Mumper Among the Gentle:

Tom Bell, Colonial Confidence Man," *William and Mary Quarterly* 55, no. 2 (1998): 231–58; Thomas Kidd, "Passing as a Pastor: Clerical Imposture in the Colonial Atlantic World," *Religion and American Culture* 14, no. 2 (2004): 149–74; T. H. Breen and Timothy Hall, "Structuring Provincial Imagination: The Rhetoric and Experience of Social Change in Eighteenth-Century New England," *American Historical Review* 103, no. 5 (1998): 1411–39; Gordon S. Wood, "Conspiracy and the Paranoid Style: Causality and Deceit in the Eighteenth Century," *William and Mary Quarterly* 39, no. 3 (1982): 401–41.

27. Hepplewhite, *Cabinet Maker and Upholsterer's Guide*, 13–15. For Rudd's actual dressing table, see Andrew and McGowen, *Perreaus and Mrs. Rudd*, 117; for the reaction against Rudd, see 165–80; and *Morning Post and Daily Advertiser* (London), March 18, 1775.

28. For a regular chest of drawers crafted by Jones, see Rauschenberg and Bivins, *Furniture of Charleston*, 2:485–87. For the chest with cabinet, 1:92–95; for the 1790s group of dressing chests, 2:568–72.

29. My analysis of furniture's potential for secrecy and nonlegibility has been shaped by contemporary studies of "wayfinding." See Romedi Passini, *Wayfinding in Architecture* (New York: Van Nostrand Reinhold, 1984); Sergio Correa de Jesus, "Environmental Communication: Design Planning for Wayfinding," *Design Issues* 10, no. 3 (1994): 32–51, esp. 33–36.

30. Chippendale, *Gentleman and Cabinet-Maker's Director*, 14. Daniel Dulany's probate inventory was taken on May 21, 1754, and entered July 24, 1764. See Gunston Hall Probate Inventory Index. For the use of upholstery and textiles in bedchambers, see Florence M. Montgomery, "Eighteenth-Century American Bed and Window Hangings," in *Upholstery in America and Europe from the Seventeenth Century to World War I*, edited by Edward S. Cooke (New York: W. W. Norton, 1987), 163–68; Linda Baumgarten, "Protective Covers for Furniture and Its Contents," in *American Furniture* 1 (1993): 3–14.

31. For this table, see Ronald L. Hurst and Jonathan Prown, *Southern Furniture, 1680–1830: The Colonial Williamsburg Collection* (Williamsburg: Colonial Williamsburg Foundation with Harry N. Abrams, 1997), 280–82; for similar Charleston and Virginia tables, see 275–86. Quotation from Hepplewhite, *Cabinet Maker and Upholsterer's Guide*, 13; see also Jessie Ball, probate inventory recorded March 11, 1747, Gunston Hall Probate Inventory Index.

32. For early modern ideas about race, especially as they pertained to the application of pigments, see Kathleen Brown, "Early Modern Concepts of Race," in *Empire and Others: British Encounters with Indigenous Peoples, 1600–1800*, edited by Michael Daunton and Rick Halpern (London: UCL Press, 1999), 88–91; Karen Ordahl Kupperman, "Presentment of Civility: English Reading of American Self-Presentation in the Early Years of Colonization," *William and Mary Quarterly*, 3rd ser., 54, no. 1 (1997): 206–10. Quotations are from Buchoz, *Toilet of Flora*, 230; *New London Toilet*, 7; Jefferson, *Notes on the State of Virginia*, 186–87; James Adair, *The History of the American Indians* [. . .]. (London: Edward and Charles Dilly, 1775), 1–2; Buffon, *Natural History*, 3:158; Wharman, *Making of the Modern Self*, 96; Roxann Wheeler, "The Complexion of Desire: Racial Ideology and Mid-Eighteenth-Century British Novels," *Eighteenth-Century Studies* 32, no. 3 (1999): 309–32. For White's watercolor, see especially Kim Sloan, *A New World: England's First View of America* (Chapel Hill: University of North Carolina Press, 2007), 120–21.

33. *Boston Gazette*, January 10, 1763, 2. For unease about cosmetics' power to make black skin white, see Rosenthal, "Visceral Culture," 581–87; Gwilliam, "Cosmetic Poetics," 152–59; Coleman, "Janet Schaw," 170–75; Lynn Festa, "Cosmetic Differences: The Changing Faces of England and France," *Studies in Eighteenth-Century Culture* 34 (2005): 25–54.

34. James Otis, *The Rights of the British Colonies Asserted and Proved* (Boston, 1764), in Bernard Bailyn and Jane N. Garrett, eds., *Pamphlets of the American Revolution, 1750–1776*, 4 vols. (Cambridge: Harvard University Press, 1965–67), 1:435; Jefferson, *Notes on the State of Virginia*, 147–48. Eliza Lucas Pinckney's letter detailing Princess Augusta's reception is quoted in Robert A. Leath and Maurie D. McInnis, "'To Blend Pleasure with Knowledge': The Cultural Odyssey of Charlestonians Abroad," in *In Pursuit of Refinement: Charlestonians Abroad, 1740–1860*, edited by Maurie D. McInnis (Columbia: University of South Carolina Press, 1999), 9–10. For fears about how civility enabled slaves to pass as "white," see David Waldstreicher, "Reading the Runaways: Self-Fashioning, Print Culture, and Confidence in Slavery in the Eighteenth-Century Mid-Atlantic," *William and Mary Quarterly*, 3rd ser., 56, no. 2 (1999): 243–72

Revolutions
of Image and Place

Mommy Dearest

BRITANNIA, AMERICA, AND MOTHER-DAUGHTER CONFLICTS IN EIGHTEENTH-CENTURY PRINTS AND MEDALS

NANCY SIEGEL

MOTHER-DAUGHTER RELATIONSHIPS ARE COMPLICATED under the best of familial conditions. But when the "mother" is the British Empire and the "daughter" the American colonies, the struggle between authority and independence becomes a conflict of international proportions. This battle played itself out visually in the eighteenth-century print market, which had become by then a most important vehicle for disseminating popular culture. Within this market, a distinct genre of works developed in which the political discord between Britain and the American colonies was expressed through their personification as female combatants. While the tradition of referring to Britain as Mother England had been well established both visually and in literature by the mid-eighteenth century, the quandary became how best to represent the American colonies in satirical form. Critical of the Crown and sympathetic to the colonial American cause, British printmakers of the mid-eighteenth century began to employ a mythic stereotype, a female Indian warrior, as an emerging symbol of the American colonists' struggle for independence.[1] Transformed from late sixteenth-century iconography of the continents, the figure of the New World came to symbolize the daughter of Britannia by the mid-eighteenth century as an uneasy mother-daughter relationship unfolded. Her often bare-breasted image became associated with her (the colonists') vulnerability or promiscuity (colonial rash behavior),

as portrayed in scenes of sexual violation by British politicos, or engaged in physical combat with Britannia. Such engravings responded to increased political tensions between colonists and Parliament surrounding the events of the Stamp Act of March 1765 and continued to proliferate until the end of the American Revolution. These prints were meant to be pointedly satirical, enhanced by the gendering of both America and Britannia as women—female opponents in pugilistic confrontations against each other in a variety of engraved scenarios. What E. McClung Fleming characterized as an Indian princess in the 1960s is here reconsidered as a more assertive female figure—the warrior. Given the aggressive and violent imagery depicted in the engravings examined in this chapter, the designation of this figure as a warrior is appropriate. As the political dynamics between Britain and the American colonies changed rapidly between the 1760s and 1780s, one finds a visual parallel to this changing power structure in the visual tropes of submissive and dominant imagery in popular engravings. In scenes of masculine superiority in the gendering of nations, and in the cultural and ethnographic superiority of Britain to the engendered Indian warrior, at stake is the issue of honor. This chapter demonstrates that honor lost, dishonorable actions, and ultimately honor regained were experienced by both Britannia and her American colonies.

It bears noting that satirical prints of the eighteenth century were narrative devices, not aesthetically driven. Through the genre of satire, engravers were quite successful at conveying harsh sentiment in buffoonish and comical forms in prints that were purchased, disseminated, and discussed by an educated and socially elite audience for whom such references were accessible and humorous. Comedic effect allowed publishers to sell imagery of dire political affairs as publicly palatable discourse, while engravers voiced political dissatisfaction through depictions of corporeal gestures and other acts of violence as the basis for their iconography. Thus the physical body served as a metaphor for the body politic.[2] Engravers expressed sympathy for the colonists' struggles against taxation, lampooned their own government's actions, and expressed concern about the weakening structure of the British Empire. Their depiction of gender and power struggles may appear simple and crude, but to read these prints as a visual language with overt political and satirical content is an important analytical element, as matters of reception, perception, and comprehension of print culture provide greater insight into their function and meaning. As the War of Independence came to a close, the nature of the visual (and political) relationship between mother and daughter changed. As intellect and reason were required to secure peace and establish the tenets of democracy for the new nation, the use of the Indian figure was no longer deemed appropriate. Her image was ultimately transformed from a representation of colonial repression into iconic Liberty, a symbol alluding to a classical past and implying victory and independence from Mother England.[3]

It is important to remember that the iconographic use of the Indian figure as a comedic trope in satirical prints originated with British, not colonial, engravers. This

trope gained popularity, in part, because the visual tradition of indigenous peoples as a distant "other" was established by the late sixteenth century through the engravings of artists and artisans like Cesare Ripa, Theodor de Bry, Théodore Galle, and John White. In fact, those late sixteenth-century and early seventeenth-century works on paper softened the notions of savagery associated with non-European peoples and ultimately influenced the manner in which a female-gendered Indian was transformed from a symbol of the New World to a synecdoche of colonial struggle. Likewise, once conflict broke out between Britain and the colonies, the transition of the native warrior from an ethnographic curiosity to a sympathetic (and at times pathetic) character was complete. This chapter examines a transatlantic print culture in the eighteenth century in which the quest for, and tension associated with, national identity played itself out in the figure of a female warrior who at times represented both irrational colonial savagery and the suffering of imperial abuse.

Questions arise as to the origin of this female figure and how she became a visual foil for political hostilities and a personification of the British colonies in America. As various studies have demonstrated, images of a stylized female Indian emblematic of America as the fourth continent became numerous by the sixteenth and seventeenth centuries on engravings, maps, medals, and decorative sculpture, while tales from explorers and missionaries to the New World established an iconography based on verbal descriptions. The resulting imagery varied widely; America at times was depicted as an Indian warrior with an aristocratic hairdo and elaborate cloak, or bare-breasted with a skirt fashioned from feathers.[4] She was clearly not European and could easily be recognized as the foreign "other," far from the safety of the motherland but curiously exotic in her appearance. Cesare Ripa's enormously influential compendium of emblems, *Iconologia* (1593), includes America as one of the four continents, a sturdy prototype of the early Indian warrior. In his 1603 illustrated edition, America (fig. 8.1) is portrayed as a Rubensesque form (much like the other three continents) with "Indian" attributes: bow, arrow, headdress, victim's head with an arrow through it lying at her feet—these became standard symbols of America as a land of exotic curiosity.[5] Théodore Galle's engraving *The Arrival of Vespucci in America* (ca. 1600), for example, depicts Vespucci discovering the female personification of the New World (fig. 8.2). Based on a drawing by Jan van der Straet (ca. 1575), this sleepy, nude native wakes from a nap, clearly submissive and posing no threat to rational knowledge and civilization, as noted by Vespucci's upright stance and navigational accoutrements. Her features, however, are far more Renaissance-inspired than they are ethnographically accurate. The visual inference demonstrates, through symbols, the existence of foreign lands and the ability to dominate through an enlightened mind and military might. Theodor de Bry and John White continued the tradition in the sixteenth and seventeenth centuries with the dissemination of indigenous Indian life and culture through their engravings and watercolors. It is interesting to compare such images

68 ICONOLOGIA
A M E R I C A.

Dᴏɴɴᴀ ignuda, di carnagione fofca, di giallo color mifto, di volto ter-
ribile, & che vn velo rigato di più colori calandole da vna fpalla a tra-
uerfo al corpo, le copri le parti vergognofe.

Le chiome faranno fparfe, & à torno al corpo fia vn vago, & artificiofo or-
namento di penne di varij colori.

Tenga con la finiftra mano vn'arco, con la deftra mano vna frezza, &
al fianco la faretra parimente piena di frezze, fotto vn piede vna tefta humana
paffata da vna frezza, & per terra da vna parte farà vna lucertola, ouero vn li-
guro di fmifurata grandezza.

Per effer nouellamente fcoperta quefta parte del Mondo gli Antichi Scrit-
tori non poffono hauerne fcritto cofa alcuna, però mi è ftato meftieri veder
quello che i migliori Hiftorici moderni ne hanno referto, cioè il Padre Giro-
lamo Gigli, Ferrante Gonzales, il Botero, i Padri Giefuiti, & ancora di mol-
to profitto mi è ftata la viua voce del Signor Faufto Rughefe da Montepul-
ciano

FIG. 8.1 Cesare Ripa, *America*, in *Iconologia*, 1613 edition of 1593 original. Engraving. Portland State University Library Digital Exhibits, https://exhibits.library.pdx.edu/exhibits/show/the-envious-tooth-of-time/item/249.

FIG. 8.2 Théodore Galle after a drawing by Jan van der Straet (ca. 1575), *The Arrival of Vespucci in America*, ca. 1600. Engraving from *L'Amerique historique* (1638), plate 6. The Miriam and Ira D. Wallach Division of Art, Prints and Photographs: Print Collection, The New York Public Library. New York Public Library Digital Collections.

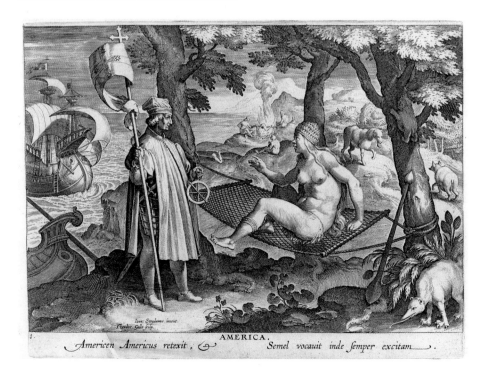

Ioan: Stradanus invent.
Theodor Galle sculp.

1. AMERICA.
Americen Americus retexit, *Semel vocauit inde femper excitam.*

with early colonial texts regarding opinions of and relationships with indigenous Americans, who are described as "wild," "savage," "pagan," and "uncivilized."[6] Regardless of the actual knowledge these illustrations conveyed about indigenous peoples, the emblematic representation of America as an ethnographically inaccurate warrior was solidified in print culture by the eighteenth century through the stereotyped symbols of the tomahawk, feather skirt, and headdress.

As Britain waged battles for control of regions in North America in the early to mid-eighteenth century, the female warrior no longer came to personify an entire continent. Rather, her image served as an icon distinct to the British-controlled colonies, whose transplanted residents began to flourish in their new environment. Meanwhile, by the 1760s, Britain's military might and political state had weakened. The Seven Years' War left England with diminished resources and increasingly disgruntled colonists; the concept of an American identity separate from but equal to Britain increasingly appealed to colonists who were not only establishing their own political structures but prospering economically. While the colonists were empowered to make decisions on a local level, they questioned taxation measures, restrictions on trade—both imports and exports—and their perceived freedom to construct political authority removed from Parliament.

The economic and political conflict between empire and colony grew in part from Britain's implied superiority, embodied in its taxation measures, a sign of entitlement and domination to which the colonists were expected to submit.[7] After a series of regional taxation measures implemented to raise revenues in Britain, the Stamp Act in particular proved to be a pivotal and pervasive statement of authority, thus resulting in one of the first unified efforts of resistance against the mother country. It is not surprising, then, that when the Stamp Act was enacted in March 1765, discussions of transatlantic relations were disseminated through the growing media of newspapers, pamphlets, and broadsides. It was in such publications precisely that political prints depicting the New World female warrior as an injured party began to appear, adding to the growing sentiment regarding colonial oppression. Lester Olson notes that between 1765 and 1783, at least sixty-five political prints featuring this character were published in Britain.[8] In his seminal work, E. McClung Fleming established five categories for what he termed the "Indian Princess" as she first appeared and was transformed in political prints from 1765 to 1815.[9] Speaking to the wide popularity of engravings bearing the princess image, Fleming notes that between 1774 and 1783 well over one hundred print shops and print sellers disseminated the image through shop displays, advertisements, and the sale of plain or hand-colored prints to a primarily male audience of collectors.[10]

With the imposition of the Stamp Act, the image of the female warrior began to appear in a disturbing genre of prints that combined sexual with political coercion; thus the violation of her physical form in engravings and printed matter became the literal and figurative violation of the body politic. Take, for example, *SIX MEDALLIONS*

shewing the chief national servises of his new Friends the old ministry from 1765 (fig. 8.3). While this print has been discussed as a work on paper, it served more accurately as a pattern for metalworkers who cast these six medallion designs in bronze. Medals and medallions typically commemorate acts and events of bravery and heraldry, but there is a parallel tradition in which these small, portable objects acknowledge dishonorable acts of political injustice and abuse.[11] Such medals were produced and sold to buyers similarly interested in purchasing satirical prints.[12] Inscribed to Earl Temple, who favored the actions of Parliament, the six images depict the degradation and humiliation of both Britannia and America through their female personifications. For example, in "Glorious Peace," Britannia is forced to her knees by Lords Mansfield and Bute; Bute commands, "Stoop you Bitch." France and Spain look on while empires spill forth from her cornucopia. Just below, the third medallion, "America Stamped," is meant to represent the enforcement of the Stamp Act on the colonies. The chosen imagery is violent and misogynist. "The Bitch Rebels," declares Grenville as he prepares to strike America with a stamp. "Force her," replies Bute, who pushes her to the ground. As she falls with her legs in the air, she holds a tomahawk, an attribute of the Indian warrior, yet her dress is clearly European in style. The demoralizing position representative of colonial oppression is depicted in feminine form, suggestive of weakness and vulnerability. Here, the hostile force of Britain is equated with the submissive position of the American colonies. Sexual violation is the veil for political violation. As James Jasinski has noted, the feminized struggle for liberty can be found in the visual representation of rape.[13]

Both British imperialists and American colonists understood the concept of submission portrayed in visual form and oral parlance as part of a critical discourse in political positioning between Crown and colony. For example, the economic burdens of the Stamp Act, which provided funds for the quartering of soldiers in British North America, caused immediate colonial distress. It was repealed within a year owing in part to strong objections from colonial representatives like Benjamin Franklin, who was called to address Parliament on the matter in 1766. The transcript of that exchange was published as *The Examination of Doctor Benjamin Franklin, before an August Assembly, relating to the Repeal of the Stamp-Act, &c.* Franklin was questioned at length regarding the changing status of public opinion. When asked, "Do you not think the people of America would submit to pay the stamp duty, if it was moderated?" Franklin replied, "No, never, unless compelled by force of arms." When pushed further on the matter, "Don't you think they would submit to the stamp-act, if it was modified, the obnoxious parts taken out, and the duty reduced to some particulars, of small moment?" Franklin replied, "No, they will never submit to it." On the colonists' perception of the British government, Franklin explained that before 1763, they thought it "the best in the world. They submitted willingly to the government of the Crown," but now their attitude had greatly altered and their respect "greatly lessened." Franklin undoubtedly established that taxation of the colonies without parliamentary representation stood

FIG. 8.3 *SIX MEDALLIONS shewing the chief national servises of his new Friends the old ministry*, 1765.
Etching, 28.5 × 19.9 cm. © The Trustees of the British Museum. All rights reserved.

FIG. 8.4 *The Colonies Reduced* and *Its Companion*, designed and engraved for the *Political Register*, 1768, after Benjamin Franklin, *Magna Britannia: Her Colonies Reduc'd*, February 1766. Engraving, 20.8 × 11.9 cm. The Library of Congress Prints and Photographs Division, Washington, D.C.

at the heart of opposition to the Stamp Act. "America has been greatly misrepresented and abused here, in papers, in pamphlets, and speeches, as ungrateful, and unreasonable, and unjust in having put this nation to immense expense for their defence, and refusing to bear any part of that expense." Most poignant are Franklin's concluding remarks. When asked, "What used to be the pride of the Americans?" he responded, "To indulge in the fashions and manufactures of Great-Britain." In answer to the question "What is their pride now?" Franklin declared, "To wear their old cloths over again, till they can make new ones."[14]

Not only was Franklin a verbally outspoken advocate of colonial freedoms, but he too combined his sentiments in images and text. He printed the engraving *Magna Britannia: Her Colonies Reduc'd* (February 1766) on the back of message cards that he distributed to members of Parliament before he testified for the repeal of the Stamp Act.[15] In this image, Britannia lies physically dismembered, an analogy of disjointed political power. A banner across her torso with a Latin inscription translates as "give a penny to Belisarius," a reference to the Roman general, blinded and left destitute by war. Her severed limbs are soon to be former colonies: her legs are labeled Virginia and New England; her arms are New York and Pennsylvania, with the olive branch of peace having fallen from her hand; it lies just out of reach as she rests against the globe

with her shield and spear at her side. In a later pirated version, *The Colonies Reduced* and *Its Companion* (fig. 8.4), designed and engraved for the *Political Register* (1768), the added companion scene hints at the political disaster that would befall Britain should she lose her colonies. Britannia is stabbed in the eye by France; America, represented as the Indian, runs into the arms of France while Britannia desperately clings to his feathers. From behind, Britannia's skirt is raised by Lord Bute so that Spain may spear and whip her. Bute exclaims, "Now I show you her weakness you may strike home." The pirating of Franklin's image speaks to the frequency with which popular images were copied, altered, or otherwise reproduced because of their ability to convey political sentiment to the consuming public.

Broadsides reported the repeal of the Stamp Act with much fanfare and celebration in the colonies. On May 16, 1766, "Glorious News" appeared in a Boston broadside reprinting news from the *London Gazette*:

> His majesty came to the House of Peers, and being in his royal robes, seated on the throne with the usual solemnity, Sir Francis Molineux, Gentleman Usher of the Black Rod, was sent with a Message from his Majesty to the House of Commons, commanding their attendance in the House of Peers. The Commons being come thither accordingly, his Majesty was pleased to give his royal assent to An ACT TO REPEAL . . . certain Stamp-Duties and other Duties in the British Colonies and Plantations in America, toward further defraying the expenses of defending, protecting and securing the same, and for amending such parts of the several Acts of Parliament relating to the trade and revenues of the said Colonies and Plantations. . . . Last night the said gentleman dispatched an express for Falmouth, with fifteen copies of the Act for repealing the Stamp-Act, to be forwarded immediately for New York.[16]

On the following Monday, May 19, a public celebration took place in Boston with a large wooden obelisk as the showpiece. Paul Revere's engraving of that structure, *A View of the Obelisk erected under Liberty-Tree in Boston* (1766), is all that remains of our visual knowledge of the wood and oil paper obelisk designed and constructed most probably by members of the Sons of Liberty (fig. 8.5). As part of the celebration, the Sons of Liberty intended to place the obelisk, lit by 280 lamps, under the Liberty Tree after its display in Boston Common, but its internal lanterns failed to extinguish and the obelisk was destroyed.[17]

Revere's engraving contains a lengthy inscription on the ideals of liberty in addition to noting individuals who supported the repeal of the Stamp Act. In the lower quadrants, Revere reproduced four allegorical scenes in which Liberty comes to the aid of America. Shown as the Indian warrior in three of them, America is first protected by Liberty as the devil flies in with the Stamp Act in his grip, then is deprived of Liberty

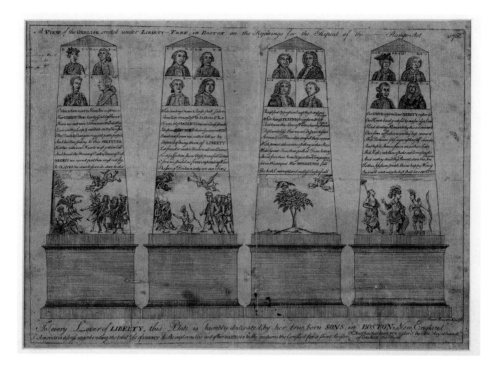

FIG. 8.5 Paul Revere, *A View of the Obelisk erected under Liberty-Tree in Boston*, 1766. Engraving, 24 × 34 cm. Courtesy of the American Antiquarian Society.

and pleads for her return, and is ultimately reunited with Liberty through Minerva's intercession—a parable of the colonies' relationship with Britain. Liberty and the warrior appear together—though only one represents America symbolically—and until the end of the Revolution, it is the Indian warrior.[18] The corresponding text makes specific reference to Liberty, but the female warrior is never mentioned by name. She is silently understood to personify the American colonies. The headdress, bow and quiver, bare breast, and skirt of feathers are her attributes as she appears and reappears in engravings depicting the American colonies as assertive, oftentimes assaulted, but ultimately triumphant over oppressive Britannia.[19]

In addition to the Stamp Act, inflammatory injustices regarding taxation measures from the colonial perspective concerned tea. Introduced to the colonies as early as 1670 by the Dutch East India Company, tea was initially a luxury item. By the mid-eighteenth century, however, it had become a necessity at the well-appointed table. It had also come to symbolize social and domestic refinement.[20] But drinking tea properly was a learned behavior—some early colonists boiled tea leaves as though they were a vegetable, ate the leaves, and discarded the brew.[21] Colonists soon adapted to the ceremony of tea drinking, and by the 1760s Americans were drinking more than

a million pounds of imported tea a year.[22] British mandates required that all tea consumed in the American colonies be imported from England through the British East India Company (though tea was nonetheless smuggled in from Holland). In June 1767, Parliament passed the first of the notorious Townshend Acts, which placed a duty of three pence per pound on all tea imported into the colonies. This offense came on the heels of a series of taxation measures, including the Stamp Act, and in response colonists began nonimportation movements calling for the refusal to purchase imported goods wherever possible, including cloth and tea:

219

> To the Stated Pilots of the Port of New York: Gentlemen- We need not inform you, that the ship is hourly expected with the Tea from England, which if landed here, will entail slavery on this Colony, and ruin its commerce. No class of men are more interested in the last than you; nor none have it more in their power to prevent the introduction of that which the tyrannical Ministry intended as the badge of our slavery.... The ship cannot enter this port. New-York, Nov. 10, 1773.[23]

The Boston Tea Party in December of that year was just one of a number of acts of defiance taken by the colonists. Lord North closed the port of Boston in March 1774 in retaliation, and Parliament passed the Coercive Acts between March and June.[24] The acts were designed to isolate extremists while separating the colonies, but they had the opposite effect. The colonists united in their opposition to British mandates as news of the acts traveled along the Eastern Seaboard through pamphlets, broadsides, and engravings. Although Lord North called for the repeal of all but the tea tax, the assertion of parliamentary sovereignty remained intact.

The image of North as a coercive figure permeated popular imagery, as in *The able Doctor, or America Swallowing the Bitter Draught* (fig. 8.6), which first appeared in the *London Magazine* in April 1774. Lord North, with a copy of the Boston Port Bill in his pocket, is shown accosting an Indian figure (America) by the neck and forcing tea down her throat while she attempts to spit the tea violently back into his face. Lord Mansfield holds her arms, while the womanizing John Montague, fourth earl of Sandwich, peers up America's skirt. Lord Bute represents military law on the far right, while, on the left, France and Spain look on in consultation with each other, as Britannia turns away in disgust.[25] As Lester Olson has noted, the title page for the *London Magazine* described the engraving as a "Humorous print."[26] The ludicrous nature of the actions taken (both physically and politically) is deemed comical. The violence, suggested by the sexual vulnerability of America, continues the visual trope of male force imposed upon a feminized colony, shown previously in the medallion designs of 1765. In actuality, the closure of Boston's port created a period of anxiety and financial panic as a result of the precarious nature of these measures. To see this unease translated into satirical form illustrates Horace's notion that through laughter, truth is revealed.

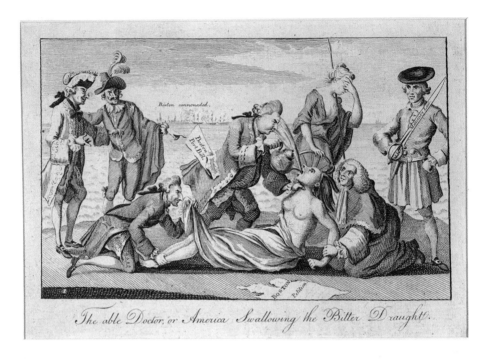

FIG. 8.6 *The able Doctor, or America Swallowing the Bitter Draught*, for *The London Magazine*, April 1774. Engraving, 13 × 21 cm. The Library of Congress Prints and Photographs Division, Washington, D.C.

It is also important to note the relationship between this print and other material in the *London Magazine*, which was by no means all of a political nature. The issue in which this print appeared contained riddles, poems, book reviews, an essay on the English disposition, a description of a masquerade at the opera house, and a map of Boston and debates on the Boston Port Bill. The engraving *The able Doctor* appeared opposite excerpts of letters from Lord Chesterfield regarding "Sentiments of the American Stamp Act," in which he traced the history of the act, including its repeal.[27] It is significant that the engraving serves as the historical denouement to the corresponding text. From Stamp Act to port closure, an image-text relationship was established, thus reinforcing the publisher's desire to deliver information in dual formats. Within a month of the appearance of the original *London Magazine* engraving, the *Hibernian Magazine* reproduced the image, but in reverse. A poem next to the print confirmed in words the violation taking place in visual form.

> BEHOLD America on the ground,
> Whilst deadly foes the wretched maid surround;
> Law binds her arms, in Mansfield's form contest;

And Sandwich, blending violence and jest,
With one hand holds her feet; and dares to lift,
With th' other the oppressed maiden's shift.
A lustful grin upon his visage seen.[28]

The author of the poem capitalized on the physical violation and humiliation of America—referred to not as an Indian specifically but as a maiden generically (note the stylized headdress that she wears, however). The words "violence" and "lustful" suggest that this is a sexualized political assault, and the implied disgust further condemns Britain's abusive parliamentary authority.

Just two months after its first appearance, Paul Revere engraved his own version of *The able Doctor* as the frontispiece for the *Royal American Magazine* in Boston (fig. 8.7). It is most appropriate that Revere was interested in copying this engraving, as he rode with news of the Boston Port Bill from New York to Philadelphia for the Sons of Liberty in May 1774.[29] (In addition to fulfilling his patriotic duty, he was producing silver tea services for the wealthy at the time.) In his version, Revere clearly labeled the pot "tea" and slightly altered Lord Sandwich's facial features to appear even more salacious than in the original British version.[30] The Indian warrior appeared not only in *The able Doctor* but also on the title page illustration of this issue of the *Royal American Magazine*, where she is shown, having laid down her quiver, offering feathers and a peace pipe to a classical muse.[31] There was a strong dichotomy between images of the warrior figure and the text on indigenous Americans. While her emblematic appearance was well understood as a visual personification of the colonists' struggle against coercion and for independence, there was no verbal counterpart; she is not identified as such in printed texts. In fact, when indigenous peoples were mentioned in journals and magazines, it was more often than not to repeat tales of woe or aggression that they inflicted on white colonists. With regard to the adoption of the Indian figure as an "appropriate" representation of the American colonies, one must remain cognizant of increasingly tense relations between colonists and indigenous peoples, simultaneous with barbaric and savage acts committed by British troops in their appropriation of Indian land. Curious, then, is the use of the Indian warrior as a symbol of British oppression, as this magazine also published "The Sentiments of an Indian on Venality and Bribery, delivered immediately before his death," an article in which the death sentence of an Indian brave accused of violent wrongdoing is met with much cheering and many huzzahs.

In August 1774, a Philadelphia publication reengraved the *London Magazine* version of *The able Doctor* in reverse (as in the *Hibernian Magazine*) but made it twice as large and, most important, altered the title to reflect a stronger nationalistic sentiment. Instead of *America Swallowing the Bitter Draught*, the title became *The Persevering Americans, or The Bitter Draught return'd*. The female warrior was now on the offensive,

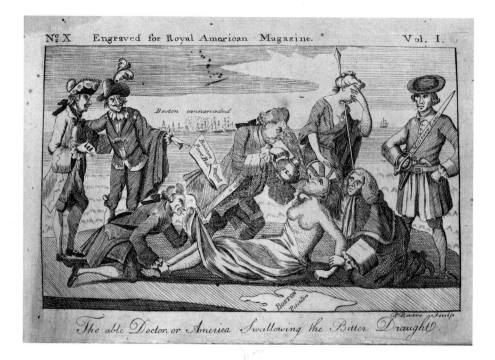

FIG. 8.7 Paul Revere, *The able Doctor, or America Swallowing the Bitter Draught*, frontispiece for the *Royal American Magazine* (Boston), June 1774. Engraving, 11.9 × 17.9 cm. Courtesy of the American Antiquarian Society.

no longer the victim. During the Revolution, this imagery continued to resonate. It appeared on powder horns carried into battle and was used as the frontispiece for *Freebetter's New-England Almanack for the Year 1776*, printed and sold by T. Green of New London, Connecticut. Much simplified in woodblock form, this print references Revere's version although printed in reverse.[32]

As tensions escalated, the first Continental Congress gathered in Philadelphia in September 1774. The delegates condemned Parliament's actions regarding the authority of taxation, though they were still prepared to remain loyal to George III. Although Lord North questioned whether the colonists could sustain themselves, they had been instituting internal governing measures for decades, mostly unopposed. Thus it was not until fighting broke out at Lexington and Concord in April 1775 that the threat of losing America became serious. Still, the colonies insisted that their actions were based on their right to protect themselves and that they were initiating no quest for independence.[33] The king declared the colonies to be in a state of rebellion, offered a pardon if the conflict would end, and sent a peacemaking delegation to discuss a rational solution; the delegates arrived—too late—on July 12, 1776. The Continental

FIG. 8.8 *Bunkers hill, or the blessed effects of Family quarrels,* June 15, 1775. Etching, 22 × 14 cm. Courtesy of The Lewis Walpole Library, Yale University.

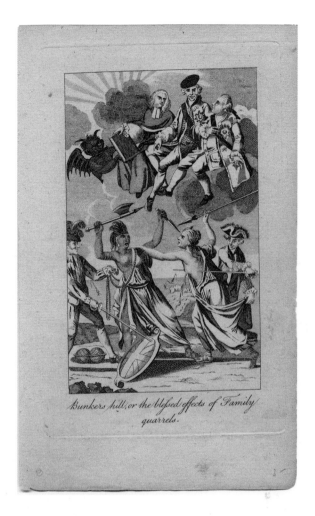

223

Congress had adopted the Declaration of Independence and the rest is, well, history. Once independence had been declared and it became increasingly clear that British authority was waning, broadsides and engraved prints duly noted the corresponding shift in power. The physical distance between Britain and the American colonies ultimately overwhelmed Britain's ability to maintain and enforce political dominance, and the colonies were likewise experiencing population and economic growth that made a longer-term imperial relationship unfeasible.

In *Bunkers hill, or the blessed effects of Family quarrels,* of June 15, 1775, mother and daughter, Britannia and the Indian warrior, are in the midst of attacking each other, seemingly unaware of the others present (fig. 8.8). Britannia, here the aggressor, lunges for America, undeterred by France's sword through her breast.[34] This is mother against daughter in a bare-breasted brawl, and the implied "blessed effects" of this family

quarrel can only be Britain's ability to stop her colony from declaring independence. Lords Mansfield, Bute, and North stay clear of the conflict, floating above the scene on clouds and accompanied by both the devil and heavenly rays of light. They understand Britain's imperative to reign over her colonies, but they keep their distance from any physical involvement in this scene, which alludes to the famous battle site of the start of the Revolution. This gendered and violent approach to representing conflict continued to serve as the visual foil for criticism of the weakening political relationship between Britain and her colony.

Elaborating on this theme in *The Female Combatants* (fig. 8.9) of 1776, Britannia, with her outsized hairdo, jabs at her opponent's breast and proclaims, "I'll force you to Obedience you Rebellious Slut." America, the female warrior, counters with a punch to Britannia's jaw and responds, "Liberty Liberty for ever Mother while I exist." Her discarded shield rests on a branch topped with a pileus cap and a banner that includes the words "for Liberty." Britannia's shield depicts navigational points, a reference to her extensive empire, atop the words "for Obedience."[35] America's bare breast and the suggestion of her promiscuity implied by the "slut" comment stand in contrast to Britannia's refined dress and checked sexuality.[36] The vulgar language underscores the ridiculous nature of the argument. What is meant to be a satire of the struggle between Britain and America has been reduced to a slapstick fight between two women. They are unable to inflict any significant damage upon each other beyond name calling. That the use of the word "slut" and the suggestion of promiscuity or prostitution are read as comedic demonstrates the widespread misogyny in popular male culture of the eighteenth century. The denigration of America, with her bare breasts and pugilistic stance, increases the sexual tension, voyeurism, and ultimately the crude appeal of this engraving.

As it became increasingly clear that British authority was diminishing, images depicting the female warrior no longer showed her jeopardized or threatened; rather, as Britain lost control of her colonies, the Indian warrior acquired the position of power and control.[37] In *The Parricide. A Sketch of Modern Patriotism* (fig. 8.10) of 1776 from the *Westminster Magazine*, Britannia is attacked by her daughter in a murderous rage, thus exacerbating the mother-daughter conflict. The vulnerability of Britannia is further emphasized as it is she, not America, who appears bare-breasted while being held down by the Duke of Grafton. Additional pro-colonial supporters, among them Charles Fox, observe the scene as the figure of Discord waves torches, adding to the frenzy. Her own symbol of authority, the British lion, rushes to attack but is held back on reins. Britannia appears weak and defenseless, about to be viciously attacked by her own government as well as by her colony. Her shield, an oval medallion with a pelican piercing its breast to feed her young, suggests a mother's sacrifice for her children and strengthens the satirical nature of this familial relationship gone astray and the

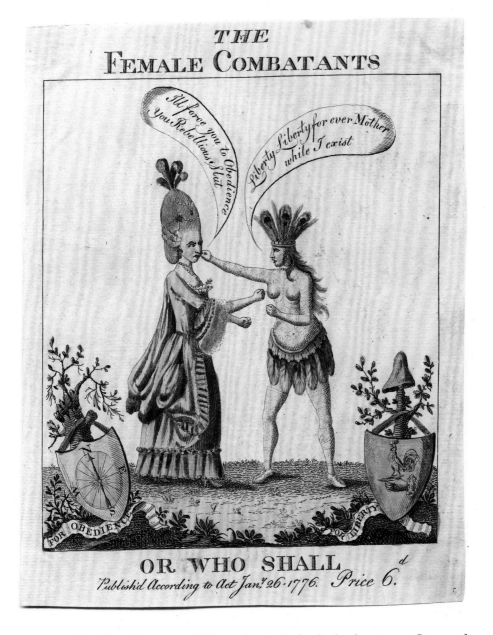

FIG. 8.9 *The Female Combatants*, 1776. Etching and engraving, hand-colored, 22 × 17 cm. Courtesy of The Lewis Walpole Library, Yale University.

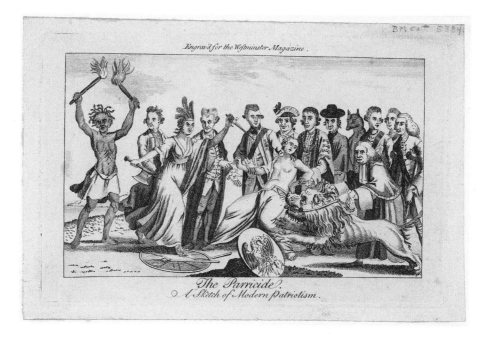

FIG. 8.10 *The Parricide. A Sketch of Modern Patriotism, Engrav'd for the Westminster Magazine*, 1776. Engraving, 11.5 × 17.7 cm. The Library of Congress Prints and Photographs Division, Washington, D.C.

impending parricide.[38] The Indian warrior, fully clothed in more classical garb and fully armed, is out for her mother's blood as she strides forward unimpeded and assisted by John Wilkes, an outspoken member of Parliament and detractor of George III's colonial policies. The print accompanied an excerpt from a popular pamphlet by James Macpherson, *The Rights of Great Britain Asserted Against the Claims of America*, which supported Britain's authority and was critical of those sympathetic to the colonies. "With a peculiar refinement on Parricide," Macpherson wrote, "they bind the hands of the Mother, while they plant a dagger in those of the Daughter."[39]

The mother-daughter relationship remains vicious and satirical in *Britania and Her Daughter* (fig. 8.11), a song published on March 8, 1780, and illustrated with an accompanying print. Britannia, dressed as a Roman soldier, advances toward America, who is flanked by Spain and France, her new suitors. Her bare breast, slight form, and position between the two men suggest her vulnerability despite the tomahawk she clutches in her hand. Britannia implores, as if protecting America's purity, "Daughter return to your duty, and let me punish those empty Boasters; those base Villains, who keep you from your Alegiance, and disturb our Quiet." America responds, "Mother if you would punish those Villains, who forced me from my Alegiance, and disturb our quiet, you must find them at home: those Gentlemen are my Allies, we are now

Arm'd and seek your life." The villainous effect is enhanced as both Spain and France vie to dominate Britannia's daughter physically, sexually, and of course, as is truly intended, politically. Spain taunts Britannia: "your Daughter shall be true to me, I'll make her wear a Spanish Padlock." France is no better a suitor: "Sacra Dieu! I vill have your daughter vether you vill let me or no; and vat you tink besides. By Gar, I vill make you my servant to vait upon us, you shall roast your own Bull for our Wedding Dinner." Though it mocks both the British body politic and the French through their language, the scene itself is a simple landscape without detail or context for these four figures whose significance relies entirely on iconography, stereotype, and verbal sparring. In the accompanying song, America is portrayed as a naïve youth determined to be treated as a grown woman with her own household to manage. The domestic analogy appears proper enough; but after dalliances with her lovers Spain and France, America is revealed through her promiscuity as a vengeful savage:

> Miss America North, so News-paper records;
> With her Mother Britania one day had some words,
> When behold Monsieur Louis, advanc'd a new whim,
> That she should leave her Mother for to live with him.
> > Derry Down.
>
> The Damsel consented but quickly found out,
> That her Paramour was not sufficiently stout;
> Besides he was poor, and she wanted fine things,
> So he sent to Don Carlos for Cash and Gold-rings.
> > Derry Down.
>
> Says Monsieur to the Don, if you take my advice,
> Then you of young Miss may come in for a slice;
> The Don being am'rous was easy brought o'er,
> And he Cuddled, and Kiss'd as Monsieur did before.
> > Derry Down.
>
> Britania beheld her with tears in her eyes,
> O! Daughter return to your duty she cries,
> But she replies no I'm a Woman full grown,
> And long for to keep a good house of my own.
> > Derry Down.
>
> If you'd used me kind when I was in your power,
> I then had lived with you at this very hour,

228

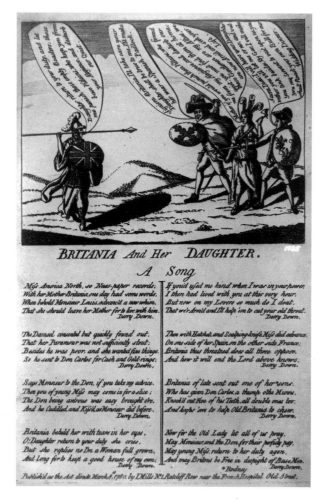

FIG. 8.11 *Britania and Her Daughter*, March 8, 1780. Engraving, 35 × 24.9 cm. The Library of Congress Prints and Photographs Division, Washington, D.C.

But now on my Lovers so much do I doat,
That we'r Arm'd and I'll help 'em to cut your old throat.
 Derry Down.

Then with Hatchet and Scalping-knife Miss did advance,
On one side of her Spain on the other side France;
Britania thus threatened does all three oppose,
And how it will end the Lord above knows.
 Derry Down.[40]

The song ends with Britannia, now a pathetic old creature, fighting back, and with a lasting plea for all Britons to be free.

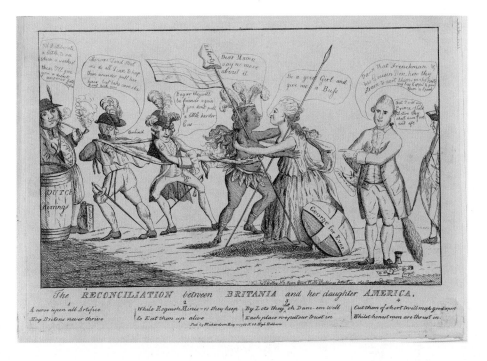

FIG. 8.12 *The Reconciliation between Britania and her daughter America*, ca. 1782. Engraving, 26.2 × 36.4 cm. The Library of Congress Prints and Photographs Division, Washington, D.C.

Britania of late sent out one of her sons,
Who had given Don Carlos, a thump o' the Munns,
Knock'd out Five of his Teeth, all double ones too,
And keeps 'em to help Old Britania to chew.
<div align="center">Derry Down.</div>

Now for the Old Lady let all of us pray,
May Monsieur, and the Don for their perfidy pay,
May young Miss, return to her duty agen,
And May Britons be Free in despight [sic] of Base Men.
<div align="center">Derry Down.</div>

A final analysis of the Indian warrior device is found in *The Reconciliation between Britania and her daughter America* (ca. 1782), in which the physical relationship between mother and daughter appears intimate and conciliatory (fig. 8.12). America, as the warrior, rushes into her mother's arms exclaiming, "Dear Mama say no more about it," while Britannia responds, "Be a good girl and give me a Buss." Both women bear

spears; the liberty cap rests atop America's, while Britannia's shield, inscribed "George for Ever," rests at her side. The personage of Charles Fox damns the Frenchman and Spaniard who try to tear the women apart, and the Dutchman observes the scene without any physical involvement. Aside from America's feather headdress, mother and daughter are equal in height and demeanor, symbolizing a physical and political truce in this exceptional print in which the skin tone of the Indian was intentionally darkened. This print makes light of the contentiousness surrounding the subject of reconciliation. Could Britannia be forgiven for inflicting such distress, for committing such acts of violence and violation?[41]

As a genre, satirical prints allowed for villainous figures such as Britannia to be caricatured in the public domain well within the safety of a visual culture already familiar with and financially supportive of the print market. Many Britons were sympathetic to the plight of the colonists and critical of their government's political actions. The war was an unpopular and costly event; repeated attempts at reconciliation occurred until the inevitable became clear. Thus, in the coffeehouses and taverns of both Britain and America, one could discuss politics in public while reading the papers and pamphlets that contained popular prints of topical interest. The satirical nature of political prints appealed to a variety of classes, and differences in who was purchasing such works on paper appear by decade and country. Before the Revolution, in Britain, prints were often sold to tradesmen and artisans, although their true target audience was clearly well-educated men who collected such prints for private portfolios.[42] Given the complexity of text and multifigural compositions, if one were not conversant in current politics, the imagery, although humorous, would be unintelligible. The success of political prints from the 1760s through the 1780s required a fairly sophisticated audience.

After the Revolution, as the industry of engraving became more lucrative and the number of individual publications continued to rise, prints in the new nation became an increasingly important element of American visual culture. As Georgia Barnhill has noted, the public was "as likely to be familiar with images of British or continental origin as with those produced in the colonies." The increasing visual literacy in America for satirical political prints appealed to an elite class until midcentury and was part of an elaborate relationship between the publisher, who commissioned and disseminated illustrations; the artist/engraver, who produced the image; and the audience, who received and interpreted the images they purchased or viewed publicly. Satirical prints were produced in a variety of formats, which raises the question of fine versus popular art. "Prints were imported along with other goods," explains Barnhill, "and sold by dealers who either specialized in prints or sold prints alongside goods as diverse as mirrors, furniture, musical instruments, and toys. Prints could be shipped from England relatively inexpensively because of their lack of bulk and then be framed and glazed later in the colonies."[43] Engravings could take the form of "framing prints," often hand-colored to

replicate painted images higher in the artistic hierarchy, or of illustrations in newspapers, broadsides, and pamphlets, more commercial methods of expression.

If one evaluates the social and political meaning of the dissemination, reception, and perception of these prints from the perspective of Jürgen Habermas's concept of the public sphere, printmaking functions as a form of social criticism and as a means of establishing public opinion. The individual female warrior represented the collective struggle of the colonists as a whole. This form of critical communication also expects the viewer/reader to accept the visual message as rational and therefore as true in spite of its comedic nature. By establishing and relying upon a visual, not just a verbal, method of conveyance, political prints appear to represent the popular or majority voice, or at least the most vocal point of view.[44] This raises the issue of the authoritative voice. Do satirical prints reflect the authoritative voice of the people, or do they merely reflect a vocal minority that can that be construed as authoritative? If Habermas's notion of the public sphere can translate in this context to represent criticism of the body politic, one must question whether there was a single, widely accepted message of satirical prints. The very nature of satire negates the idea of what Michael Jones describes as "fair and balanced," strengthening the argument that political commentary cannot be unbiased.[45]

In contrast to the symbolism associated with the female warrior, the actual relationship between colonists and Indians was far more contentious than British engravings suggested. While the physical distance from North America and the limited understanding of, or involvement with, indigenous peoples allowed British engravers to establish a mock representation of the American colonies in the guise of an Indian woman, it is unlikely that colonial American engravers or publishers would have come up with that particular image had they chosen their own personification of their struggle.[46] The proximity of real aggression loomed too close for comfort. The exception came when necessity dictated the adoption of an identity that was clearly non-European, exempt from "proper" Christian behavior and the perception of civility. For example, when the Sons of Liberty dressed in stereotypes as Indians at Griffin's Wharf, their temporary identity as "savages" gave license to unbridled acts of destruction. As John Higham has noted, the colonists were too close physically and psychologically to conflicts with Indians to see the image of a female warrior as representative of their struggle against England.[47] For British engravers, however, representing the colonies as a woman suggested weakness, and implementing the Indian reference further distanced the colonists from their British identity, despite the fact that a majority of colonists considered themselves British.

Whether she appeared in political prints as defenseless and vulnerable or as savage and brutal, the female warrior was emblematic of the struggle for colonial American justice and independence.[48] After the Revolution, she came to represent not a colonial entity but a unified nation. Her image was pervasive and could be

found on congressional medals, textiles, coins, and decorative sculpture. However, with the establishment of the Constitution and federal government, the vocabulary of democracy and liberty would take new forms in the early Republic. While printmakers still used the image of the Indian warrior to depict America, the manifestation of Liberty as a Greco-Roman goddess simultaneously appeared, only to supersede the Indian as the preferred emblem.[49] Liberty surfaced in the late eighteenth century in the midst of a neoclassical revival in the arts. This female heroine was easily adopted as a recognizable figure of the new Republic with an association void of references to the Revolution. If images of the fighting female warrior during the revolutionary era suggested willful determination, images of Liberty represented victory and peace. Bow and arrow were replaced by liberty cap, staff, and shield; headdress was replaced by a simple coiffure; and Liberty's demeanor suggested femininity, matronly protection, and independence from Britain.[50] The conflict between mother and daughter could be put to rest, at least temporarily—until 1812.

NOTES

I am grateful to have received research fellowships from the Lewis Walpole Library, Yale University; Winterthur Museum, Garden and Library; and a Jay and Deborah Last Fellowship from the American Antiquarian Society in support of this project. I would like to thank Georgia Barnhill, director emerita of the Center for Historic American Visual Culture at the American Antiquarian Society, for her assistance, support, and ever enthusiastic commitment to the field of American print culture. Also at the American Antiquarian Society, I would like to thank Lauren Hewes and Jaclyn Penny, in addition to Caroline Sloat for her comments on an earlier draft of this essay that was presented at a Society for Historians of the Early American Republic conference and discussed at "The Causes, Course, and Consequences of the American Revolution" conference at the Massachusetts Historical Society in 2015. Special appreciation is extended to Kathleen Parvin. And, of course, my thanks to George Boudreau and Margaretta Lovell for including my work in this wonderful publication and for their stalwart efforts to bring this project to fruition.

1. The indigenous peoples of North America are referred to throughout this essay as Indian rather than as Native American or Native American Indian. It is important to note the wide variance in terminology in scholarship, both current and past, with regard to ethnographic identification. Further complicating the language of self and other identification is the eighteenth-century British ethnocentric and pejorative use of imagery and terminology, in contrast to and with respect for current usage and preference.

2. For a recent study of the metaphorical body in the early Republic, see the symposium papers in Maurie D. McInnis and Louis P. Nelson, eds., *Shaping the Body Politic: Art and Political Formation in Early America* (Charlottesville: University of Virginia Press, 2011).

3. See E. McClung Fleming, "Symbols of the United States: From Indian Queen to Uncle Sam," in *Frontiers of American Culture*, edited by Ray B. Browne, Richard H. Crowder, Virgil L. Lokke, and William T. Stafford (Purdue: Purdue University Press, 1968), 1–24.

4. For a discussion of sixteenth-century examples of America as the fourth continent, see Clare Le Corbeiller, "Miss America and Her Sisters: Personification of the Four Parts of the World," *Bulletin of the Metropolitan Museum of Art* 19 (1961): 209–23. For a study of colonial representations of Indians, see Ellwood Parry, *The Image of the Indian and the Black Man in American Art, 1590–1900* (New York: Braziller, 1974). See also John Higham, "Indian Princess and Roman Goddess: The First Female Symbols of America," *Proceedings of the American Antiquarian Society* 100, part 1 (April 1990): 45–79; and E. McClung Fleming, "The American Image as Indian Princess, 1765–1783," *Winterthur Portfolio* 2 (1965): 65–81.

5. Cesare Ripa, *Iconologia* (1603 ed.; reprint, New York: Garland Publishing, 1976), 360. Ripa's first edition, of 1593, was not illustrated, and later editions represent America as a male warrior—see, for example, the Johann Georg Hertel edition (1758–60), reprinted by Dover Publications in 1971. The first English edition did not appear until 1709 in London. See also Fleming, "Symbols of the United States," 7. The representation of Britannia as a woman has Roman origins; she appeared as a captive on Roman coins in A.D. 119. See Alice Sheppard, *Cartooning for Suffrage* (Albuquerque: University of New Mexico Press, 1994), 41–42.

6. For a fascinating study of European and Indian relations, see James Axtell, *The European and the Indian: Essays in the Ethnohistory of Colonial North America* (New York: Oxford University Press, 1981). For critical interpretations of the imagery of John White, see Michael Gaudio, *Engraving the Savage: The New World and Techniques of Civilization* (Minneapolis: University of Minnesota Press, 2008); and Kim Sloan, *A New World: England's First View of America* (Chapel Hill: University of North Carolina Press, 2007).

7. See Paul A. Varg, "The Advent of Nationalism," *American Quarterly* 16, no. 2, part 1 (1964): 169–81. See also Harry Dickinson, ed., *British Pamphlets on the American Revolution, 1763–1785*, 4 vols. (London: Pickering & Chatto, 2007), general introduction.

8. For example, Olson cites a growth in newspapers from twenty-one in 1763 to forty-two by 1775. Lester Olson, *Emblems of American Community in the Revolutionary Era: A Study in Rhetorical Iconology* (Washington, D.C.: Smithsonian Institution Press, 1991), 7, 8.

9. E. McClung Fleming traced the evolution of the allegorical figure representing America through five stages. America was depicted as (1) one of the four continents (roughly 1575 to 1765); (2) the daughter of Britannia and symbol of the thirteen colonies (1765 to 1783); (3) a symbol of the United States after 1783; (4) a Greek goddess (this occurred as a gradual metamorphosis after 1783 until about 1815, when she came to symbolize American unity); (5) Brother Jonathan and Uncle Sam (the female form was replaced by these male figures in the "popular arts" in the nineteenth century). In addition to "American Image as Indian Princess," see E. McClung Fleming, "From Indian Princess to Greek Goddess: The American Image, 1783–1815," *Winterthur Portfolio* 3 (1967): 37–66.

10. Fleming, "American Image as Indian Princess," 66.

11. See, for example, the *Medals of Dishonour* exhibition at the British Museum in 2009.

12. See the introduction in the exhibition catalogue by Philip Attwood and Felicity Powell, *Medals of Dishonour* (London: British Museum Press, 2009); see also p. 51 for a similar pattern of medallions, in this case related to the humiliation of Louis XIV, by a Dutch artist.

13. Douglass Adair, "The Stamp Act in Contemporary English Cartoons," *William and Mary Quarterly* 10, no. 4 (1953): 540. See also James Jasinski, "The Feminization of Liberty, Domesticated Virtue, and the Reconstitution of Power and Authority in Early American Political Discourse," *Quarterly Journal of Speech* 79 (1993): 149, 151.

14. *The Examination of Doctor Benjamin Franklin, before an August Assembly, relating to the Repeal of the Stamp-Act, &c* (London: Great Britain, Houses of Parliament, 1766; reprint, New York: James Parker, 1766). This sixteen-page pamphlet is in the collection of the American Antiquarian Society.

15. For a complete discussion of this print, see E. P. Richardson, "Stamp Act Cartoons in the Colonies," *Pennsylvania Magazine of History and Biography* 96 no. 3 (July 1972): 289–91. On the day Parliament repealed the Stamp Act, *The Repeal*, by Benjamin Wilson, was published in numerous versions, suggesting its popularity (British Museum #4183). The engraving was reproduced to accompany a full-page broadside in 1768 with the title "Explanation," in which the emblem is discussed as the "miserable State of Great Britain," in relation to Belisarius, and in terms of the political moral of the picture. The lower right corner of the plate bears the inscription "Engraved in Philadelphia." Broadside, 1768, collection of the American Antiquarian Society.

16. "Glorious News. Boston, Friday, 11 o'clock, 16th May, 1766" (Boston: Printed for the benefit of the public, by Drapers, Edes & Gill, Green & Russell, and Fleets, May 16, 1766), collection of the American Antiquarian Society.

17. Clarence S. Brigham, *Paul Revere's Engravings* (New York: Atheneum, 1969), 29.

18. Liberty does appear on her own as a classical figure, such as in Revere's engraving of Samuel Adams for the *Royal American Magazine* of 1774, in which the bust of Adams is flanked by Liberty and Justice/Minerva. However, she represents the plight of freedom as she stands atop "Laws to Enslave America" and does not represent America at this time. For further discussion of the obelisk, see Fleming, "American Image as Indian Princess,"

76; see also David Hackett Fischer, *Liberty and Freedom: A Visual History of America's Founding Ideas* (New York: Oxford University Press, 2005), 100–101.

19. Revere's engraving for the March 1775 issue of the *Royal American Magazine*, "America in Distress," depicts America as classical Liberty rather than as the Indian warrior. The image was copied from the British version, "Britannia in Distress," for the *Oxford Magazine* of 1770. The scenes are nearly identical, including the use of the liberty cap and pole. However, in the American version, a bow, quiver, and feather headdress fall from Liberty's hand to the floor. Revere cleverly references the female warrior; she is acknowledged but not depicted in this scene by an American artist for an American audience. Here, unlike in the obelisk engraving, Liberty does represent America. Curiously, in *A Certain Cabinet Junto*, also from January 1775, Liberty represents Britannia with bow and quiver at her feet, but without the feather headdress, the stereotypical icon of the Indian warrior. Perhaps the print that he copied influenced Revere's depiction of America in "America in Distress." Unlike *The able Doctor*, there is no image/text relationship between the placement of these images and the corresponding articles.

20. William H. Ukers, *The Romance of Tea* (New York: Knopf, 1936), 84–85.

21. Julia Andrews, *Breakfast, Dinner, and Tea: Viewed Classically, Poetically, and Practically* (New York: D. Appleton, 1859), 302. See also Jane T. Merritt, *The Trouble with Tea: The Politics of Consumption in the Eighteenth-Century Global Economy* (Baltimore: Johns Hopkins University Press, 2017).

22. Benjamin Labaree, *The Boston Tea Party* (New York: Oxford University Press, 1964), 8–9. See also Benjamin Carp, *Defiance and the Patriots: The Boston Tea Party and the Making of America* (New Haven: Yale University Press, 2010), and Alfred Fabian Young, *The Shoemaker and the Tea Party: Memory and the American Revolution* (Boston: Beacon Press, 1999).

23. "To the Stated Pilots of the Port of New York," broadside (New York, November 10, 1773), collection of the American Antiquarian Society. Major port cities such as Boston, New York, Philadelphia, and Charleston each dealt separately with nonimportation issues, as cities were suspicious of one another's motives, and lack of adherence allowed greater economic advantages. See Labaree, *Boston Tea Party*, 23.

24. Wesley S. Griswold, *The Night the Revolution Began* (Brattleboro: Stephen Greene Press, 1972), 127.

25. The *London Magazine* version appeared in April 1774, vol. 43, p. 184 (image size 3 ⅝ × 6 in.), while the *Hibernian Magazine* version appeared soon after, in May, vol. 4, p. 251. Revere's version was printed in June 1774 for the *Royal American Magazine*. In August 1774, the *London Magazine* version was reproduced by a Philadelphia engraver with the altered title "The Persevering Americans, or The Bitter Draught return'd" (6 ¼ × 9 ¾ in.) (Harvard Library); in 1776, a simplified woodblock version appeared as the cover image for the *Freebetter's New-England Almanac for the Year 1776* (New London: Printed and Sold by T. Green, 1775). There is also a copperplate at the American Antiquarian Society, which is a copy of the *London Magazine* version with the addition of the numbers 1–10 to identify figures and objects; on the reverse of the plate is a trade card for William Putnam, a fabric merchant of Salem. Notes on the folder suggest that Salem engravers Benjamin Blyth, Joseph Hiller, and/or Jonathan Mulliken may have engraved the plate. No pulled prints are known (my sincere thanks to Georgia Barnhill for discussing this plate with me). Lastly, an 1884 version appeared in Francis Drake's *Tea Leaves* (Boston: A. O. Crane, 1884).

26. Lester C. Olson, "Pictorial Representations of British America Resisting Rape: Rhetorical Re-Circulation of a Print Series Portraying the Boston Port Bill of 1774," *Rhetoric and Public Affairs* 12, no. 1 (2009): 10.

27. *London Magazine*, April 1774, 185, collection of the American Antiquarian Society.

28. Reproduced in Olson, *Emblems of American Community*, 141–42.

29. See Brigham, *Paul Revere's Engravings*, 5. For the various interpretations of this iconography, see E. McSherry Fowble, *Two Centuries of Prints in America, 1680–1880: A Selective Catalogue of the Winterthur Museum Collection* (Charlottesville: University Press of Virginia for the Winterthur Museum, 1987), 144–45; Ron Tyler, *The Image of America in Caricature and Cartoon* (Fort Worth: Amon Carter Museum, 1976), 47; and Griswold, *Night the Revolution Began*, 126.

30. A profitable career could rarely be had in the eighteenth century from the production of engravings alone. Revere, in addition to his silversmith work, provided engravings for almanacs, magazines, cookbooks, bookplates, certificates of membership and attendance of all kinds (including one for a volunteer fire department), invitations to Masonic

meetings, and commercial advertisements. While his engravings for the *Royal American Magazine* are well known, he also produced engraved notices and trade cards for importers of goods from England, clockmakers, innkeepers, and shopkeepers; not surprisingly, he had a fair number of commissions for advertisements from metalworkers as well. Revere also produced an attendance certificate for a series of lectures on human dissection by Professor John Warren at the dissecting theater at Harvard Medical School. Revere included a vignette of a physician removing the internal organs of the corpse of a man who had recently been hanged (the rope was still around his neck), while dangling skeletons frame the central blank left for the name of the attendee. The engraving is titled *University at Cambridge* and is in the collection of the American Antiquarian Society. See also Brigham, *Paul Revere's Engravings*, 146–51. The *Royal American Magazine* had a large circulation of roughly one thousand copies. It ran from January 1774 to March 1775 and was published by Isaiah Thomas until Thomas sold it to Joseph Greenleaf, who published it from July 1774 to March 1775. The fifteen issues contained twenty-two engravings, thirteen signed by Revere. Images and text were copied from London magazines.

31. *Royal American Magazine*, June 1774. Among Revere's many engravings for the *Royal American Magazine* was the frontispiece for the July issue, *Spanish Treatment at Carthagena*, also in the collection of the American Antiquarian Society.

32. Olson notes the existence of the powder horns in "Pictorial Representations," 25. Finally, a much later American version, erroneously attributed to Revere, reveals interesting changes. The print is based on the Revere version but with a Victorian sense of morality; the artist has tamed the licentious act of America's sexual violation by removing the voyeuristic action and covering her breasts. The female figure representing America was also translated from an Indian woman into what became an iconic personification of Liberty, still female but with more European features. See the image as reproduced in Drake, *Tea Leaves*, with the caption "Lord North Forcing Tea Down the Throat of America." Clarence Brigham discusses the existence of a number of these versions in *Paul Revere's Engravings*, 118. Was the sexual politics associated with the violation of America, both literally and figuratively, deemed less offensive when the act was committed against an Indian woman rather than a Europeanized female figure? Clearly, the concept of "taming the savage" and a disregard for cultural identity are undercurrents here.

33. For an exceptional summary of the British-American colonial conflict from the Stamp Act until the initiation of the Revolution, see Dickinson, *British Pamphlets*, introduction.

34. Olson reads the figure stabbing Britannia as France. *Emblems of American Community*, 87–88. Fischer reads him as a member of the British ministry. *Liberty and Freedom*, 141–42.

35. The use of the pileus cap and corresponding pole relate to the ceremony for the manumission of Roman slaves, who donned their caps and were touched with a rod, symbolizing their freedom. See Yvonne Korshak, "The Liberty Cap as a Revolutionary Symbol in America and France," *Smithsonian Studies in American Art* 1, no. 2 (1987): 53. See also Amelia Rauser, "Death or Liberty: British Political Prints and the Struggle for Symbols in the American Revolution," *Oxford Art Journal* 21, no. 2 (1998): 151–71.

36. The *Oxford English Dictionary* notes 1402 as the first documented use of the word "slut" as a pejorative term suggesting a lack of morality with regard to sexual behavior. Thus the word was part of a general parlance by the late eighteenth century.

37. Olson quantifies the number of political prints between 1765 and 1781 in which the Indian is depicted as possessing new power and authority. *Emblems of American Community*, 89.

38. Donald H. Cresswell, *The American Revolution in Drawings and Prints* (Washington, D.C.: Library of Congress, 1975), 216, fig. 700.

39. Mary Dorothy George, *Catalogue of Political and Personal Satires Preserved in the Department of Prints and Drawings in the British Museum* (London: Oxford University Press, 1935), 220. See also Olson, *Emblems of American Community*, 154; Cresswell, *American Revolution in Drawings*, fig. 700. Cresswell says *The Parricide* appeared in the May 1 issue of *Westminster Magazine*, while Olson says it appeared in the April 1776 issue.

40. Reproduced in Cresswell, *American Revolution in Drawings*, 327. The son referred to is noted as Rodney. Although the tune is not suggested, the use of Derry Down refers to a well-known English tune. See also Olson, *Emblems of American Community*, 93, 159–61.

41. For an interpretation of Thomas Paine's *Common Sense* related to reconciliation, virtue lost, and rape, see Jasinski, "Feminization of Liberty," 152.

42. Diana Donald, *The Age of Caricature: Satirical Prints in the Reign of George III* (New Haven: Yale University Press, 1996), 18.

43. Georgia Barnhill, "The Markets for Images from 1670 to 1790 in America," *Imprint* 25, no. 1 (2000): 24, 16.

44. David D. Hall, "Introduction," in *The Colonial Book in the Atlantic World*, vol. 1 of *A History of the Book in America*, edited by Hugh Amory and David D. Hall (Cambridge: Cambridge University Press, 2000), 10. For a discussion of the public sphere, see Jürgen Habermas, *The Structural Transformation of the Public Sphere* (1962), trans. Thomas Burger (Cambridge: MIT Press, 1989).

45. See Michael Wynn Jones, *The Colonial History of the American Revolution* (New York: G. P. Putnam's Sons, 1975), 9.

46. Olson discusses the image of the Indian in *Emblems of American Community*, in a chapter titled "The Colonies Are an Indian," 75–123. Olson uses "Indian" as distinct from "Native American" as it denotes a European-contrived image of native cultures and peoples.

47. Higham, "Indian Princess and Roman Goddess," 55.

48. See Fleming, "Symbols of the United States," 8.

49. Fleming, "Indian Princess to Greek Goddess."

50. This essay addresses the theoretical application of Indian warrior imagery and not the historical aspects of European and Indian relations. While there is a vast scholarship on the combative relationship between the two groups, an ethnohistorical approach to the depiction of Indian women reveals a complex set of interrelationships, encompassing religious, racial, and cultural issues.

"The Family of Derby Has a Taste in This Way"

THE HOMES OF ELIAS HASKET AND ELIZABETH DERBY, 1762–1799

EMILY A. MURPHY

IN 1802, ELIZA SOUTHGATE traveled to Salem, Massachusetts, to visit her dear friend Mrs. John Derby and several other members of the Derby family. On one occasion, a party went to visit the mansion and gardens on Essex Street in Salem that Elias Hasket Derby Jr. had recently inherited from his parents. In the breathless language of a veteran novel reader, Eliza Southgate wrote to her mother of her reaction to the place: "The novelty of the scene filled my mind with sensations I never felt before. I could not realize every thing and expected every moment that the wand of the fairy would sweep all from before my eyes and leave me to stare and wonder what it meant. You can scarcely conceive anything more superb."[1] The house and garden that threw the eighteen-year-old into literary transports was the last home of Elias Hasket (1739–1799) and Elizabeth Derby (1727–1799) (fig. 9.1). During their thirty-eight-year marriage, the Derbys' choice of homes and furnishings, along with those of Mr. Derby's parents and siblings, represented a deliberate acquisition of material goods, and patronage of local artisans, that would display good taste and ensure the family's social and political position in Salem, while also guaranteeing their good credit in the eighteenth-century mercantile community.

By the time Hasket (as he was generally known) married Elizabeth Crowninshield in 1761, the Derby family had been in Salem for four generations, but before the 1750s they were not among the leading families of Salem. Roger and Lucretia Derby, who

FIG. 9.1 The Derby Mansion was torn down in 1815, but the architectural drawings for it by both
Charles Bulfinch and Samuel McIntire have survived. This is a reproduction of Charles Bulfinch's
preliminary drawing for the Derby Mansion on Essex Street. Reproduced as the frontispiece of C. H.
Webber and W. H. Nevins, *Old Naumkeag: An Historical Sketch of the City of Salem, and the Towns of
Marblehead, Peabody, Beverly, Danvers, Wenham, Manchester, Topsfield, and Middleton* (1877). National
Park Service Museum Collections, SAMA 27189. Photo: National Park Service.

arrived in Massachusetts in 1671, were a moderately well-to-do tallow chandler and
shopkeeper, respectively, but it was their grandson Richard (1712–1783) who began
the rise in the family fortune through a career as a mariner, ship captain, and finally
merchant. By the 1750s, Richard was in the town's top tax bracket and owned a large
"mansion house" near the mouth of the South River in Salem. The area around what
was soon to be known as Derby Street was not the most fashionable section of Salem;
there were some large houses, but the important families in town—the selectmen,
judges, representatives to the General Court, and other social and political leaders—all
had substantial mansions along Main Street (now Essex Street), centered around the
First Church and the Town House at Town House Square, the intersection of Main
Street and School Street (now Washington Street). Essex Street runs east-west along
the spine of the Salem peninsula, and the area around Town House Square was the
most desirable real estate in the town and included the wharves on the South River.
Over the next forty years, the Derby family, particularly Richard's second son, Elias
Hasket, would make it a goal not only to enter this bastion of privilege but to put
their own stamp upon it.

CREDIT AND SOCIAL STANDING IN MERCANTILE CULTURE

Mercantile culture was in a unique situation in the eighteenth century. Unlike land, which bestowed steady wealth, privilege, and social status upon each successive generation, a merchant house was difficult to convey from one generation to the next. A merchant house rose or fell on the credit of those who ran it, and thus each generation had to earn its own influence in the international trade networks. Credit—a relationship of trust between two people—was central to the European mercantile community of the seventeenth and eighteenth centuries. Cash was extremely scarce, and thus merchants relied on bills of exchange to keep goods and services flowing throughout the Atlantic world. These bills were often part of a three-way exchange, for in order to pay a debt, a merchant might draw on money owed to him by someone else.

These transactions greatly expanded the network of credit, for creditors had to ask themselves if they trusted not only the person who owed them money but also the third person who was being drawn on to pay the debt. A further layer of complexity was added for Massachusetts merchants, who not only had to handle a variety of contacts in North America, the Caribbean, and Europe but were also working with both Massachusetts currency and British pounds sterling.[2]

In order to maintain credit and cultivate good connections, Georgian merchants had to be able to participate in the world of gentility, demonstrating education, proper deportment, and an understanding of the appropriate clothing, furnishings, and architecture for someone of their status. Richard Derby Sr. seems to have been deeply aware of this, and of his own deficiencies; his own handwriting and spelling were poor, but he ensured that at least his second and youngest sons had an education from a tutor, and as soon as Hasket was old enough, he was writing much of his father's correspondence. Like his sons, Derby's daughters had the advantage of an exclusive education at girls' schools in Boston, where they learned fine needlework, dancing, and perhaps a little French or Italian.[3]

As his rising wealth allowed, Richard furnished his house with silver and good furniture, and as early as 1747 already owned at least one enslaved person, as a receipt for shoes in the Derby Family Papers shows. Between 1755 and 1780, he owned at least six enslaved people: Jane is mentioned in 1754 as marrying an enslaved man belonging to Samuel Gardner; Obed ran away in 1774, when Richard was taxed for three enslaved people; Phoebe married Mingo, who belonged to near neighbor Warwick Palfrey in 1778; and in 1783, Richard's will mentioned a "negro child Peggy," "negro girl Cate," and "negro man Cesar." This placed Richard in the upper echelons of slaveholders in Salem, as the majority of slaveholders in the town had only one enslaved person in their household. Enslaved children were often employed in child care, and women would have done laundry and other cleaning, while men were employed in a range of occupations. There were enough enslaved people in Richard's household

239

that it is very likely that Phoebe was a maid to Richard's second wife, Sarah. A neatly attired enslaved servant was a status symbol in eighteenth century Anglo-America, and Phoebe's presence in the home, fetching and carrying items for her mistress, would have added to the appearance of wealth in the large house and met with approval from visiting merchants.[4]

240

Through the efforts of Richard Sr., the Derbys had risen to the top of the economic elite in Salem. Richard was the third-wealthiest man in Salem in 1759, and with the growth of his mercantile investments after the end of the Seven Years' War, he had become the wealthiest man in town by 1769. However, in order for the family to maintain its primacy, Richard's children needed not only to improve the profits of the business but also to present a successful face to the world. Since marriage was often the point at which successful sea captains would begin to focus on mercantile activities, the weddings of Richard Derby Sr.'s six children, particularly his second son, Elias Hasket, provided Richard with the occasion to give the next generation a genteel start on their own careers.[5]

CREATING A GENTEEL GENERATION

The marriages of Richard Sr.'s oldest and youngest children—Richard Jr. and Sally—into the old, wealthy, and well-established Gardner family gained social legitimacy and political power for the Derbys. At the same time, the Derbys provided similar legitimacy for another rising family. The marriage of Mary Derby to George Crowninshield and of Elias Hasket Derby to George's sister Elizabeth were good business moves for both families, as George was a very competent captain, and, in theory at least, the Crowninshields and Derbys could be business partners in future ventures.

George and Elizabeth's father, John Crowninshield, was a first-generation American colonist—his father, Johannes Caspar Richter von Kroninshildt, immigrated to Boston in 1694. Like Richard Derby Sr., John was left with little from his father's estate but managed to build a successful mercantile business by the 1750s. He and his wife, Anstis Williams, raised their nine children in their "Mansion House" on the eastern side of Essex Street, a block from Richard Sr.'s home (fig. 9.2). John's third son, George, followed the family business, but instead of sailing mainly on his father's ships, he spent a substantial amount of time sailing for Richard Derby Sr. This business connection became more personal in 1757, when George married Richard's oldest daughter, Mary.[6]

Mary Derby Crowninshield was apparently well liked by all who knew her. Even the hard-to-please Reverend William Bentley was complimentary about her in his private diary: "She was indeed an extraordinary woman & maintained with a dignity of person, a dignity of action, which was assisted with the purest manners. In her

FIG. 9.2 The childhood home of Elizabeth Crowninshield and George Crowninshield, this house was built in 1727 by their father, John. Now known as the Crowninshield-Bentley House, it was moved from its original location on Essex Street in Salem in the 1940s and restored to its eighteenth-century appearance. Photograph by The Moulton-Erickson Photo Co., ca. 1891–1901. Courtesy of the Salem Public Library.

family we have had nothing like her." Bentley's description indicates that, as opposed to her Crowninshield relations, Mary measured up to the highest standards of the genteel world, where good manners were merely the outward expression of a virtuous and tasteful mind.[7]

Richard Derby Sr. was generous to the young couple, giving them first an older house on Essex Street near the East Meeting House, then later a fine Georgian house on Derby Street, along with a large amount of household furniture and goods totaling £4,000, according to Richard's 1783 will. Mary's genteel taste was probably beautifully expressed in furniture upholstered in the shalloon fabric that Richard ordered in January 1757 from his London merchant contacts Lane and Booth. Richard also presented Mary and George with some large pieces of plate, including a magnificent silver teapot by the Boston silversmith Benjamin Burt. As with both their parents' families, the couple also acquired enslaved servants as soon as it was financially feasible. In 1771, they were assessed for one "servant for life," and in 1774 they inherited an enslaved girl from George's mother's estate. In 1783 another girl, Cate, came to their household from Mary's father's estate.[8]

The Crowninshield-Derby connection was further strengthened in 1761, when Elias Hasket married George's younger sister, Elizabeth. By this time, however, the Crowninshield mercantile interests were not doing as well as the Derby interests; this can be measured in the fact that Elizabeth received a dowry of household goods worth about £50, the smallest dowry bestowed on the Crowninshield daughters, and far from the hundreds of pounds Richard Derby bestowed on his own children.[9]

The idea of a potential partnership between two merchant houses, commanded by Richard Derby and John Crowninshield, respectively, came to an end in May 1761, only a month after Hasket and Elizabeth's wedding, when John Crowninshield died suddenly. Crowninshield's death was followed the next year by that of his youngest son, Benjamin, and three years later by that of his oldest son, John Jr. With his father's

estate tied up in probate, and with low expectations for a great inheritance (he eventu-
ally received £79 1s. 11d., about a third of the value of the schooner listed in his father's
inventory), George continued to sail for the Derbys and other merchants in Salem for
a few more years.[10]

Both George and Hasket received enough gifts from Richard Sr. on their respec-
tive weddings to make them freeholders, but they did not have their independence.
Richard presented them with houses, but he maintained legal ownership of the
buildings and land until his death. This put both young men in a bind, for they and
their new wives could maintain a genteel lifestyle in their lovely Georgian homes,
and because they were paying taxes on the buildings, they could participate in town
government—but because they did not legally own the property, neither of them
could mortgage their homes or otherwise leverage their assets to make more money.
Hasket in particular was at a disadvantage, since he was not a captain and therefore
could not earn commissions on the cargo he shipped. This tactic had a twofold result:
by maintaining legal ownership of their homes, Richard made it more difficult for
his son and son-in-law to set up rival mercantile firms. In addition, this arrangement
also provided some protection for his daughters at a time when business and personal
property were not legally separated, and bankruptcies among smaller merchants were
common.[11]

FURNISHING A MERCHANT'S HOME

Elizabeth Crowninshield obviously understood the value of display and its impor-
tance to a merchant's credit. Although the dowry she received for her wedding to
Elias Hasket Derby in April 1761 was more than enough to completely furnish a
tradesman's home, her family chose to buy a few really expensive items. A mahogany
chest of drawers and table, another small table, and a mirror were worth almost £14,
a set of harrateen bed hangings was worth more than £14 alone, and the bedstead,
mattress, pillows, quilt, sheets, and other linens were together worth £10. The rest of
her dowry—clothing, iron ware, and a brass kettle—indicate that initially the young
couple was living in a single room, most probably in Richard Derby Sr.'s mansion
house, for the furniture would handsomely furnish a room, and the brass kettle and
iron ware would even allow Elizabeth to prepare and serve small meals there.[12]

The fact that John and Anstis Crowninshield gave their daughter such an expen-
sive item as a set of bed hangings denoted the importance of these items in the
Georgian household. The "best bed" was the parents' bed, used as much as a display
of wealth and social status as it was for sleeping or lovemaking. Harrateen, fine English
wool woven tightly and often pressed between heavy heated rollers to stamp a rippled
texture or designs like butterflies, flowers, and "vermicelli," or "worm trails," into the

FIG. 9.3 Bedchamber in
the Derby House, Salem,
Massachusetts, with reproduction
bed hangings in green harrateen.
National Park Service Museum
Collections, Salem Maritime
National Historic Site. Photo:
National Park Service.

surface of the fabric, was the single most popular type of fabric for bed hangings in the British Empire in the 1760s. Green was by far the most popular color for bed hangings because of its association with health, followed by scarlet, and the existence of "one old set green harrateen bed hangings," recorded in Hasket's 1799 probate inventory, indicates that Elizabeth's dowry curtains were the ultrafashionable green (fig. 9.3).[13]

Another reason for the selection of items for Elizabeth's dowry may have been the relationship of men and women to space in the Georgian household. Parlors, drawing rooms, and halls were all public spaces, constantly traversed by servants, family members, and visitors, and these spaces were also where the deliberate performance of genteel hospitality occurred. For women, the bedchamber was a space where they could read, correspond with friends and relations, and control access, in the same way a gentleman's library was used for both personal reflection and dividing friends and honored guests from mere acquaintances, who were entertained in the parlor. Thus the choice of bedchamber furniture made Elizabeth's dowry not only a financial present to the newly married couple but also a personal gift to Elizabeth alone, and a reminder of the family she was leaving behind. Derby money may have built the house and furnished the parlors, but the friends and guests whom Elizabeth invited into the bedchamber for tea would be surrounded by Crowninshield wealth.[14]

The expensive pieces of furniture that Elizabeth brought to her marriage were intended to be displayed in the fine Georgian-style brick house Richard had built for

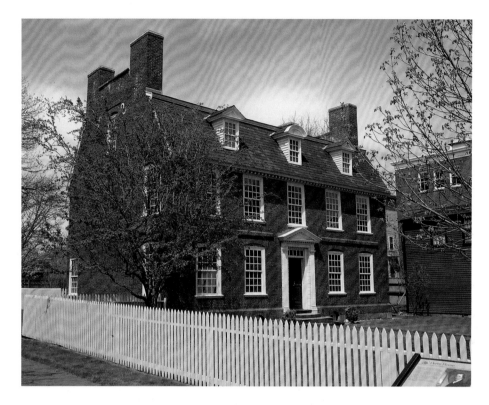

FIG. 9.4 The Derby House, Salem, Massachusetts, completed in 1762, and now part of Salem Maritime National Historic Site. Photo: National Park Service.

the young couple in 1761–62. The Derby House, as it is now called, was not as large as some of the contemporary frame houses of the wealthy families in Salem, but it was beautifully proportioned, with a gambrel roof displaying dormers with alternating peaks and bonnet tops. In addition to being a lovely example of Georgian architecture, Hasket and Elizabeth's new home was well placed. Richard Jr. and Mary had both received houses on or close to Essex Street, the main thoroughfare in Salem. Hasket, however, had his house placed at the head of Derby Wharf, newly constructed the same year that his house was. The placement of houses was extremely important, and just as John Hancock's house dominated Beacon Hill in Boston, Derby House became a feature of the harbor front in Salem and could be glimpsed by every vessel entering or leaving the South River on the way to or from the wharves along Front Street.[15]

The design of the Derby House is significant, for although its modest size reflected the neighborhood of moderately successful merchants, sea captains, and business owners, its geometrical proportions and quality of ornament, such as the dormers and the nicely proportioned pediment around the front door, are in the high Georgian style (fig. 9.4). Indeed, the same dormers and pediments were found on the

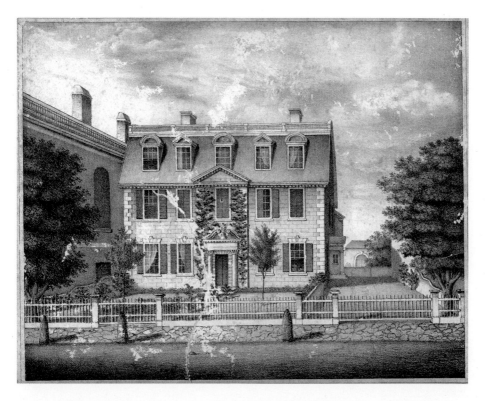

FIG. 9.5 Lithograph of the ca. 1749 Pickman House by Pendleton Brothers, ca. 1832. This was the
house of Benjamin Pickman, and it stood on Essex Street next to the present-day Peabody Essex
Museum. Richard Derby Sr. worked for the Pickmans as a young man, and the design of the 1762
Derby House was obviously inspired by this house. National Park Service Museum Collections,
SAMA 3941. Photo: National Park Service.

large frame houses build on upper Essex Street by the Pickmans (fig. 9.5), Cabots,
Ropes, and Lindalls, all old families who were in the top echelon of taxpayers in Salem
in the 1740s and 1750s.

The Derby House aped the design of these larger mansions, but it was made
of brick, one of the most expensive building materials in eighteenth-century New
England. By using this material to build not a center-chimney New England home, but
a Georgian home that would look as comfortable on the shores of the Potomac River
in Virginia or on the streets of Annapolis, Maryland, or even in the rolling countryside
of southern England, as it did on Derby Wharf, the Derbys made a strong statement
about their participation in gentry culture. They were not New England merchants;
they were British merchants, fully aware of the most recent fashions and of what sort
of display was needed to participate in that gentry culture.

The interior of the house followed this fashionable intent. The parlors on the first
floor and the formal chambers on the second were paneled and painted, and wallpaper

FIG. 9.6 The newel post of the staircase of the Derby House. This double spiral newel post was found in several homes in Salem from the 1740s through the 1760s. National Park Service Museum Collections, Salem Maritime National Historic Site photograph 04B-056.

or fabric was displayed on the walls above the wainscoting. The colors of the rooms followed the fashion, with the parlors on the first floor and the staircase in a moderately expensive olive or pea color, a neutral ground that would showcase any colorful wallpaper placed on the walls, while the bedchamber was painted a fine deep green, the most expensive pigment on the market in the mid-eighteenth century. Without a central chimney, there was space in the center of the house for a grand staircase, featuring a finely carved newel post in the shape of a corkscrew, spiral balusters, and paneled undersides to the short flight of stairs from the upper landing to the second floor (fig. 9.6). The stair balustrade is a deliberate copy of staircases found in many of the high-end Georgian townhouses in Salem and surrounding communities, such as the Cabot House on Essex Street, built in 1748; the Pickman House, built 1750; and the country home in Danvers of Marblehead merchant Robert Hooper, built in 1754. The staircase in particular shows that the Derbys intended to entertain their friends and peers, for such a staircase was a tasteful passage to the formal chambers on the second floor. The expense of the interior fittings and the use of arched window openings and a fine Palladian door surround meant that this brick house was intended as a showpiece—a place where social interactions could be performed in a proper setting.[16]

Although Richard Derby Sr. supplied the house, it was up to his son to furnish it properly for his new bride. Elizabeth's dowry furnished one upstairs bedchamber, but the rest of the house remained. Between January and August 1762, Hasket spent more than £280 at the shop of furniture maker Nathaniel Gould to dress the two parlors at the front of the first floor. The mahogany chairs and tables, tea table, and pair of bottle stands, among other items, indicate that the young couple intended to entertain their peers in style.[17]

In the decade after their marriage, Hasket and Elizabeth added regularly to their family—for a total of seven children—as Hasket became more firmly entrenched in his father's business and began to strike out on his own, purchasing a few fishing vessels and investing in the voyages of his father and brothers. Judging from the extant receipts in the Derby Family Papers, they spent no more on the house until 1765, when Hasket hired local artist and painter Benjamin Blythe to paint the fence and the water pump in the backyard, and Blythe also did some painting around the windows of the house. Hasket and Elizabeth also began to add to their collection of plate, purchasing two pairs of casters and salts from the Boston silversmith Benjamin Burt for the sum of £103 3s. 7d. Like their siblings, they also purchased enslaved people—in 1771 they were assessed for two "servants for life" in the Massachusetts tax valuation, and although slavery was outlawed by two legal decisions in 1783, two other African Americans, Rose and Sabe, who were perhaps indentured to the family, worked and lived in the household until Elias Hasket and Elizabeth both died in 1799.[18]

In the late 1770s or very early 1780s, the Derbys had their portraits painted by Benjamin Blythe, the local portrait artist. Blythe is most famous for his portraits of John and Abigail Adams, and he was well known among the merchants in Essex County for his three-quarter-length pastel portraits. He painted Elias Hasket as a successful merchant, holding a quill and piece of paper and wearing the brown superfine wool "ditto" suit with silk-thread death's-head buttons so popular among John Singleton Copley's sitters. Elizabeth and her youngest daughter, Anstis, both wear draped gowns reminiscent of the Grecian and Turkish gowns so popular among aristocratic and gentry portrait sitters in the period. Elizabeth's hair is piled high in a conical form that was at the height of its popularity in England in the 1770s, festooned with pearls and roses (fig. 9.7). Anstis holds a basket of fruit and flowers, and her brother Ezekiel Hersey wears a blue suit. Blythe was no Copley, but Elias Hasket and Elizabeth were not yet millionaires. Blythe's stiff but appealing portraits were exactly appropriate for a merchant family still earning its fortune, as they captured the elements that mattered to those viewing them—Elizabeth's fine lace, Hasket's thread buttons, Ezekiel's white collar—at an affordable price. These portraits, hanging in the parlor, showcased the wealth and gentility of the family through the appearance of its individual members.[19]

Although Hasket was responsible for paying the taxes and maintaining the house, he was not the legal owner of the building until 1783. Land ownership was an

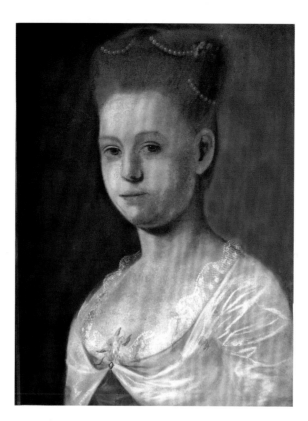

FIG. 9.7 Benjamin Blythe, *Elizabeth Crowninshield Derby (Mrs. Elias Hasket Derby)*, ca. 1775–80. National Park Service Museum Collections, SAMA 1674. Photo: National Park Service.

important mark of gentry status in both England and America, and speculation in building was seen as a gentlemanly investment, more stable and proper than investing in trade. Thus, in addition to purchasing his own vessels in the early 1770s, Hasket also began speculating in land as soon as he had the money, purchasing and then reselling property, including building a new brick house on an unidentified lot in 1774, just as the American political landscape was shifting rapidly.[20]

GENTEEL DISPLAY, POLITICS, AND THE OUTBREAK OF VIOLENCE

Politics and trade were inextricably linked for merchants in the British Empire. Tariffs, trade restrictions, and treaties were all determined by the need to keep British vessels moving around the world, and an ambitious merchant could advance his interests only by keeping an eye on international politics. As the Revolution approached, the merchants of Massachusetts found that the consumer goods that they were importing had become an integral part of political controversy as the nonimportation and nonconsumption movements gained popularity. As the second

largest port in Massachusetts, Salem became the scene of some significant political and military actions.[21]

Through the 1760s, Salem's sociopolitical milieu was dominated by a subset of interlinked elite families who served as representatives to the General Court and on the Governor's Council and filled judicial seats and important town posts. The decision by Salem representatives William Browne and Peter Frye to support Governor Hutchinson's rescission of the famous Circular Letter of 1768 was the break needed by another group of interlinked families—the Pickerings, Gardners, and Derbys—to achieve political control of the city. In this effort, proper display was an important factor. The ledgers for the Derby family's distillery, where molasses from the West Indies was turned into New England rum, show that in 1768, when Richard Derby Jr. and John Pickering were campaigning to replace Browne and Frye, both Richard Jr. and Hasket were taking at least a barrel of rum a month each "for the house" (for household use). The consumption of more than thirty gallons of rum a month in households that contained only two adults can be accounted for by the entertainments and gatherings necessary to garner votes in the competitive politics of the era. Rum meant punch, and the added expense of the spices, sugar, citrus fruit, decorated punch bowls, silver ladles, and punch glasses that were necessary accoutrements for a political gathering would have shown the Derbys' potential political allies that they had the requisite genteel manners.[22]

Like his father, Hasket was reluctant to take an active part in Massachusetts politics—his older brother, Richard Jr., represented the family and Salem at the local and colonial levels—but he contributed to the patriotic cause in Salem by supporting the nonimportation agreements begun by Boston merchants in response to the Townshend Acts. With his fellow Salem merchants, Hasket agreed that "from the first of January 1769 to the first of January 1770 they will not send or import, either on their own Account or on Commissions, or purchase of any Factor or others, who may import any Kind of Goods or Merchandizes from Great Britain, except Coal, Salt, and some Articles necessary to carry on the Fishery. They likewise agree not to import any Tea, Glass, Paper, or Painters Colours until the Acts imposing Duties on those Articles are repealed."[23]

This may not have been an altogether selfless decision on the Derbys' part, for the nonimportation agreements did not prohibit the sale of items already in their warehouses. The Derbys could thus profit greatly by selling their stock, while lesser shopkeepers would be driven out of business. The agreement also exempted articles that were necessary for the fishery and did not mention West Indies goods at all. Thus shipping molasses into Salem for the family distillery was still allowed, as was shipping finished goods between Great Britain and other ports, like those in the West Indies, where there was no nonimportation movement.[24]

With the coming of war, the brick house that showcased Derby wealth and taste to all who sailed into the South River became vulnerable, as it was easily within range

of any Royal Navy vessel that intended to bombard Salem. Like many of their neighbors, the Derbys fled after the burning of Charlestown in 1775, fearing a naval attack on their town. It was probably concern for the safety of his family that spurred Hasket in early 1776 to purchase a farm in Danvers, near the border of Salem but out of firing range of any frigate in Salem Harbor. His concerns were still valid two years later, for when he contracted with Isaac King in March 1778 to manage the farm, Hasket allowed King to live in the lower room on the western side of the house, unless "said Derby is obliged to move from town, in that case King is to have the out House."[25]

Unlike Hasket's other purchases of real estate in Salem in the early 1770s, the farm was not a speculative property. Instead, it was intended to be a retreat, and a place where Hasket could exercise the gentleman's virtue of improvement, particularly the improvement of agriculture. Hasket's obituary, written by his son-in-law, notes the genteel work he did on the farm in Danvers: "He possessed a good taste in gardening and agriculture, and most judiciously—both for his own enjoyment and the benefit of his country—applied a part of his wealth to improvements in that department. By his successful experiments in his excellent garden and farm, in Danvers, he taught the neighboring farmers that their lands are capable of productions which they had before thought could be prepared only in more genial soils. It was in these improvements that Mr. Derby found some of his most tranquil enjoyments, and they imparted delight to all who had the curiosity to visit them."[26]

Like English gentry estates, Hasket's Danvers farm was a place where he could show patronage to the local community. Since he did not have to depend on the farm for income, he could experiment with new means of cultivation or new species and pass on what he learned to neighboring farmers, thus improving the agriculture of the region and encouraging local production of staples.

The brick house on Derby Street and the farm in Danvers were a good start, but soon Hasket's investments in privateering and, later, international trade enabled his family to solidify its leadership in the new American Republic and create a new statement of mercantile gentility in Salem through a reshaping of the oldest part of the town.

Today, privateering is often confused with piracy, but an eighteenth-century merchant knew the difference. Privateering was an accepted part of warfare for centuries before the Revolution; the first "letters of marque and reprisal" were issued in England in the thirteenth century. Initially, these letters responded to specific grievances by merchants and allowed them to forcibly recover property, but by the eighteenth century they had become systematized in Europe as a way for a country to increase naval strength without the government having to foot the bill. American vessels had participated in privateering during the colonial period. In fact, during times of conflict, the admiralty gave the governors of British colonies permission to issue commissions and letters of marque and to appoint judges for courts of vice-admiralty. On November

1, 1775, Massachusetts became the first state to pass an act authorizing privateering commissions and letters of marque.[27]

Issuing privateering licenses was extremely useful to the colonial legislatures. First, the large bond provided cash to the provincial government, and the requirement that one-third of a privateer's crew must be landsmen (sailors on their first voyage) ensured the training of new sailors, leaving experienced sailors available for fishing, merchant, provincial navy, and Continental navy vessels.[28]

251

Successful privateering ventures could be enormously profitable. In May 1776, Hasket's sloop *Revenge*, armed with twelve cannons and sixteen swivel guns, with a crew of eighty-five men under Captain Joseph White, headed out and soon captured the ship *Anna Maria* and the schooner *Polly*. By the end of the year, the *Revenge* alone had captured eight more vessels, and Hasket had eight other vessels sailing as well. According to one historian, the prizes captured by these vessels sold for about £37,500, an astonishing amount of money. Even after the profits were distributed to the captains and crews of the privateers, Hasket would still have made a considerable amount. Hasket seems to have been particularly fortunate with his privateers, and he quickly reinvested the proceeds in larger vessels, which in turn sent larger prizes back to Salem.[29]

Privateering may have caused a labor shortage, but it created an economic boom. In August 1776, James Warren wrote to Samuel Adams from Boston, "The Spirit of Privateering prevails here greatly. The Success of those that have before Engaged in that Business had been sufficient to make a whole Country Privateering mad. Many kinds of West India Goods, that we used to be told we should suffer for want of, are now plentier and cheaper than I have known them for many years." The goods that the privateers brought in were varied and, as Warren pointed out, made finished goods much more available in the port towns and at cheaper prices than had been available before the war, especially with the nonimportation and nonconsumption acts in place. For example, in 1777, the cargo of the two-hundred-ton *Royal Charlotte* that was sold at auction in Salem included beans, oats, three bottles of anchovies, Cheshire cheese, tin and iron kitchenware, wine glasses, decanters, hair powder, a lady's side hunting saddle, two suits of boys' clothes, calico, tallow, butter, bread, a jar of raisins, porter, port wine, champagne, grindstones, and corsets, among many other items, for a total of £5,718 19s. 9d. The "spirit of privateering" created another wrinkle in the relationship between consumption and politics: after years of patriotic self-deprivation and the creation of common interests over the boycott of many of the very items on the *Royal Charlotte*, these items now became symbols of the success of the American cause and a patriotic statement of support.[30]

By the end of the Revolution, Hasket was sending out many larger vessels, like the twenty-eight-gun *Grand Turk*, the twenty-gun *Exchange*, and the eighteen-gun brigantine *Hersey*, all of which brought back multiple prizes, in the case of the *Grand*

Turk alone, more than £250,000. In total, Hasket sent eighty-five vessels on 110 cruises, supplying personally more than 40 percent of Salem's privateering activity, 12 percent of Massachusetts's effort, and 5 percent of the entire American privateering fleet. More than eight thousand men shipped on these vessels, and together they captured twenty-nine ships, fifty-eight brigs, ten snows, twenty-five sloops, and twenty-two schooners.[31]

Privateering activity was vital to the revolutionary effort, for prize auctions kept the economy thriving and brought in vital supplies; in addition, chasing the privateer vessels diverted the Royal Navy from attacking American ports. Over the course of the war, Britain lost approximately two thousand vessels and their cargos, a loss estimated at £18 million in 1780s currency. With the end of the Revolution, however, privateering also came to an end. In 1783, shortly after the news of the Treaty of Paris reached America, John Pickering wrote to his brother Timothy, "There were many persons in Salem dejected on the return of peace, but a greater spirit of industry arises among the inhabitants than I expected to see, after the Idleness and dissipation introduced by the business and success of Privateering."[32]

Hasket's privateering ventures had made his family extremely wealthy, and the brick house on the waterfront, which had been fashionable in 1762, was no longer an appropriate stage for a family that could now afford higher ceilings, larger rooms, and the tasteful furnishings appropriate for such a space. When William Browne, the son of the wealthiest man in Salem before the Revolution, fled to England, the Committee of Correspondence and Safety condemned his property. This property included the Browne family town house and lot, one of the largest in Salem, which was situated in the most fashionable area of town, next to the First Church on Essex Street. Hasket immediately snapped up the town house; he first rented the "mansion house, outhouses, together with all the orchard and land," during the war, and then purchased the property from the Committee for the Sale of Absentees' Estates in 1784.[33]

Hasket's purpose in renting and then purchasing the house probably went far beyond that of an investor or property owner. This was the house that General Gage had used as his office in Salem when he moved the legislature to the town in 1774, and it had been the scene of several confrontations between Gage and the Whigs, including Hasket's older brother, Richard Derby Jr. It was also the house from which his friends on the Committee of Correspondence had been dragged off to jail at the end of the summer of 1774. Even if he never intended to live in the house himself, Hasket surely understood the irony (or the poetic justice) of his control of the Browne property.[34]

In 1782, the Derbys purchased another mansion around the corner from the Browne house, this one from a member of the Pickman family, another Loyalist family that had been among the leaders of prerevolutionary Salem. Apparently, the subtle significance of their control of the Browne house was not enough for Hasket and Elizabeth; one of their first actions was to add a cupola crowned with an eagle to the

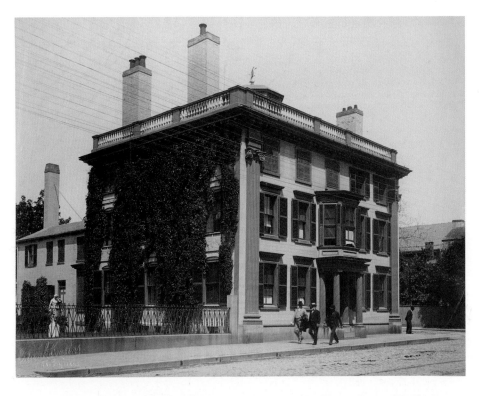

FIG. 9.8 The 1764 Benjamin Pickman House, purchased in 1782 by Elias Hasket and Elizabeth Crowninshield Derby and inherited by their son John in 1799. In this ca. 1870 photograph by Frank Cousins, the renovations done by Samuel McIntire are visible, including the cupola on the roof and ionic pilasters at the corners of the Washington Street side of the house. The bay window was added on top of the front portico sometime after 1825. "John Derby Mansion," photograph from the Frank Cousins Papers, David M. Rubinstein Rare Books and Manuscript Library, Duke University.

top of the enormous three-story brick structure in order to highlight their allegiance to the United States. The Pickman House had been built in 1764, and when the Derbys bought it, it was a three-story, double-pile house. Besides the cupola, the Derbys refaced the street side, adding ionic pilasters at the corners of the house, a pediment over the entry, and new window surrounds, updating the house in the fashionable new Federal style (fig. 9.8).[35]

THE EAST INDIA TRADE AND THE APEX OF THE DERBY FORTUNE

Salem became an extremely important port in the early years of the Republic. Because the port had never been closed, as Boston's had, and thanks to the general success of privateering in the port, the town had ships, men, and money ready to invest in the international trade that had been officially closed to American merchants under British

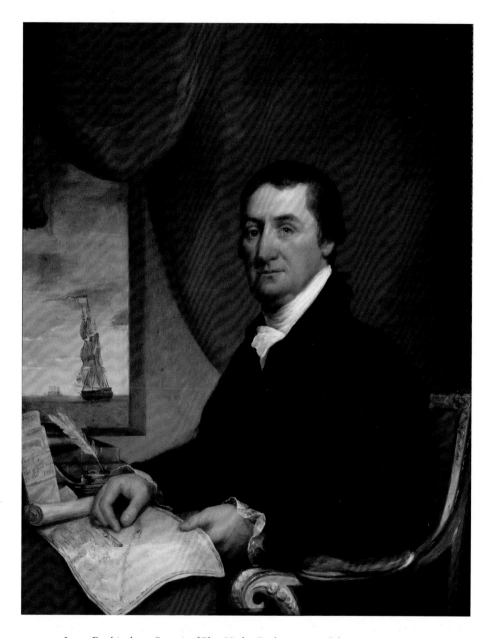

FIG. 9.9 James Frothingham, *Portrait of Elias Hasket Derby*, ca. 1799. Oil on canvas, 41 ½ × 32 ¼ in. Peabody Essex Museum, gift of the Derby Family, 1824. Photo: Peabody Essex Museum, Salem, Massachusetts. This portrait, painted posthumously, depicts Elias Hasket Derby at the height of his powers, seated on a rich gilded chair (almost a throne) with the *Grand Turk* out the window. On the desk are ledgers, a chart, and, next to his right hand, a copy of the orders that resulted in the *Grand Turk*'s being the first Salem vessel to reach the port of Canton, China.

rule. As tensions increased in Europe in the last decade of the eighteenth century, Americans took advantage of their neutral status to carry goods for both the French and the British from their respective colonies in Asia. Hasket was one of the first and most successful of the Salem merchants in international trade, opening markets in Russia, China, the Philippines, and many other international ports for a town that by 1790 was the sixth-largest population center in the new nation. Hasket may have enjoyed gardening as a hobby, but his family chose to depict him as a merchant in his last portrait, with the ship *Grand Turk*, a former privateer that was the first vessel from Salem to reach the port of Canton, China, visible in the window behind him (fig. 9.9).[36]

Thus, by the early 1790s, even the refurbished Pickman House was not fashionable enough for a family that had leveraged privateering wealth into an enormous fortune in East Indies trade. The Derbys needed a completely new mansion, one that would adequately reflect their wealth and social status.

Beyond purchasing the land and financing the building of what is still known, more than two hundred years after its destruction in 1815, as the Derby Mansion, Hasket seems to have taken little interest in the construction of his new home. The garrulous local minister William Bentley, who left posterity a beautifully detailed, albeit biased, picture of life in Salem in the Federal era, stated that Elizabeth Derby was responsible for the new house and that "it was at her instigation the Elegant Mansion house was built." This statement is further substantiated by Hasket himself in a letter to his agents: "Mrs. Derby wants something to complete her house; she will write you. It is business I know nothing of. I have given her an order for £120; you will do as she may direct with it."[37]

Hasket's lack of interest in his own mansion seems to have been rather unusual among gentlemen of the period. The Enlightenment was, after all, the era of the "gentleman designer," when designing buildings was considered a very appropriate hobby for a gentleman—at least, a gentleman was expected to be aware of the social status involved with such a project. Richard Derby Sr. took an interest in obtaining plans of houses, and it is possible that he was chiefly responsible for the design of the "Little Brick House," as the house he gave to Hasket and Elizabeth came to be known after they removed to the Pickman House. But Hasket was less interested in architecture than in gardens, and in 1790 he engaged an Alsatian immigrant, Georg Heussler, a trained gardener who had worked at royal courts in Germany and England, to improve the gardens and agriculture at the farm in Danvers and the new house in Salem. Reverend Bentley approved of the farm and gardens during a visit in 1792 and felt that the gardens were so perfectly organized and laid out that they were able to calm partisanship and promote harmony among the group of ministers that Hasket had invited.[38]

It was Elizabeth Crowninshield Derby who threw herself into the process of ordering plans and conferring with the designer about the design of the house in town. Bentley described her as "a Woman who felt & enjoyed all the pride of great

wealth, with an understanding not distinguished & poorly cultivated, but a woman who took great pride in being known as a Charitable woman, as she was indeed to the poor in general, but constantly so to all her poor & dependent kindred. . . . All have anecdotes of her folly & vanity, but all reverence her charity & kind dispositions." Later, he was a little less charitable, writing that she was "well-known for vanity which she exposed to constant and deserved ridicule." Bentley's criticism is that Elizabeth had not internalized the rules of polite behavior, as her more dignified sister-in-law Mary Crowninshield had done. In the mannered world, modesty, restraint, and respect for others was of paramount importance, and failure to meet these expectations exposed a person, especially a woman, to ridicule. Because of their wealth and social status, the Derbys could not be ignored, but Elizabeth's dress, perhaps, was a little too flashy, displaying an ill-regulated body, her love of show a little too obvious. Her Crowninshield antecedents meant that her "vanity" was contrasted to her husband's "natural disposition [which] led him rather to retire from public observation," for he "had no love for display" but loved and indulged his family.[39]

The fortune that Hasket accrued enabled Elizabeth to indulge her taste for fashion and fine furniture, but, more important, it also gave the Derbys a chance to be seen as patrons of American artisans, just as the wealthy in England patronized designers like Robert Adam and Thomas Chippendale. Elizabeth turned to Samuel McIntire, the designer and carver who had renovated Pickman House, and with whom the Derbys had a long and fruitful relationship.[40]

McIntire's style was very distinctive. He tended to work in the Adams style, but the neoclassical designs had the addition of his own carving. He was particularly fond of highly ornate baskets of fruit, no two of which were exactly alike, and he used this motif on his furniture and architectural elements. This combination of neoclassical style with agricultural motifs like overflowing baskets, grapevines, wheat sheaves, and cornucopia probably spoke to the elite of Salem, particularly those of Hasket's generation, through its symbolism. The rhetoric of Hasket and his fellow revolutionaries was based on classical commentaries on the democracies of the ancient world, and McIntire's designs were a visualization of the blessings of the ancient republics of Greece and Rome for the new Republic of the United States.[41]

Before building the house, the Derbys needed to clear the large lot between Essex and Front Streets where the William Browne House stood. Not everyone approved of the plan: "The taking down the large house of Col. Brown by Mr. Derby is a strange event in this Town, it being the first sacrifice of a decent building ever made in the Town to Convenience, or pleasure," wrote Bentley. But the Derbys were making a statement. It was not enough that they controlled the properties of two of the important colonial-era Tory families in Salem; they dramatically altered one and tore down the other—whether it was a "decent building" or not—to build a house in the latest fashion popular in the new United States.[42]

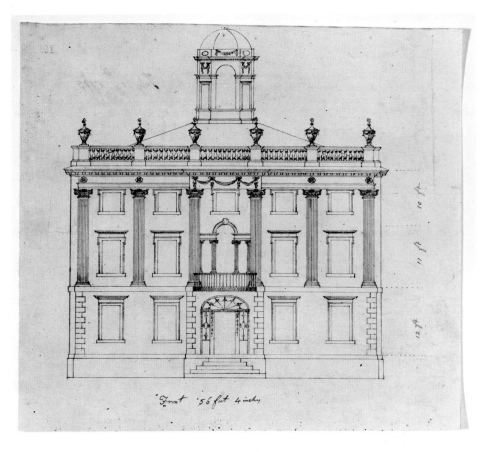

FIG. 9.10 Samuel McIntire's plan for the elevation of the main block of the Derby House, ca. 1795–98. Pen and ink on paper. Peabody Essex Museum, MSS 264, Samuel McIntire (1757–1811) Papers. Photo: Peabody Essex Museum, Salem, Massachusetts.

In order to aid in the design of this magnificent structure, Elizabeth sent for designs from fashionable homes in New York and Philadelphia. In addition, the Derbys probably looked at the sketches of the Bingham Mansion in Philadelphia, which Boston architect Charles Bulfinch had designed in 1789 and was at that moment using as the basis for a house in Boston for the politician and lawyer Harrison Gray Otis. Bulfinch was also hired to do preliminary elevation and floor plan sketches for the Derbys' house (see fig. 9.1). McIntire studied all these plans, along with houses that Bulfinch had built in Boston, and continued to redraw his designs even after construction began on the lot. The house he designed was about fifty-six feet along the street side, forty-eight feet deep, and sixty-seven feet along the garden side. Three full floors and a garret under the hipped roof were topped by an elegant cupola, and the garden side boasted an oval room, twenty-six by thirty-one

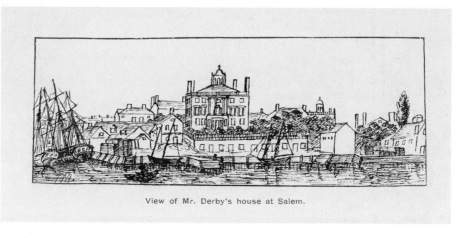

View of Mr. Derby's house at Salem.

FIG. 9.11 Sketch of the rear of the Derby House from the South River in Salem by Robert Gilmor, 1797. Reproduced in *Bulletin of the Boston Public Library* 11, no. 1 (April 1892).

feet, which was topped on the outside with a balustrade that echoed the one along the roofline (fig. 9.10).[43]

Whenever Elizabeth could, she chose the richest style of ornament, and she seems to have been a difficult client. On one early plan, she scrawled that the enormous façade was "not large a-nuf." In the hands of a practitioner less skilled than McIntire, her choice of rich ornament would have been overwhelming, and a few people thought the mansion a bit overdone, among them Robert Gilmor, a visitor from Baltimore who came to Salem in 1797 and reported with some disapproval that "the principal merchant here, Mr. Derby, had just built a most superb house, more like a palace than the dwelling of an American merchant" (fig. 9.11). This sort of accusation was leveled at many postrevolutionary mansions being built up and down the coast and throughout the port cities of the new nation. Charles Bulfinch himself, as he sketched the Bingham Mansion in Philadelphia, commented, "the utmost magnificence of decoration makes it a palace in my opinion far too rich for any man in this country." Similarly, when financier Robert Morris began building his mansion in Philadelphia, American expatriate Angelica Schuyler Church wrote to her sister, Elizabeth Schuyler Hamilton, that she had heard "Mr. Morris is building a palace," and asked if Elizabeth could send her copies of the plans. The description of these new private homes as "palaces," which inevitably carried associations of aristocracy, hierarchy, and the British government, indicates some social discomfort with these new buildings. In the case of the Derby Mansion, it was perhaps also a commentary on the Derbys' British mercantile connections and Federalist political adherence. When Morris's mansion was left unfinished, it became known as the "folly," another name associated with aristocratic overreach.[44]

258

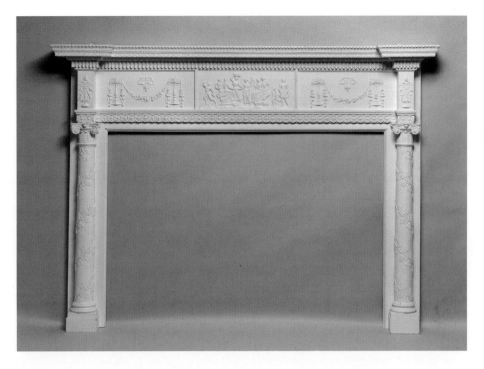

FIG. 9.12 This 1798 mantel removed from the Derby Mansion before its destruction in 1815 is an example of the rich ornamentation found throughout the house and described by Eliza Southgate. It is made of carved wood and composition ornaments. The Metropolitan Museum of Art, New York, Rogers Fund, 1946, 46.76. Photo: www.metmuseum.org.

But the majority of visitors agreed with Eliza Southgate, who recorded her impressions of the building: "At the further part of the entry a door opened into a large, magnificent oval room, and another door opposite the one we entered was thrown open and gave a full view of the garden below. . . . The large marble vases, the images, the mirrors to correspond with the windows, gave it so uniform and finished appearance that . . . everything appeared like enchantment." From the garden behind the house, the oval ballroom was covered by a dome, which "is railed around on top and forms a delightful walk; the magnificent pillars which support it fill the mind with pleasure" (fig. 9.12). Even Reverend Bentley, who had no respect for the man-sion's mistress, approved of the design. "It was the best finished, most elegant, & best constructed House I ever saw. It was entirely of wood with an excellent façade in the Ionic order, with a noble flight of marble steps to the top of the basement story. Its stucco work had nothing like it in the rotunda on the south side & the buildings & gardens were in exquisite taste."[45]

In their reactions to the mansion, both Southgate and Bentley not only gave the Derbys' work their approval, but they were also able to reinforce their own places in

genteel society. Southgate was overcome with feeling at the sight: the ballroom appeared "like enchantment," and the beauty of the pillars at the back of the house filled "the mind with pleasure," both expressions of sensibility that were appropriate to a young mind filled with wonder at the world. Bentley, for his part, was able to confirm his own knowledge and experience of such buildings through his admiration of the "exquisite taste" of the garden and rear view. The Derbys had achieved their desired effect with this building. At one view, it conveyed the wealth, privilege, and good taste of its owners.[46]

Elias Hasket Derby's training in his father's counting house taught him the mechanics of mercantile trading, and his father's wedding present made him part of the economic elite, but the Revolution gave Hasket a chance to acquire the trappings of a gentleman and physically change the face of Salem, Massachusetts. Richard Jr.'s career involved wide-ranging political issues related to the development of a new government, but Hasket's revolutionary participation was focused on local interests. While he did not seek higher political office, his participation in local politics gave him influence among the radicals who controlled Salem during the Revolution, a willingness to join in military action confirmed his patriotism, and the privateers he employed aided the war effort and helped to make Salem rich. Those privateers also positioned the town of Salem to open new markets around the world, since the merchants of Salem came out of the Revolution with the ships, men, and cash to take on potentially risky ventures. Hasket was a leader in that trade, which lasted into the early nineteenth century.

Some of the wealth that Hasket earned from privateering went into the acquisition of homes that would be suitable staging areas for the display of goods and behavior that marked his family as members of the gentry, but a few of the decisions that he and Elizabeth made about their houses could be interpreted as political choices, even fifteen years after the end of the war. Hasket's rental, and then purchase, of the Browne house demonstrated an eagerness to claim not only the political territory that the radicals had taken from the Tories in Salem, but a physical conquest of space that was once open to only a select set. The purchase and renovation of the Pickman House, and the razing of the Browne, took those sentiments one step further. It was not enough that the old Georgian space be claimed by the new powerful elite in Salem; that space had to be dramatically altered or even erased and replaced with a new American space that demonstrated the latest in design and good taste in the new Republic.

NOTES

1. Eliza Southgate, *A Girl's Life Eighty Years Ago: Selections from the Letters of Eliza Southgate Bowne* (New York: Charles Scribner's Sons, 1887), 113.

2. John Smail, "Credit, Risk, and Honor in Eighteenth-Century Commerce," *Journal of British Studies* 44, no. 3 (2005): 439–56. One of the best analyses of an American merchant house is William

T. Baxter, *The House of Hancock: Business in Boston, 1724–1775* (Cambridge: Harvard University Press, 1945). There is a growing literature on the role of credit in early modern English business and society that, I think, is more advanced than anything written on American mercantile society. See John Brewer, *The Sinews of Power: War, Money, and the English State, 1688–1783*, 1st American ed. (New York: Knopf, 1989); Margaret R. Hunt, *The Middling Sort: Commerce, Gender, and the Family in England, 1680–1780* (Berkeley: University of California Press, 1996); and the work of Craig Muldrew, especially *The Economy of Obligation: The Culture of Credit and Social Relations in Early Modern England* (New York: St. Martin's Press, 1998), and "'A Mutual Assent of Her Mind'? Women, Debt, Litigation, and Contract in Early Modern England," *History Workshop Journal* 55 (2003): 47–71. Some work on credit and society in America has been combined with the study of identity and deference. See J. E. Crowley, *This Sheba, Self: The Conceptualization of Economic Life in Eighteenth-Century America* (Baltimore: Johns Hopkins University Press, 1974); Daniel Vickers, "Competency and Competition: Economic Culture in Early America," *William and Mary Quarterly* 47, no. 1 (1990): 3–29; Michael Zuckerman, "The Fabrication of Identity in Early America," *William and Mary Quarterly* 34, no. 2 (1977): 183–214; Michael Zuckerman, "Authority in Early America: The Decay of Deference on the Provincial Periphery," *Early American Studies* 1, no. 2 (2003): 1–29.

3. For a discussion of gentility and mercantile culture, see David Hancock, *Citizens of the World: London Merchants and the Integration of the British Atlantic Community, 1735–1785* (New York: Cambridge University Press, 1995); and Lorinda B. R. Goodwin, *An Archaeology of Manners: The Polite World of the Merchant Elite in Colonial Massachusetts* (New York: Kluwer Academic/Plenum, 1999), 33–34. More on the Derbys' education can be found in Emily Murphy, "To Keep Our Trading for Our Livelihood: The Derby Family of Salem, Massachusetts" (PhD diss., Boston University, 2008), chaps. 2 and 3.

4. Receipt from Peter Cheever, January 26, 1748/49, MSS 37, box 15, folder 2, Derby Family Papers, Phillips Library, Peabody Essex Museum (hereafter Derby Family Papers); Essex Institute, *Vital Records of Salem, Massachusetts, to the End of the Year 1849*, 6 vols., vol. 4, *Marriages* (Salem, Mass.: Essex Institute, 1924); will of Richard Derby Sr., Essex County Probate Records, Salem, Mass., vol. 355, fol. 367. The statistics about slave ownership in Salem come from the Massachusetts Tax Assessment of 1771, which has been made into a searchable database on the Harvard website, http://sites.fas.harvard.edu/~hsb41/masstax/masstax.cgi. However, the tax only assessed "servants for life" over the age of sixteen, and New England householders preferred children as household labor. See the small but growing literature on the African American experience in eighteenth-century New England. William D. Piersen's *Black Yankees: The Development of an Afro-American Subculture in Eighteenth-Century New England* (Amherst: University of Massachusetts Press, 1988) was one of the first to propose that there was an African American culture in New England and that it was substantially different from southern plantation culture, and recent works have added to that argument; see especially Alexandra A. Chan, *Slavery in the Age of Reason: Archaeology at a New England Farm* (Knoxville: University of Tennessee Press, 2006); and Catherine Adams and Elizabeth H. Fleck, *Love of Freedom: Black Women in Colonial and Revolutionary New England* (New York: Oxford University Press, 2010).

5. Richard J. Morris, "Redefining the Economic Elite in Salem, Massachusetts, 1759–99: A Tale of Evolution, Not Revolution," *New England Quarterly* 73, no. 4 (2000): 603–24. Morris makes an eloquent argument for the continuity of economic elites, but economic primacy, it seems, did not automatically confer social or political primacy. For marriage and its importance in eighteenth-century Anglo-America, see Lisa Wilson, *Ye Heart of a Man: The Domestic Life of Men in Colonial New England* (New Haven: Yale University Press, 2000), and the work of Amanda Vickery, particularly *Behind Closed Doors: At Home in Georgian England* (New Haven: Yale University Press, 2009), and *The Gentleman's Daughter: Women's Lives in Georgian England* (New Haven: Yale University Press, 1998).

6. *The Diary of William Bentley, D.D., Pastor of the East Church, Salem, Massachusetts*, 4 vols. (1905; reprint, Gloucester, Mass.: Peter Smith, 1962), 4:335–36; Abbott Lowell Cummings, Dean A. Fales, and Gerald W. R. Ward, *The Crowninshield-Bentley House* (Salem, Mass.: Essex Institute, 1976); Essex Institute, *Vital Records of Salem*, vol. 3, *Marriages*.

7. *Diary of William Bentley*, 4:217; Goodwin, *Archaeology of Manners*, 33–34.

8. "Richard Derby (1712–1783), Merchant House Correspondence: Lane, n.d.," MSS 37, series 1, and "Richard Derby (1712–1783), Miscellaneous Receipts, 1755–1758," MSS 37, series 2, both in Derby Family Papers; Martha Gandy Fales, *Early American Silver for the Cautious Collector* (New York: Funk & Wagnalls, 1970), 23–24.

9. "Account of the Estate of John Crowninshield, 1766," Essex County Probate Records, Salem, Mass.; "Elias Hasket Derby (1739–1799), Estate of Anstiss Crowninshield, 1763–1774," MSS 37, series 3, Derby Family Papers. The "memorandum of sundry household furniture and cloathing and lining [linen]" was reported in Massachusetts old tenor money, £1,000 of which was worth £100 sterling. See John J. McCusker, *Money and Exchange in Europe and America, 1600–1775: A Handbook* (Chapel Hill: University of North Carolina Press for the Omohundro Institute of Early American History and Culture, 1978), 133.

10. Cummings, Fales, and Ward, *Crowninshield-Bentley House*, 8–9; "Inventory of the Estate of John Crowninshield, 1761," and "Settlement of the Estate of John Crowninshield, 1766," both in Essex County Probate Records, Salem, Mass.

11. "Will of Richard Derby (1712–1783);" Salem Tax Records, Salem, Mass.

12. For comparison, see the inventory of Richard Willard, a mariner who lived in half of the Narbonne House on Essex Street. His half of the house was valued at £125, while the entire contents of his house were worth £47. See Geoffrey P. Moran, Edward F. Zimmer, and Anne E. Yentsch, *Archeological Investigations at the Narbonne House: Salem Maritime National Historic Site, Massachusetts* (Boston: National Park Service, 1982), 65.

13. Abbott Lowell Cummings, *Bed Hangings: A Treatise on Fabrics and Styles in the Curtaining of Beds, 1650–1850* (Boston: Society for the Preservation of New England Antiquities, 1961), 12–13, 17, 27; Florence M. Montgomery, *Textiles in America, 1650–1870: A Dictionary Based on Original Documents; Prints and Paintings, Commercial Records, American Merchants' Papers, Shopkeepers' Advertisements, and Pattern Books with Original Swatches of Cloth* (New York: W. W. Norton, 1984); "Elias Hasket Derby (1739–1799), Estate Papers, 1799–Feb 1801," MSS 37, series 3, Derby Family Papers. For more on the association between the color green and health, see Michael Pastoreau, *Green: The History of a Color* (Princeton: Princeton University Press, 2014).

14. Jessica Kross, "Mansions, Men, Women, and the Creation of Multiple Publics in Eighteenth-Century British North America," *Journal of Social History* 33, no. 2 (1999): 385–408. Kross makes a compelling argument for gendered space in the Georgian mansion, but I think she gives short shrift to the bedchamber. The expense of the furnishings alone made many best bedchambers the most expensive rooms in the house, and in many great houses the formal bedchamber was as expensively fitted out as the parlors.

15. Charles W. Snell, *Derby Wharf and Warehouses: Together with Data on the Physical History of the Ezekiel Hersey Derby and John Prince Wharf Lots, Lots A and B, Historical Data, Salem Maritime National Historic Site, Massachusetts* (Denver: National Park Service, 1974); Charles W. Snell, *Derby/Prince/Ropes House Historical Data, Salem Maritime National Historic Site, Massachusetts* (Denver: National Park Service, 1976), 12–13.

16. Frank Cousins and Phil M. Riley, *The Colonial Architecture of Salem* (Boston: Little, Brown, 1919; reprint, Mineola, N.Y.: Dover Publications, 2000), 171–78; Richard L. Bushman, *The Refinement of America: Persons, Houses, Cities* (New York: Knopf, 1992), 119–21. The color on the walls was analyzed by the National Park Service in the early 2000s, and the findings match the documentary findings in Peter Baty, "The Methods and Materials of the House-Painter in England: An Analysis of House-Painting Literature, 1660–1850" (BA thesis, University of East London, 1993). The importance of wallpaper in British middle- and upper-class households is covered in Vickery, *Behind Closed Doors*. One of the frustrating aspects of the Derby Family Papers is that there are no household accounts, and very few receipts remaining from Hasket and Elizabeth, particularly during their residence in the Derby House. Therefore, there is no record of any actual entertaining done in the house.

17. Nathaniel Gould Account Book, vol. 1, 1758–1763, Nathan Dane Papers, MS N-1090, Massachusetts Historical Society, Boston; Kemble Widmer, *In Plain Sight: Discovering the Furniture of Nathaniel Gould*, exh. cat. (Salem: Peabody Essex Museum, 2014).

18. "Elias Hasket Derby (1739–1799), Miscellaneous Receipts, 1761–1776," MSS 37, series 3, Derby Family Papers.

19. For the intersection of portraiture, consumption, and society in the eighteenth century, see Carrie Rebora, Paul Staiti, Erica E. Hirshler, Theodore E. Stebbins Jr., and Carol Troyen, *John Singleton Copley in America*, exh. cat. (New York: Metropolitan Museum of Art, 1995); Margaretta M. Lovell, *Art in a Season of Revolution: Painters, Artisans, and Patrons in Early America* (Philadelphia: University of Pennsylvania Press, 2005); and Zara Anishanslin, *Portrait of a Woman in Silk: Hidden Histories of the British Atlantic World* (New Haven: Yale University Press, 2016). Benjamin Blythe's work has been extensively studied by Bettina A. Norton. See her essay "The Brothers Blyth: Salem in Its Heyday," in *Painting and Portrait*

Making in the Northeast: Dublin Seminar for American Folklife Proceedings, 1994, edited by Peter Benes and Jane Montague Benes (Boston: Boston University, 1995), 46–63.

20. Dan Cruickshank and Neil Burton, *Life in the Georgian City* (London: Viking, 1990), 111–15; Hancock, *Citizens of the World*, 285–87; Charles W. Snell, *Historic Structure Report, Derby/Hawkes House (Building 3), Historical Data Section, Salem Maritime National Historic Site, Massachusetts* (Denver: National Park Service, 1983).

21. An exhaustive discussion of consumer politics can be found in T. H. Breen, *The Marketplace of Revolution: How Consumer Politics Shaped American Independence* (New York: Oxford University Press, 2004).

22. Joseph B. Felt, *Annals of Salem*, 2nd ed., vol. 2 (Salem: W. & S. B. Ives, 1849), 564–65; James Duncan Phillips, *Salem in the Eighteenth Century* (Boston: Houghton Mifflin, 1937), 240–50; Malcom Freberg, "Introduction," in Massachusetts General Court, House of Representatives, *Journals of the House of Representatives of Massachusetts*, vol. 45, *1768–1769* (Boston: Massachusetts Historical Society, 1976), vii–ix. For the importance of rum and its consumption to the political discourse of eighteenth-century America, see David W. Conroy, *In Public Houses: Drink and the Revolution of Authority in Colonial Massachusetts* (Chapel Hill: University of North Carolina Press, 1995), 253–72; and Peter Thompson, *Rum Punch and Revolution: Taverngoing and Public Life in Eighteenth-Century Philadelphia* (Chapel Hill: University of North Carolina Press, 1999).

23. "Non-Importation Agreement," *Essex (Mass.) Gazette*, August 30, 1768.

24. John W. Tyler, *Smugglers and Patriots: Boston Merchants and the Advent of the American Revolution* (Boston: Northeastern University Press, 1986), 20; Andrew Jackson O'Shaughnessy, *An Empire Divided: The American Revolution and the British Caribbean* (Philadelphia: University of Pennsylvania Press, 2000), 105–6. Distillery receipts are in MSS 37, Derby Family Papers.

25. "Contract, Elias Hasket Derby and Isaac King for Management of Farm," March 28, 1778, MSS 37, Derby Family Papers; "Land Deed, Samuel Epes to Elias Hasket Derby, 1776," Essex County Land Records, Salem, Mass.

26. [Benjamin Pickman], "Obituary of Elias Hasket Derby," *Salem (Mass.) Gazette*, September 10, 1799; Hancock, *Citizens of the World*, 294–301.

27. One of the best overviews of the history of privateering is Gardner Weld Allen, *Massachusetts Privateers of the Revolution* (Boston: Massachusetts

Historical Society, 1927). See also William Bell Clark, ed., *Naval Documents of the American Revolution*, vol. 2 (Washington, D.C.: Government Printing Office, 1966), 834–39.

28. Worthington C. Ford, ed., *Journals of the Continental Congress, 1774–1789*, vol. 4, *1776* (Washington, D.C.: Government Printing Office, 1906), 252–54.

29. "Auction Sales in Salem, of Shipping and Merchandise, During the American Revolution," *Essex Institute Historical Collections* 49 (1913): 97–124; Richard Haskayne McKey, "Elias Hasket Derby and the American Revolution," *Essex Institute Historical Collections* 97 (1961): 178–79.

30. *Warren-Adams Letters, Being Chiefly a Correspondence Among John Adams, Samuel Adams, and James Warren, 1743–1814*, vol. 2 (Boston: Massachusetts Historical Society, 1917), 438; "Auction Sales in Salem."

31. Richard Haskayne McKey, "Elias Hasket Derby, Merchant of Salem, Massachusetts, 1739–1799" (PhD diss., Clark University, 1961), 135–37.

32. Quoted in John J. McCusker and Russell R. Menard, *The Economy of British America, 1607–1789, with Supplementary Bibliography* (Chapel Hill: University of North Carolina Press for the Omohundro Institute of Early American History and Culture, 1991), 362–63.

33. S. W. Jackman, "Salem and St. Georges, William Browne, Loyalist," *Essex Institute Historical Collections* 118 (1982); receipt, Committee of Correspondence and Safety to Elias Hasket Derby, October 21, 1776, in "Elias Hasket Derby (1739–1799), Miscellaneous Receipts, 1761–1776," and "Receipt, Committee for Sale of Absentees Estate in the County of Essex to Elias Hasket Derby, May 2, 1780," in "Elias Hasket Derby (1739–1799), Legal Documents, 1761–1800," both in MSS 37, series 3, Derby Family Papers; "Land Deed, Committee for the Sale of Absentee Estates to Elias Hasket Derby, 1784," Essex County Land Records, Salem, Mass.

34. Phillips, *Salem in the Eighteenth Century*, 323–31. See chap. 3 for a discussion of the legislative session of 1774.

35. Fiske Kimball, *Mr. Samuel McIntire, Carver, the Architect of Salem* (Portland, Maine: Southworth-Anthoensen Press for the Essex Institute of Salem, Mass., 1940), 63–66; *The Diary and Letters of Benjamin Pickman (1740–1819)*, edited by George Francis Dow (Newport, R.I., 1928).

36. James R. Fichter, *So Great a Profit: How the East Indies Trade Transformed Anglo-American Capitalism* (Cambridge: Harvard University Press, 2009); U.S. National Park Service, *Salem: Maritime*

Salem in the Age of Sail (Washington, D.C.: U.S. Department of the Interior, 1987).

37. *Diary of William Bentley*, 2:300; "Elias Hasket Derby (1739–1799) Merchant House Correspondence: Lane, n.d.," Derby Family Papers, MSS 37, series 1, Salem, Mass.

38. *Diary of William Bentley*, 1:373. For a further discussion of the importance of the mansion in genteel life, see Bushman, *Refinement of America*, 119–21, chap. 3. As Bushman depicts it, it was men who were responsible for building the major homes in the colonial and early Federal periods. See also Margaret B. Moore, "'The Laudable Art of Gardening': The Contribution of Salem's George Heussler," *Essex Institute Historical Collections* 124, no. 2 (1988): 125–41.

39. *Diary of William Bentley*, 2:300–301, 260; Bushman, *Refinement of America*, 44–45, 119–21; Goodwin, *Archaeology of Manners*, 64, 178–80; [Pickman], "Obituary of Elias Hasket Derby"; Derby, "Elias Hasket Derby," 84.

40. Hancock, *Citizens of the World*, 320–47.

41. Dean T. Lahikainen, *Samuel McIntire: Carving an American Style* (Salem, Mass.: Peabody Essex Museum, 2007).

42. *Diary of William Bentley*, 2:141.

43. Fiske Kimball, "The Elias Hasket Derby Mansion in Salem," *Essex Institute Historical Collections* 60 (1924): 273–74; "Architectural Drawings," drawings 109–25, series 3, Samuel McIntire Papers, MSS 264, Phillips Library, Peabody Essex Museum; Dorothee Wagner von Hoff, *Ornamenting the "Cold Roast": The Domestic Architecture and Interior Design of Upper-Class Boston Homes, 1760–1880* (Bielefeld, Germany: Transcript, 2013), 218–21; Amy Hudson Henderson, "Furnishing the Republican Court: Building and Decorating Philadelphia Homes, 1796–1800" (PhD diss., University of Delaware, 2008), 92–97.

44. Kimball, "Elias Hasket Derby Mansion," 290; Robert Gilmor, "Memorandum Made in a Tour to the Eastern States," *Boston Public Library Bulletin* 11 (1892–93): 85; Bulfinch quoted in Billy Gordon Smith, *The Lower Sort: Philadelphia's Laboring People, 1750–1800* (Ithaca: Cornell University Press, 1990), 23; Angelica Schuyler Church quoted in Ryan K. Smith, *Robert Morris's Folly: The Architectural and Financial Failures of an American Founder* (New Haven: Yale University Press, 2014), 98.

45. Southgate, *Girl's Life Eighty Years Ago*, 113; *Diary of William Bentley*, 4:362.

46. Bushman, *Refinement of America*, 81–82.

Imagining Pasts

IMAGES AND MEMORY
IN EARLY AMERICA

From Region to Nation

M. F. CORNÈ'S *LANDING OF THE PILGRIMS* AND THE CIRCULATION OF IMAGES IN THE EARLY REPUBLIC

PATRICIA JOHNSTON

> The breaking waves dash'd high
> On a stern and rock-bound coast,
> And the woods against a stormy sky
> Their giant branches toss'd.
> And the heavy night hung dark
> The hills and waters o'er,
> When a band of exiles moor'd their bark
> On the wild New England shore.
> —Felicia Dorothea Hemans, 1826

THE IMAGE OF HEROIC SETTLERS bravely confronting rocky, forested wilderness to attain religious freedom infuses Felicia Dorothea Hemans's poem "Landing of the Pilgrim Fathers in New England." The British romantic poet's portrayal of the 1620 event reflected prevailing ideas after celebrations of the bicentennial of the landing, a time when the Pilgrim legend found new significance. From the mid-eighteenth century, the Pilgrim story was revisited periodically in order to meet changing social and political needs. Before the 1820 bicentennial transformed the Pilgrims' landing into a national myth of the Republic's foundation, the landing was very much a regional tale, one that reinforced New England's identity and, more specifically, Federalist values.

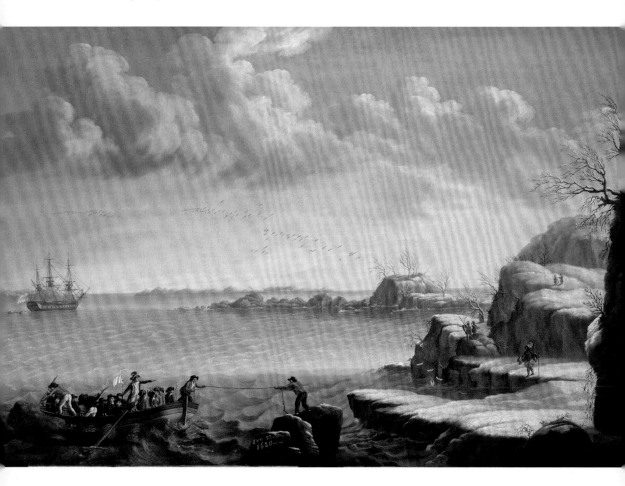

FIG. 10.1 Michele Felice Cornè, *Landing of the Pilgrims*, 1803. Oil on canvas, 37 ¼ × 57 ½ in. Courtesy of the Diplomatic Reception Rooms, U.S. Department of State, Washington, D.C., 1971.146.

In the early nineteenth century, the visual arts played a key role in revising, fortifying, and circulating the Pilgrims' shifting symbolism.

The earliest known American oil-on-canvas depiction of the landing of the Pilgrims at Plymouth Rock was painted by Michele Felice Cornè (1752–1845), an Italian artist who had made his way to Salem, Massachusetts (fig. 10.1).[1] The 1803 image, made for the prominent merchant Elias Hasket Derby Jr. (1766–1826), depicted the dominant turn-of-the-nineteenth-century representation of the event, and other Salem merchants were quick to order copies for their own collections.[2] One of Cornè's paintings, either the Derby canvas or (more probably) another lost version, further popularized this interpretation of the landing when it was exhibited at the inauguration of the East India Marine Society Museum's second location, which opened its doors to the public with great fanfare in 1804. The pastor of Salem's East Church,

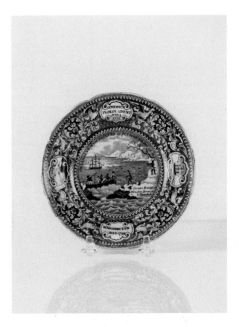
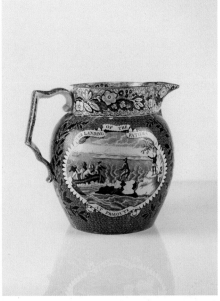

FIG. 10.2 Plate with *The Landing of the Fathers at Plymouth, Dec 22, 1620*, ca. 1820–30. Enoch Wood & Sons, Staffordshire, England. Earthenware with blue underglaze, 10 in. diameter. Courtesy of the American Antiquarian Society.

FIG. 10.3 Pitcher with *The Landing of the Fathers at Plymouth*, ca. 1820–30. Enoch Wood & Sons, Staffordshire, England. Earthenware with blue underglaze. Courtesy of the American Antiquarian Society.

Reverend William Bentley (1759–1819), one of the first visitors to the museum, observed that the East India Marine Society had "spared no pains to supply & decorate it. On one Chimney is painted the landing of Plymouth," suggesting an overmantel on a wooden ground created in situ.[3]

Corné's *Landing of the Pilgrims* resonated deeply with the merchant class in the early national period, and the artist received commissions for at least four more canvases of the same subject. Today, Corné's five known versions have entered collections that prize their historical subject (the U.S. State Department, the White House, Pilgrim Hall Museum in Plymouth) and their aesthetic value as American art (Pennsylvania Academy of the Fine Arts, Phoenix Art Museum).

This particular interpretation of the Pilgrim story, emphasizing the landing and the rock (rather than the Thanksgiving of the post–Civil War period), dominated the legend's portrayal in the first quarter of the nineteenth century. This same composition appeared in different media produced around the world—the image was transferred onto English Staffordshire pottery and Chinese reverse glass paintings

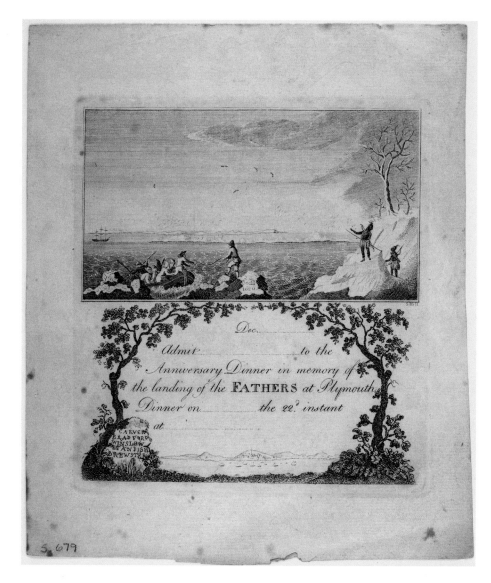

FIG. 10.4 Samuel Hill, invitation to the "Anniversary Dinner in memory of the landing of the Fathers at Plymouth," ca. 1798–1800. Engraving on paper, 14 × 13.5 cm. Courtesy of the American Antiquarian Society.

for the American market (figs. 10.2, 10.3). There are also two known watercolor copies (Museum of Fine Arts, Boston, and Plymouth Antiquarian Society), perhaps done as school projects, to judge from their appearance. There is also at least one other anonymous copy in oil (private collection).[4] All of these images share with Corné's pictures a common ancestor—the composition in yet another medium—an engraving by

Boston's Samuel Hill (ca. 1798–1800) (fig. 10.4). The proliferation around 1800 of this particular formulation of the Pilgrim narrative demonstrates three key issues raised by the art of the early Republic: imagery later interpreted as revealing an emerging *national* culture was often created to express local and regional concerns; multiple media must be studied if we are to understand the complexity of the diffusion of images in the early Republic, because overlap of imagery between media was standard; and viewers of Federal-period art had fewer expectations of originality and authorship than viewers in later modernist periods.

Cornè arrived in Salem in August 1800 aboard the *Mount Vernon*, a family trading vessel captained by Elias Hasket Derby Jr. In his manifest, Captain Derby did not mention Cornè by name, but he was probably one of the "3 gentlemen" listed on the roster along with the crew. The artist boarded the ship in Naples harbor, apparently seeking refuge from the political upheaval caused by the Napoleonic Wars. Not surprisingly, Cornè seems to have become very fond of the *Mount Vernon* and painted her at least eight times. Almost immediately, the artist became well established in Salem as a painter of ship portraits; the Peabody Essex Museum, the descendent of the East India Marine Society Museum, holds more than fifty Cornè paintings of this genre, done during his brief tenure in Salem from 1800 to 1807. Most of Cornè's income came from such marine scenes, but he also received commissions from Salem's merchant elite for landscapes designed for residential wall paintings and overmantels, as well as for oil paintings of more ambitious historical subjects.[5]

No record survives of Cornè's art training. It may be that he was trained as a decorative or sign painter, since many of his figures lack classical proportions and graceful poses. Despite periodic awkwardness, it is likely that Cornè had some art education, because his work demonstrates facility with materials and techniques, along with a working knowledge of European conventions of history painting that indicates ambition and sophistication.

Salem's vibrant art market in the first decade of the nineteenth century demanded American subjects: portraits, ships, and history. Though Cornè had arrived only recently from Italy, he launched into painting scenes from American national history. Given his inexperience with the United States, these subjects must have been specifically suggested by his patrons. He painted another foundational legend, the landing of Columbus, and other images of the first explorer. He also painted the American bombardment of Tripoli during the recently concluded Barbary Wars. Cornè's paintings of the Pilgrims and other scenes from American history provided staples that he could add to his more steady ship portrait practice.

Of Cornè's five known paintings of the landing of the Pilgrims, the earliest is probably the one now on view in the U.S. State Department Diplomatic Reception Rooms in Washington, D.C. It is signed and dated 1803 in the lower right corner and

has a secure Salem provenance, descending in the Derby family before it went on the art market in the 1970s.

In the Derby version of the painting, a shallop full of men reaches the rocky shore (fig. 10.1). Cornè's depiction of the crystal-clear air of the cold, bright winter day sparkles with vivid color. His brush strokes suggest the softness of the snowy shores and the billowing clouds. This suppleness contrasts with the firm linear treatment that forms a rhythmic pattern of waves in the protected harbor and the dark bold strokes that depict a flock of birds streaking across the sky on their journey south. Cornè's style grows out of the topographic tradition in landscape, in which acute attention to the environment projects an eyewitness experience. He further emphasizes the sense of accurate historical reporting by prominently labeling the rock in the front center—the date is unmistakably December 22, 1620—the date celebrated in the early Republic as the disembarking of the Pilgrims at Plymouth.[6]

Despite Cornè's formal strategies, which create a sense of historical accuracy, the scene depicted is almost entirely fiction. To begin with, the shallop is filled with seventeen men, who are portrayed more like the landing of a nineteenth-century British army regiment than seventeenth-century settler families. Though there were no soldiers on the Mayflower, the men are dressed in military uniforms and tricorne hats dating from the late eighteenth and early nineteenth centuries. Are those Revolutionary War redcoats? Wearing Napoleonic-era hats? One of the center figures holds a rifle, its bayonet piercing a white flag. Several of the other men in red are armed similarly. The type of ship anchored behind them in the harbor is also anachronistic, its guns suggesting a nineteenth-century warship rather than a seventeenth-century merchant vessel.

Waiting on land to greet them are Native Americans, who are depicted as curious and welcoming, even though every contemporary account of the landing recalls that none were present. Cornè scattered Native Americans throughout the hilly landscape, alternating them with the bare trees to form a decorative pattern. The largest indigenous man seems to walk toward the shore to greet the arriving English; the next-largest one points toward them. Toward the top of the hill, the figures get progressively smaller, until they become barely distinguishable from the trees. The painter seems fascinated with their headdresses as well as their weaponry: bows and arrows carried on the back and very long spears in their hands. Cornè displays no firsthand knowledge of the indigenous people's ethnography. Despite the clear, cold December day, the Native Americans are bare-chested, their costumes more appropriate for the Caribbean than for Massachusetts.

In his construction of Native Americans, Cornè (following Samuel Hill's engraving) makes reference to the conventions of early modern Europeans, who used palm trees and other tropical motifs to convey a generic exoticism of the newly discovered Americas, regardless of regional climatic variations.[7] One of the earliest and most

FIG. 10.5 Thomas Jefferys, *A Map of the Most Inhabited Part of New England; containing the Provinces of Massachusets Bay and New Hampshire, with the Colonies of Conecticut and Rhode Island, Divided into Counties and Townships*, 1755 (detail). The Library of Congress Geography and Map Division, Washington, D.C., G3720 1755.J4.

widely circulated visual depictions of the landing of the Pilgrims is the 1755 cartouche for *A Map of the Most Inhabited Part of New England*, by Braddock Mead (alias John Green), cartographer, and Thomas Jefferys, publisher (fig. 10.5). In this image, there is no Plymouth Rock; two figures strain to bring provisions up a steep hill, with others following in the small boat behind them. On solid ground, the first arrivals (men, women, and children) are welcomed by a slightly bowing, deferential Native American and a classically draped woman holding a pole with a liberty cap. At their feet is a dead beaver, a symbol of the wealth promised by the New World's fur trade. All are set in a semitropical landscape, pine branches blending into palm trees.[8]

Cornè certainly did not go to Plymouth to make studies for his painting, for it bears no resemblance to the beaches south of Boston—which are characterized more by salt marshes, flat sandy stretches, and intermittent high sand dunes than by rugged rocks. As Carl Crossman and Charles Strickland have demonstrated, Cornè based the paintings on the print by Samuel Hill (ca. 1766–1804), a Boston engraver best known for his illustrations for the *Massachusetts Magazine*.[9] Hill designed his engraving for a Boston group, the Sons of the Pilgrims, for an invitation to their annual meeting.

The earliest extant example seems to date from 1800, but it might have been in use from 1798, the year in which the Sons of the Pilgrims began their annual dinners. The image was revived periodically over the next thirty years for related events in Boston and Plymouth.

Perhaps to suggest the nearby hills that would have been visible to approaching ships, and where the settlement was built above the harbor, artists of the early Republic pictured Plymouth harbor as rocky, despite the gentle sandy shores that drew the Pilgrims to land there. This depiction had literary parallels—for example, Joseph Croswell's 1802 play *A New World Planted*:

> These massy rocks, high cliffs and sounding shore,
> Are fix'd as faithful centinels to check
> The bold invasions of the encroaching sea.[10]

It became so much a part of the story, perhaps because of the Pilgrim narrative's emphasis on the moment of stepping upon a boulder, that Felicia Dorothea Hemans, an ocean away and a quarter century later, in her well-known 1826 poem quoted above, described the landing as taking place "on a stern and rock-bound coast." Thus Corné's paintings present the standard dramatization—one might even say misinformation— that prevailed in Boston, located only forty miles away from the landscape in question. Perhaps this was acceptable because the artistic representation was understood to be a dramatization of a historic event.

The early Republic's fascination with the theme of the Pilgrims is reflected in the many artistic depictions of the event, its commemorations in poetry, sermons, and orations, and in extravagant social celebrations. Early images of the Pilgrims typically fall into one of three main iconographical schema—their departure from Holland, the signing of the Mayflower Compact, and, most often, the landing—three events that John Seelye, author of a masterly history of the changing cultural significance of Plymouth Rock, characterized as "a statist trinity, a sacred triad of tableaux that would have as their equivalents the Declaration of Independence, the Revolution, the Constitution."[11] John Quincy Adams's 1802 Forefathers' Day oration at Plymouth Rock, for example, emphasized the early colony's legal and political significance, suggesting that its Mayflower Compact prefigured the Constitution. Using the characteristic classical references of the day, he alluded to the Pilgrims' permanent influence on American national identity, quoting Tacitus: "Think of your forefathers! Think of your posterity!"[12] The speech was sold throughout New England, including Corné's home of Federalist Salem.[13]

After the Revolution, the Pilgrims' founding of Plymouth Colony was seen as an allegory of the founding of the new nation. This is borne out by the popularity of depictions of other moments of foundation and discovery, such as Columbus

encountering the New World, which Cornè and many others also painted. But the Pilgrims were not simply a metaphor for the emergence of nationalism after the Revolution; they held—perhaps more significantly—regional and partisan meaning as well.

Prior to the national interest sparked in 1820 by the two-hundredth anniversary of the settlement, which transformed the landing of the Pilgrims into a quintessentially American symbol, reverence for these early settlers was episodic and local. After two bursts of interest, coinciding with the Great Awakening of the 1740s and the American Revolution in the 1770s, Plymouth Rock became a touchstone once again around 1798. In this third episode, during which Hill's engraving and Cornè's paintings were commissioned, the rock functioned as a Federalist icon. These three early moments of veneration for the Plymouth experience had a cast quite different from later visualizations. Schoolchildren today are typically showered with images of Thanksgiving dinners with Pilgrims and Native Americans sharing turkey, cranberries, and corn—sentimental emblems constructed by the colonial revival movement and then sharpened in the era of studying diversity.[14] By contrast, in the colonial period and early Republic, the landing was the most popular representation of the founding colonies; it formed the thematic roots of New England's identity, and Plymouth Rock itself served as its primary icon.

In a typical example of the rock as symbol of the Pilgrims' achievements, Robert Treat Paine's 1798 "Ode" imagined that "Round the consecrated ROCK / Coven'd the patriarchal flock." Paine went on to describe how this gathering produced a new "charter of the land" that allowed the Pilgrims to escape from British oppression.[15] Thus at the turn of the nineteenth century, the most prevalent iconographic representation of the Pilgrims was that of place, in particular, a regionally specific New England place—Plymouth Rock—rather than the ruggedness of colonial life or the happy harvest celebration of survival.

Ironically, for the first hundred years of the colony's existence, no one seems to have even noticed the large rock at the edge of Plymouth Bay. Governor Bradford did not mention the rock or describe the landing in his journal, nor did any other first settler. In 1715, the rock made its first public appearance, when it was drawn on a town map as a boundary marker.[16]

It is arguable whether such a landing ever took place. The Pilgrims had waded ashore all along the coast of Cape Cod, as they searched for a spot to settle. It's just as likely that they would have avoided the rock as a navigational hazard as that they would have sought it out for anchorage.[17] The story of the landing at the rock seems to date from the early 1770s, when Deacon Ephraim Spooner told the story of Elder Thomas Faunce, whose father, John Faunce, came over in 1623, nearly at the beginning of the colony. Elder Faunce was born in 1646, and as a child knew many of the original

Pilgrims. In 1741, at age ninety-five, he was carried to the waterfront in a litter, where he tearfully protested some merchants' plans to build a wharf that would encase the rock on the sacred spot of the landing. In the crowd was the impressionable six-year-old Ephraim Spooner, who was the only person to vividly recall this event in the 1770s. Spooner became the key historical source for the legend of the rock. He conveyed this information to Dr. James Thatcher, whose 1835 *History of the Town of Plymouth* further solidified the story of the rock, "which [Faunce's] father had assured him was that, which had received the footsteps of our fathers on their first arrival, and which should be perpetuated to posterity."[18] The wharf was eventually built, with the rock left partially exposed.

Interest in the rock increased as the Revolution drew closer. The Old Colony Club, founded in 1769 by Loyalists, first commemorated the landing that December, perhaps in a show of support for their British colonial status. Annual celebrations began, which included toasts and feasts, songs and poems, and an invited preacher. By the second year, the club's Whigs outnumbered its Loyalists, and the celebrations of the landing and the rock began to take on revolutionary symbolism.[19] In 1774, the Liberty Boys decided to haul the Forefathers' Rock, as it was commonly called in Plymouth, up to the courthouse to stand next to their defiant liberty pole. In the process, they broke the rock in two, foretelling, they rationalized, "a division of the British empire."[20] James Thatcher, later the prominent Plymouth physician and historian, was a young surgeon's mate in 1775, when he recorded his feelings about the rock in his journal: "with its associations, [it] would seem almost capable of imparting that love of country, and that moral virtue, which our times so much require. . . . Can we set our feet on their rock without swearing, by the spirit of our fathers, to defend it and our country?"[21] At the time of the Revolution, Seelye has argued, though Plymouth Rock was "distinctly a local artifact, it was as an ideological icon with nationalistic significance that the Rock was lifted up and placed next to that undeniably political symbol, a Liberty Pole."[22] Annual celebrations and founders' day sermons marking the Pilgrims' landing continued through the late 1770s, then went on hiatus.

The early Republic's revival of interest in the landing and Plymouth Rock can be dated quite precisely: in Plymouth, periodic celebrations started in 1793, and the annual Forefathers' Day sermons resumed in 1798. Emulating Plymouth, Boston held its first Forefathers' Day celebration the same year. This revitalization of the Pilgrims, their landing, and the rock had new meanings in the early national period. Seelye has speculated that by 1800, Plymouth Rock was again a political symbol, but "one with a very tight regional base, which warranted an emphasis on differences within the new nation, not revolutionary ardor."[23] Commenting on its regional resonance, the Reverend Timothy Dwight, who visited the rock in 1800, emphasized, "No New Englander who is willing to indulge his native feelings can stand upon the rock where our ancestors set the first foot after their arrival on the American shore

without experiencing emotions. . . . No New Englander could be willing to have that rock buried and forgotten."[24] In many ways, Dwight's assessment reflects the period's regional contests for leadership in establishing a recognized national identity. The Jamestown colony predated the Plymouth colony, yet by asserting that the values associated with the new United States—self-governance and religious freedom—derived from New England rather than from Tidewater or Chesapeake Bay settlements, the region's boosters made a claim that New England stood for the nation.

The rock, however, signaled more than a regional identity for New Englanders—it became a specifically Federalist symbol. Though Federalists dominated New England, they were embattled nationally, and Jefferson's Republican Party won the presidency in 1800.

When in 1798 Boston began its own celebrations of Forefathers' Day, called the Feast of the Shells, it was an openly Federalist affair, widely covered in the press, which sought to advance a New England regional identity. In its reporting of the 1800 "anniversary of the landing of our *forefathers* at *Plymouth*," Boston's *Columbian Centinel* proclaimed, "while our national elections exhibit a degrading picture of discord and division in other parts, *New-England* continues a firm, unbroken, undivided phalanx, which, may yet to be able to preserve, as it has heretofore secured, the liberties and rights of our country."[25]

As Seelye has noted, the name Feast of the Shells was "a complex allusion referring to the prevalence of shellfish served, to the Ossianic poems of James Macpherson, in which shells are used for festive drinking, and to the symbolic scallop shell carried by early pilgrims to the Holy Land."[26] Contemporary newspapers reported that the celebrants emphasized the theme by serving succotash—that Native American mixture of corn and beans—out of an enormous shell borrowed from the museum of the Massachusetts Historical Society.[27] Albert Matthews's 1914 history of Forefathers' Day celebrations claims that the Boston feast generated the terms commonly used today—toasts honored the "Pilgrims," and newspaper accounts mentioned "Plymouth Rock"; such specification had not been necessary in hometown celebrations.[28]

Boston's Feast of the Shells reached its partisan height between 1798 and 1805, the years when Cornè was commissioned to do several paintings of the landing, and when, as John Seelye observes, "Plymouth Rock and the Pilgrims had been pretty much taken over as rhetorical tokens by the Federalists."[29] In the early years, the Federalist bent of the raucous dinners was expressed in toasts, poetry, and song. Toasts of 1800 proclaimed, "May *Federalism* . . . prove the country's best defense," and "May federalism always preserve its intelligence, and its intelligence preserve every thing."[30] While the Feast of the Shells generated attacks from the opposition press, with a jab that "Sons of Tories" would be a better name for the group than "Sons of Pilgrims," it also generated public interest in the Pilgrims.[31] Theatrical reenactments in Boston included *Plymouth Rock, or The Landing of Our Forefathers* (1799), which incorporated a Thanksgiving

feast scene and a reading of Robert Treat Paine's *Ode*; Joseph Croswell's 1802 *A New World Planted, or The Adventures of the Forefathers of New-England*, which emphasized the threats to the Pilgrims from within their own community; and *The Pilgrims, or The Landing of our Forefathers at Plymouth Bay* (1808), which added treatment of the conflict with Native Americans.[32] Jedidiah Morse and Elijah Parish extended the reach when they included celebratory odes and orations delivered at Plymouth in their 1804 *A Compendious History of New-England, Designed for Schools and Private Families*.[33]

Given the passionate Federalism of most Salem merchants, which Reverend Bentley once described as "of the most virulent nature," it is not surprising that images of the Pilgrims landing would be popular in that seaport. Cornè's primary patrons, the Derbys, were fervent Federalists. By this they primarily meant advocating for a strong navy to provide governmental protection of shipping lanes and free trade after the Revolution. It was a viewpoint the shipowners shared with their sailors. As is common in American party politics, Federalist alignments had class dimensions. "In the town of Salem," Bentley noted, "the Republicans are the middle class & the Federalists in wealth, the top and bottom."[34]

No doubt one of Salem's prominent Federalist merchants (probably Derby) provided Cornè with Samuel Hill's engraving for the Feast of the Shells as the basis for his painting, for the composition of Cornè's image came directly out of the invitation to these Boston Federalist extravaganzas. It may be slightly surprising that Salem's shipowners would commission a painting based on a small engraving rather than ask for an original treatment. But this was consistent with Cornè's practice. A study of many of his more ambitious historical subjects demonstrates that they were based on images already in circulation. For example, his painting *The Death of Captain Cook* is based on an engraving of the 1781 painting by George Carter (National Library of Australia), copies of which circulated widely in Salem. His two paintings titled *Columbus and the Egg* derived from a Hogarth print. What was important to Cornè's patrons was ownership of a familiar and meaningful image, not possession of artistic originality.

Cornè's multiple painted treatments of a theme typically differ little from one another. His painting *Landing of the Pilgrims*, commissioned by Commodore Edward Preble (1761–1807), hero of the Battle of Tripoli, and now at the Phoenix Art Museum, is almost identical to the Derby version (fig. 10.6). There are more pink tones in the sky. There are fewer men in the shallop, and those in red coats are in the back rather than the front of the vessel. The figure hauling the rowboat toward Plymouth Rock is in a different pose, turning to the right to anchor the rope to the rock, rather than facing the small boat and reeling it in. The Native Americans, however, are in nearly identical positions on the snow-covered rocky ledges.

Like the Derby picture, this painting has a well-documented provenance. On his return from the Barbary Coast, Preble assumed a naval position in Boston supervising

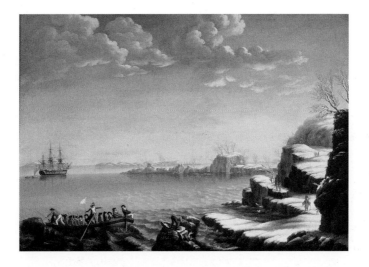

FIG. 10.6 Michele Felice Cornè, *Landing of the Pilgrims*, ca. 1804–7. Oil on canvas, 36 × 51 ¼ in. Collection of Phoenix Art Museum, gift of E. Q. Barbey Family, 2001.124.

the construction of U.S. warships, a role that took him periodically to meet with shipbuilders in Salem. This was a comfortable place for him to travel, since he was related by marriage to the prominent Federalist merchant family. His brother Eben Preble was the widower of two Derby sisters, Mary (d. 1794) and Elizabeth (d. 1799), who were daughters of Richard Derby and cousins of Elias Hasket Derby Jr. Preble was looking for an artist because Congress had voted to honor him with a gold medal, to be produced by the Philadelphia mint. He must have met Cornè through the Derbys; the artist sketched a portrait of the commodore for one side of the medal and provided three sketches to serve as the basis for the naval battle scene on the reverse.[35] Preble must have seen Derby's *Landing of the Pilgrims* and ordered one for himself on the spot, or in any event sometime before his death in 1807. He was certainly impressed with Cornè's work, for he paid the artist $50 to create a large painting commemorating the American attack on Tripoli on August 3, 1804, which he sent to the Navy Department in 1805 (U.S. Naval Academy Museum), and later commissioned a smaller version, probably for his Portland home (Maine Historical Society).[36] Preble's *Landing* eventually passed to his nephew, Rear Admiral George Henry Preble (1816–1885), who, after his own distinguished military career, was elected a member of the New England Historic Genealogical Society in 1866 and became a life member in 1869. Admiral Preble donated the painting to the NEHGS, which placed it on deposit at the Peabody Museum from 1935 to 1973.[37] During this time, the painting was catalogued and published as part of the museum's collection (described erroneously as

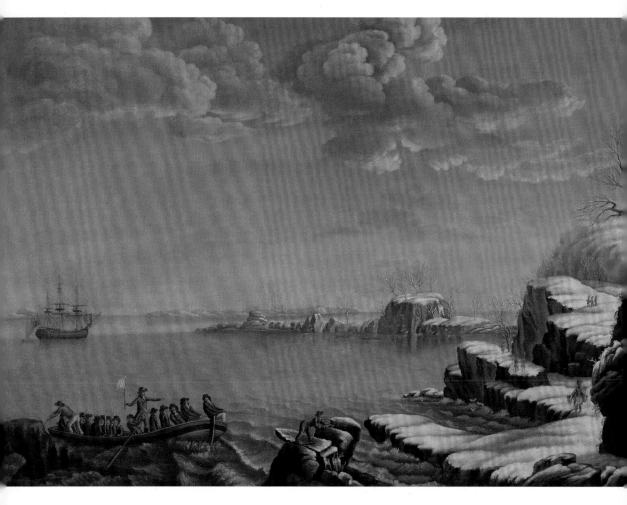

FIG. 10.7 Michele Felice Cornè, *Landing of the Pilgrims*, ca. 1804–7. Oil on canvas, 36 ⁹⁄₁₆ × 52⅛ in. Courtesy of the Pennsylvania Academy of the Fine Arts, Philadelphia, gift of Mrs. Henry S. McNeil in loving memory of her husband, Henry S. McNeil, 1985.46.

painted on board rather than on canvas), leading to subsequent confusion.[38] Eventually, it was sold, and in 2001 was donated to the Phoenix Art Museum.

Another very similar painting is now in the collection of the Pennsylvania Academy of the Fine Arts, but unfortunately, when it went on the art market in the 1980s, its provenance was lost to the confidentialities of art dealing (fig. 10.7). It is nearly identical to the Phoenix painting and can be dated safely to the latter half of Cornè's Salem years (ca. 1804–7). Like the Preble painting, the small man on the rock turns to the right as he ties up the shallop. The Native Americans are positioned similarly to those in the first two versions, another indication that patrons prized repetition over originality, even though the scene is imaginative.

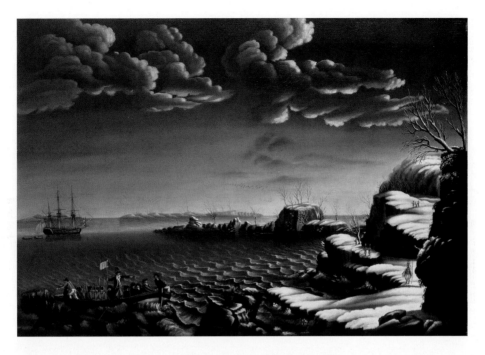

FIG. 10.8 Michele Felice Cornè, *Landing of the Pilgrims*, ca. 1804–7. Oil on canvas, 36 × 52 ¼ in. White House Historical Association (White House Collection), gift of Mr. and Mrs. John P. Humes, 1984, 489.

The version currently hanging in the White House also lost its provenance to the art market (fig. 10.8). Its composition has similarities to the others: the turned figures, the native people's placement, and the date painted on the rock. The catalogue of the White House art collection describes it as more stylized than the others, with its clouds rendered as "strong, almost abstract shapes; the snow covers the shore like frosting on a cake; and the squiggly waves might have been applied with a pastry tube."[39] Such stylization may suggest an abstraction resulting from continual replication of an image. It may also suggest copying by a less experienced artist, although it is more likely, though it is neither signed nor dated, that Cornè painted it for another Salem patron while he resided there.

One more painting on canvas by Cornè of the landing of the Pilgrims is extant, though it does not fit the mold of the other four (fig. 10.9). Currently hanging in Pilgrim Hall in Plymouth, this version was bequeathed to the museum in 1853 by Robert Gould Shaw (1776–1853), grandfather of the more famous Civil War colonel of the same name, who is memorialized leading the African American 54th Regiment into battle in the Augustus Saint-Gaudens sculpture on the Boston Common. The elder Shaw was Boston's wealthiest merchant. He made his millions in the China

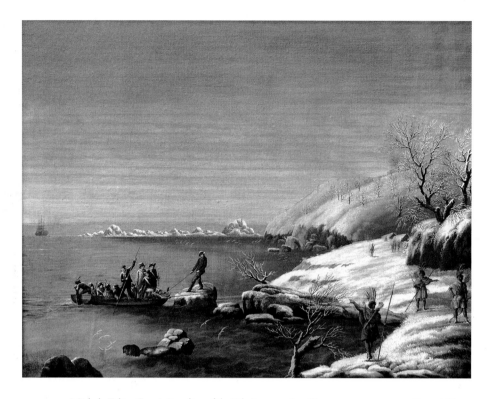

FIG. 10.9 Michele Felice Cornè, *Landing of the Pilgrims*, ca. 1820. Tempera on canvas, 46 ½ × 58 ¾ in. Courtesy of Pilgrim Hall Museum, Plymouth, Massachusetts, gift of Hon. Robert G. Shaw, 1853, PHM 250.

trade, and later in real estate investments. If he commissioned this work directly from Cornè after the artist's move to Boston, the work dates from after 1807 but before 1822, when he moved to Newport, Rhode Island.

Shaw's painting is different from the other four, which suggests that Cornè did this work at a different point in his career. It is painted on a rougher grade of canvas, with tempera rather than oil. The positioning of the figure on the rock is unique; he stands and leans backward rather than bending. The Native Americans are placed and dressed somewhat differently. Though the size of the painting is roughly similar to the other four, this work has more in common stylistically with Cornè's broad-brushed and quickly painted room-sized wall papers than with his oils. That perhaps is the result of the change in medium from oil to tempera.[40]

No records in the Shaw archives shed light on when the merchant met Cornè, but some clues remain about his ideas on the value of art. Into the mid-1830s, Shaw corresponded with Ethan Allen Greenwood, who was a painter and the proprietor of the New England Museum and the Gallery of Fine Arts from 1818 to 1825. Perhaps the *Landing* was commissioned with that institution in mind, in the belief

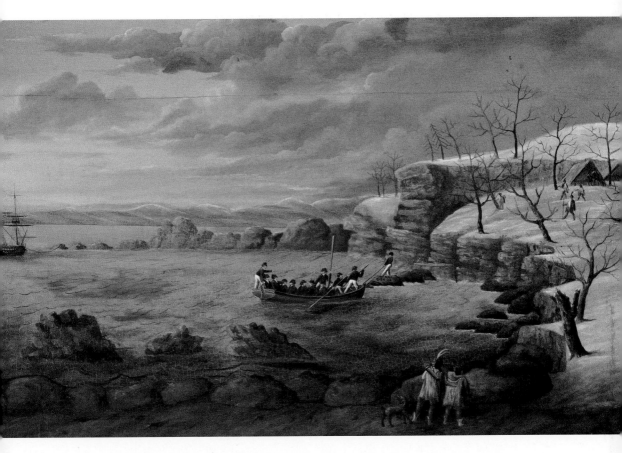

FIG. 10.10 Samuel Bartoll, *Landing of the Fathers at Plymouth*, A.D. 1620, 1825. Oil on wooden panel, 33 ¾ × 53 in. Peabody Essex Museum, Commissioned by the East India Marine Society, 1825, M293. Photo: Peabody Essex Museum, Salem, Massachusetts.

that this subject was appropriate for a public audience.[41] Certainly, Shaw thought of the painting as different from the rest of his art collection, which he grouped together in his will simply as "pictures" and left to his family. The *Landing* was the only painting explicitly named in the 1853 codicil to his will, and he left it to an institution—Pilgrim Hall Museum—with which he seems to have had no previous contact.[42] If this painting, as I believe, is later than the other Cornè *Landings*, it may have had a different meaning for Shaw than it had for his fellow Federalists at the Feast of the Shells a decade or two earlier. After the War of 1812, the Federalist Party was fading from the scene, and most of its members joined the new Whig Party. Shaw himself followed that trajectory. A Freemason, Shaw was also president of the Massachusetts chapter of the Society of the Cincinnati, which emphasized service to the American Republic.

As the bicentennial of the landing neared in 1820, about the time Robert Gould Shaw probably commissioned this work, the meaning of the story of the Pilgrims expanded from a narrow Federalist and New England event to one of national significance. Samuel Hill's composition enjoyed renewed interest in the 1820s and 1830s, as the small engraving became a world traveler. The image made its way to England, where Enoch Wood & Sons copied it for several Staffordshire ceramic designs (figs. 10.2, 10.3). Oral tradition has it that the ceramics were ordered originally by the Pilgrim Society for use at their anniversary dinner in 1824, when Pilgrim Hall in Plymouth was dedicated, and that the design was later reissued many times.

The next year, 1825, the East India Marine Society moved its museum to its third location, and for the occasion it commissioned Samuel Bartoll, a Marblehead sign painter, to copy Corne's rendition of Hill's engraving for display in the new quarters (fig. 10.10). Bartoll's copy is a fireboard, painted on wood and used to cover the hearth when the fireplace was not needed in the summer; it was made to provide consistency, for the new hall had four fireplaces, but only three fireboards were transferred from the previous exhibition space.[43] The new fourth fireboard took its subject from the "landing of Plymouth" that Bentley had observed "on one Chimney" in the second museum space; it is sometimes confused with Corne's extant works, which are all on canvas.

This painting depicts the central figure tying up the landing party's boat in the same stance as the Shaw version, with the standing figure facing left and angled back to the right. Perhaps they both share this element from the lost chimney painting. Bartoll added his own touches to the scene, incorporating more foreground landscape, peopled with two inquisitive Native Americans and their dog watching the landing. He also added the suggestion of a Native American village at the site, though his architecture seems to be combination of the traditional arched Wampanoag wetu with the more pointed triangular forms of western tipis.

It is no surprise that the new museum commissioned an image of the Pilgrims' landing, twenty years after the first paintings. The remnants of the Federalist elite merchant families in Salem maintained intense interest in the Pilgrims as a cultural symbol, and their celebrations became memorable social events. Mary Jane Derby Peabody recalled that in 1824, "while I was yet a schoolgirl," Henry Colman, the new Unitarian minister of Barton Square Church in Salem, "came and begged us all to go to the Plymouth hall. . . . Mr. Everetts oration to a crowded house in the morng- & dressing in small quarters & the ball in the eveng were most exciting and entertaining to me." Harvard College student Benjamin V. Crowninshield went to the festivities and wrote to his father in Salem that he had seen the Derbys there.[44]

The Bartoll commission for a copy of Corne's *Landing of the Pilgrims* coincided with another surge of interest in picturing Pilgrims. In 1810, the young Samuel F. B.

Morse took a turn at representing the heroism of the colonial founders, with a large close-up image of five men near shore in a shallop (Boston Public Library, Charlestown branch). The Boston artist Henry Sargent took on the most ambitious task, beginning in 1815 a huge painting of Samoset meeting the Pilgrims. That painting was damaged, and Sargent then painted another from 1818 to 1822, which was exhibited at the opening of Pilgrim Hall in 1824 and still hangs there today. The increasing use of the Pilgrim narrative as a national allegory is demonstrated by the embarkation of the Pilgrims carved by Enrico Causici in 1825 above one of the doorways of the U.S. Capitol Rotunda. In the relief sculpture, a Native American offers a gift to arriving Europeans, but his crouching position suggests his acknowledgment that his visitors considered his status inferior.[45] By the quarter-century mark, the Pilgrims had been transformed from regional into national symbols.

The continual representation of the Pilgrims in the early Republic provides insights into the creation, circulation, and function of art in the period. Patrons in the early Republic made few assumptions about the hierarchy of the arts on the basis of media. They appreciated messages communicated by engraved images or painted decorative arts as well as oil on canvas. Artists borrowed freely; they transferred images to ceramics, glass, paper, wood, and canvas. Images were copied and recopied all over the world—prototypes were sent to China and England to be reproduced for the American market, while at the same time transforming European aesthetic conventions into American art. Because some media cost less and circulated more widely than others, visual conventions reached different audiences, and helped shape ideas of nationhood among broad segments of society. Federalist patrons were far more motivated to own an image with significant meaning—with layered resonances from the local to the regional to the national—than to own a unique work that would set them apart from their peers. The possession and display of such a work signaled their political and patriotic values in the new United States.

NOTES

Research for this chapter grew out of two National Endowment for the Humanities Landmarks of American History grants at Salem State University in 2004 and 2005, and was continued with the support of an NEH research fellowship in 2011. I thank my research assistants over several years for helping track down family records and images, particularly Heather Cole, Cristina Rivera, and Josilyn DeMarco. For commenting on earlier versions of this chapter, I thank Jessica Lanier, David Steinberg, and my academic reading group at Salem State University: Elizabeth Kenney, Nancy Schultz, Peter Walker, Avi Chomsky, and Elizabeth Blood. I also thank the faculty fellowship program at the College of the Holy Cross for support with pictures and permissions.

1. There are earlier English and Dutch representations of the Pilgrims. On Dutch images, particularly *Departure of the Pilgrims from Delfshaven*, see Jeremy Dupertuis Bangs, "Towards a Revision of the Pilgrims: Three New Pictures," *New England Historical and Genealogical Register* 153 (January 1999): 3–28. Other (rare) early sources of Pilgrim images are histories, such as Henry

Trumbull, *History of the Discovery of America, of the Landing of Our Forefathers at Plymouth, and of Their Most Remarkable Engagement with the Indians in New-England* (Norwich, Conn.: For the Author, 1810), in which the frontispiece depicts a confrontation between Englishmen and Native Americans, bayonets and arrows drawn.

2. I thank Lynn Turner and other staff at the U.S. Department of State for sharing the object folder on the painting with me and providing the reproduction. Notes in the object folder suggest that the painting was made for Elias Hasket Derby Sr. (1739–1799), but his death date makes this impossible. Therefore the reference is probably to Elias Hasket Derby Jr., although his brother with the same initials, Ezekiel Hersey Derby, also commissioned works from Cornè. The painting is reproduced and discussed in Gerald W. R. Ward, ed., *Becoming a Nation: Americana from the Diplomatic Reception Rooms, U.S. Department of State* (New York: Rizzoli, 2003), catalogue entry on Cornè by William Kloss, 40, 46.

3. *The Diary of William Bentley, D.D., Pastor of the East Church, Salem, Massachusetts,* 4 vols. (1905; reprint, Gloucester, Mass.: Peter Smith, 1962), 3:93 (entry for June 11, 1804). Unfortunately, the subject and medium of the paintings that Cornè painted for the museum are not described in the receipt for them. Cornè signed a receipt dated June 28, 1804, saying that he had received payment in full for "the painting of three fire places in the Hall, at $30 ea" and "the painting of three fire boards for Ditto at $12 ea," or a total of $126. MH-88, box 14 and box 11, folder 1, Papers of the East India Marine Society, Phillips Library, Peabody Essex Museum, Salem, Mass. I believe one of the fireplace paintings to be a lost overmantel of the landing of the Pilgrims. The "three fire boards" (on wood) are on display at the Peabody Essex Museum. Although the literature on Cornè consistently identifies at least one of his *Landing of the Pilgrims* paintings as a fireboard, this is an error that developed because Samuel Bartoll was later commissioned to make a fireboard of this subject. Of the five known versions by Cornè, all are on canvas.

4. Most of these are listed and some are reproduced in Carl L. Crossman and Charles R. Strickland, "Early Depictions of the Landing of the Pilgrims," *Magazine Antiques,* 98, no. 5 (1970): 777–81. The reverse glass paintings are reproduced in that article; they are in private collections and I was unable to get reproductions. Crossman and Strickland reproduce an image that they identify as a painting on wood panel in the collection of the Peabody Museum of Salem (now the Peabody

Essex Museum); I believe that this is the Preble version discussed below, the oil-on-canvas painting that was on loan there from the New England Historic Genealogical Society, which was subsequently sold to the Phoenix Art Museum (fig. 10.6).

5. The most developed discussion of Cornè's art and biography is the 1972 exhibition catalogue *Michele Felice Cornè, 1752–1845: Versatile Neapolitan Painter of Salem, Boston, and Newport,* foreword and notes by Philip Chadwick Foster Smith, essay by Nina Fletcher Little (Salem: Peabody Museum of Salem, 1972).

6. The Pilgrims landed on December 11, 1620 (old style). The landing was celebrated on December 22 (instead of the correct date of December 21) because of a conversion error in the calendar.

7. Benjamin Schmidt discusses the phenomenon of representing New England with palm trees in "Collecting Global Icons: The Case of the Exotic Parasol," in *Collecting Across Cultures: Material Exchanges in the Early Modern Atlantic World,* edited by Daniela Bleichmar and Peter C. Mancall (Philadelphia: University of Pennsylvania Press, 2011), 31–57.

8. Margaret Beck Pritchard and Henry G. Taliaferro, *Degrees of Latitude: Mapping Colonial America* (New York: Colonial Williamsburg Foundation, 2002), 176–79.

9. Crossman and Strickland, "Early Depictions of the Landing."

10. Joseph Croswell, *A New World Planted, or The Adventures of the Forefathers of New-England* (Boston: Printed for the author by Gilbert & Dean, 1802), 8.

11. John Seelye, *Memory's Nation: The Place of Plymouth Rock* (Chapel Hill: University of North Carolina Press, 1998), 17; see also 47–49. Though I am generally in agreement with Seelye's literary analysis, I take issue with his dates and sequence of production for the engraving and paintings of the landing; see 51–54. I also propose more specific dating than Crossman and Strickland do in "Early Depictions of the Landing."

12. John Quincy Adams, *An Oration, Delivered at Plymouth, December 22, 1802: At the Anniversary Commemoration of the First Landing of Our Ancestors, at That Place* (Boston: Russell and Cutler, 1802). Adams's speech is discussed in Seelye, *Memory's Nation,* 54–59.

13. For example, at the store of Cushing and Appleton. *Salem (Mass.) Gazette,* February 1, 1803, 4.

14. Cultural fascination with Plymouth Rock continues, as can be seen in two artistic projects: John McPhee, "Travels of the Rock," *New Yorker,*

February 26, 1990, reprinted in John McPhee and Carol Rigolot, eds., *The Princeton Anthology of Writing: Favorite Pieces by the Ferris/McGraw Writers at Princeton University* (Princeton: Princeton University Press, 1990), 351–68; and Deborah Bright and Erica Rand, "Queer Plymouth," *GLQ: A Journal of Lesbian and Gay Studies* 12, no. 2 (2006): 259–77.

15. This poem was incorrectly attributed to Thomas Paine in several New England newspapers, including the *Boston Columbian Centinel*, January 5, 1799, 4.

16. Robert D. Arner, "Plymouth Rock Revisited: The Landing of the Pilgrim Fathers," *Journal of American Culture* 6, no. 4 (1983): 23–35, esp. 31.

17. John Seelye, *Memory's Nation*, 7, 25.

18. Quoted in Seelye, 35.

19. Arner, "Plymouth Rock Revisited," 25–26.

20. James Thatcher, *History of the Town of Plymouth* (1835), quoted in Seelye, *Memory's Nation*, 23. The top half of the rock split again in 1834, when it was transported from the courthouse to Pilgrim Hall. It was cemented together and placed in a cage to protect it from tourists. All surviving parts were rejoined in 1880, under a Victorian canopy. The current neoclassical shrine dates from the tercentenary in 1920. Arner, "Plymouth Rock Revisited," 27.

21. Quoted in Seelye, *Memory's Nation*, 40.

22. Seelye, 40.

23. Seelye, 33.

24. Timothy Dwight, *Travels in New England and New York*, vol. 3 (1822; reprint, Cambridge: Harvard University Press, 1969), 73.

25. "Feast of the 'Sons of the Pilgrims,'" *Boston Columbian Centinel*, December 24, 1800, 2.

26. Seelye, *Memory's Nation*, 43. The Feast of the Shells is described in Thomas Wentworth Higginson, *Life and Times of Stephen Higginson* (Boston: Houghton Mifflin, 1907), 219–29.

27. *Boston Columbian Centinel*, December 25, 1799, 3; *Salem (Mass.) Gazette*, December 27, 1799, 3.

28. Albert Matthews, *The Term Pilgrim Fathers and Early Celebrations of Forefathers' Day* (Boston: Colonial Society of Massachusetts, 1914), 324.

29. Seelye, *Memory's Nation*, 46.

30. "Feast of the 'Sons of the Pilgrims,'" *Boston Columbian Centinel*, December 24, 1800, 2.

31. *Constitutional Telegraph*, December 27, 1800, 3.

32. These plays are discussed in Seelye, *Memory's Nation*, 47–50. An advertisement for performances of the first play listed was published in the *Boston Columbian Centinel*, April 24, 1799, 3; an advertisement for the last one appeared in the *Boston Repertory*, December 23, 1808, 3. Croswell's

play was published in 1802 and sold; advertisements were also placed for Boston productions of a romantic drama, *The Feast of the Shells*, which was unrelated to the Pilgrim story but from which the title may have been taken, for a period from circa 1796 to circa 1807, for example, in the *Massachusetts Mercury*, March 14, 1800, 3.

33. Jedidiah Morse and Elijah Parish, *A Compendious History of New-England, Designed for Schools and Private Families* (Charlestown, Mass.: Samuel Etheridge, 1804); review in *New-England Palladium*, December 14, 1804, 4.

34. *Diary of William Bentley*, 3:282 (entry for March 27, 1807), and 4:17 (entry for April 23, 1811).

35. Email to the author from James W. Cheevers, associate director and senior curator, U.S. Naval Academy Museum, Annapolis, Maryland, January 5, 2006.

36. Edward Preble to the Honorable Secretary of the Navy, July 10, 1805, in Edward Preble Papers, vol. 15, Library of Congress, Washington, D.C.

37. Phone conversation with Timothy Salls, archivist, New England Historic Genealogical Society, December 2005.

38. The painting was assigned the catalogue number M4140 and included as catalogue number 172 in M. V. Brewington and Dorothy Brewington, *The Marine Paintings and Drawings in the Peabody Museum* (Salem, Mass.: Peabody Museum, 1981), 41. It was described as oil, with no ground specified, and identified as on deposit from the NEHGS.

39. The entry on the painting in the catalogue of the White House art collection lists only the dealer, Hirschl and Adler, and the eventual donor. See William Kloss, *Art in the White House: A Nation's Pride* (Washington, D.C.: White House Historical Association, 2008), 52–53. My request to examine this work in person was denied by the White House.

40. My thanks to Stephen O'Neill, curator of Pilgrim Hall Museum, for discussing this painting with me and sharing the museum's research.

41. Greenwood's papers, including a letter to Shaw about the future of the museum, are at the American Antiquarian Society, Worcester, Massachusetts. See Georgia Brady Barnhill, "Ethan Allen Greenwood: Museum Collector and Proprietor," in *New England Collectors and Collections*, edited by Peter Benes and Jane Montague Benes (Boston: Boston University Press, 2004).

42. Will of Robert G. Shaw, August 8, 1853, docket 38412, Suffolk County Probate Records, vol. 151, 85. An error in the probate record index made it difficult to find on microfilm; my thanks to

Elizabeth Bouvier, head of archives at the Supreme Judicial Court, Commonwealth of Massachusetts, for retrieving and summarizing the original will for me. The codicil was apparently written after his wife's death, instructing "that the Picture of the Landing of the Pilgrim Fathers be given to 'The Pilgrim Society of Plymouth' incorporated 1820."

43. The receipt for the Bartoll painting, dated September 28, 1825, shows that he was paid $30 for "painting a representation of the Landing of the Fathers @ Plymouth A.D. 1620," and $10.50 for revarnishing Corne's three 1804 fireboards. The same receipt shows that Bartoll was also paid for lettering a sign to be hung above the hall and for gilding a frame, thus showing the diversity of tasks that artisan painters like Bartoll performed. MH-88, box 14, Papers of the East India Marine Society.

44. Mary Jane Peabody, "Autobiography," 1876–79, MS N-126, box 3, Derby-Peabody Papers, Massachusetts Historical Society, Boston; Benjamin V. Crowninshield to Benjamin W. Crowninshield, ca. 1824, "Family Letters Received," Crowninshield Family Papers, MH-15, box 13, folder 2, Phillips Library, Peabody Essex Museum. I thank Jessica Lanier for these references.

45. On Causici's work, see Vivien Green Fryd, *Art and Empire: The Politics of Ethnicity in the United States Capitol, 1815–1860* (New Haven: Yale University Press, 1992), 25–28.

Remembering the "Olden Time"

JOHN FANNING WATSON'S CULTIVATION
OF MEMORY AND RELICS IN EARLY NATIONAL
PHILADELPHIA

LAURA C. KEIM

EVENTS HAPPEN; A GENERATION LATER, history is crafted. This crafting is done through written and spoken word, literally bit by bit, artifact by artifact. Usually, the historian did not personally experience the era of his or her interest, so the task of making history occurs at least a generation beyond the time of focus. History making is both an excavational and a creative process, a task of reclamation, a digging through the layers of time to reveal its mysteries. Inevitably, pieces of the past are missing, and the historian must make informed guesses about the unknown, creating the story anew. John Fanning Watson (1779–1860) was one such historian; he chronicled and crafted a history of the founding of Pennsylvania and the early years of the American nation. Working largely through a Philadelphia-focused lens, Watson constituted history by recording oral histories and traditions and saving artifacts, relic bits of wood, paper, cloth, and other items both large and small that he deemed worthy of preserving.

During the early national period in and around Philadelphia, Watson and his Germantown friends Deborah Norris Logan (1761–1839) and Reuben Haines (1786–1831) pursued the history, memory, and understanding of America's colonial past and revolutionary founding through documentary research, oral history, and artifactual remains (figs. 11.1–11.3).[1] Watson visited Logan at her home, Stenton, for tea on Saturdays, a regular practice that began on May 23, 1823. Watson and Haines joined with other like-minded individuals, including Haines's boyhood friend Roberts

FIG. 11.1 John Fanning Watson (1779–1860), undated portrait photograph found inside the cover of his manuscript annals. Approximately 8 × 6 in. John Fanning Watson Collection on the Cultural, Social, and Economic Development of Pennsylvania [0697], Historical Society of Pennsylvania.

FIG. 11.2 Portrait of Deborah Norris Logan (1761–1839), copy after Charles Willson Peale (detail). Oil on canvas, 14 × 12 in. Courtesy of The National Society of The Colonial Dames of America in the Commonwealth of Pennsylvania at Stenton, Philadelphia, gift of Deborah Norris Glover.

FIG. II.3 Rembrandt Peale, *Reuben Haines* (1786–1831), ca. 1831. Oil on canvas, 77 × 64 cm. Courtesy of The Wyck Association.

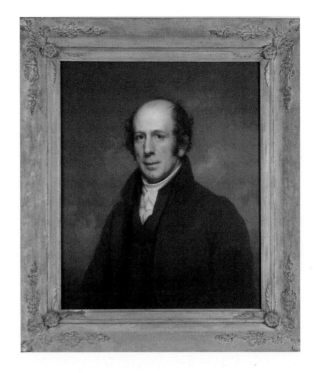

Vaux (1786–1836), to establish the Historical Society of Pennsylvania in 1824, which welcomed Logan as its first female member in 1827. The men also created the Society for the Commemoration of the Landing of William Penn, known as the Penn Society, in November 1824.[2] Vaux and Haines were also active participants in the Committee of History, Moral Science, and General Literature of the American Philosophical Society, founded in 1815. In these activities, they cultivated a culture of relics that connected their world to the past through objects. Artifacts associated with people, places, and events from the colonial and revolutionary periods facilitated the contemplation of history and offered a sense of visceral and personal connection with a lost and vanished time.

Developing their context is essential to the interpretation of all artifacts. In order for twenty-first-century historians to understand the significance of John Fanning Watson's relics, we must examine Watson's own history and writings, thereby creating a full and rich frame of reference, including his web of relationships, for interpreting his surviving collections and other objects associated with him and his circle of fellow pursuers of history.[3] Returning imaginatively to the time and place in which Watson collected and generated relics helps us grasp the meaning of these artifacts for him and the other antiquarians and lovers of history with whom he celebrated and shared reminiscences and remnants of early Philadelphia.

The three antiquarians who anchor this narrative, Watson, Logan, and Haines, met "together in frequent and grateful concourse, to render thanksgivings" based on the history they knew or studied. Deborah Norris Logan had witnessed the first reading of the Declaration of Independence in the State House Square on July 8, 1776, from her family's garden on Chestnut Street, had lived through the American Revolution, and later transcribed and catalogued much of the James Logan correspondence found in her home, Stenton, which became a bearer and source of memory and relics.[4] Watson, who was a generation younger, collected and recorded her artifacts, memories, and lore.[5] Reuben Haines, connected to both Logan and Watson through community and common interest, participated in the culture of relics through his own collections of historical artifacts, which he included among his varied treasures and natural history collections in his museum room on the second floor of Wyck, his family house in Germantown.

The Penn Society's and Watson's religious lexicon for his discussion of relics imbued objects from the past with a certain mystical quality. These material remains represent a connection to something that cannot be physically experienced in the present—the past. As relics, they represent a visceral longing to understand and participate in a lost time. This chapter draws together some of the historical relics that remain in Germantown collections and elsewhere and weaves together an understanding of these relic collectors, demonstrating their significance for historians today.

Not surprisingly, the most venerated figures in the Pennsylvania culture of relics were founders William Penn, Benjamin Franklin, and George Washington. At a dinner on October 24, 1825, U.S. District Attorney Charles Jared Ingersoll (1782–1862) gave a speech glorifying the current state of the achievements of Pennsylvanians. Ingersoll concluded with the religious language that the followers of the cult of history applied to their understanding of the past: "May the sciences and refinements which embellish and enlighten, the charities that endear, and the loyalty that ennobles, forever flourish here [Pennsylvania] on the broad foundations of Peace, Liberty and Intelligence. And among increasing millions of educated moral and contented people, may the disciples of Penn, Franklin and Washington, meet together in frequent and grateful concourse, to render thanksgivings to the Almighty for the blessings we enjoy by his dispensation."[6]

Preservationists have established that buildings and objects that are fifty years old are at a crucial point in their material existence, often old enough to be out of fashion and worn enough to be in need of capital investment, but not quite old enough to be interesting and celebrated as objects of an earlier time. It is not surprising, then, that the mid-1820s, fifty years after the Declaration of Independence and the War of Independence, was a pivotal time, a window when historically-minded Americans began to look back, to take stock of the past in an effort to seek it out, and to determine and connect themselves to their founding history. As part of the process, these early antiquarians sowed the seeds of preservation for future generations through their

veneration of buildings, artifacts, and manuscripts. They created some of the first secondary histories, like Watson's *Annals of Philadelphia*, begun as a manuscript in 1823 and first published in 1830.[7] Deborah Norris Logan created her own manuscript commonplace book of Logan and Norris "Family Records," which includes quotations on the practice of history (especially from the noted Dr. Samuel Johnson, the English writer and lexicographer), genealogies, obituaries, and transcribed histories and accounts of the Logan and Norris families.[8] Relics are objects left behind, the remains of things and people past, and in a religious sense objects are esteemed and venerated because of their association with a saint or martyr. In the world of the early national historians and antiquarians of Philadelphia, one of the saintliest of saints was William Penn, the founder and peace-loving Quaker proprietor of Pennsylvania. Another venerated figure was George Washington; when he and other founding fathers grew old and began to die, buildings and objects associated with these men took on heightened significance. General Lafayette, hero of the Revolution, was venerated as a living saint when he visited America on his grand tour as the nation's guest in 1824–25. Objects associated with him and his visit would take on relic status in the ensuing years.

Three relic snuffboxes in Germantown collections at Wyck, Stenton, and the Germantown Historical Society speak to the web of relationships between the history lovers in the Penn Society and the connections they forged through their exchange of relics in the mid-1820s.[9] This veneration of relics kindled intense emotional feelings among the antiquarians through their sense of being connected to something beyond themselves in time, something invisible and almost mystical.[10] John Fanning Watson presented one such turned walnut box, with a removable lid inlaid with veneers of sweet gum, oak, mahogany, and elm, to Reuben Haines in July 1825, along with a letter describing it. The box is labeled on the bottom with inscribed fitted paper on which Watson wrote an explanation of the box in his characteristically expressive and celebratory tone:

Relics
of the Olden Time!
The box is of Walnut, a
Forrest Tree when Penn visited
Philda in 1682. It stood till 1818
before the State House.
The Sweet Gum is now, in 1825,
the last <u>living</u> contemporary of Penn's day.
The Oak is the butment wharf of a
bridge over Dock Creek—the first
built in Philda, Dug up in 1823 in
Ches[nu]t St at Hudson's Alley—
The Mahogany is part of the Beam

> *of Columbus' House, the first*
> *in America.*
> *The Elm is of the Treaty*
> *Tree of Shakamaxon–*
> *From J. F. Watson to*
> *R. Haines Esq.*

Watson composed the letter that accompanied the Haines snuffbox at the Bank of Germantown, where he lived and served as cashier from 1814 until 1848.[11] Watson explained that he sent the box to Reuben Haines because Reuben was "so capable of deriving moral pleasure from the contemplation of the historical facts with which they are connected." He justified creating his box of relic wood with a direct reference to Shakespeare and Mulberry Tree relics. Watson invoked this connection by quoting several verses from William Cowper's popular 1784 antislavery poem *The Task*, which referred to the mulberry relics. "If the Bard of Avon, could confer such value upon the 'Touchwood Trunk [Cowper]' of his renowned Mulberry Tree, we may be pardoned for venerating & esteeming the Relics of *our* Soil—'Such Relics as devotion holds, Still sacred, and preserved with pious care [Cowper].'"[12]

For Watson, making the connection to William Penn's time and the presence of "olden time" could be accomplished by literally touching a piece of wood from a tree that was alive when William Penn was in Pennsylvania. The wood became associated with and imbued with the memory of Penn and was in turn celebrated in its own right as an object of historical import and imagination. Additionally, Watson appreciated these relic woods as they were from "*our* Soil," venerating the independent American nation.

Reuben Haines had the pleasure of presenting Lafayette with an identical relic box during his reception at Wyck on the sweltering early afternoon of July 20, 1825, as part of his nearly four-hundred-day long "Triumphal Tour" as "the Nation's Guest." A letter from Watson also accompanied this Lafayette box, which read, "The love of relicks, connected with incidents on which the soul delights to dwell is a passion *natural* to man and especially to those of the finest moral feelings; and the reason is obvious: by such associations, such constituted minds, are capable of generating the *ideal presence*, and to commune with men and things of other times."[13]

Watson visited Stenton to call on Deborah Logan, "the 'Female Historian' of Pennsylvania," later in the afternoon after the Lafayette reception at Wyck. He also presented Logan with her very own relic wood box (fig. 11.4).[14] Deborah recounted the day of Lafayette's visit in her diary:

> But not a "workday world" to day, for its events are such as occur only once, I mean the visit of "the Nation's Guest [Lafayette]" at Germantown, Chestnut [Hill], and Barren Hill, &c &c.

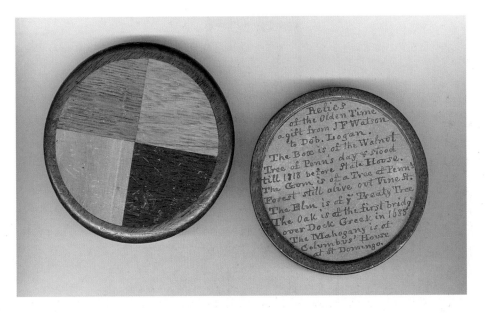

FIG. 11.4 Snuffbox, ca. 1825. Turned walnut with inset veneers of sweet gum, elm, oak, and mahogany, 3 ¼ in. d × 1 ¼ in. h. John Fanning Watson presented this box to Deborah Norris Logan at Stenton on July 20, 1825, the day Lafayette visited the borough of Germantown to the northwest of Philadelphia. Courtesy of The National Society of The Colonial Dames of America in the Commonwealth of Pennsylvania at Stenton, Philadelphia, gift of Rosemary Ellis Crawford.

July 20th: 25

A[t] Breakfast I rec[eive]d a note from Reuben Haines saying that the General was to Breakfast at McNits and would be over at his home between nine and ten o'clock, and inviting me or any of my family to come and see him there—Algernon [Deborah's son] went. . . .

John Eddowes and his sister Kitty and my friend Watson drank tea with me in the afternoon. The latter presented me with a Box made of 4 different kinds of wood, remarkable for their localities, one a piece of mahogany from a board of that kind used in building Columbus ("The world-seeking Genoese") a house still preserved with veneration at Hayte [sic]. Another piece is of the Treaty Elm.[15]

Additional historically-minded friends or Revolutionary War heroes received relic boxes from Watson. Their identities are known largely through his correspondence. Those recipients identified by Lois Dietz are J. Thompson (March 1825), Peter S. DuPonceau (July 1825), Mayor Joseph Watson (July 1825), Roberts Vaux (July 1825), James Barron (September 1825), and David Lewis (December 1825). The dates of this correspondence suggest that Lafayette's visit may have been a motivating factor in Watson's focus on the presentation of these inlaid relic snuffboxes.[16]

Found in a mid-nineteenth-century desk at Wyck in the late twentieth century and presumed to have been part of Reuben Haines's relic collections is another, smaller relic wood box, which, although not associated with Watson in a documented way, embodies the interests of the Penn Society. The box is a small, quite flat round disk sliced in half and slightly hollowed. Set inside the top and bottom are two pieces of fitted round paper. One paper is inscribed:

> *This Box*
> *made of a piece*
> *of timber, a part*
> *of the house in*
> *Laetitia Court, Phila*
> *built by*
> *William Penn*
> *is*
> *presented by*
> *John Bacon*
> *Oct. 24, 1826*

Once fitted to the inside of the other side is a drawing of a plow with a now incomplete inscription around the edge: "The rough is of no party . . . divides only to produce a more perfect union" and " . . . e Plough is of the Parts."[17]

The Letitia Court House, originally erected circa 1713 for Thomas Chalkley, a Philadelphia merchant and Quaker preacher, near Second and Chestnut Streets, was deeded from William Penn to his daughter Letitia in the early years of the eighteenth century (fig. 11.5).[18] This building was a site of particular focus for Watson, and he devoted one of his many chapters in the published version of the *Annals of Philadelphia* to discussion of the house, its associations with William Penn, and how it should be preserved and kept as a relevant relic house in the future. Watson suggested that Letitia House would make a good headquarters for the recently founded Historical Society of Pennsylvania. "In 1834–35, he pleaded that the venerable inn would make a 'perfect museum where many of our citizens could be brought to deposit of their old relics.'" Watson sentimentally called the chapter in the *Annals* "Penn's Cottage in Letitia Court," conjuring images of quaint country life, then becoming fashionable in suburbanizing nineteenth-century Germantown, for an early eighteenth-century urban structure. Watson laid out the facts he had gathered from oral histories taken from every aged person he could ask to assert that Penn must have lived at Letitia Court. As recorded in the *Annals*, he interviewed Colonel Anthony Morris, age eighty-four, Thomas Bradford, age eighty, the aged Robert Venables, who died at ninety-eight in 1834, Joseph Sansom, Esq., age about sixty, and Timothy Matlack, age ninety-two.[19]

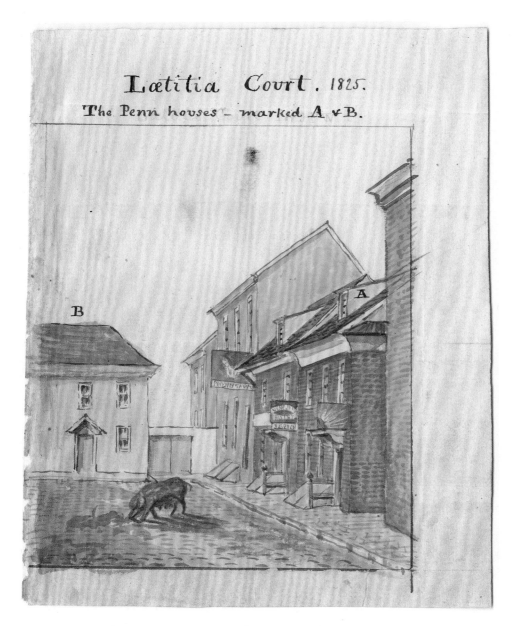

FIG. 11.5 The Letitia Court House, marked "A," 1825. Watercolor on paper, 6 ¼ × 5 in. This sketch is inserted before p. 239 in Watson's manuscript annals at the Library Company. The house was moved to Philadelphia's West Fairmount Park in 1883, off Girard Avenue near the Philadelphia Zoo. The Library Company of Philadelphia.

Deborah Logan in many instances added her own annotations directly into the manuscript version of the *Annals*, lending to it a sense that it was a shared commonplace book with contributions and comments from a small coterie of readers and participants in the history-making process. She asserted her authority by writing about Penn's having

lived at Letitia Court in her own distinctive handwriting.[20] Watson hoped that the Penn Society would preserve the house: "It may possibly be deemed over fanciful in me to express a wish to have this primitive house purchased by our Penn Association, and consecrated to future renown. I hope, indeed, the idea will yet generate in the breasts of some of my fellow members the real poetry of the subject."[21]

In this quotation, Watson used the word "fanciful" to describe his state of mind in relationship to his desire to "consecrate" the Penn House, a word that captured something of the zeitgeist of the 1820s.[22] Watson also referred to the Letitia House as "primitive" and hoped his idea would generate in the "breasts" of his fellow Penn Society members a "poetic" effect. For Watson, relic making was a tug at the heartstrings and evoked a spiritual response. Relics aroused emotion and their pursuit was an artistic/poetic endeavor that stirred the soul and sensibilities. This spiritually transformative power of relics was also captured in words like "fancy" and "olden" for Watson.[23]

Despite his imploring, Watson did not succeed in persuading the Penn Society members to purchase the Letitia Court House for a museum. It was, however, the subject of one of Philadelphia's first acts of historic preservation. The Letitia Court House was moved to West Fairmount Park in 1883, to save it and confer on it special status as a component of the historic buildings in Philadelphia's Fairmount Park.[24]

Another Haines relic associated with Lafayette's visit to Germantown is the "Franklin Chair" (fig. 11.6). One of four known to survive, the circa 1760, London-made, French-style rococo chair was purchased by Benjamin Franklin in London for use in his rented rooms in the home of the widow Margaret Stevenson at 36 Craven Street, London.[25] Reuben Haines owned the chair by February 27, 1822, when he recorded an expenditure "covering Benjamin Franklin's chair $10" in his account book.[26] Presumably, Haines collected the chair as a relic of Benjamin Franklin. The Wyck research file asserts that Mary Ann "Molly" Donaldson, a governess for the Haines family, played a role in the acquisition of the chair.[27] According to family tradition, this chair was specially reserved for Lafayette when he received the townspeople of Germantown on the hot and steamy afternoon of July 20, 1825, as they paraded past him through the open "Hall," today known as the "Conservatory" at Wyck. That the chair had belonged to a founding father, Franklin, in combination with its French style, rendered it an appropriate seat for the aging and lame Lafayette. In the same way that Watson labeled his relics with a descriptor so that significance would be recorded and remembered in the future, the Haines family affixed a handwritten label inside the rear seat rail that reads, "Franklin Chair used by General Lafayette at his reception at Wyck July 20, 1825." Presumably, Watson would have been in attendance

FIG. 11.6 The Franklin Chair, ca. 1760. Mahogany and beech, 35 × 26 × 26 in. Reuben Haines collected this chair as a Benjamin Franklin relic. A handwritten paper label affixed to the inside of the rear seat rail reads, "Franklin Chair used by General Lafayette at his reception at Wyck July 20, 1825." This photograph documenting the chair's early twentieth-century leather-upholstered appearance is opposite p. 43 in Charles Francis Jenkins, *Lafayette's Visit to Germantown* (1911). Courtesy of The Wyck Association, gift of W. Lawrence Kimber.

during the Lafayette reception at Wyck, although that has not, to my knowledge, been confirmed by surviving accounts of the day. According to the Haines descendant, who returned the Franklin chair to Wyck in 2007, his mother had so valued the chair as a relic that she kept a ribbon across the arms. No one had permission to sit in the chair for many years while in her possession, which explains its excellent condition relative to the other three known survivors. An artifact that physically embodied such august figures as Franklin and Lafayette epitomized the Watsonian passion for objects and their resonant meaning and transformative historical power.

Watson also highlighted the Haines family in the *Annals of Philadelphia* for their work in silk manufacture. Watson devoted about a page and a half in the published version of the *Annals* to a discussion titled "Culture of Silk." He began by quoting James Logan, the colonial provincial secretary and grandfather of Deborah Logan's husband. Watson noted that in 1725 James Logan described "'the culture of silk in this country as extremely beneficial and promising.' . . . He is glad it proves so good, and he doubts not, in time, the country may raise large quantities." In 1770, the American Philosophical Society promoted silk culture widely in the Greater Philadelphia region, where a public filature for the production of thread from silkworm cocoons opened in

FIG. 11.7 Relic textile fragments glued in Watson's manuscript annals, p. 165, ca. 1825. Silks and inks on paper, approximately 19 × 12 in. Quaker Susanna Wright (1697–1784) raised the silkworms that provided the fibers for this yellow silk in Columbia, Pennsylvania, along the Susquehanna River. At the right, above Watson's notes, are Deborah Logan's detailed handwritten annotations describing the magnitude of Susanna Wright's silk raising and processing. The Library Company of Philadelphia.

June 1770. Watson reported that in 1771, nearly twenty-three hundred pounds of silk fibers were brought to the filature for processing. One would not know from the published *Annals* that the information about Susanna Wright of Columbia, Pennsylvania, and her production of a "60-yard mantua produced from her own cocoons," was the contribution of Deborah Logan. But Watson's manuscript version reveals that the details about Susanna Wright's silk production are written in Deborah Logan's script and quite literally represent her additions to the text (fig. 11.7).[28]

On the same page of the manuscript annals where the specimen of Susanna Wright's buff-colored silk is found, there is a sample of the grayish blue-green silk made by Reuben Haines's daughter, "Miss C. Haines, of Germantown at the same time [ca. 1770]": "The daughters of Reuben Haines [1727–1793], in Germantown, raised considerable [silk], and his daughter Catharine, who married Richard Hartshorne, wore her wedding dress of the same material—preserved on page 230 of the MS Annals." A silk dress of circa 1810, believed to have been made for Hannah Marshall Haines (1765–1828), Reuben III's mother, and of the same blue cloth as that preserved in Watson's annals, is said to have been produced by the Misses Haines (Catharine and Martha). The dress survives in the collection at Wyck along with the family belief that it was made from silk produced on the property.[29] The silk in the manuscript annals was "sent to Watson by J[ames] P[emberton] Parke, to whom it was given by Dr. Parrish, the brother of Susanna Wright."[30] James Pemberton Parke was a publisher, bookseller, and stationer in Philadelphia and one of Reuben Haines III's closest friends from childhood.

For Watson and early Americans, silk thread, the product of the silkworm, was a luxurious and exotic fiber, originally imported from Asia. Although a costly luxury commodity, woven silk cloth was imported to the colonies throughout the eighteenth century, usually from or through London. Access to silk increased after the American Revolution, when direct trade with China began. The ability to import silk directly from the source, and even more so to produce it at home, signaled wealth, ingenuity, economic viability, and a certain independence and status in the world.[31] Reuben Haines III of Wyck, Watson's contemporary, moved his family to Wyck full-time in 1820. He gave up the family's large rented town house in Philadelphia in order to consolidate his living expenses, creating a sense of greater economic independence. He was also interested in fashioning his own utopian experiment, focusing his energies on agriculture, collecting, improving the world, and seeking the company of good and like-minded friends. In his quest to explore the utopian experiments of others, Reuben visited Shaker villages, and he added Shaker boxes to his collections almost as anthropological artifacts. He also supported the ventures at New Harmony in Indiana, where the Rappites manufactured great quantities of silk, samples of which are preserved in John Fanning Watson's relic box. These samples are identical to some Harmonist silks in the collection at the Winterthur Museum.[32] The American-made silk represented a cultural achievement deemed worthy of celebration.

Watson traveled quite widely in the United States and kept copious travel journals, which survive at the Historical Society of Pennsylvania and in the Joseph Downs Collection at the Winterthur Library. Watson's personal motto was "To Note and to Observe." His daughter, Mrs. Lavinia F. Whitman, related that "the Wissahickon was his favorite resort; here he would engage in sketching and angling. . . . In all our rambles, his mind seemed to be always inquiring,—never at rest; and I remember now that I often grew weary with having this and that spot pointed out, and its history told; it appeared to me then of so little consequence."[33]

Watson was particularly fascinated with William Penn and visited the site of his ruined Pennsbury Manor, Penn's late seventeenth-century gentleman's plantation house north of Philadelphia on the Delaware River, on an excursion with Reuben Haines. When the two men encountered Pennsbury on July 8, 1826, little remained of the old mansion. Watson's interest in the place was not dampened and he proceeded to record its dimensions, 60 × 40 feet, and noted the "ancient cherry trees." He wrote that seeing "so few remains of its former importance and character" conjured up "melancholy feelings." Watson sketched the place and interviewed the resident of the old brew house, Robert Crozier, who according to Watson had come to live at Pennsbury "sometime after the Peace of 1783."[34]

The link between Penn and the Logan family was palpable to Watson, and he and Deborah Norris Logan certainly spent many pleasant and enjoyable Saturdays

together over tea, beginning in May 1823. Deborah wrote in her diary of their time together, "When two people are drawn together by anything similar in their tastes and pursuits it makes them good company to each other." Watson, whom Deborah eventually came to call her "Antiquary Friend," presented Deborah with a book he found in his own research, written by Francis Daniel Pastorius and addressed to her grandmother Mary Norris.[35] The book was his thank-you to Deborah for the gift of a relic chair, which he had persuaded her to give to him for his own collection.

Deborah unearthed the "Old Cane Chair," with a broken seat and a lost arm, from the Stenton garret. Watson must have been a charming talker and smooth extractor of both information and artifacts, because Deborah lamented that she would need to have the "sad, mutilated" chair repaired before she gave it to Watson, "lest his wife throw out 'such a piece of Old Trumpery'" (fig. 11.8).[36] After being repaired by "Billy Reger" and turned over to Watson, this chair, which had been owned by William Penn prior to belonging to James Logan, served as the "President's Chair" at the first gathering of the Penn Society in 1824.[37]

Another special relic Watson owned was William Penn's desk and bookcase. Watson recorded the list of William Penn furniture he knew in his *Annals of Philadelphia*. "His clock and his writing desk and secretary I have seen."[38] Watson saw the desk in the shop of Nathaniel Coleman, a Burlington County silversmith, who used it as a tool chest. Watson persuaded Coleman to give him one of the pendant-drop brass drawer pulls and stamped escutcheon plates for his relic collection (fig. 11.9). Watson's handwritten tag, which accompanies the pull in Watson's own relic box, now in the collection at Winterthur Museum, explained the provenance of the desk and bookcase through this bit of hardware, which was transferred from William Penn, to Peter Worell, to George Dillwyn ("said to have purchased the desk at a sale at Pennsbury"), to Nathaniel Coleman, to himself. By tagging the hardware, Watson preserved its journey from owner to owner over time.[39] One original turned elm bun foot that originally screwed into the desk survives in the Germantown Historical Society Collection (fig. 11.10). Today, the desk has small tapered turned feet. Logan descendant John Jay Smith (1798–1881), whom Watson called his "disciple," furthering his use of religious language applied to history and relic making, donated the desk, with its replaced components, to the Library Company of Philadelphia in 1873. In 1827, Smith wrote to Watson, "The feet of the said bookcase (which is E[nglish] oak inlaid with mahogany) are now detached—have a monstrous screw to attach them to the bottom—are also of Eng oak & the size & shape of a quart jug—I hooked them & brought them along—if you'll promise to use them as mantle ornaments! I'll give you one pair."[40]

Along with the large-scale furniture relics, Watson's own Treaty Tree relic wood box, designed like a sewing box, was his storage container for smaller labeled relics (fig. 11.11).[41] His manuscript annals are full of images, including prints and sketches by him and others, and numerous textile fragments and currency presented as relics.

FIG. 11.8　Penn-Logan-Watson Armchair, ca. 1690–1720. Walnut and cane, 48 ½ × 25 ¼ × 19 ¾ in. John Fanning Watson learned of this broken William Penn relic chair in the attic at Stenton. Deborah Norris Logan repaired the chair before giving it to Watson, who allowed its use as "The President's Chair" at the first gathering of the Society for the Commemoration of the Landing of William Penn. An engraved brass label inset in the center of the crest rail reads, "'Fruitful of Recollections Sit and Muse' This seat of Wm Penn and Jas Logan a gift to JF Watson by Debh Logan 1824." Courtesy of Independence National Historical Park, donated to Independence Hall by John Howell Watson in 1874.

304

Braſs handle.

FIG. 11.9 Sketch of William Penn desk and pendant-drop hardware, manuscript annals, Historical Society of Pennsylvania, p. 105, 1829. Ink on paper, approximately 19 × 12 in. John Fanning Watson Collection on the Cultural, Social, and Economic Development of Pennsylvania [0697], Historical Society of Pennsylvania. Another important Penn relic for Watson, he first encountered this desk and bookcase when used by silversmith Nathaniel Coleman for tool storage. Watson sketched the desk and "harvested" one of its brass drawer pulls, also sketched here, which he kept in his personal relic box, now in the Winterthur Museum.

Whereas the annals are a combination scrapbook and commonplace book full of his reminiscences and those of people he met and interviewed, the relic box was for small three-dimensional relics: buttons, fused glass beads, arrowheads, leather fragments related to George Washington, more textile fragments, bits of wood, sand of the Sahara, William Penn's desk drawer pull, Queen Elizabeth's sweetmeat bag and knitting sheath (brought to Philadelphia by the Norris family), a gem-encrusted buckle, calling cards, an unreadable silver-plated photograph, Indian hemp, coffin fragments, and so on. These three-dimensional relics are tagged or labeled so that their history and association can be preserved with them.

These collections of relics are in many cases further explicated in the text of the annals, or fragments in the annals may complement them. One such example is a gem-studded buckle in the box. Its handwritten tag reads: "Buckle of Miss Mary Donaldson as she danced at the Ball of Treaty of Peace." In the manuscript annals is a dress fragment of natural silk woven with silvered metallic threads, composed with stripes of at least two widths with flowers between. The text in Watson's hand that

FIG. 11.10 William Penn desk foot, ca. 1720. Turned elm, 8 in. h × 4 ½ in. d. Courtesy of the Germantown Historical Society at Historic Germantown. The foot matches the shapes created by oxidation and fits into the threaded holes on the bottom of the William Penn desk at the Library Company of Philadelphia. John Jay Smith harvested the feet from the desk in 1827, offering a pair to John Fanning Watson if he promised to use them as mantel ornaments. The later nineteenth-century ownership history of this foot is lost.

accompanies the dress fragment reads, "The above exhibit—Ladies dress of Philada, worn soon after the Peace sang[?] about the year 1785—The material of the gown & Petticoat cost 16 shillings. The latter then worn over a hoop measured 5 yards in circumference—It was ornamented with silk tissue on which were <u>penciled</u> in various colours, representing festooned flowers of much beauty—the same young lady wore brocade-sattin high heal'd shoes & large chrystal-set buckles."[42]

Although Watson does not state that the lady who wore this dress was Mary Donaldson, the coincidence of the description of the "chrystal-set buckles" she wore and the buckle worn by Mary Donaldson that survives in Watson's relic box strongly suggests that we can put together a picture of Mary Donaldson's peace ball attire through Watson's description, the buckle, and the dress fragment.[43] The survival of these relics allows us to conjure up an image of Mary Donaldson and allows us to experience the distant eighteenth-century past through Watson's 1820s lens.

A discussion of relics would not be complete without mention of the Treaty Tree. Inside Watson's box, made of veneered elm, purportedly from the tree that stood at Shackamaxon, where William Penn may have treated with the local Lenape Indians in the late seventeenth century, is an idealized watercolor of this view. It is the same view included in the manuscript annals.[44] The Treaty Tree, which blew over in a storm in 1810, embodied the beautiful, the ideal, and the good in Pennsylvania. Pennsylvanians

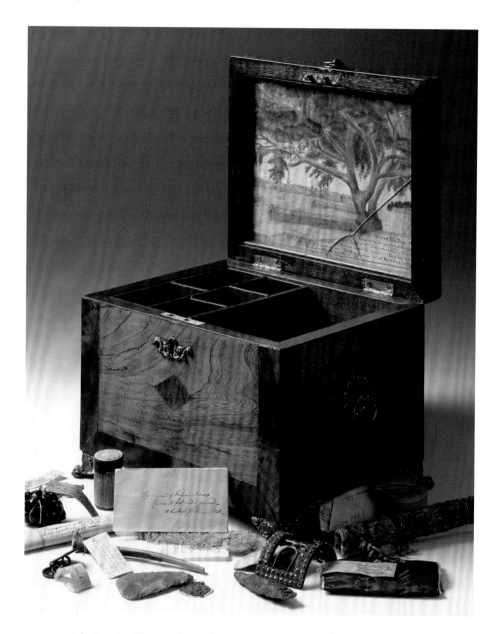

FIG. 11.11 John Fanning Watson reliquary box, 1810–23, including eighteenth-century and older artifacts. Veneered elm, walnut, mahogany, brass, ink, watercolor, paper, 7.7 × 10.75 × 8.5 in. Courtesy Winterthur Museum, Museum purchase, 1958.102.1. The box is probably an adapted sewing box. A similar watercolor of the Treaty Tree at Kensington appears on p. 241 of Watson's manuscript annals at the Library Company of Philadelphia.

FIG. 11.12 Treaty Tree relic box, ca. 1818. Turned elm, ¾ in. h × 2 in. d. This small box, which belonged to Deborah Norris Logan, is nearly identical to one that Roberts Vaux gave to the American Philosophical Society in 1818. "Unbroken faith" became the antiquarian's shorthand for Voltaire's phrase "made without an oath and never broken," in reference to the legend and cult of the Treaty Tree. Courtesy of The National Society of The Colonial Dames of America in the Commonwealth of Pennsylvania at Stenton, Philadelphia, gift of Coryndon Luxmoore.

believed (and many still do) that their colony was unique because William Penn's policies ensured freedom of worship and that native peoples' land would be purchased in a system of treaties. Penn strove for fair treatment of the tribes. So the Treaty Tree came to be imbued with a mythological and mystical ideal of freedom, opportunity, toleration, and, in the words of Voltaire, unbroken faith.[45] The Treaty Tree became an important symbol for the Penn Society, whose members used its woods in the small relic boxes already discussed.

Another small Treaty Tree box in the collection at Stenton contains a bead of wampum alleged to be from the wampum belt that William Penn may have received from the Indians at the purported signing of the Shackamaxon Treaty (fig. 11.12).[46] The inscription on the paper label applied to the bottom of the box suggests that Deborah Logan already owned the Treaty Tree box and that the bead was a later gift. The paper label that covers the bottom of the box is inscribed: "The Bead in this box was sent S[arah] M[iller] Walker from the Belt in the Archives at Harrisburg. On presenting it to Dear Aunt Logan, she expressed her pleasure by saying she valued it more highly than gold and would place it in the Treaty Tree Box."[47] Although the author whose handwriting is on the Stenton box is not certain, it may be that of John Jay Smith or perhaps Sidney George Fisher (1809–1871). Smith was James Logan's great-grandson and served as the librarian of the Philadelphia and Loganian libraries from 1829 to 1851. His own *Recollections* were published posthumously. Smith would coauthor the *American Historical and Literary Curiosities* with John Fanning Watson. He would have called Deborah Logan "Aunt Logan," and it is logical that, given her own antiquarian interests, Deborah would have valued the wampum bead "more highly than gold."[48]

On his deathbed, as described by his daughter, John Fanning Watson lay surrounded by his relics. By his bedside was the old secretary desk that had belonged to William Penn, a Penn chair also sat in by Prince William and Lafayette, an old Penn family clock case, and a tray with seven canes of relic wood. "The walls were hung round with pictures of ancient houses, scenes &c., all framed from some portion of the woods represented; and from two of the windows were suspended cannon balls,—placed there but a few days previously;—one was from the battle of Germantown, presented by Benjamin Chew, Sen., Esq. The other reads, 'This Ball is a curiosity.—It is older than Philadelphia;—was found imbedded in the root of a large tree-stump, in a house of Budd's long row.' JF Watson 1836."[49]

The pictures are probably those listed in the published *Annals of Philadelphia* in the section "Relics and Remembrances," and they depict Columbus's landing, Penn's landing at Philadelphia, the Declaration of Independence, Letitia House, the Old Court House, the Treaty Tree, Washington's house, the slate-roof house, the drawbridge and Dock Creek, the frigate *Alliance*, the house of Sven Sener, the landing of Penn at Chester, the Dutch city of New York, Benezet's house and bridge, and the Indians at Harrisburg.[50]

From this deathbed description, we might assume that Watson's last living memory was of the historical associations he helped create. His relics represented his community of fellow history lovers as well as the historical figures and the past he revered. The relics embodied the relationships and connections, past and present, that he so enjoyed. Excavating the bits of artifacts and studying Watson's writings to re-create their Watsonian context reconnects some of the threads of the relationships represented in his collections. Watson's relics moved him and clearly satisfied his soul's longings to commune with men and women of "olden" times. His collecting was an imperfect art form in itself that involved the creation of something new, a new "olden" artifact or a new story, out of the old, preserving the old in its "olden" form for future generations, who would tread in his tracks while drawing their own conclusions about the past that he examined and collected.

Watson's collecting and creating relics, assembling them, labeling them, writing about them, and sharing them with other historically-minded souls, started a process of defining history and preserving the American past that continues today. The religious reverence he applied to his process set the stage (for better and for worse) for later historians and preservationists. The Watson model of keeping the past sacred, special, removed, and reserved just for those who appreciate it has served our culture well in making us aware of the need to know and save our past. However, the preciousness and exclusivity of this approach has brought the preservation movement to a crossroad.[51]

Does present-day America's disenchantment with history and historic places suggest that we have undergone a fundamental cultural shift in the last 150 years?

Whereas America was a fundamentally Christian culture that welcomed the spiritual notion of communing with the past through relics in the early nineteenth century, twenty-first-century America is a fundamentally secular society, one in which objects of our fancy can appear in two dimensions, often instantaneously, on the digital screen. If we treat our artifacts as so precious that the public is not given permission to commune with them in a participatory way that can generate meaning, visitors to historic places will not relate to and perhaps will never develop the visceral connection to the real artifacts or experience their power to transform us and take us out of ourselves. We will miss the familiarity, connection, and understanding that Watson, Haines, and Logan enjoyed.

In the "Advertizment" at the front of the Historical Society of Pennsylvania's copy of Watson's manuscript annals, Watson describes his work and intention, which is to revive and transmit knowledge of "bygone" days, or the "olden time." The annals, with their assemblage of artifacts, illustrations, and stories, are Watson's preservation achievement. "It is an effort to rescue from the ebbing tides of oblivion, all these fugitive memorials of unpublished facts & observations," Watson wrote, "—or reminiscences and traditions,—which would best illustrate the domestic history of our former days. . . . It has however power to please apart from its style & composition because it is in effect a *Museum*, of whatever is rare, surprising or agreeable." Watson was fundamentally a collector, whose lens and point of view offer delight in the past he preserved and celebrated.

NOTES

1. Slightly elevated on the Piedmont, six miles from the original settlement of Philadelphia, sits Germantown, founded as an independent borough by German Quakers and Mennonites in 1683 along a Native American trail, then known as the Great Road. Since the incorporation of the City of Philadelphia in 1854, Germantown has been a neighborhood in Northwest Philadelphia, which developed as a compact semi-urban suburb in the second half of the nineteenth century.

2. Doris Devine Fanelli and Karie Diethorn, *History of the Portrait Collection, Independence National Historical Park* (Philadelphia: American Philosophical Society, 2001), 23–24. The full list of the founding subscribers of the Historical Society of Pennsylvania (HSP) can be found in Watson's manuscript annals at the HSP, 2:447. They include Peter S. Du Ponceau, Z. Collins, Roberts Vaux, John Read, Jos[eph] P[arker] Norris (Deborah Logan's brother), Nichol Collin, Joseph Watson, John Bacon, Richard Peters, W. Meredith, Thomas

Biddle, B. R. Morgan, Geo Vaux, T. Poulson, T. I. Wharton, John F. Watson, Joseph S. Lewis, Robert Wharton, Benjamin H. Coates, Stephen Duncan, William Rawle Jr., Caspar Wistar, and George Washington Smith. Reuben Haines's name is notably absent from the list. The HSP grew rapidly in its founding year. By December 27, 1824, meeting records show that the HSP's membership had expanded to include Joseph Hopkinson, Joseph Reed, Thomas C. James, Thomas H. White, Gerard Ralston, William Mason Walmsley, William H. Meredith, Daniel B. Smith, Charles Jared Ingersoll, Edward Bettle, and Thomas McKean. The leaders of the Penn Society included Peter S. Du Ponceau (secretary in 1826), Richard Peters (president in 1826), Charles Jared Ingersoll, and Thomas I. Wharton. Through membership in these organizations, Vaux and Haines cultivated like-minded associates. Vaux and Haines were also founders of the Eastern State Penitentiary in Philadelphia. The founders and members of many of Philadelphia's

intellectual and reforming societies overlapped to a great extent, reinforcing social networks based on shared interests.

3. For a thorough biographical sketch of Watson, see Deborah Dependahl Waters, "Philadelphia's Boswell: John Fanning Watson," *Pennsylvania Magazine of History and Biography* 98, no. 1 (1974): 3–52. See also Frank Sommer, "John F. Watson: First Historian of American Decorative Arts," *Magazine Antiques*, March 1963, 300–303.

4. James Logan (1674–1751), William Penn's secretary, built Stenton on 511 acres of land just south of Germantown. The HSP posthumously published Deborah Logan's transcribed and annotated Penn-Logan correspondence in two volumes in 1870–72. Gary Nash notes that Deborah Logan "made massive deletions of material she thought might cast a shadow" on James Logan and calls her the "unofficial censor of the Annals of Philadelphia." Gary Nash, *First City: Philadelphia and the Forging of Historical Memory* (Philadelphia: University of Pennsylvania Press, 2002), 209. For Deborah Logan's recollection of hearing the reading of the Declaration in July 1776, see diary of Deborah Norris Logan, July 9, 1826, MS 380, 10:8–9, HSP (hereafter diary of Deborah Norris Logan). Writing fifty years later, Logan incorrectly remembered Charles Thomson as the Declaration's orator; Colonel John Nixon had in fact read the document that day. But her outstanding memory explained "I distinctly heard the words of that instrument read to the people, (I believe from the State House steps, for I did not see the reader, a low building on 5th street which prevented my sight). Deborah Logan's diary includes eighteen volumes, written between 1811 and 1839. The earliest volume is at the Library Company of Philadelphia.

5. James Logan's grandson Dr. George Logan (1753–1821) married Deborah Norris, whom John Fanning Watson visited at Stenton on numerous occasions in the 1820s, beginning in 1823.

6. C[harles] J[ared] Ingersoll, *A Discourse Delivered Before the Society for the Commemoration of the Landing of William Penn on the 24th of October, 1825* (Philadelphia: R. H. Small, 1825), 36.

7. Manuscript versions of Watson's *Annals of Philadelphia* survive in the collections of both the Library Company of Philadelphia (LCP) (1823) and the HSP (1829). The LCP manuscript, now unbound, functions as both commonplace book and scrapbook full of recorded stories and anecdotes, along with fabric scraps, sketches of buildings, silhouettes, engravings, maps, currency, etc. It has the sense of a rough draft from which the published work originated. The HSP manuscript

includes many of Watson's own sketches, descriptions, collected newspaper clippings, and other let-in historical documents, largely correspondence, with few annotations by anyone but Watson himself. Still bound, the book functions like an archive, with many original eighteenth-century documents added into the volume. It seems to be a kind of wrapping up of his early Philadelphia history project, a compilation of many of his primary sources, so that they could be housed in their proper home at the HSP. E. L. Carey and A. Hart published the first printed edition as a single volume in 1830, titled *Annals of Philadelphia and Pennsylvania in the Olden Time; Being a Collection of Memoirs, Anecdotes, and Incidents of the City and Its Inhabitants [. . .]*. A second edition in two volumes followed in 1844, which was reprinted through 1870. The three-volume third edition of 1877 included additions by Willis Hazard and was reprinted several times until 1927. Perhaps Watson was inspired by Francis Daniel Pastorius's "Beehive" manuscript, for he transcribed some documents related to Pastorius, the founder of Germantown, now at the Germantown Historical Society, and made reference in the HSP's copy of the annals to Pastorius's monumental commonplace book, known as the "Beehive," on p. 172. See also Pastorius's "Young Country Clerk's Collection" covering the period 1692 to 1719, in the Annenberg Rare Book and Manuscript Collection at the University of Pennsylvania, which is retitled on the flyleaf in Watson's hand, "Forms & precedents of conveyancing & magistracy, and of letters on business and courtesy; as used by Francis D. Pastorius, the founder of Germantown [. . .] seen and examined by John F. Watson year 1860." This would have been just months before Watson's death at age eighty.

8. Deborah Logan's Family Records Book is in the Algernon Sydney Logan and Robert Restalrig Logan Papers, Pennsylvania State Archives, Harrisburg, MG-247.

9. The Germantown Historical Society snuffbox is in poorer condition than the Logan and Haines boxes are. The inscribed paper on the bottom is abraded and less readable but is clearly in Watson's hand. This box does not seem to be a gift for someone else but has Watson's name at the bottom of the inscription, suggesting that it was his own. The poor condition and chipping of the inlaid woods in the top make it very clear that the samples in the tops of these boxes were thin veneers of the relic woods. In his early twentieth-century addresses about Lafayette's visit to Germantown, Charles F. Jenkins mentioned two such relic boxes, noting, "Apparently, Watson had two boxes made

exactly alike, retaining one for himself; and this through the process of time has descended to our Site and Relic Society of Germantown, and is now part of the museum of relics." Charles Francis Jenkins, *Lafayette's Visit to Germantown, July 20, 1825* (Philadelphia: William J. Campbell, 1911), 35.

10. Watson reported to Reuben Haines that Richard Penn "burst into a flood of tears —: regarding trees that were the last living vestiges of his Great Proprietor's Day!" (The exclamation point was typical of Watson.) Watson to Haines, July 1825, Wyck Collection, 89.1246 (stored with paper-based original objects at Wyck).

11. Watson called the small round three-inch-diameter boxes "Snuff boxes." Ibid. At least one relic box was used as a snuffbox. On the occasion of Charles J. Ingersoll's address to the Penn Society in 1825, President John Quincy Adams was present and "received a complimentary relic box—which he proceeded to use as a snuff box, much to the dismay of the assembly." See Fanelli and Diethorn, *History of the Portrait Collection,* 24. The Bank of Germantown was located at 5275–77 Germantown Avenue and occupied this property from 1825 to 1869. For much of this time, the bank was the home of John Fanning Watson, until about 1850. In 1849, William and Lydia Alburger sold undeveloped land to Phebe B. Watson, John's wife, on which the Watsons built a modest three-bay cottage. This house, recently documented by University of Pennsylvania Department of Historic Preservation graduate student Violette Levy, still stands at 122 East Price Street in Germantown. See Philadelphia Deed Book G.W.C, no. 8, p. 205, Philadelphia City Archives. See also Harry M. Tinkcom and Margaret B. Tinkcom, *Historic Germantown: From the Founding to the Early Part of the Nineteenth Century* (Philadelphia: American Philosophical Society, 1955), 59.

12. Watson to Haines, July 1825, Wyck Collection, 89.1246 (stored with paper-based original objects at Wyck). Allegedly planted by Shakespeare at his Stratford home, the wood from a mulberry tree was made into saleable Shakespeare relics beginning in 1756. http://www.folger.edu /html/exhibitions/fakes_forgeries/FFFmulberry .asp, accessed September 27, 2009.

13. Quoted in Jenkins, *Lafayette's Visit to Germantown,* 36–37. The wording of Watson's letter to Deborah Norris Logan of July 20, 1825, which accompanied the relic wood box he presented to her, echoed that of Jenkins. Watson's letter is housed in the Stenton archives.

14. Benjamin Dorr, *A Memoir of John Fanning Watson: The Annalist of Philadelphia and New York, Prepared by Request of the Historical Society of Pennsylvania, and Read at Their Hall* (Philadelphia: Collins, 1861), 24. Deborah Logan recorded in her diary, "He [Watson] came about 4 oclock in the afternoon. . . . And he staid, indulging in Antiquarian lore, till near 10 . . . and for our part, we heard and communicated things innumerable: and I believe the time of our Guest was spent quite to his mind." Diary of Deborah Norris Logan, 6:57–58, quoted in Barbara Jones, "Deborah Logan" (master's thesis, University of Delaware, 1964), 119. On November 30, 2009, during a meeting in the UK with Logan descendants on behalf of the National Society of the Colonial Dames of America in the Commonwealth of Pennsylvania, I was entrusted with Deborah Logan's relic box and Watson's original letter to Deborah that accompanied it, for transport to Stenton; both the letter and box are now housed at Stenton. The box is nearly identical in appearance to the Reuben Haines box, and the letter is similar in tone. Instead of having a straight side, the Logan box profile flares out at the lid.

15. Diary of Deborah Norris Logan, 1825, 8:71–72. The preceding pages include a let-in newspaper clipping detailing the "Extreme Warm Weather" experienced in the region at this time. The primary wood of Deborah's relic box is walnut, with the inlaid veneers on the lid listed on the inscribed paper set inside the bottom rim as [sweet] gum, elm, oak, and mahogany. I thank Joel Fry, curator of Bartram's Garden, for the insertion of "sweet" to accurately describe the gum used in the veneers. Fry explains, "There are two different local trees called gum, so they are always distinguished by sweet gum and sour gum. They are not related in any botanic way, and plain 'gum' more usually is used to refer to the sour gum or tupelo." Email to author, July 20, 2017.

16. Note in the Wyck relic box file from Lois Amorette Dietz (a.k.a. Lois D. Stoehr), author of "John Fanning Watson: Looking Ahead with a Backwards Glance" (master's thesis, University of Delaware, 2004). This list was compiled from the Watson correspondence in the HSP. While Watson may have commissioned these relic boxes from others, it is possible that he turned and inlaid them himself. In Benjamin Dorr's published memoir, Watson's friend John S. Littell wrote, "His habits were of the Franklin order—temperate in all things." Watson "was fond of gardening and agricultural pursuits. . . . [He had] quite a mechanical turn and displayed his taste and ingenuity in constructing rustic seats, flower trays, &c.—Understanding the true art of beautifying without much cost." Dorr, *Memoir of John Fanning Watson,* 22–23.

17. John Bacon (1779–1859) was related to Reuben Haines by marriage. John, who was treasurer of Philadelphia 1816–29, was the father of William Henry Bacon, who married Hannah Haines of Wyck. William Henry owned a paneled-back "Cromwellian," or seventeenth-century-style, chair, which is stenciled under the seat, "The Wm Penn Chair—The property of Wm H. Bacon," now in the Wyck Collection. At the Germantown Historical Society is a Treaty Tree box, a plain but large rectangular box, that was given to Francis Bacon in 1844 by his parents, Mary Ann and John Bacon, who were then both sixty-five years old and celebrating more than fifty years of marriage. The inscribed paper inside the lid refers to "This great 'Treaty Tree,' the time honored Emblem of Unbroken Faith."

18. Roger W. Moss, *Historic Houses of Philadelphia* (Philadelphia: University of Pennsylvania Press, 1998), 225n21.

19. Michael Kammen, *Mystic Chords of Memory: The Transformation of Tradition in American Culture* (New York: Knopf, 1991), 53, 72.

20. See the copy of Watson's manuscript annals at the LCP, let-in watercolor titled "Laetitia Court 1825 The Penn House," before p. 239.

21. John Fanning Watson, "Penn's Cottage in Laetitia Court," in *Annals of Philadelphia and Pennsylvania [. . .]*, 2 vols. (Philadelphia, 1870), 1:158–62.

22. Yvette Piggush describes the desire to commune with relics as a component of the fancy culture of the early nineteenth century. "Fancy" was a word used to describe grained and decoratively painted furniture and objects, and according to Sumpter Priddy, the term referred to a "cultural phenomenon" and a state of mind in the vernacular culture of the 1790–1840 period, characterized by fantasy, the fanciful, and the imaginative. Its intent was to delight the senses and transport the viewer through an absorbing emotional response, not unlike the sentimental temporally transportive response Watson describes in communing with relics. See Piggush, "Fancy History: John Fanning Watson's Relic Box," *Common-Place* 10, no. 1 (2009), http://www.common-place-archives.org/vol-10/no-01/lessons/; Sumpter Priddy, *American Fancy: Exuberance in the Arts, 1790–1840* (Milwaukee: Chipstone Foundation, 2004), xxi–xxxiv. "Olden" simply means "of a bygone era," according to Merriam-Webster's, but the Oxford English Dictionary suggests that the term can also connote mythmaking, storytelling, legends, and fanciful imagination. In British early Victorian culture, "olden" tended to evoke a nostalgic and idealized

way of thinking about the past as domestic, vernacular, and Shakespearian. Shakespeare used the word in the early seventeenth century in *Macbeth*, act 3, scene 4, line 74. See Peter Mandler, "'In the Olden Time': Romantic History and English National Identity, 1820–50," in *A Union of Multiple Identities: The British Isles, c. 1750–c. 1850*, edited by L. Brockliss and D. Eastwood (Manchester: Manchester University Press, 1997), 78–92. Perhaps this Victorian idealization of Shakespeare is part of why Watson quoted "the Bard of Avon" in his letters accompanying the Haines and Logan relic boxes.

23. For the British, "olden" conjured up the quaintness of late medieval and Elizabethan times and related to interest in Gothic and Renaissance revival styles in architecture and the decorative arts in the 1820s–60s. See Mandler, "'In the Olden Time.'" Watson applied the term "olden" to anything related to the founding of early Pennsylvania very broadly, so that his heroes ranged from William Penn to George Washington.

24. Moss, *Historic Houses of Philadelphia*, 12, 225.

25. The other armchairs are owned by Independence National Historical Park and the Franklin Institute. The third was privately owned by a descendant of Mary "Polly" Stevenson Hewson, Margaret Stevenson's daughter, who had a special relationship with Franklin and ultimately emigrated to Philadelphia. Delaware furniture dealer James Kilvington sold the Stevenson chair to a California collector in 2016. See Page Talbott, "Benjamin Franklin at Home," in *Benjamin Franklin: In Search of a Better World*, edited by Page Talbott, exh. cat. (New Haven: Yale University Press, 2005), 152–54; and the Franklin tercentenary website, www.benfranklin300.org.

26. Account book of Reuben Haines—WP 126/21, 2/27/1822, Wyck Papers, on deposit at the American Philosophical Society, Philadelphia.

27. See the Franklin Chair Object File, 2007.1, at Wyck.

28. See Watson, *Annals of Philadelphia and Pennsylvania [. . .]*, 2 vols. (Philadelphia: Elijah Thomas, 1857), 2:436–37. Susanna Wright (1697–1784) had been a close correspondent of James Logan in her youth, sharing books and discussing philosophical topics in letters. She also corresponded with Deborah Logan and their shared coterie of women poets and writers in her older age.

29. According to Sandra Mackenzie (Lloyd), "In terms of style and details of manufacture, this dress is inconsistent for the time period and even American manufacture." Mackenzie, "What a Beauty There Is in Harmony: The Reuben Haines Family of Wyck" (master's thesis, University of

Delaware, 1979), 105. See John M. Groff, "'All That Makes a Man's Mind More Active': Jane and Reuben Haines at Wyck, 1812–1831," in *Quaker Aesthetics: Reflections on a Quaker Ethic in American Design and Consumption*, edited by Emma Jones Lapsansky and Anne A. Verplanck (Philadelphia: University of Pennsylvania Press, 2003), 325n56. Another relic box, made of oak and lined with bright blue paper, is purportedly constructed of wood from the oak under which George Fox preached to the Quakers at Flushing in 1672. Engraved in the plaque on the lid are the initials *JBH*, for Jane Bowne Haines (1790–1843). Jane Bowne grew up in Manhattan and Flushing, Long Island, in a family house very close to the location of the George Fox tree. Thus this box would have held both Quaker and geographical significance for Jane Haines.

30. Dietz, "John Fanning Watson," 55n23. See also J. P. Parke to John F. Watson, June 16, 1824, in "Letters and Communications Addressed to John F. Watson in the Subject of His Annals of Philadelphia, and Respecting the Primitive Manners and Customs, and the Early Historical Incidents of Philadelphia and the Adjacent Country," Col. 697, Am 30163, folder 31, John F. Watson Papers, HSP.

31. Zara Anishanslin, *Portrait of a Woman in Silk: Hidden Histories of the British Atlantic World* (New Haven: Yale University Pres, 2016), 109.

32. Groff, "'All That Makes a Man's Mind More Active,'" 102.

33. Quoted in Dorr, *Memoir of John Fanning Watson*, 23. Deborah Logan observed these tendencies in Watson from their first visit. She explained in her diary that he was "engaged at present in Antiquarian Researches, and is writing a manuscript of his notices and observations . . . was really very entertaining;—[he carried] a note and Sketch Book in his Pocket to assist his memory.—he says he has left his Book with my Brother [Joseph Parker Norris] who has promised to add notes and Corrections: after which I am to see it." Diary of Deborah Norris Logan, 6:57–58. This notebook/sketchbook may be the same ledger-sized manuscript copy of the annals now in the LCP, which, as noted above, contains direct annotations by Deborah and Joseph Parker Norris along with many of Watson's own sketches.

34. John Fanning Watson, "Summer Excursions—Trip to Reading 1825; To Delaware Canal 1826; To Pennsb[ry] & Point-Breeze," Joseph Downs Collection of Manuscripts and Printed Ephemera 189, 58x29.4, quoted in Dietz, "John Fanning Watson," 14–16.

35. Diary of Deborah Norris Logan, 6:89, quoted in Jones, "Deborah Logan," 120, 122.

36. Diary of Deborah Norris Logan, 7:110.

37. "Billy Reger" is named as the chair's repairman in Deborah's diary, according to Jones, "Deborah Logan," 121. See also Deborah Louise Dependahl, "John Fanning Watson, Historian, 1779–1860" (master's thesis, University of Delaware, 1971), 76. Watson also called the group "The Penn Association." Almost all the subscribers personally signed the copy of Watson's manuscript annals at the HSP; see 2:447.

38. Donald L. Fennimore, *Metalwork in Early America: Copper and Its Alloys* (Winterthur, Del.: Winterthur Museum, 1996), 426; John Fanning Watson, with additions by Willis Hazard, *Annals of Philadelphia and Pennsylvania* [. . .], 3 vols. (Philadelphia: J. M. Stoddart, 1877), 2:101.

39. Watson's drawing is preserved in the manuscript annals at the HSP, 1:105. See Fennimore, *Metalwork in Early America*, 426, 455n104. See also Sommer, "John F. Watson," 301, figs. 2 and 3. The Burlington, New Jersey, Quaker silversmith Nathaniel Coleman removed the looking glasses from the doors of the Penn desk and bookcase about 1792 to hang on the walls of his parlor in his home on High Street. For an image of the Colemans in their parlor that includes one of the Penn looking glasses, see Pansylea Howard Wilburn, "Quaker Silversmith Nathaniel Coleman of Burlington, New Jersey," *Silver Magazine*, January/February 2001, 32–39. The watercolor by J. Collins, titled *Nathaniel Coleman and Wife* (1854) is in the Burlington County Historical Society and can be found in Edgar de N. Mayhew and Minor Myers Jr., *A Documentary History of American Interiors from the Colonial Era to 1915* (New York: Charles Scribner's Sons, 1980), 118, fig. 58. Watson examined the desk and bookcase circa 1827–29, and perhaps acquired it for his own relic collection about that time. Watson probably left the desk and bookcase to John Jay Smith, his "disciple" and the librarian of the Loganian Library, who gave it to the library in 1873. See the object file for the desk at the LCP.

40. John Jay Smith to Watson, May 8, 1827, "Letters and Communications to John F. Watson, 1823–1828," Am 30163, box 2, 229, HSP, quoted in Linda August, "Penn's Desk," http://www.library company.org/artifacts/pennsdesk.htm.

41. Watson's relic box may have been made as a lady's sewing box. In the published *Annals*, in the section titled "Relics and Remembrances," Watson lists many relics from early Philadelphia and their present owners. "There is in my house, a lady's

314

work-stand, of the Treaty tree, ornamented with the walnut tree of the Hall of Independence, and, with some of the mahogany beam of Columbus' house &c." Watson, *Annals of Philadelphia* (1857 ed.), 2:502. The woods of the Winterthur Watson relic box correspond to this description and are elm, walnut, and mahogany.

42. Watson, manuscript annals at the LCP, 218.

43. Mary Donaldson may or may not have a connection to the Mary Ann Donaldson who was governess to the Haines family at Wyck, and who may have played a role in Reuben Haines's acquisition of the Franklin armchair.

44. This view is Watson's own re-creation of the popular William Birch view of the Treaty Tree, which had blown over in a storm about 1810. His colored sketch appears on p. 241 of the manuscript annals at the LCP.

45. Voltaire's *Lettres philosophiques* (1733) described Penn's 1682 treaty as "the only treaty between those people and the Christians that was not ratified by an oath and that was never infring'd." Voltaire's "made without an oath and never broken," often shortened as "unbroken faith," became a common saying in the cult of the Treaty Tree tradition, as seen accompanying Edward Hicks paintings that alluded to Benjamin West's monumental history painting *Penn's Treaty with the Indians*, and in prints such as the George Lehman image of the tree at Shackamaxon (ca. 1827), now at Kensington. Andrew Newman, *On Records: Delaware Indians, Colonists, and the Media of History and Memory* (Lincoln: University of Nebraska Press, 2012), 98–101.

46. An identical box sold at Pook & Pook in Downingtown, Pennsylvania, on October 10, 2016,

lot 1623. This Treaty Tree box is inscribed to the American Philosophical Society from Roberts Vaux, 1818. https://www.pookandpook.com /lot/painted-penn-s-treaty-1682-unbroken-fait h-elm-trin-1596287, accessed April 9, 2018.

47. Sarah Miller Walker (1799–1874) was a young lady who spent time with Deborah Logan as a companion in her older age and absorbed Deborah's antiquarian inclinations. A series of letters from Deborah to Sarah at the HSP suggest that Deborah helped Sarah weather the emotional storm of a relationship with a suitor that had gone wrong.

48. Watson's caption for this images reads, "This picture, altho' *rough* presents an accurate delineation of the Trunk and limbs of the great Elm tree at Kensington where Wm. Penn held his Indian treaty—Long it stood, an emblem of his *Unbroken Faith*! Many fragments of the tree have been preserved as *Relics*—I have some x." See his manuscript annals at the LCP, 241. See also Newman, *On Records*, 99. Like Watson's *Annals*, Watson and Smith's *American Historical and Literary Curiosities* presents a collection of objects and historical documents, in this case using lithographs.

49. Quoted in Dorr, *Memoir of John Fanning Watson*, 32.

50. Watson, *Annals of Philadelphia* (1857 ed.), 2:503.

51. For a recent study examining the long-term effects of a nostalgic approach to history in Germantown, see David W. Young, "The Battles of Germantown: Public History and Preservation in America's Most Historic Neighborhood During the Twentieth Century" (PhD diss., Ohio State University, 2009).

Contributors

GEORGE W. BOUDREAU is a cultural historian of eighteenth-century Anglo-America; his research focuses on exploring the intersections of historic spaces, objects, and texts. A 1998 PhD from Indiana University, he has received research fellowships from the Philadelphia (now McNeil) Center for Early American Studies, Library Company of Philadelphia, American Philosophical Society, David Library of the American Revolution, Jamestown Rediscovery–Omohundro Institute for Early American History and Culture, and International Center for Jefferson Studies at Monticello. An active public historian, he has worked with numerous historic sites for decades, and has directed six summer teachers' programs, sponsored by the National Endowment for the Humanities, between 2005 and 2016. His 2012 book *Independence: A Guide to Historic Philadelphia* combines his two fields of interest. He is currently completing a book on the interpretation of historic sites.

PAUL G. E. CLEMENS teaches colonial and constitutional history at Rutgers University in New Brunswick. He received his PhD from the University of Wisconsin–Madison in 1974. In 1980 he published *The Atlantic Economy and Colonial Maryland's Eastern Shore: From Tobacco to Grain*, and subsequently published a series of articles, often with the late Lucy Simler as coauthor, about colonial labor and population questions in colonial Pennsylvania, and on consumer behavior in the middle Atlantic region. His most recent book is *Rutgers Since 1945: A History of the State University of New Jersey*.

EDWARD S. COOKE JR., the Charles F. Montgomery Professor of American Decorative Arts in the Department of the History of Art at Yale University, focuses on American material culture and decorative arts from the seventeenth

century to the present. More recently, he has explored material culture in a comparative global perspective. He is currently finishing a book on the self-invention of Boston in the context of the Atlantic world in the period 1680 to 1720.

STEPHEN G. HAGUE is a historian of Britain and its empire at Rowan University in New Jersey. He is the author of *The Gentleman's House in the British Atlantic World, 1680–1780* (2015), which explores the interstitial boundary between the upper middling sort and lesser landed gentry in the eighteenth century by examining small classical houses in England and British North America. He has published on the gentleman's houses in the Atlantic world, neo-Georgian architecture during the Colonial Revival, historic buildings and community, and the architects Charles Barry and A.W. N. Pugin. He has held fellowships at the Lewis Walpole Library, the Winterthur Museum and Library, the Athenaeum of Philadelphia, and the Library Company of Philadelphia. He has a doctorate from Oxford University and is a Supernumerary Fellow of Linacre College, Oxford.

PATRICIA JOHNSTON, the Rev. J. Gerard Mears, S.J., Chair in Fine Arts at the College of the Holy Cross, is a scholar of American art and its wider visual culture. Her edited volume *Seeing High and Low: Representing Social Conflict in American Visual Culture* (2006) examines how concepts of high and low art changed from the eighteenth to the twentieth centuries, and how this evolution influenced representations of social conditions. Her first book, *Real Fantasies: Edward Steichen's Advertising Photography* (1997), won three awards for its study of the relationship between fine and commercial photography. She has held research fellowships from the Smithsonian American Art Museum, American Antiquarian Society, Charles Warren Center

316

for Studies in American History at Harvard University, and the Research Division of the National Endowment for the Humanities. She directed five NEH summer institutes on early American art. In 2010 and 2014, she organized international conferences, supported by the Terra Foundation for American Art, which were the basis for her most recent book, *Global Trade and Visual Arts in Federal New England*, edited with Caroline Frank (2014).

LAURA C. KEIM is the curator of Stenton, the ca. 1730 seat of the Logan family near Germantown. She was the curator of Wyck, home of the Wistar-Haines family, also in Germantown, and continues to serve as curatorial advisor to Historic Germantown, the consortium of sixteen sites in Northwest Philadelphia. She is a lecturer in the Graduate Program in Historic Preservation at the University of Pennsylvania and holds an MS from that program, an MA in early American culture from the University of Delaware's Winterthur Program, and an AB in art history from Smith College. She has published a Stenton guidebook, the exhibition catalogue *Logania: Stenton Collections Reassembled*, and articles in the *Magazine Antiques, Antiques and Fine Art*, and *Ceramics in America*. Her primary research interests include architecture, the decorative arts, the material culture of the British and North American Atlantic world in the eighteenth and early nineteenth centuries, and the history of collecting and reinvention of the past in England and America.

MARGARETTA MARKLE LOVELL is a cultural historian working at the intersection of history, art history, anthropology, and museology. She holds the Jay D. McEvoy Chair in the History of American Art at the University of California, Berkeley, and studies material culture, painting, architecture, and design in what is now the United States. She received her PhD in American studies at Yale, and has taught at Stanford, Harvard, the University of Michigan, Ann Arbor, and the College of William and Mary. She has also held the Ednah Root Curatorial Chair for American Art at the Fine Arts Museums of San Francisco. Her

Art in a Season of Revolution: Painters, Artisans, and Patrons in Early America was awarded the Smithsonian American Art Museum's Charles Eldredge prize. Current research interests include eighteenth-century American painting and decorative arts, with an emphasis on artists, artisans, their markets, and their patrons; nineteenth-century American painting (especially landscape painting); and aesthetic theory. She is currently working on a book on Fitz Henry Lane and an article on a Scottish-owned painting by John Singleton Copley.

ELLEN G. MILES is curator emerita, Department of Painting and Sculpture, at the Smithsonian National Portrait Gallery. After earning a BA from Bryn Mawr College and a PhD from Yale University, she joined the curatorial staff of the National Portrait Gallery, where her gallery publications and exhibitions include *American Colonial Portraits, 1700–1776* (with Richard Saunders, 1987); *Saint-Memin and the Neoclassical Profile Portrait in America* (1995); *George and Martha Washington: Portraits from the Presidential Years* (1999); *A Brush with History: Paintings from the National Portrait Gallery* (with Carolyn Carr, a traveling exhibition of the collection, 2001); *Gilbert Stuart* (with Carrie Rebora Barratt, 2004); and *Capital Portraits: Treasures from Washington Private Collections* (with Carolyn Kinder Carr, 2011). She has contributed to several other museum collection catalogues, notably the National Gallery of Art's *American Paintings of the Eighteenth Century*, and has become an expert especially on Gilbert Stuart and on portraits of George Washington.

EMILY A. MURPHY has a BA in liberal arts from St. John's College in Annapolis, an MA in American studies from Pennsylvania State University, and a PhD in American studies from Boston University. She has worked in the field of public history for more than twenty years in both the private and the public sector, for historic house museums, the Special Collections Division of the Maryland State Archives, and, currently, in cultural resources management for the National Park Service. Her publications include *"A Complete and Generous Education": 300 Years of Liberal Arts, St. John's College, Annapolis;*

Merchants, Clerks, Citizens, and Soldiers: A History of the Second Corps of Cadets; and *Nathaniel Hawthorne's Salem: A Walking Tour of Literary Salem.*

NANCY SIEGEL is a professor of art history at Towson University and specializes in American landscape studies, print culture, and culinary history of the eighteenth and nineteenth centuries. Her current projects include the exhibition *Curious Taste: The Appeal of Transatlantic Satire,* and the book manuscript "Political Appetites: Revolution, Taste, and Culinary Activism in the Early Republic." She provides historical cooking demonstrations and lectures on culinary history, and she led the seminar "Culinary Culture: The Politics of American Foodways, 1765–1900" for the Center for Historic American Visual Culture at the American Antiquarian Society (2015). Her publications include *The Cultured Canvas: New Perspectives on American Landscape Painting* (2012); *River Views of the Hudson River School* (2009); *Within the Landscape: Essays on Nineteenth-Century American Art and Culture* (2005); *Along the Juniata: Thomas Cole and the Dissemination of American Landscape Imagery* (2003); and *The Morans: The Artistry of a Nineteenth-Century Family of Painter-Etchers* (2001).

CAROL EATON SOLTIS, project associate curator at the Philadelphia Museum of Art, received her PhD in the history of art at the University of Pennsylvania. She curated the first exhibition on Rembrandt Peale and wrote its catalogue while at the Historical Society of Pennsylvania. She assembled a catalogue raisonné of Rembrandt Peale's work for the Peale Family Papers at the National Portrait Gallery, where she cocurated an exhibition on Rembrandt and contributed to its catalogue. She has written and lectured on a variety of aspects of antebellum American art and was cocurator and coauthor of the exhibition and catalogue *Thomas Sully: Painted Performance.* Her most recent book, *The Art of the Peales,* is an in-depth catalogue of the Philadelphia Museum of Art's Peale Collection.

JENNIFER VAN HORN holds a joint appointment as assistant professor in the Department of Art History and the Department of History at the University of Delaware. She teaches courses in American art, material culture, and museum studies. She is the author of *The Power of Objects in Eighteenth-Century British America* (2017), which was a finalist for the George Washington Prize (2018). She has also published essays on George Washington's dentures, women's needlework, and iconoclasm in the Civil War South. Her current research focuses on slavery and portraiture. She is completing a book tentatively titled *Resisting the Art of Enslavement: Slavery and Portraiture in American Art, 1720–1890,* about the role enslaved African Americans played as producers and viewers of portraits in the plantation South.

Index

325